DOWN TO EARTH

Stellar Inflight presents this book to

Anne Willis of Spafax

to mark the 2001 Brisbane Conference
of the World Airline Entertainment Association

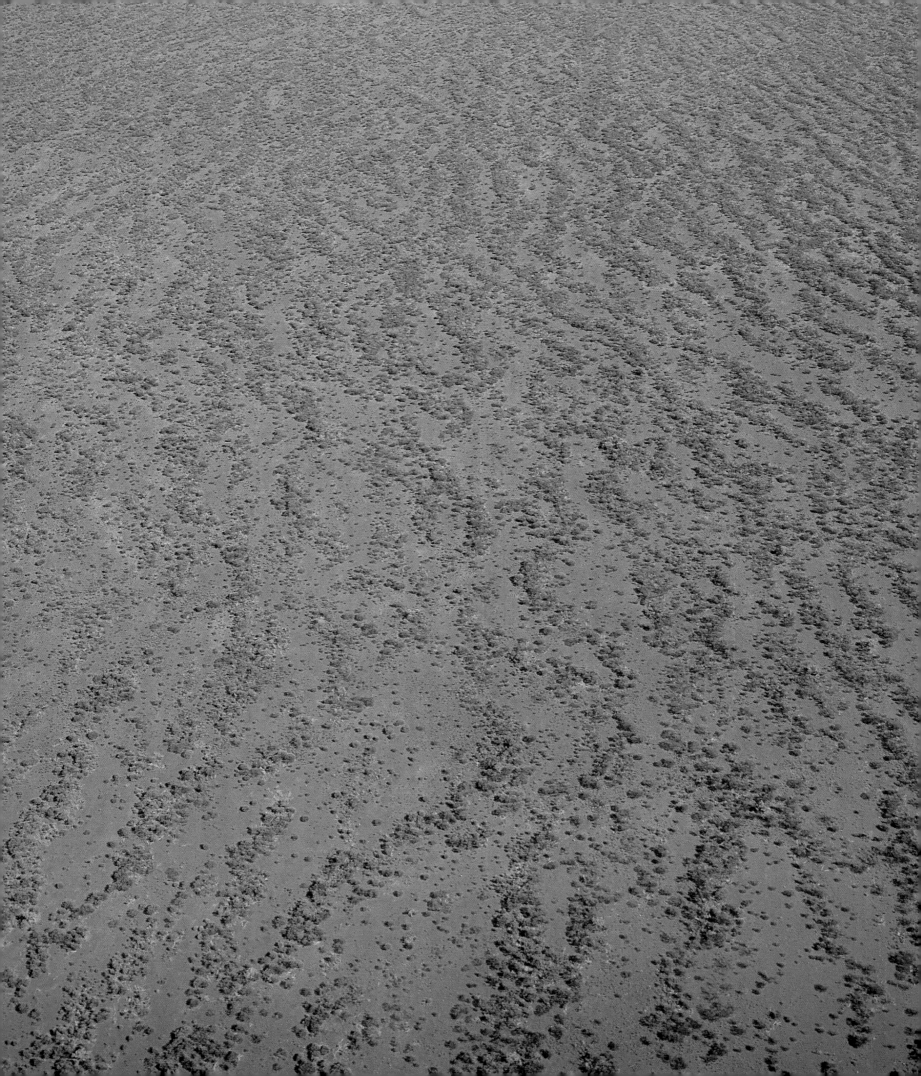

DOWN TO EARTH
AUSTRALIAN LANDSCAPES

RICHARD WOLDENDORP

TIM WINTON

FREMANTLE ARTS CENTRE PRESS
IN ASSOCIATION WITH SANDPIPER PRESS

First published 1999 by
Fremantle Arts Centre Press
in association with Sandpiper Press
PO Box 158, North Fremantle
Western Australia 6159.
http://www.facp.iinet.net.au

Reprinted 2000.

Designer John Douglass, Brown Cow Design
Production Manager Cate Sutherland

Typeset by Fremantle Arts Centre Press
and printed by South Wind Productions, Singapore.

National Library of Australia
Cataloguing-in-Publication data:

 Woldendorp, Richard, 1927- .
 Down to Earth.

 ISBN 1 86368 259 7.

 1. Australia - Pictorial works. I. Winton, Tim, 1960- . II. Title.

 994

The State of Western Australia has made an investment in this
project through ArtsWA in association with the Lotteries Commission.

For Lyn, my wife.

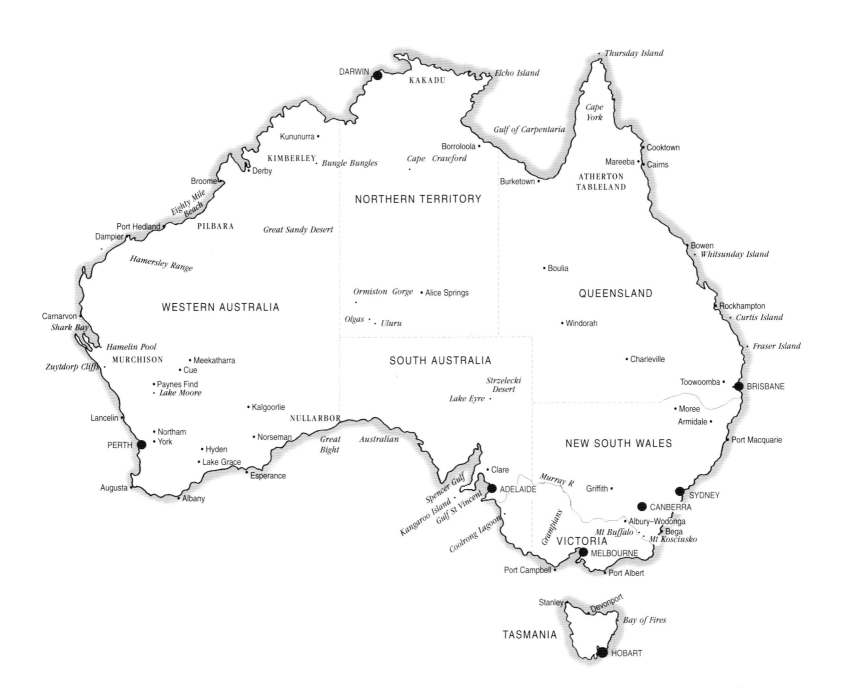

DARWIN

KAKADU

• Thursday Island

Elcho Island

Cape
York

Gulf of Carpentaria

Kununurra •

KIMBERLEY • Bungle Bungles

Borroloola •

Cape Crawford

Cooktown

Mareeba

Cairns

Broome

Eighty Mile
Beach

Burketown •

ATHERTON
TABLELAND

NORTHERN TERRITORY

Port Hedland

PILBARA

Great Sandy Desert

Bowen

Whitsunday Island

Dampier

Hamersley Range

Boulia •

QUEENSLAND

WESTERN AUSTRALIA

Ormiston Gorge • Alice Springs

Rockhampton

Carnarvon

Curtis Island

Shark Bay

Olgas • Uluru

Windorah •

Fraser Island

Hamelin Pool

MURCHISON

• Meekatharra

• Cue

SOUTH AUSTRALIA

Charleville •

Toowoomba

BRISBANE

Zuytdorp Cliffs

• Paynes Find
• Lake Moore

Strzelecki
Desert

Moree

• Kalgoorlie

Lake Eyre •

Armidale

Lancelin

NULLARBOR

NEW SOUTH WALES

Port Macquarie

• Northam

PERTH • York

• Norseman

Great
Bight

Australian

Clare •

Hyden •

• Lake Grace

Murray R

Griffith •

SYDNEY

Esperance

Spencer Gulf

ADELAIDE

CANBERRA

Augusta

Kangaroo Island

Albury–Wodonga

• Albany

Gulf St Vincent

Grampians

Mt Buffalo

Bega

Mt Kosciusko

Coolrong Lagoon

VICTORIA

MELBOURNE

Port Campbell •

Port Albert

Stanley

Devonport

Bay of Fires

TASMANIA

HOBART

FOREWORD

Since arriving from Holland some forty-eight years ago, I have been fascinated with the Australian landscape. Among the many reasons for this is the sheer contrast between this country and my place of birth. In fact, the landscape is completely different from anything I had experienced in the northern hemisphere. The Australian landscape may not manifest the same kind of grandeur as other parts of the world, but it has its own particular forms and a unique flora and fauna that have created the distinctly Australian character. Reflecting my own discovery and revelation of this unique character, my first book, with Peter Slater, was appropriately named *Hidden Face of Australia*.

Later, in the 1980s, I released a book with Reader's Digest, *Australia, The Untamed Land*, and this was the beginning of my approach of viewing Australia from the air. The aerial perspective gave me an overview on this worn-down landscape, as well as a better understanding of the evolution of the continent. From above, the skin of the earth can be seen, the growth patterns and the weathering down of the years. I also like the aerial point of view as it gives me the opportunity to produce more graphic images, images that have a painterly quality. This perhaps, in part, is because of my early training in painting and graphic arts.

This book contains photographs accumulated over many years. Photographs that reflect moments of discovery, of pattern and form, often of unusual aspects of the natural landscapes. But I am also intrigued by the man-made world, in particular the effect of the seasonal activity of agriculture on the landscape.

However, it is really with nature that I feel the strongest sense of wonderment and excitement. It also excites me to know that I will never complete the task of seeing, and learning from, the diversity of Australia.

Richard Woldendorp

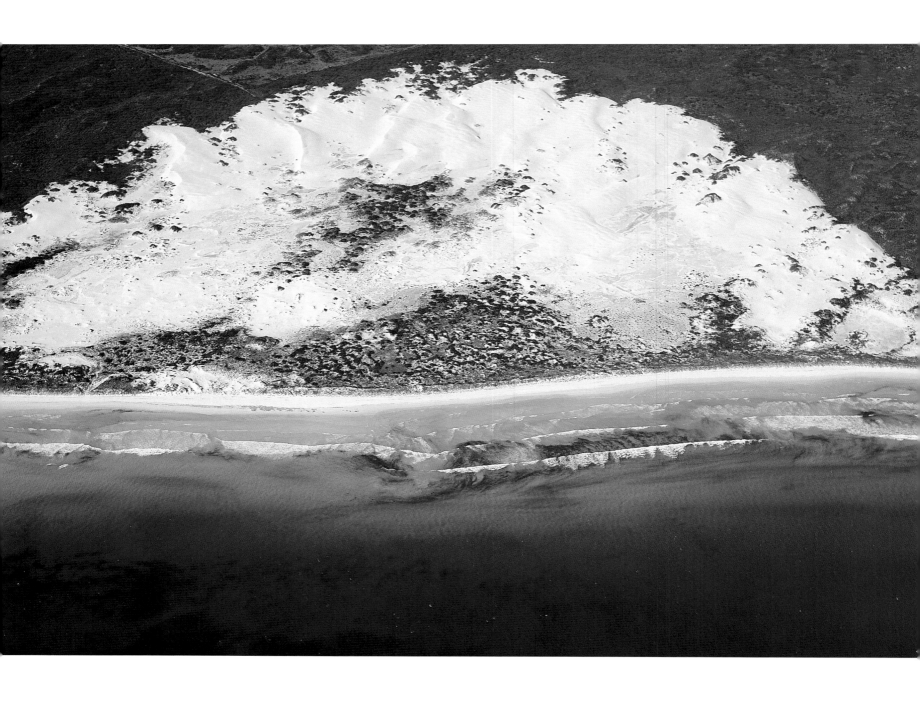

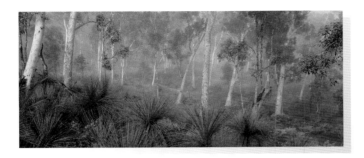

STRANGE PASSION
a landscape memoir

BY

Tim Winton

I

Landscape is a personal passion of mine, perhaps even an obsession. I travel silly distances, undergo myriad discomforts to be out in it, to revisit country I'm intimate with, encounter places and landforms I'm a stranger to. I seek out images of landscape in art and literature, feel it drawing me with a force I can't always explain, but it's an itch I scratch without ever having to feel particularly lonely because it seems that many Australians share a similar preoccupation. We go to it for different reasons. We bring our own baggage, take away a range of emotions, experience the land in all our deep and shallow ways and, whether we grow up with this urge or have it come upon us late in life, it's a palpable hunger. Australians have a real fascination with

open spaces. Just imagine what the nation spends each year heading out to camp, climb, hike, fish or explore by four-wheel drive. Much of that money goes into equipment never used, plans never more than notional, but the idea is stuck in our heads. The land is out there. Somehow its looming presence presses upon us, perhaps even helps define us. The best of our painters and poets and prophets have taken their inspiration from it as have the richest and most cynical advertisers. No matter how urbanised (or suburbanised) we become, our interest in landscape intensifies rather than diminishes.

A strange passion, really, in a world growing more abstract by the minute. Strange, too, considering how the first newcomers to terra australis

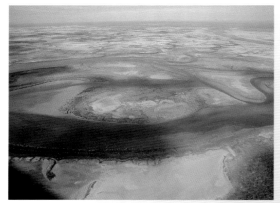

felt about this continent that loomed suddenly from the bushfire haze centuries ago. How they loathed it for failing to be Europe. How infuriated they were at its 'perversity', its odd weather and backward running rivers and kooky animals. How disappointed they were time and again. Witness the names: Bitter Creek, Useless Loop, Mount Misery. A 'fresh' continent, the great south land 'discovered' at last, but what collective disappointments, what confounding of expectations must have ensued for the English to be only able to imagine the future of their new possession as a dumping ground for the Victorian underclass. It strikes me as stranger still that after being horrified by the place for so long, people had warmed to it before the end of last century, devised a whole mythology in song and ballad and gone all nationalistic over it. Suddenly they felt they had the hang of it. But did we ever really get the hang of terra australis? How much of our enthusiasm for landscape masks the anxieties still with us? Do we love it for itself or simply because it's supposedly ours? One reason many of us love it is because it used to be the biggest thing in our lives. For a few of us, it might still be. The land itself and its indigenes are still the most impressive, most distinctive features of Australia. No post-invasion achievement, no architecture, no monument, no cultural

outpouring, not even the casual and liberal lifestyle many of us revel in, has held a spark to the grandeur of the land itself. Everything we do is over-shadowed by the pure silence of the interior, by hallucinatory clouds of cockatoos, by water grinding against rock, by the chatter of mangroves clicking and tut-tutting in the tide, by the silhouette of Uluru, the spread fingers of Sydney Harbour, the honeycomb of coral reefs spawning, seen and unseen.

I'm preoccupied with landscape because there was more of it than anything else in my life. It was the architecture I learned as a child. Living in the paved over spaces of Europe, years later, I realised that architecture is what you finally console yourself with once you've brought the landscape to its knees. At its most egotistical and monumental, architecture finds itself a sad and desperate parody of nature or else a shaking of the fist in its face. Even at its best it comes off a poor second to natural forms. Sydney's opera house and harbour bridge seem a bit try-hard after Uluru or the Bungle-Bungles. I pray that my children never see the final taming of the land by industrial force, but unless Australians come to terms with the idea of a balance between culture and nature, I fear it's inevitable. Because despite our affection for it, we remain essentially at war with the land, like our invading ancestors. Some part of us still feels that landscape is enemy territory until we transform it, make it in our image.

II

I grew up in the outer suburbs of Perth in the 1960s. Not a promising start for a landscape lover, you might think. In the 1950s the coastal bushland of Karrinyup began to be bulldozed to make way for cheap public housing. The old dunes which bore marri, tuarts, banksias, acacias and considerable

wildlife were bulldozed and our grid of limestone streets became the latest suburb. Within a street or two all around, the bush resumed. It was a place in transition.

At the end of our street the great wild space of the swamp loomed, drawing everything to it, rain, birds, frogs, snakes. As you walked toward it, the noise of nature overrode the tinkle of Pope sprinklers. As kids we roamed the land on foot or on our fat-tyred Dragstar bikes.

We hid in hollow logs, tried to knock parrots from trees with our gings, encountered dugites and bobtails, bees and strafing magpies in our meandering daily journeys. The swamp was, of course, the ultimate destination, but enigmatic, fraught with danger. Kids made rafts from the upturned roofs of old cars and paddled precariously through the reeds onto the lake proper. They dug bunkers and built humpies, stripped stolen bikes and garnered vast collections of frogs and tadpoles. There were stories of quicksand, of capsizes and skirmishes with strangers. In the faint distance, market gardens pumped soak water into the air. I yearned for the swamp and its thrum of life. The street was so uniform, such an earnest attempt at order, and where it ended the chaos of life resumed. From swathes of drying lupins and bread-coloured wild oats the steely surface of the lake appeared like the suddenly opened eye of God. Waterbirds whose names I never knew rose in clouds. The reeds hissed and trembled around the footsucking perimeter.

We searched for lost toddlers down there, went out in phalanxes to recover dogs or bikes. We lit fires and fought them, felt the land cool and warm underfoot.

I lived outside. I wanted to always be out there and I only came indoors under threat of a thrashing, to eat or sleep or wash.

But it was a retreating landscape, the bushland of my childhood. For a good while, without us really noticing, the bush shrank by increments as the suburb grew and the roads were paved. More houses were built, more

families moved in, people from the English midlands, from Serbia, the Netherlands. The street got a public phone box. People paved their driveways. The gully behind our place was bulldozed and the trees burned, the ash raked flat to make way for the football oval. I liked the oval, eventually, but bare hectares of mowed grass, even grass with the magnetic focus of goalposts at either end, had no power like the mazelike tracks and bowers that preceded it. Year after year secret places disappeared.

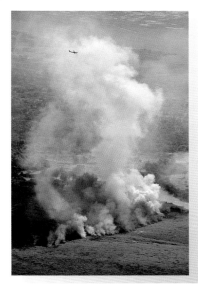

Up the hill an enormous tract of bush was torn down to build a shopping mall with a carpark that seemed as big as an airport. Windrows of tuarts and banksias burned for days, and at sunset sparks rose into the deepening summer sky. From our bikes we saw a new era ushered in, the beginning of the hypermall. These shopping satellites were stepping stones in the construction of an unchecked suburban sprawl which made Perth the bland, car-oriented city it has become. Year after year the bush burns and the coastal plain coagulates with tract housing, dormitory suburbs of brick, tile and reticulation. I imagine there are kids living out at every edge, in transitional places like the one I grew up in, but I suspect that the rate of transition, the momentum of clearing and selling, building and paving is now so fast that a child has no time to learn secret places, to make a relationship with the landscape beyond the surveyors' pegs.

In his deeply idiosyncratic memoir, *False Economy*, the nature writer William Lines describes a boyhood at Gosnells at the extreme opposite end of Perth where a similar semi-rural place was transformed in the era of blustering expansionism. His story, full of bitterness and regret, predates my boyhood by ten years and his experience was more a forest one than my coastal scrubland version, but I hear him loud and clear when he writes:

> Ever busy, ever building, ever in motion, ever discarding the old
> for the new, few people paused to think about what they were so

busy building and what they had destroyed and thrown away. But most of what they built was depressing, brutal and ugly. [1]

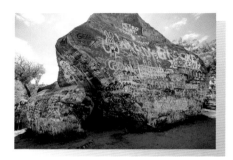

I never knew the Gosnells of Lines' childhood but the first time I saw the long, inflamed colon of Albany Highway in the late sixties it seemed like a harsh version of purgatory indeed: strings of neon caryards, boxy housing developments and industrial gulags. There was no hint of the jarrah forest that preceded it. Like any kid I didn't imagine that places had pasts until I saw them passing. Loss is an inevitable part of life but people have a right to expect something better for the passing of things. The mantra of economic growth relies on us all getting something bigger and better. History, as William Lines has written, taught us otherwise.

Other people must surely have found these surroundings as distressing as I did. Yet they were silent. Likely opponents lacked the vocabulary to understand the transformation of the world in which they lived. Few words existed to describe destruction. The dominance of the language of economics shrank alternative vocabularies. The leading men of Australia applauded the whole, endless clutter ... as growth and development. With their eyes on the future, most people were too busy to notice the spreading ugliness, and they unwittingly but irrevocably bequeathed ugliness to the future. [2]

III

I was always curious. An eavesdropper. I liked to poke at things with sticks. I was told not to stare but could never help myself. I liked to look at things. Often, though, looking simply isn't enough. Most of what I've learnt has come out of the corner of my eye. A feeling for place creeps up on you when

you're not trying to dig it up with your eyes. When it comes to landscape, seeing is about experience. This is among the hardest lessons that newcomers to Australia have had to learn. The earliest Dutch, English and French sailors who encountered the continent were confounded by what they saw because they saw through the lens of their culture, their class, their previous experience. And terra australis didn't quite compute. Later, the officers organising settlements like the Swan River Colony often saw and reported what was convenient to their ambitions. Intrepid Victorian explorers locked the land into the grids of their imperial maps, ignored features or beings they didn't want to see and saw what they did see as divinely provided for their conquest. They managed to 'see' in ways that never challenged their own vision. Years later D H Lawrence struggled doggedly to see past the limits of his cultural understanding when he tried to apprehend the Australian bush. In *Kangaroo* he writes:

> You feel you can't see — as if your eyes hadn't the vision in them
> to correspond with the outside landscape. [3]

It's such a truthful, painful admission of impotence.

In time experience gave those born to it or those visionary enough to understand it other means of seeing. Often this simply came from learnt responses to the land itself, emotions Australians developed about species, places, landforms. For many this came from generations of farming, lives of tilling, grazing, fencing and burning which produced an intimacy of sorts, a relationship with the soil, a knowledge of climate. Some of our urban nostalgia for landscape has its source in the period when Australia was largely an agricultural enterprise.

Australians did learn to love their landscape. Often because they had to like it or lump it. For some, affection was wrung from their hearts by the sheer weight of pounds, shillings and pence as fortunes were made in wool, wheat and gold. To ambitious people who didn't mind bending a few rules,

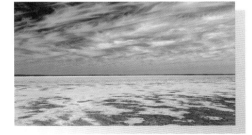

Australia was a land you could leave your mark on, make a reputation in, and in this regard not much has changed. But there were people who learned to love the landscape simply for itself. Naturalists, painters, moony middle sons, poets, mystics who allowed the ranges, gullies, deserts, forests, rivers and beaches to be no more useful than a source of wonder, as grist to nobody's mill. The bewildering diversity of species, the riches of isolation, the distinctness of region and place, the subtlety and beauty of the thing itself slowly emerged from the haze.

This learning to see has been a long, slow and sometimes bitter process. So often we couldn't see for looking. Sometimes, by the time we saw the pre-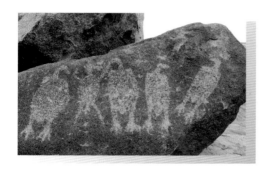ciousness of a landscape we had already destroyed it. This fumbling continues today. And all the while, for almost every moment of each of our centuries, we were blind to the original inhabitants who seemed a little blurry to the first newcomers, faint to the settlers and invisible to successive generations. For 40,000 years, perhaps more, Aboriginal peoples lived with their hard-won experience, so conjoined to the land that they saw almost without looking and by the time pink Australians began to feel pride in their conquered island it was as though the indigines had never been. So slowly, painfully, cruelly have we begun to see.

IV

I don't suppose it's any secret that the best way to see landscape is on foot. This is where the child has the natural advantage of being too young and too poor to drive. It's this enforced humility of means which often allows kids to see more in their surroundings. You travel slowly, with no urgent purpose, no watch to dog you, and you cross the same ground time and again, building up a picture of things; where the gum bulges best from the tree, where the yellow sand breaks the surface. You get a feel for the blossom

time of the Christmas tree, the up-close leafiness of lichen. I found the world outdoors, the open realm of landscape, offered more privacy than the indoor world of obligation. As a kid you often own little more than your privacy, your secret places, the thoughts in your head. Everything else you get is lent to you on stern conditions. I harboured what power I had up tuart trees, in burnt out logs or in the balding hollows behind scrubby dunes. I left a crowded, noisy house, the perpetually shared bedroom and wandered into my own space.

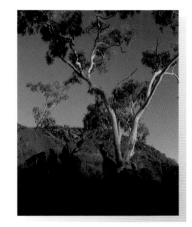

In landscape the world seemed properly open. The lines of the land followed contours that made sense. Wind blew this way, water flowed that way, the sun slanted from over there. Somehow I needed the open-endedness of natural forms in order to cultivate privacy. Part of this, of course, was the simple ability to get away from people, to get peace and quiet, to escape other people's requirements and demands and rules. Some of it was about inhabiting somewhere without reservation, a place you could experience with only internal rules of your own devising. And part of this open-endedness came from the simple low-tech behaviour of contemplation aided by the exquisite rhythms of the natural world — the fugue-like chants you fall into as a child walking in cool sand, the patterns of wind across water or the swaying crowns of trees, the sounds of cicadas or bees in long grass, the slow stroke of your own freestyle, the hiss of the stick you trail in the dirt all afternoon. Do we ever see more clearly than during these aimless days without agenda, mission or purpose? As an adult one buys audio tapes, joins relaxation classes, studies meditation in order to recapture the lost instincts of childhood. But secrets are still required to be divulged. They're bad for you, apparently. It's a strong or odd person these days who will maintain their own privacy in the face of the therapeutic and economic pressure to reveal all. The triumph of individualism over the relative communalism of earlier generations doesn't seem to have brought about any enhancement of privacy. The contemporary free market adult can barely remember what privacy is.

There is great power in being happily alone harbouring secrets in special places. Landscape so often provides these sanctuaries and we forget how precious they are.

When the bushland around my street began to disappear, a big part of my world began to be closed off. Roads, fences, drainage ditches literally sectioned the landscape up. Incisions, excisions and enclosures appeared slowly at first but at some point they were everywhere I looked. Bush finally gave way to the suburb and the realm of the private disappeared in favour of the public. Ugliness was suddenly upon us: the shopping bunkers, the carparks, the pine logs of public enclosure. In the end there was only the sea left unfenced, unowned. In the world of childhood it was a saving refuge and because of the shrinkage of my natural world I looked to it fiercely.

V

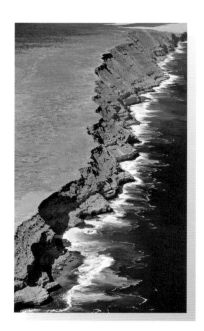

The rise of the Australian suburb truly celebrates the pre-eminence of the car in our lives. Our cities are built as much for the car, it seems, as for the citizen. We see more and more of life from the confines of the vehicle. How much landscape have I seen through the window of a car, I wonder? I suppose, like most of us, I've had Australia mediated at speed in bleary glimpses. Rather like all those similar drowsy hours having Australia blur past on TV. I look but see less than I like to think. In a car you can't smell the peculiar scents of places, you hear no birds, no wind, only the engine and your mum's Seekers tapes. You're oblivious to fluctuations in temperature, travel too fast to notice any creature that doesn't blunder into your roobar. You might be in the landscape but you're not of it.

In the summer of '69 and '70 my parents bought a Hillman Hunter and a trailer camper and drove the family

across the continent. We were gone six weeks or more and saw so many people and places. Some places were more notions than places: the endless red dirt beyond Kalgoorlie and Norseman, the dreamlike vista of saltbush on the Nullarbor Plain. I remember staring, wobbly-kneed, at the edge of a huge blowhole in the desert that connected with the grinding sea of the Great Australian Bight. I felt it like a vortex, sucking me into the world beneath the earth's skin, and in the end I retreated, shaken, to the sweaty back seat of the Hillman.

In those days the road across the Nullarbor was unsealed, a great unbending limestone track whose dust rendered us ghostlike at day's end. The plain itself was supposed to be 'empty' and at car speed it certainly looked vacant, but in our too brief stops, with the motor finally off we found otherwise. It sometimes took twenty minutes for our heads to clear before we could hear birds, notice tiny tracks, see that there were marsupi-

als, birds and reptiles aplenty. My brother and I took our natural history so earnestly that while we were camped in a gravel pit somewhere near Eucla we took some time to inves- 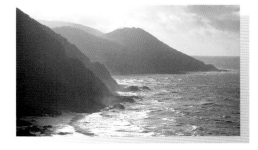 tigate what seemed to us to be the shed carapace of some arid-lands creature we found in a washout some distance from camp. Years later my mother informed us that what we'd been marvelling about was in fact a capaciously used but mercifully weatherbeaten sanitary pad which she hadn't the nerve to identify there and then.

Television delivers landscape in pretty pictures; it's almost impossible to experience this way, and sadly the car muffles the experience similarly. At best, places are overlaid with emotion. How we felt when we saw something helps us to recall it. True, I was awestruck and frightened by the blowhole near the Bight; I was suitably humbled. But I was carsick at Glenrowan, hungry all along the Great Ocean Road, bitched with my brother around the Murray River, though I managed to see blinding white flocks of cockatoos between punches. Since then I've been depressed at 110 kilometre per hour through the stony range country outside Alice Springs,

worried about fuel on the Gibb River Road, and for many thousands of kilo-metres could honestly have been driving through a carwash for all I noticed. But I have seen things through the windscreen to strike me dumb. Like solitary dunes spaced kilometres apart in the Pilbara, each facing faultlessly in uniform direction, rising like storm swells with glittering stones at their crests, marching from the interior towards the distant sea. Or trees along the Greenough floodplain whose crowns kiss the soil in deference to the perpetual southerly. Even the sight of the vast veined mudscape of King

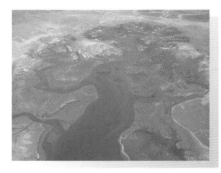

Sound near Derby as the tide seems to suck all moisture from the ground, the very sap from the glossy mangroves. Sometimes you're wrenched from the vacuum in the vehicle, simply unable to let yourself blow through without at least the most superficial experience of a place. You hear the wingbeats of a wedgetail eagle, the whoosh of a barramundi sucking down a mullet, see a leafball of green ants hanging from a branch near your face and stay long enough to hear that chick-ering within which sounds to me like nothing less than gossip.

VI

To see, you need to stay. The landscape that affected me most after my childhood in the shrinking bushland of northern Perth was the south coast of Western Australia. My father was transferred to Albany and I went literally kicking and screaming. I might have been carsick in Glenrowan, but I was soulsick in Albany, lonely and confused in that peculiarly adolescent way. Miserable for a long time, yes. But I stayed long enough for the sombre, acne-scarred extrusions of granite, the peopleless powder-white beaches and the rainlashed fragrant heathlands to console me somehow, to penetrate my vision past mere glimpsing.

One means of such absorption in landscape was surfing. Originally I surfed simply for the creaturely, thoughtless thrill of speed like any young

man, but the hours and hours spent sitting in cold southern water waiting for swells to arrive seemed to sharpen my senses and gave me time to notice the way the wind and sea chewed away at the cliffs, how the reefs we surfed seemed to be remnants of these same cliffs, evidence of a steady process. I surfed with dolphins and less enthusiastically with sharks, saw the water black with salmon, watched ten kinds of seabirds feast on pilchards. I felt in the end, as though I was a part of something. Some days I surfed with hippies — older, weathered blokes whose conversation I enjoyed. They had whimsical opinions about nature I'd never encountered before, romantic views that were, I suppose, part of the seventies zeitgeist. They smoked dope and lived on the dole, 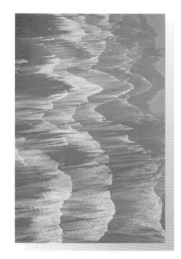 moving from place to place with their aged-looking women and snot-nosed children, and surfed as though it was their vocation. Any place with people in it was suspect to them. The city was irredeemably corrupt and the world had lost its way. I was fourteen, the churchgoing son of the local cop, but I was for the hippies. In town the respectable citizenry were butchering whales and bussing tourists out to witness the fun while the state's most remarkable natural harbour turned into an industrial drain. A stinking scum of algae suffocated the life out of the broad estuarine shallows. Crabs and mussels became poisonous to eat. The local fathers preached the sacred inevitability of progress and I had the feeling that those idle primitives in their vans at the beach were hardly less reasonable in their particular unreasonableness. They sure as hell did less damage.

I trekked and camped along the coast, fished for groper from dolerite bluffs, climbed the Stirling and Porongorup Ranges, wriggled into caves and canoed creeks and inlets to feel the places eating into me, making marks I could feel more than understand. Even though I left at sixteen, I return often to this region to drink places in. Not simply to revisit my lost youth, but to reacquaint myself with the particularities of the region, the odd smell of the heath scrub, the bloody flowers of the red flowering gum, the

turquoise bays unlike any other in the world, the blue unAustralian light which forms shadows you can see into, the remnant stands of karri shivering above coppery inlets. It was these places that taught me how small I was. Not small the way a child often feels, wanting desperately to be big

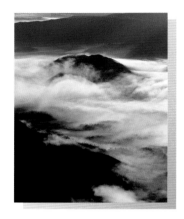

and thereby earn the privileges of citizenship and adulthood. Small in a way that was illuminating and entirely satisfactory. Scrambling up a rockface, tumbling blind along the seabed and pressed down by waves beyond the limits of breath and strength, or fumbling numb-knuckled with matches and twigs to make a fire in the rain, you learn a kind of humility which schooling, politics and television couldn't provide. All the talk around me insisted that I was a master of the universe, a human, and a white one at that. I was the whole point of things. That strange dark landscape around Albany told me otherwise and it was a relief to know.

VII

Wilderness appealed to those bored or disgusted with man and his works. It not only offered an escape from society but also was an ideal stage for the Romantic individual to exercise the cult that he frequently made of his own soul. The solitude and total freedom of the wilderness created a perfect setting for either melancholy or exultation.

Roderick Nash,
Wilderness and the American Mind

Roderick Nash's alkaline and terribly respectable definition of the nature lover would probably describe my outlook arriving back in the city to begin university. I was romantic and short on irony and a little out of step with the times. The first time I saw the campus I felt my soul shrink. Set amidst

the sterile battalions of a pine plantation it mimicked the style of the concrete bunker shopping mall that had eaten up 'my' bushland at Karrinyup. It was and remains an architectural atrocity, a storage facility, an industrial space with niggardly corridors, mean fittings and bolted windows. Every room reeked of cigarette smoke and nylon carpet. The very ugliness of the place made me feel captive there. I've been in airports I'd rather spend four years in. In a way the cynical architecture matched the times. I was a would-be hippy surrounded by punk-rockers. Industrial-ugly was chic; it came with a flippant nihilism I could never manage. As an eighteen year old I could still be the only person in a tutorial who might read Wordsworth's 'Tintern Abbey' without sneering. I wanted the natural world to have me:

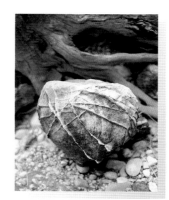

> ... laid asleep
> While with an eye made quiet by the power
> Of harmony, and the deep power of joy,
> We see into the life of things.

Being a little out of step, I think, helped me learn to write. There's nothing like feeling misunderstood to send you careering on your way.

Between semesters I escaped with my camping gear, my surfboard and notebooks and roamed the beaches and heathland of the south coast. I wrote two novels inspired by this landscape, stories that arose from places, not people. I peppered that rainy world of aquamarine inlets and grey granite faces with adjectives like 'sombre', 'brooding', 'haunted', 'indifferent'. Okay, I was projecting, but I was finding my way. I wrote about characters who proceeded from such places and whose own adjectives tended to follow suit. If they were anything my stories were about figures in landscape. Writing husbanded an interest in people, forced me to deal with them as characters, I suppose, which kept me connected to

the human world, but I was just as interested in those characters' relationship to the natural world as I was in their fumbling interaction with each other.

People's anxieties about relationships are the prime ground for fiction. I've always been fascinated by Australians' other anxiety, their worrisome itch about the land. Something about the country bothers us, and I suspect it's not completely dissimilar to what bothers us about each other — that is, who has the upper hand? Where does the real power lie?

I have been in places where I've felt this anxiety. Some forests like the dense karri and tingle stands of the southwest of WA can still induce in me

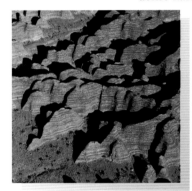

a mild, pattering panic, with their choking undergrowth and skyless canopies. How my relatives hated and feared those trees, celebrating in clearings they hacked out, claiming victory over something that was not at war with them, though in their frustration they believed it conspired against them. I've stood shaking in mazelike gorges in the Kimberley, been apprehensive in caves in the interior whose ceilings bristle with the mouthless faces of Wandjinas. I've retreated anxiously to the four-wheel drive more than once after walking a short way into the desert.

Some of this is the simple power of beauty. The old cliché of something being 'breathtaking'. In the technological age it's still possible to be awestruck by form, by grandeur of scale, by the mystery of process, of evolution. Quite often in Australia the power landscape holds over us is the palpable power of life and death. Seeing a tide thick with fish, a soak refilling from an unseen source, a native plum heavy with fruit, this bounty seems more precious when one knows how thin the margin of error is for the business of survival on this land. I've been awestruck, appalled and even afraid upon arriving somewhere that I simply can't take in. There's a panic in being unable to imagine or integrate a piece of landscape, and it's often amusing to take people back to places I've become naturalised to and to observe their very similar reactions.

A much more threatening power that our landscape holds is in its ability to cause us to think, to remember, to consider. In the nineteenth century Anthony Trollope wrote of it:

> One seems to ride forever and come to nothing, and to relinquish at last the very idea of an object ... Of all the places that I was ever in this place seemed to be the fittest for contemplation. [4]

Many Australians and visitors have experienced journeys here that turn out to be more process than arrival. Nolan, Boyd, John Wolseley and Patrick White have all worked with this kind of inspiration. The size and scale of the continent has produced hard-won spiritual insights. It has been one of the great religious places of the world and may yet be again.

Distance can be so overwhelming as to bring things to a standstill. Landscapes change so slowly as you go that you lose time altogether. I have driven in the Pilbara, in the Territory and the Kimberleys when one seems to be doing little more than running on the spot at 3500rpm. The going is more vivid than the getting there. For the traveller on horseback or bicycle or on foot, this is even more evident. What this induces is often illuminating. Time stops, you see into things. It can be exhilarating, it's true. But also terrible. In a chapter of his study of the antiquarian spirit in Australian history, *Hunters and Collectors*, Tom Griffiths deals with the horror and melancholy experienced by whites stirred by uneasy consciences. He quotes nature writer Alec Chisholm who sometimes felt uneasy:

> ... chiefly when dusk enveloped the ridges and gullies on dull days in winter. The ironbarks now had shed their friendliness. They were, perhaps, the revengeful phantoms of the black men who had once frequented these forests. Especially was I uneasy when passing a spot on a ridge-top in which white pipeclay contrasted with the sombre colour of the trees. [5]

This reminds me strongly of the story in the gospel of St Mark where a man healed of his blindness blurts out, before he can even focus, that he sees 'men as trees, walking'. Alec Chisholm's suspicion that he sees trees as dead men walking is altogether less sunny. Tragically this apprehension of a brutal past in our landscape was mostly met with silence.

To the earliest visitors terra australis seemed blank, withholding. It confounded their expectations so they recoiled or simply projected onto it a sort of English fantasy which we see in early colonial art and some of which survives today in the deeply inappropriate names of birds and settlements. Later it seems, the invaders learned to close their eyes and minds to the wild forms of landscape for fear of seeing anything that might disturb the picture they had formed of their successful colonial lives. This racking down of the shutters has persisted to today. The nation's conscience

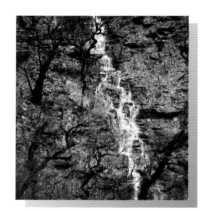

writes with the old anxieties of conquest, of racism and the emerging realisation that the land itself has been enclosed and defiled. Europeans brought to these shores their war against nature, their Enlightenment understanding of nature as a mere series of mechanisms. Conquest was their destiny, and the rise of industrialism made their conquests speedier, more thrilling. Aborigines, seen as fauna, were just a part of nature, the enemy to be subdued. The technological age has probably intensified this godlike delusion. The new reign of economics as a virtual theology reinforces it. Lots of fine work has been done in recent years by scholars looking anew at our history of conquest and subjugation, and slowly the stories of the indigenous experience emerge. Likewise we have new interpretations of our relationship to nature by philosophers and biologists and ecologists. The contempt these fresh perspectives are met with from those in power is a measure of the grip the myth of progress, the destiny of conquest, still has on the culture. Old reassuring symbols are clung to, it seems, regardless of what they really stand for. William Lines writes passionately about the symbol that the tree stump quickly became in Australian history. 'The

stump,' he says, 'represented victory' and not a few Australians would dearly like to remain in the stunted shadow it casts across our recent history. Some enthusiasts who believe nature should be respected but 'managed' have replaced the stump with the pine log. The greenish, arsenic-laced symbol of enclosure. Every beach, every grove of trees or national park, has a rash of them. A pine log denotes a piece of landscape of official interest. It says, look, there's some nature over there. Look, but don't touch, don't walk, don't go. Stay with your vehicle. Look, but do not experience, lest you see. Who says we don't appreciate nature? Who says we haven't moved on? The ubiquitous pine log proves it. It's the euphemistic barbed wire barrier between us and no-man's-land. It defines the limits between us and our old foe, the natural world. The inoffensive pine log is supposed to be a symbol of truce, I know, a sign of care and responsibility, but I'm afraid it looks like gloating to me. It's a sign of victory over nature, of policy over reverence, form over substance. At least a stump didn't strive for political correctness. It was brutal but plain speaking.

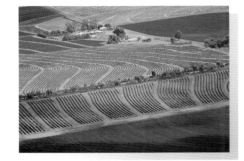

VIII

I was twenty-one the first time I flew in an aeroplane. On a flight from Perth to Sydney I saw the wheatbelt stretching breadlike into the saltlands and noticed how the two commingled ominously. We tracked over the Bight, crossing near Esperance and staying with the coast the whole distance to the Eyre Peninsula in South Australia. I'd seen these places before but now I struggled to connect them with my earlier view. The endless dreariness of the WA wheat country was changed to a subtle quilt of textures. The colour was mostly uniform blond, but light fell on crops of different height, stirred by wind, and it was beautiful. The Southern Ocean, usually a maelstrom, looked blue as nursery wallpaper. The cliffs of

the Bight still had shadow and therefore power, but the whitecaps of the Southern Ocean looked, from 10,000 metres, no more menacing than dandruff. The new perspective was fascinating but it left me with mixed feelings which I've never really resolved. Seeing the land from above offers a fresh outlook, something that can't be had in nature, so it always comes with a thrill and a shock at the very outrageousness of it. In a plane, too, you often see the geological connections between things, see landforms dissolve into one another. You can take it in quickly, comprehend distances (well, versions of distances) relieved for a while of human limitations.

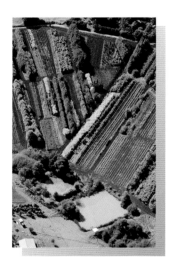

But so many things can be diminished from the air. Trees often seem belittled. So impressive on the ground in their life bearing and shade throwing, from a great altitude they're reduced to mere texture. From far enough up, Uluru can look no more remarkable than a stale school bun. I've flown over country in the north Kimberley that days before on foot I found heartbreakingly rugged. From the air it seemed merely, well, interesting. Jump-ups and breakaways and nests of spinifex that so recently had me in tears of frustration and fright seemed beautiful, harmless. An afternoon's hike gone in moments. So much to envy the birds.

Aborigines sometimes question the 'European' urge to climb high and look out across land from a bluff or peak. I suppose if you know what's there, if you're intimate with it in a bodily, spiritual way, you don't need to look. In colonial days explorers and surveyors climbed points of elevation to see what lay before them. They captured it with their maps, claimed it for their empire simply by being there, looking. Looking with something very specific in mind. These days the urge remains but not every gaze is a colonising of what lies ahead. Some of that staring comes from a slow-waking reverence, a respectful curiosity, a yearning to understand.

Flying very high (if it doesn't terrify you) can induce godlike fantasies.

You feel safe from the land and its logic, its necessities of shade and water, food and fuel. Even the Great Sandy Desert can seem cute in a pastel sort of way. But come down a few thousand metres to where the trees are still trees and the ranges riven with shadows and the smoke of bushfires penetrates the cockpit — that can be a different matter. The perspective is more birdlike than godlike. Here it's still possible to feel small. The land is still big but not wallpaper. You're close enough to feel the heat of stones, and the skin of the land looks creaturely, like the hide of a crocodile, the pelt of a kangaroo, the feathers of corellas, the bark of boabs. You see its very bones revealed by wind and water. It's so beaten down it often looks stubborn, threadbare. Most of it is the embodiment of pure necessity, though there are always surprises: patches of rainforest in the driest range country, the livid animation in the seagrass meadows of Shark Bay, the shocking colours of corals, of even spinifex. Or the bewildering tumults of water pouring out of land that defies any sign of rain. The land divides itself up in gullies, craters, rivers, valleys and its shadows retain some secrecy instead of being mere lines. From the air you see the repetition of pattern and shape: the scal-

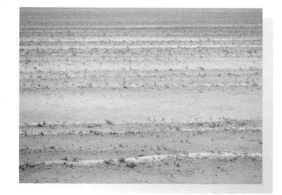

loping of beaches in the very pattern of the shells that are tossed on their shores, the pointillism of salt lakes repeated in the crowns of trees, the same design you see in the pitted surface of rocks and wood you later hold in your hands. To see the land from the air is to witness the forces it has endured: ice ages, floods untold, wind, several mining booms, the feudal grazing industry. And yes, there is an abstract beauty that has nothing at all to do with what you're looking at. Shape, colour, repetition, juxtaposition. Even completely manipulated landscapes with their rigid fence or road lines, their concentric plough patterns, their terrible spiderwebs of cattle erosion can be beautiful.

Mostly from the air I've felt small rather than godlike. The humbler the plane and the fewer its engines the smaller I feel. Not to mention queasy. The perspective is temporary, conditional, but it can be truly revelatory.

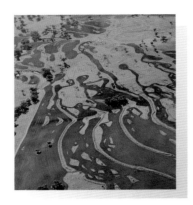

From the air I've seen the vandalism of clearfelling in native forests which would otherwise be hidden from view. I've seen salt creeping up on land cleared with government backing. Rivers turning colours they were never meant to be. Those times I've felt tiny and impotent and furious. And yet I've flown offshore and seen pods of humpback whales coursing up the coast the way they never were in my youth and felt small in a happier way. I've flown over kilometres of country burnt out by lightning and looked at the contused fields of ash shifting in the wind and been forced to see myself connected to all that carbon, the stuff you and I and all the rest are made of.

Humans have become accustomed to imagining themselves at the centre of the universe. Galileo never quite shook us out of that. We're used to being the pinnacle of creation, the final power. Travelling into landscape reminds us of our true position, as dependants, as fellow travellers. Confronted with our sudden smallness we may panic, become angry, disoriented, afraid, and scramble back into the shell of our pre-eminence — the airconditioned car, plane, house, university, shopping mall. But there is something to be gained from persistence if at first we see wood but no trees. An engagement with landscape can be profoundly humbling, and revelatory, a scrambling of precious codes. The land can mystify us in a time when we're resigned to being hoodwinked. It can enchant us when we're used to being hypnotised. I don't mean to make a personal cult of the land. Like it or not, everything I've learned about nature has been revealed with a gun, a spear or a knife and fork in my hand. I know the odds of our being able to live without somehow doing it at nature's expense. But I've longed for some way to be a conscientious objector in the war against nature. I'm not the romantic young man I was, but I now have children and I see the results of the way we live with growing alarm.

At the very least we must resolve to live in some balance with our natural world, to understand that it has a life independent of us. Even this grudging acknowledgement brings a sacred responsibility. In a nation where nothing is sacred but the race to have all the toys, it might seem bizarre to see the continent as sacred. Only our 'way of life' is seen in sacred terms. I just hope we'll be wise enough one day to sacrifice some luxury, some speed, some chattels in order to preserve the land that gives us such a life. I don't care for New Age notions of the sacred, for something truly sacred will eventually demand something of us, something deeper than the credit card. Learning respect and paying it is sometimes a solemn and painful business. Part of this learning is at the heart of our reconciliation with Aboriginal Australia. It seems to me that non-indigenous Australians may yet be required to modify the way they live — not merely the way they speak — in order to make peace with this place. Like the kids they once were, Australians bolt for the outdoors the moment the bell goes. They stream out in hordes and stomp across the bits they can't drive over. They try to catch the light on the stones, the lorikeets in trees, with their disposable cameras and fill albums with the results while planning the next excursion. Why? Perhaps because deep down, at some level, they recognise that conquest has brought neither beauty nor satisfaction. The ugliness of urban Australia leaves them hungry. And love it as they do, they are still not intimate with the land of their birth. We're looking for a common language to describe these yearnings, these suspicions even now. Thankfully there are people in our midst who have been where many of us would like to go, who have a language of feeling, a tradition of thought that prevails despite all. Listen to Bill Neidjie's practical mysticism:

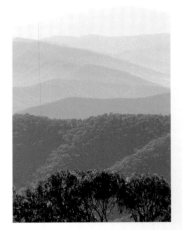

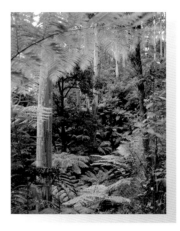

I love it tree because e love me too.
E watching me same as you
tree e working with your body, my body,
e working with us.
While you sleep e working.
Daylight, when you walking around, e work too.

That tree, grass ... that all like our father.
Dirt, earth, I sleep with this earth.
Grass ... just like your brother.
In my blood in my arm this grass.
This dirt for us because we'll be dead,
we'll be going this earth.
This the story now. [6]

What an age to go looking for a sense of scale, something as important as ourselves, some quiet low-tech moment, a bit of humility.

Notes:
1. William J Lines, *False Economy*, Fremantle Arts Centre Press, 1998, p 280.
2. ibid, p 282.
3. D H Lawrence, *Kangaroo*, Penguin, Melbourne, 1982, p 87.
4. Anthony Trollope, *Australia*, 1871, University of Queensland Press, 1967, as quoted in Suzanne Falkiner, *Wilderness*, Simon & Schuster, Sydney, 1992.
5. Quoted in Tom Griffiths, *Hunters & Collectors*, Cambridge University Press, 1996, p 104.
6. Bill Neidjie, *Story about Feeling*, Magabala Books, Broome, 1989, p 4.

Other references:
Roderick Nash, *Wilderness and the American Mind*, Yale University Press, New Haven, 1973.
Jon Krakauer, *Into the Wild*, Villard Books, New York, 1996.
Simon Ryan, *The Cartographic Eye*, Cambridge University Press, Melbourne, 1996.
Tim Flannery, *The Future Eaters*, Reed Books, Melbourne, 1994.
William J Lines, *Taming the Great South Land*, Allen & Unwin, Sydney, 1991.
Sasha Grishin, *John Wolseley: Land Marks*, Craftsman House, Sydney, 1998.
Charles Birch, *On Purpose*, New South Wales University Press, Sydney, 1990.

DOWN TO EARTH
AUSTRALIAN LANDSCAPES

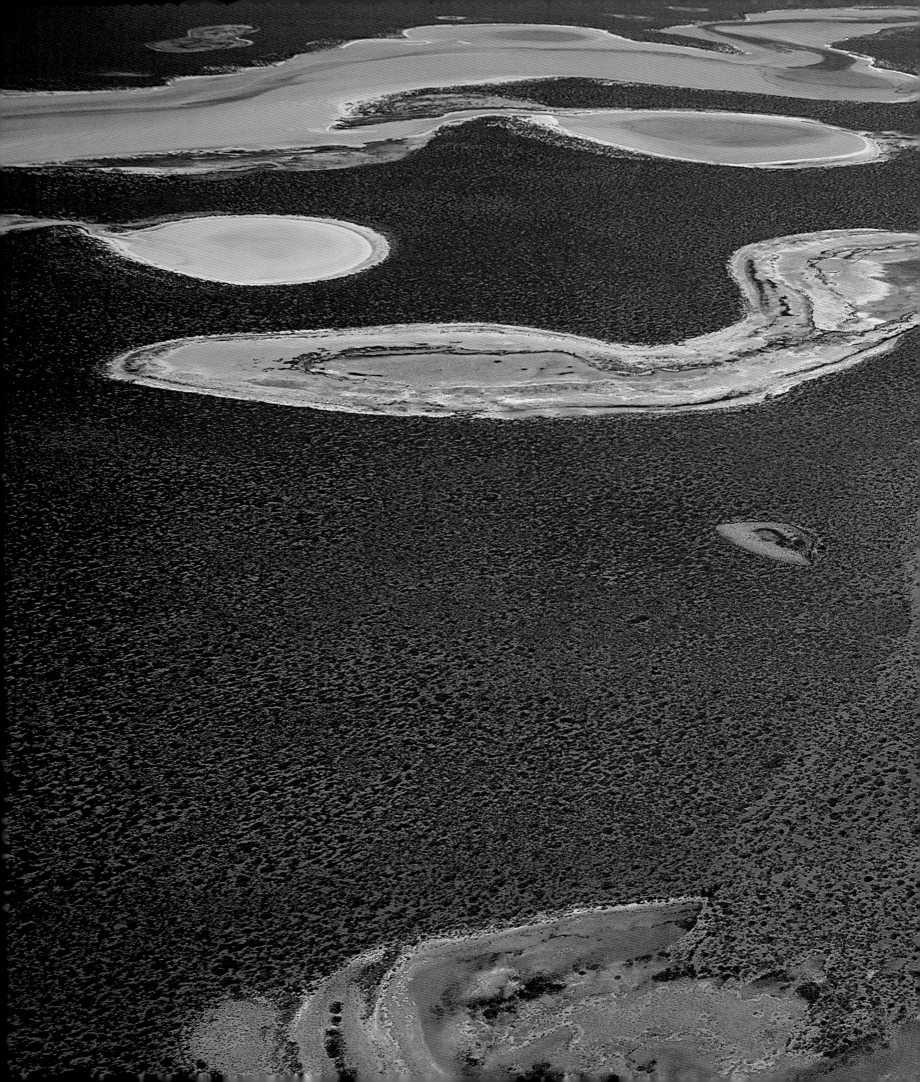

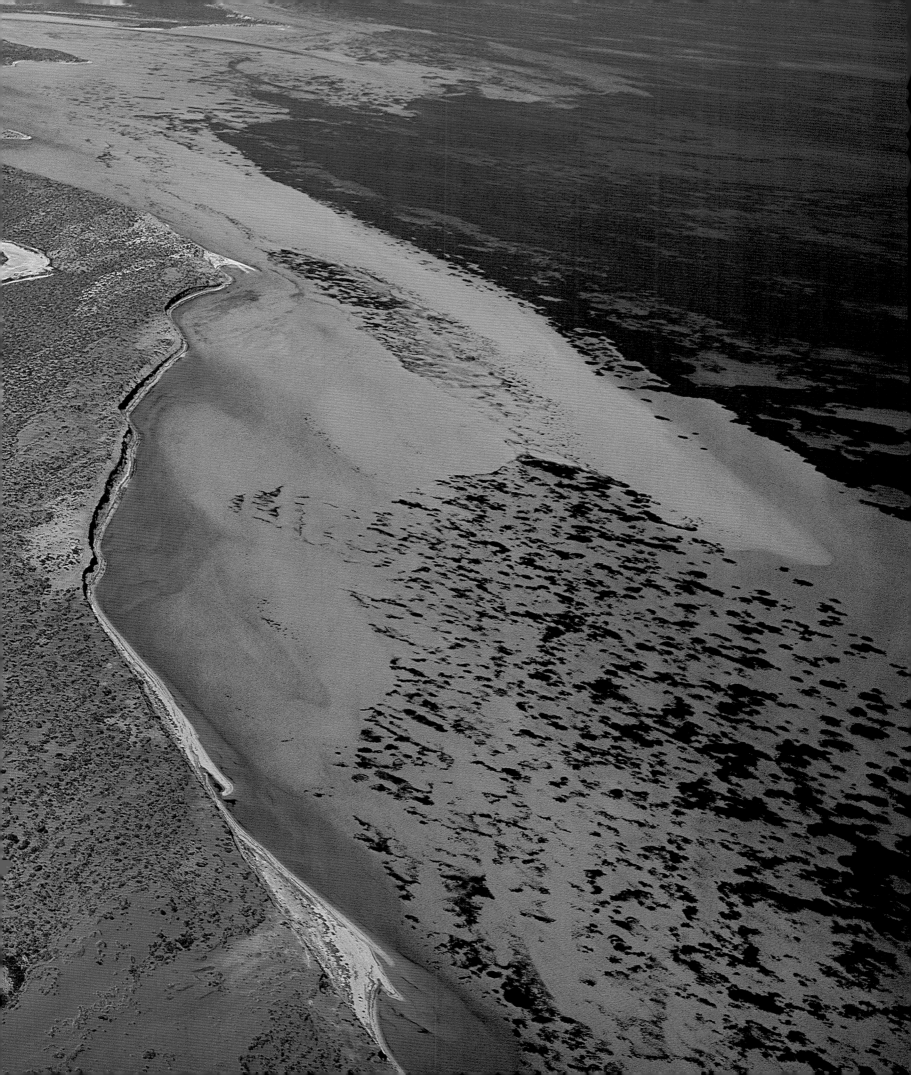

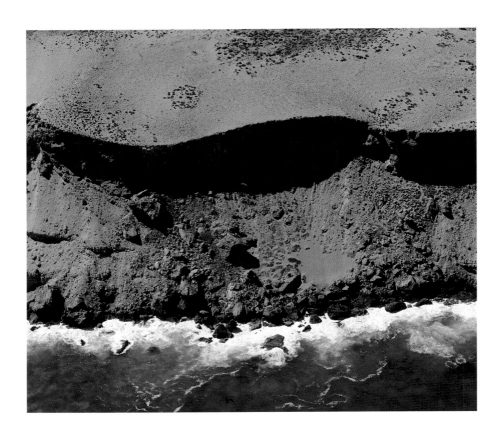

Dunes, blown from the eastern interior, perch on Zuytdorp Cliffs, some 170 metres above the sea. The *Zuytdorp*, a Dutch ship, was wrecked here in 1712.

Opposite: Hamelin Pool, the shallow eastern lobe of Shark Bay, becomes very saline and in its shoreline shallows live the extremely ancient algal stromatolites. Fossils of these organisms occur in the two to three billion year old rocks of the nearby Pilbara. Yellow wildflowers carpet the background desert after rains.

Previous page: The Big Lagoon complex within the Francois Peron National Park in the Shark Bay World Heritage Area. Peron Peninsula is a site for the reintroduction of animals recently extinct on mainland Australia.

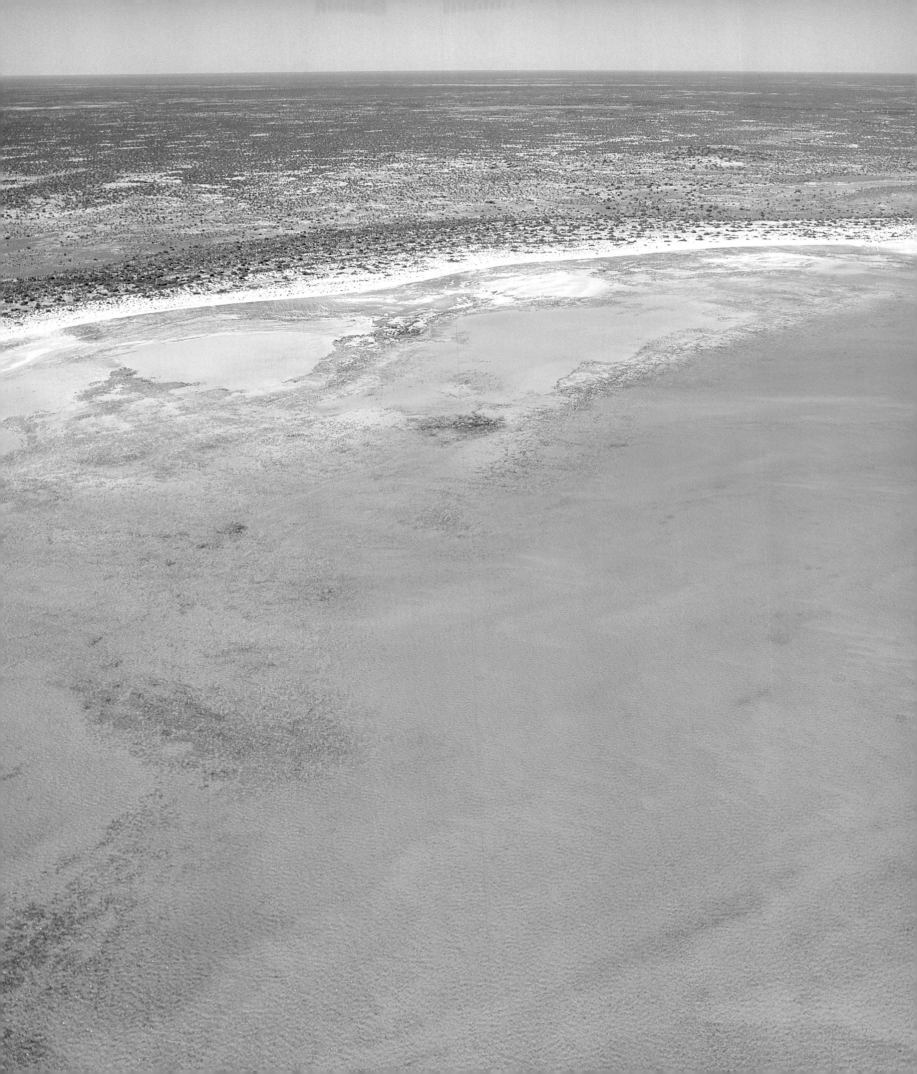

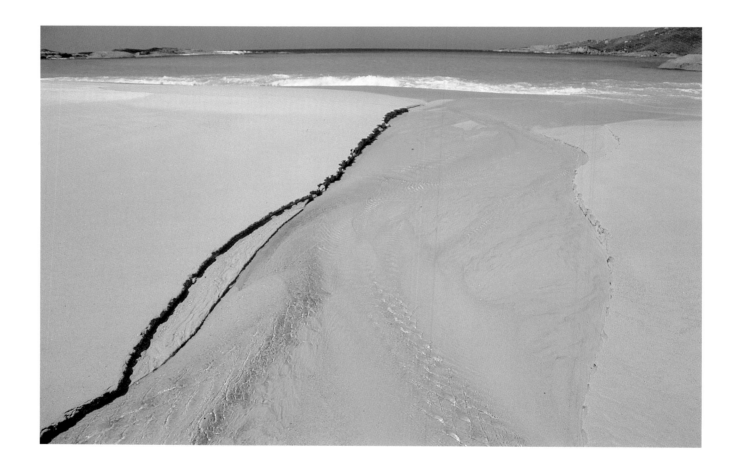

Tannin-stained waters from a wetland creek cutting a channel and terraces — modelling the behaviour of major rivers in broad valleys — across the sand near Lowlands Beach, south-west Australia.

Opposite: Beach sand scalloped by longshore drift, scoured by wind and churned by four-wheel drives at Rockingham, a southern suburb of Perth, Western Australia.

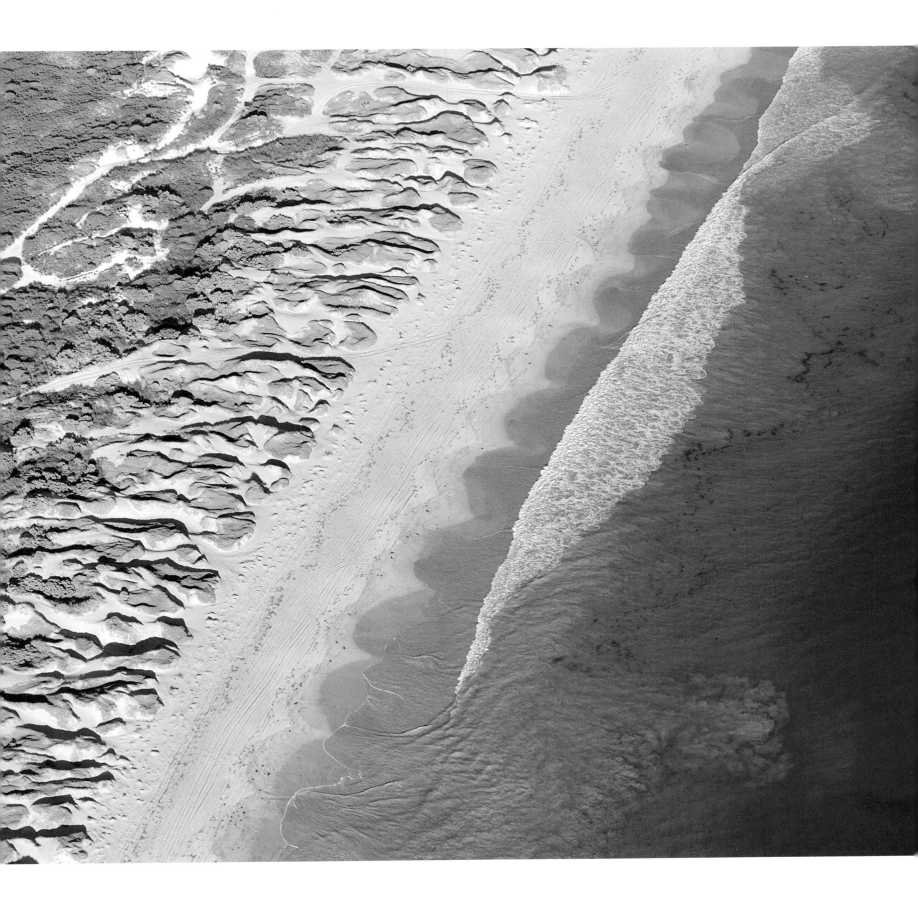

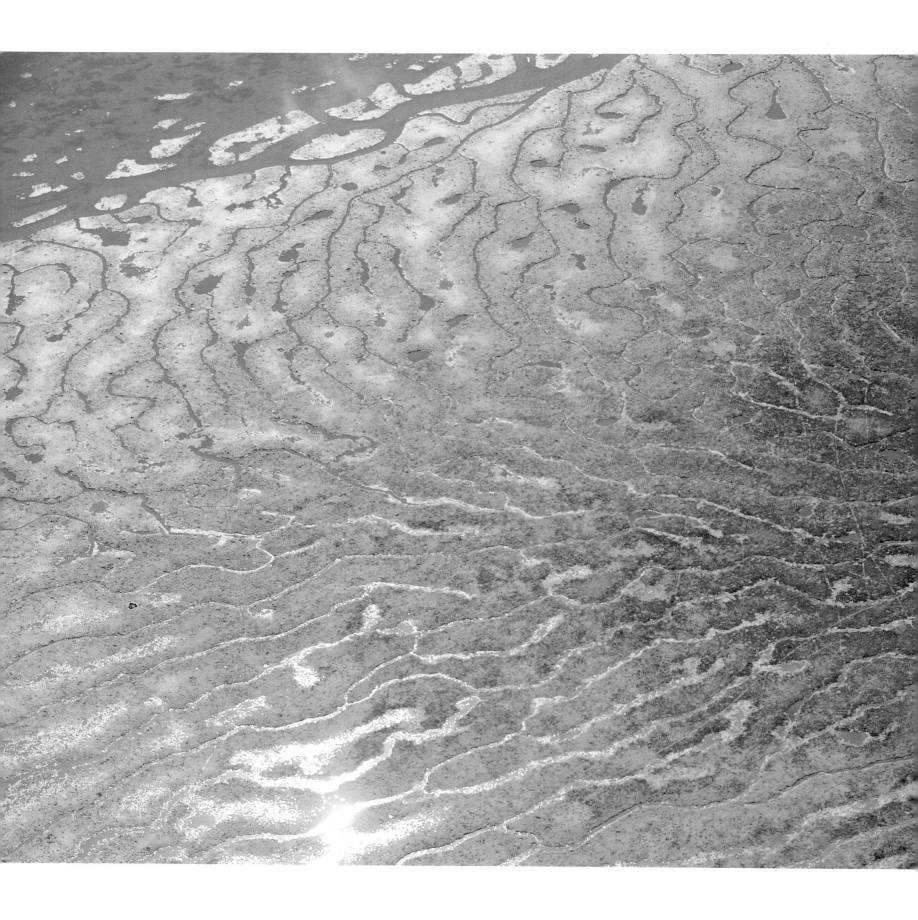

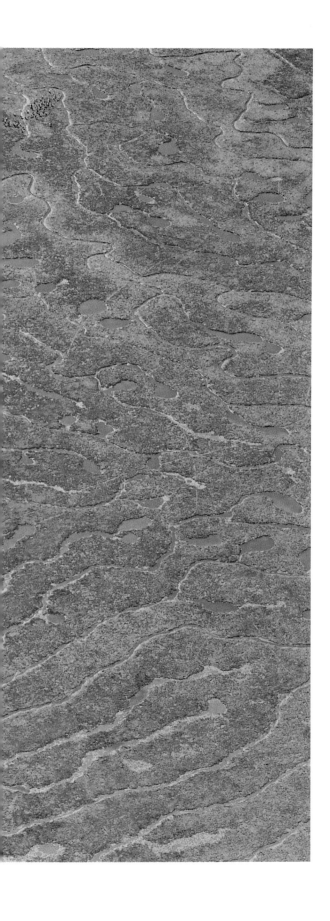

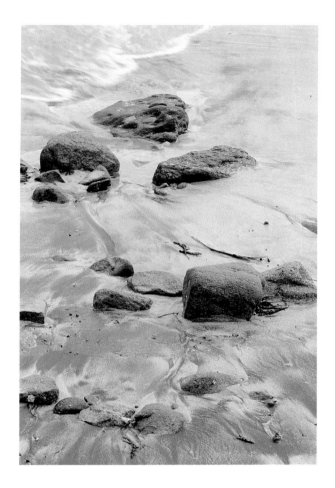

The primary elements, atmosphere, water, rock.

Opposite: Low tide across the mudflats of Gulf Saint
Vincent, South Australia, creates
exquisite ripple patterns.

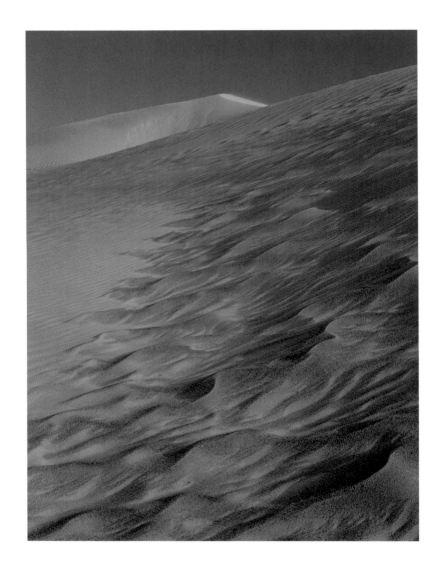

Wind-scoured dune surface at Lancelin, Western Australia.

Opposite: Fraser Island, Queensland, is the world's largest sand island, with dunes to 240 metres. Its story goes back 700,000 years. The south-east trade winds blow exquisite detail into the surface as the sand is pushed inexorably inland.

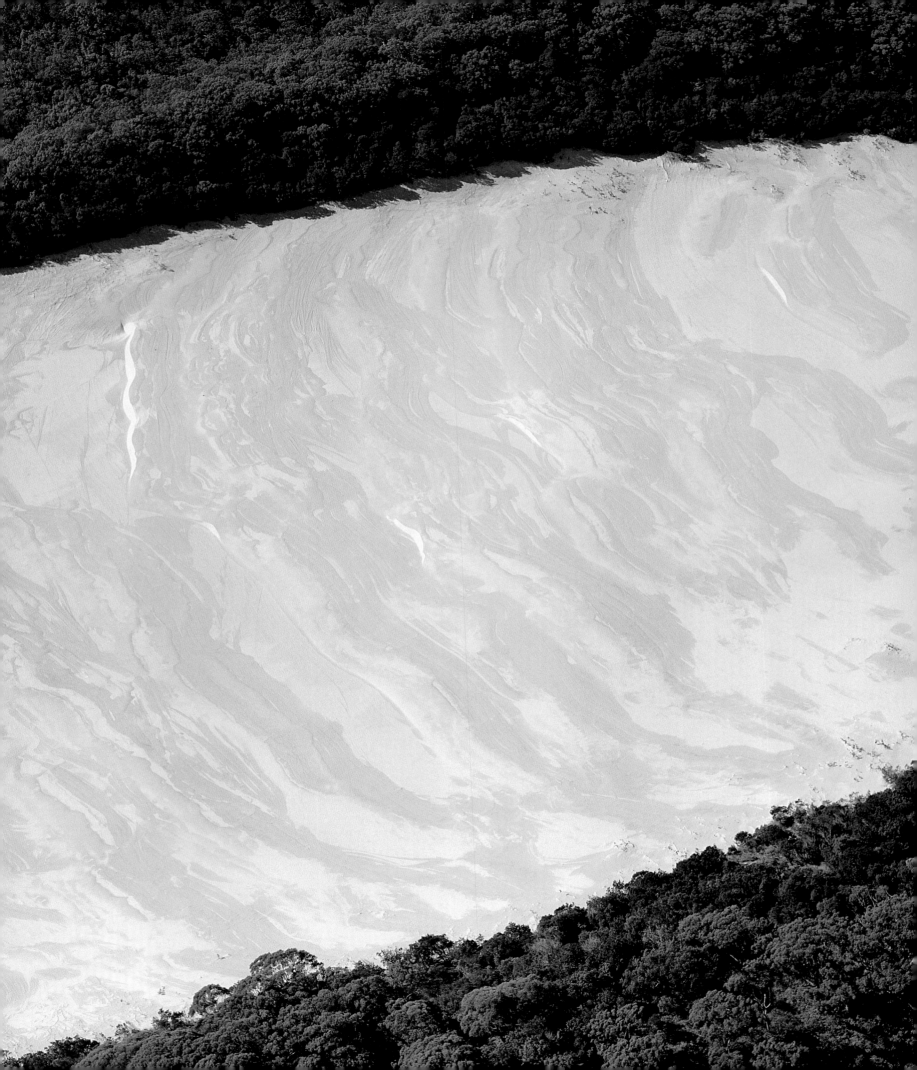

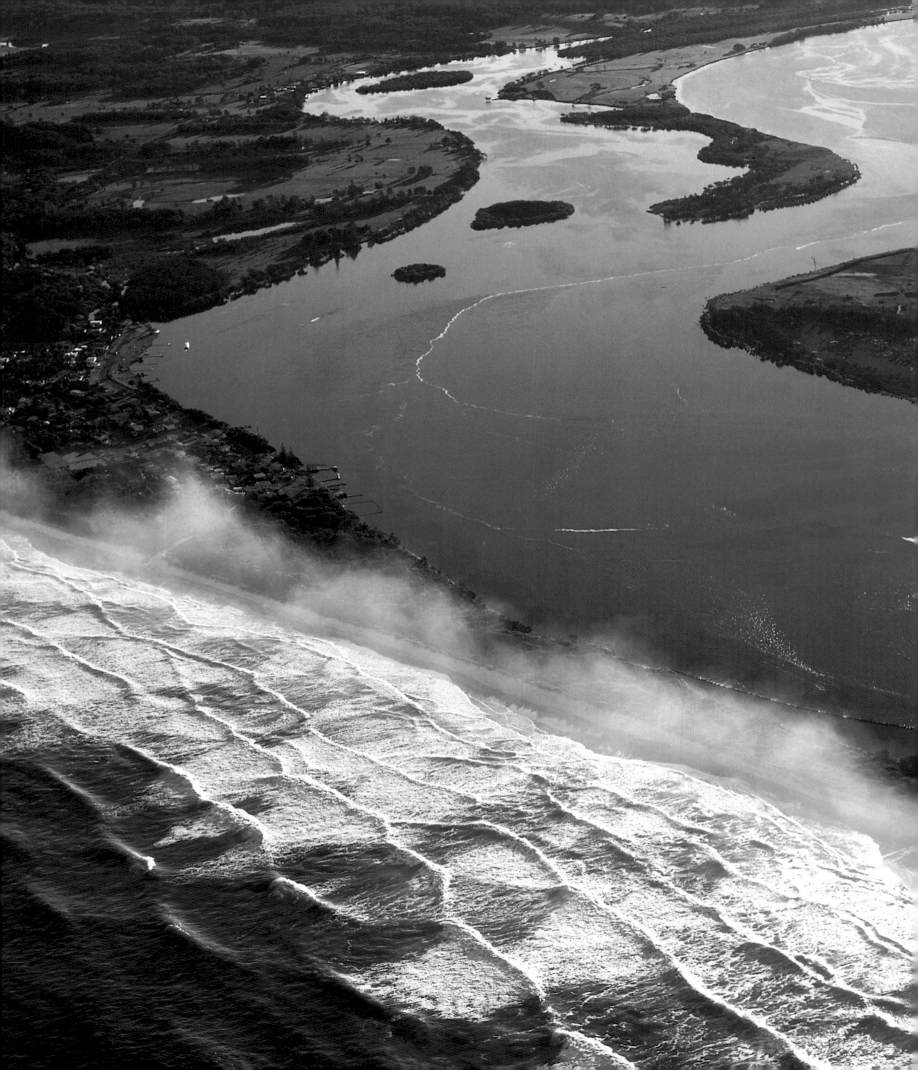

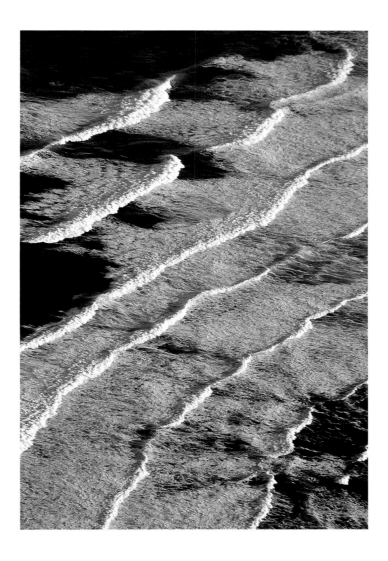

Well-spaced constructive waves surfing onto the shore
in early evening light.

Opposite: The mouth of the Macleay River, north of Port
Macquarie, northern New South Wales. The timeless Australian
coast — waves at journey's end spawned at the far reaches of the
Pacific, Southern or Indian Oceans, in some distant storm.

Overleaf: Landward and seaward palettes — the tip of Cape
Capricorn, Curtis Island, Queensland. Pink sand from the
blow-out feeds both incoming and outgoing tides. The calmer
'inside' waters, with coloured sand bleeding out from the
blow-out, take time to wash out the iron oxide, while outgoing
tides sweep the coloured sand into a turbulent wave and
active tidal 'sand cleaner' area to produce the bleached flats.

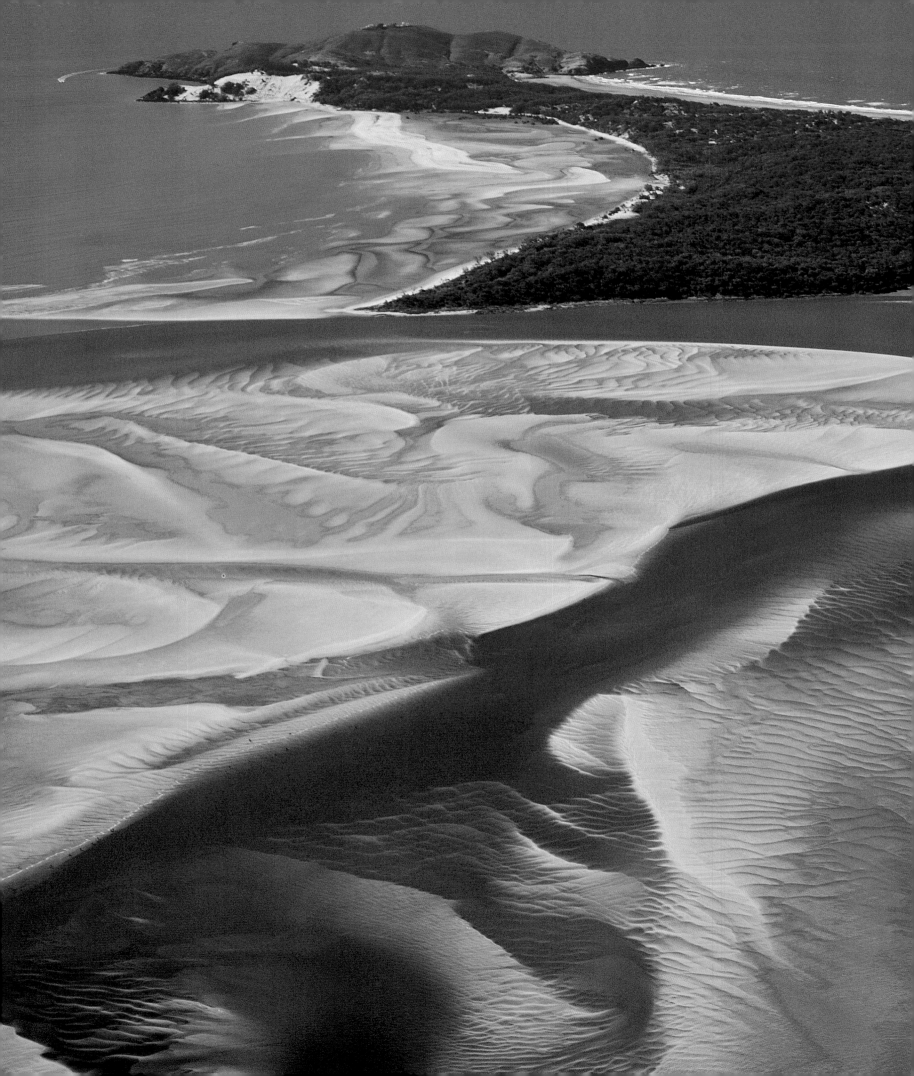

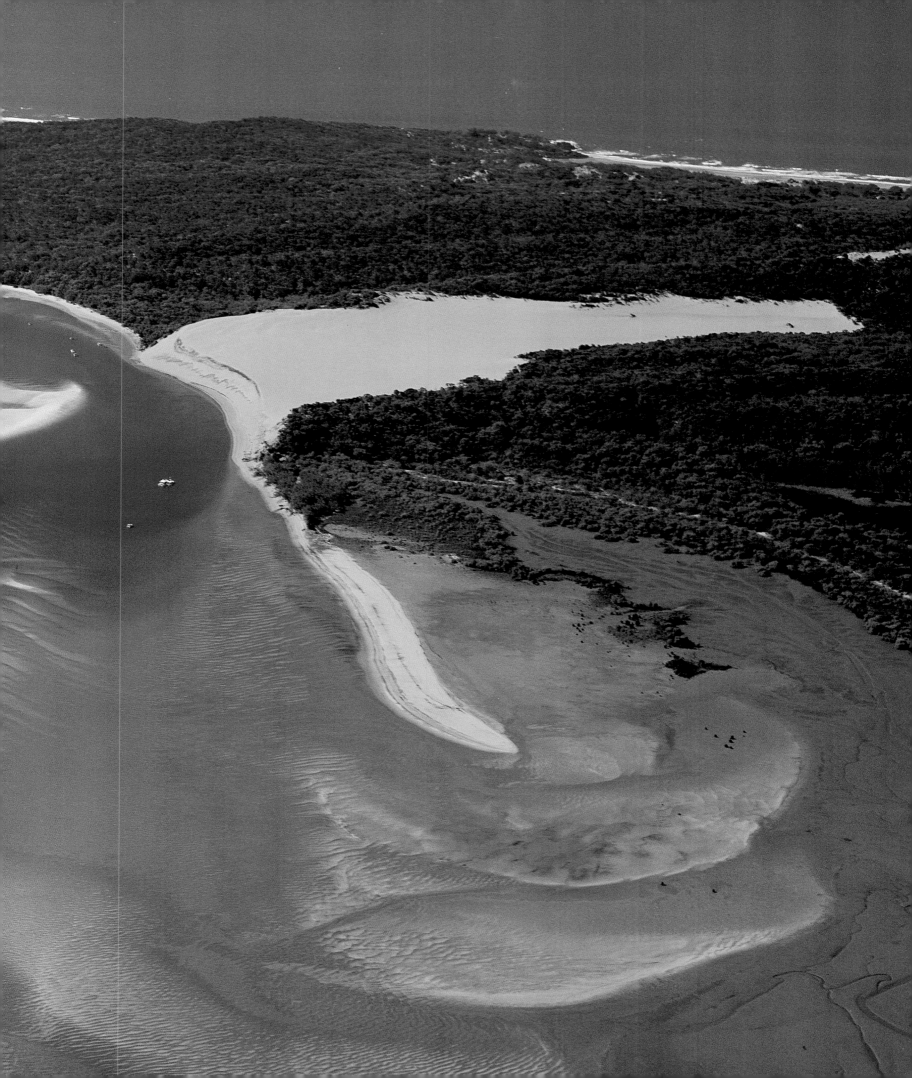

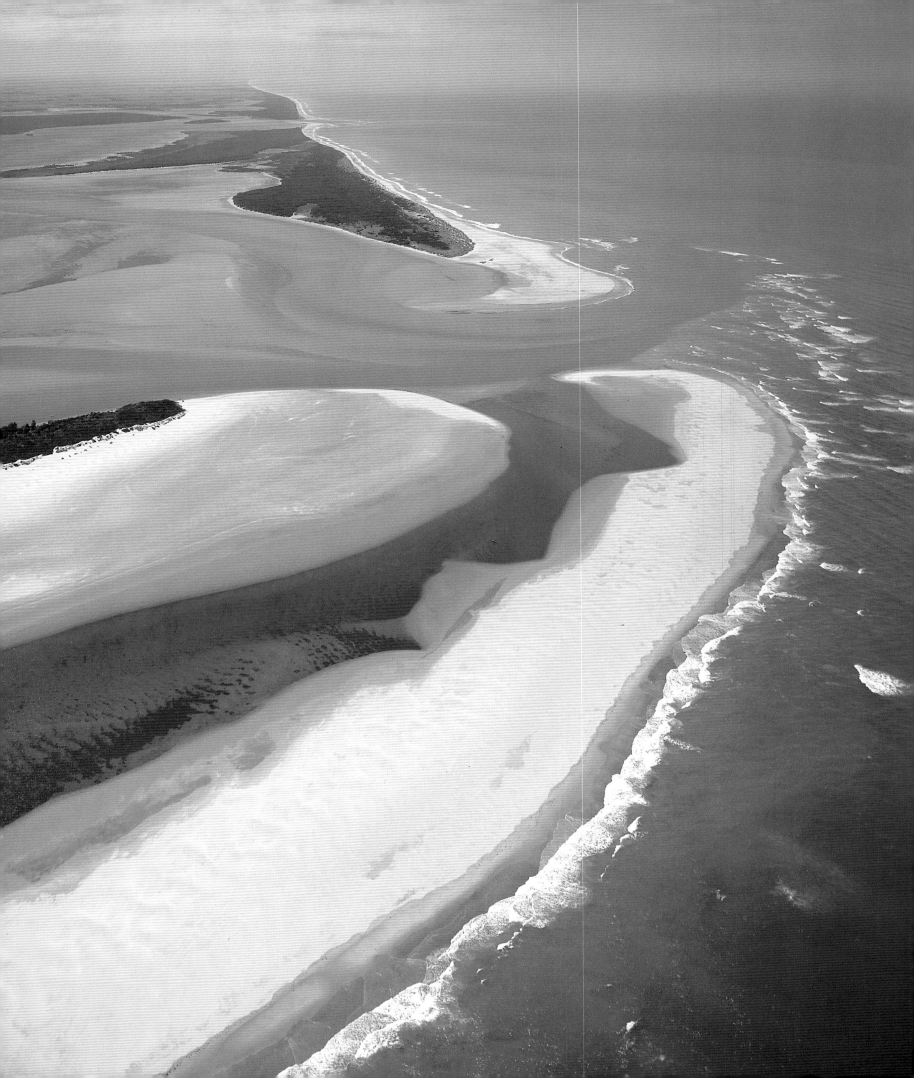

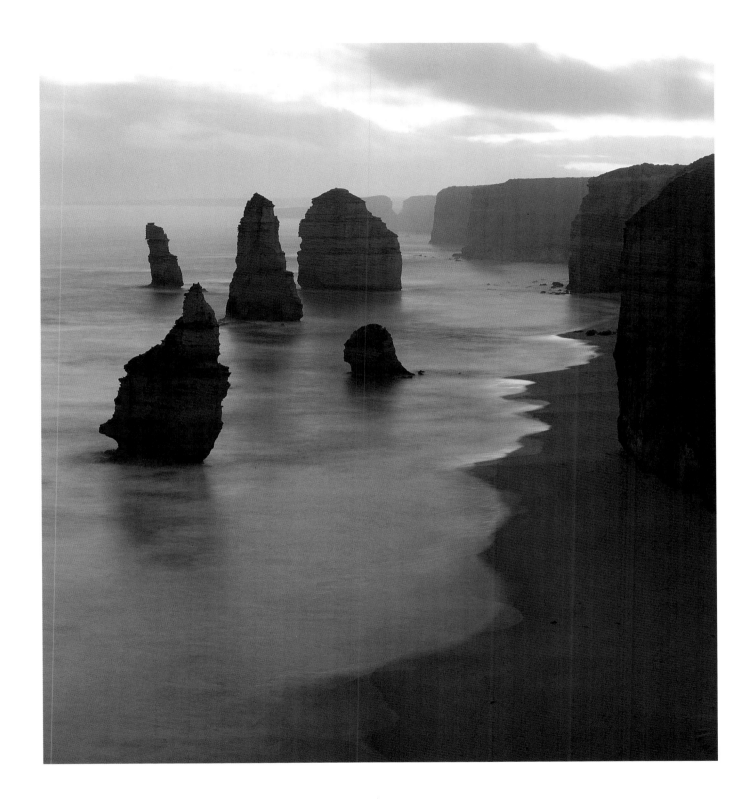

Like a fleet of dark galleons in the sunset approaching a secret estuary, some of the sea stacks of the Twelve Apostles on the Shipwreck Coast, Port Campbell, Victoria. Here, the soft shelly sandstone cliffs are rapidly retreating before the wild seas of the Southern Ocean, temporarily leaving remnants as sea stacks.

Opposite: Port Albert Entrance, southern Victorian coast.

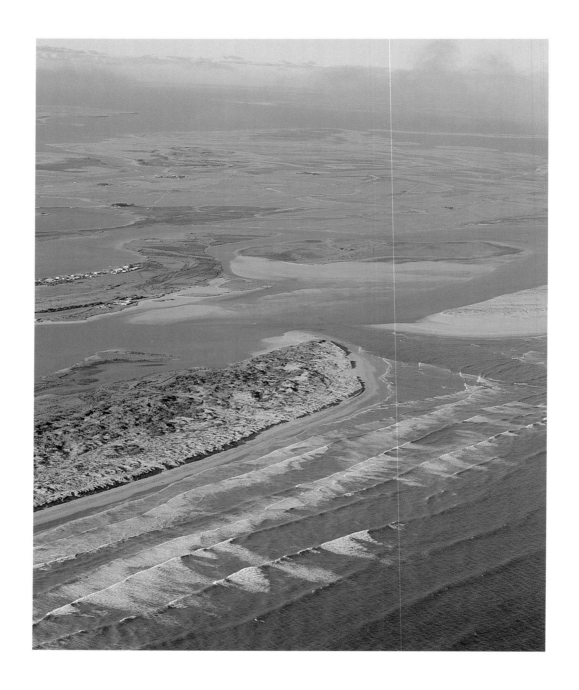

The mouth of the Murray, Australia's greatest river, breaking through the massive sand barrier at Younghusband Peninsula, which forms the eastern shore of Encounter Bay and locks off Lake Alexandrina and the incredible 160 kilometre Coorong lagoon.

Opposite: Seal Island in Encounter Bay, south of Adelaide, South Australia.

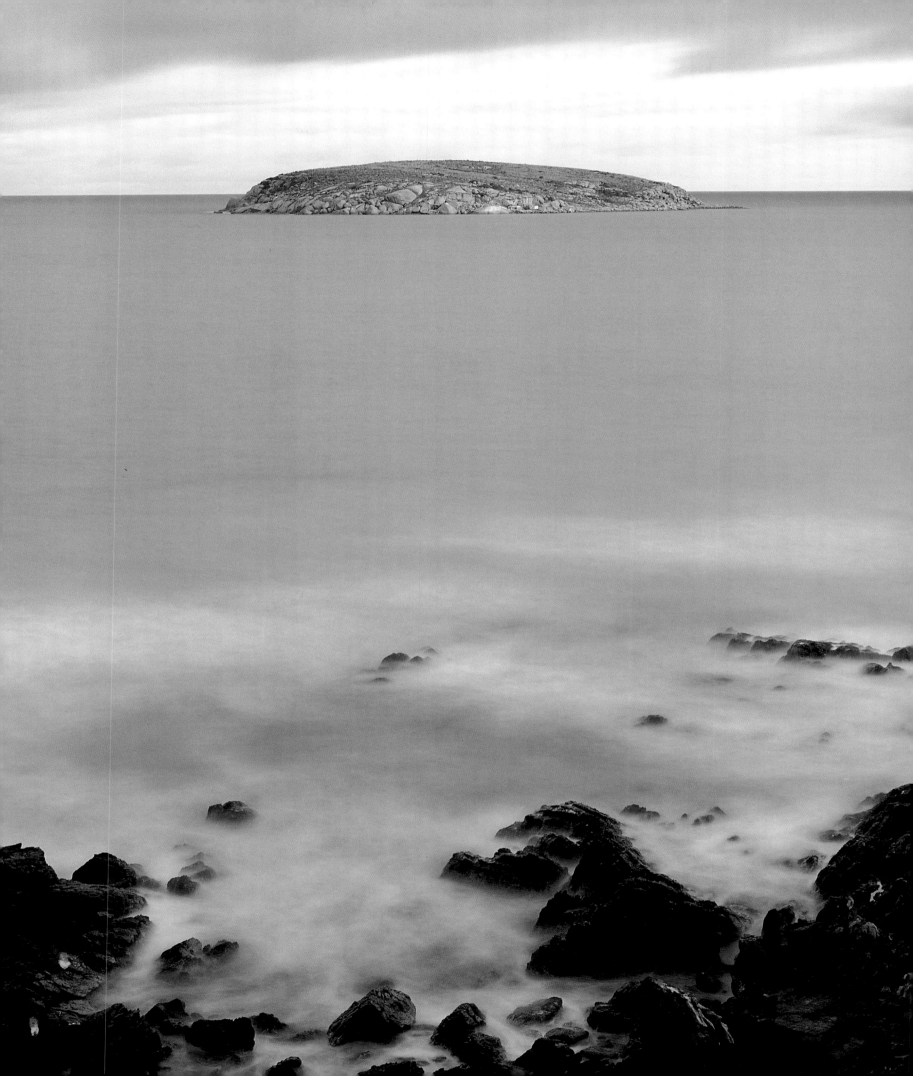

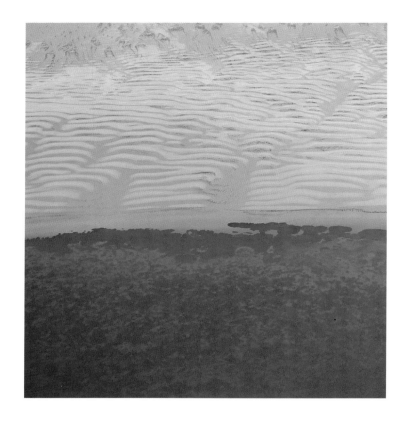

Gulf Saint Vincent, South Australia.

Opposite: Sandy Point, Gulf Saint Vincent. The Flinders Ranges
are in the background.

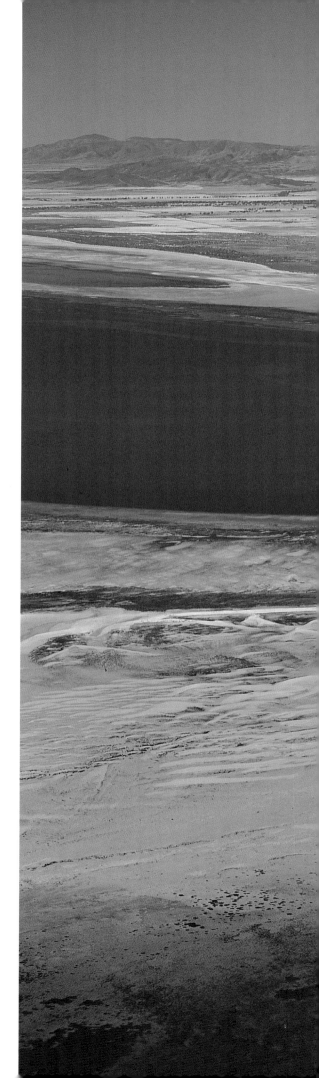

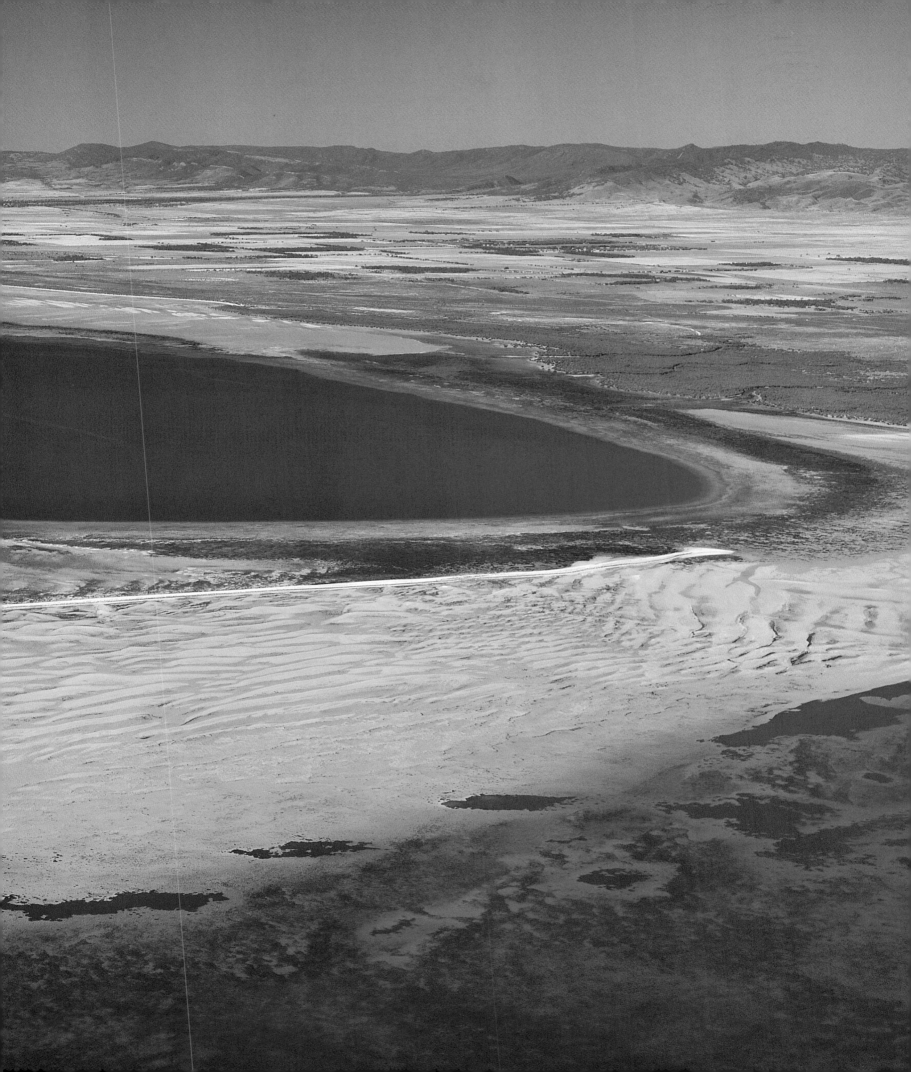

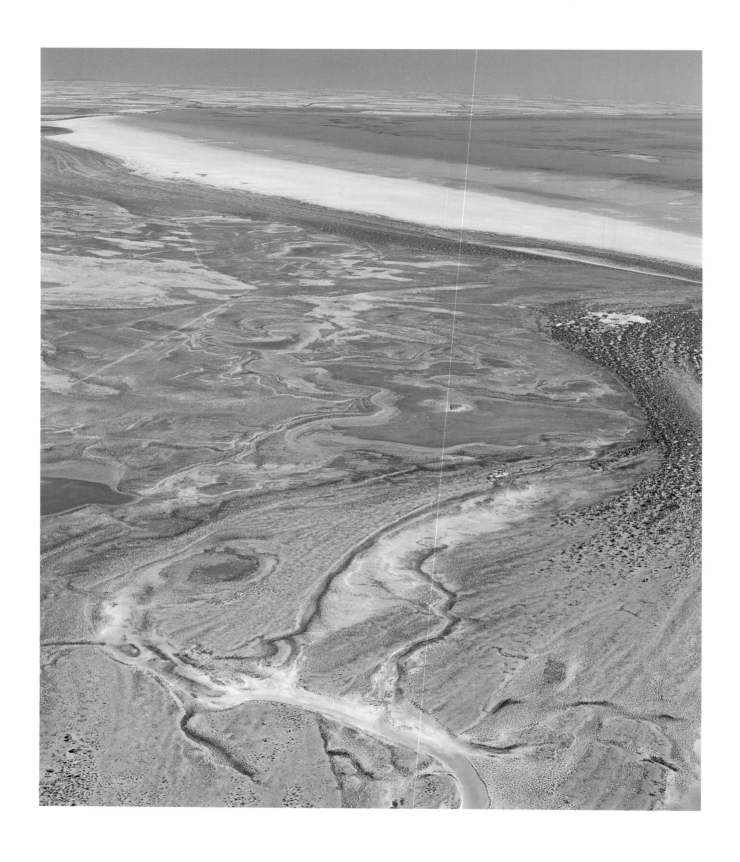

Jarrold Point to Wood Point from above the gravels and sandbeds of Broughton River, with the waters of Spencer Gulf lapping the broad beach of calcareous sand. South of Port Pirie, South Australia.

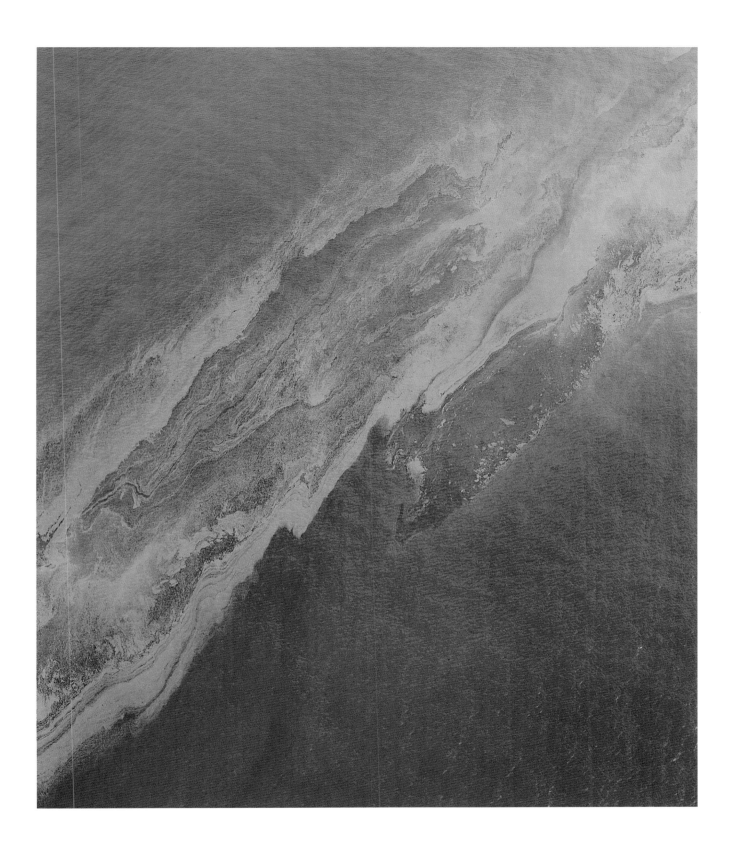

Algal blooms off the coast at Augusta, Western Australia, an event which occurs annually when the Blackwood River carries away phosphate fertilisers to the sea from upstream farm lands.

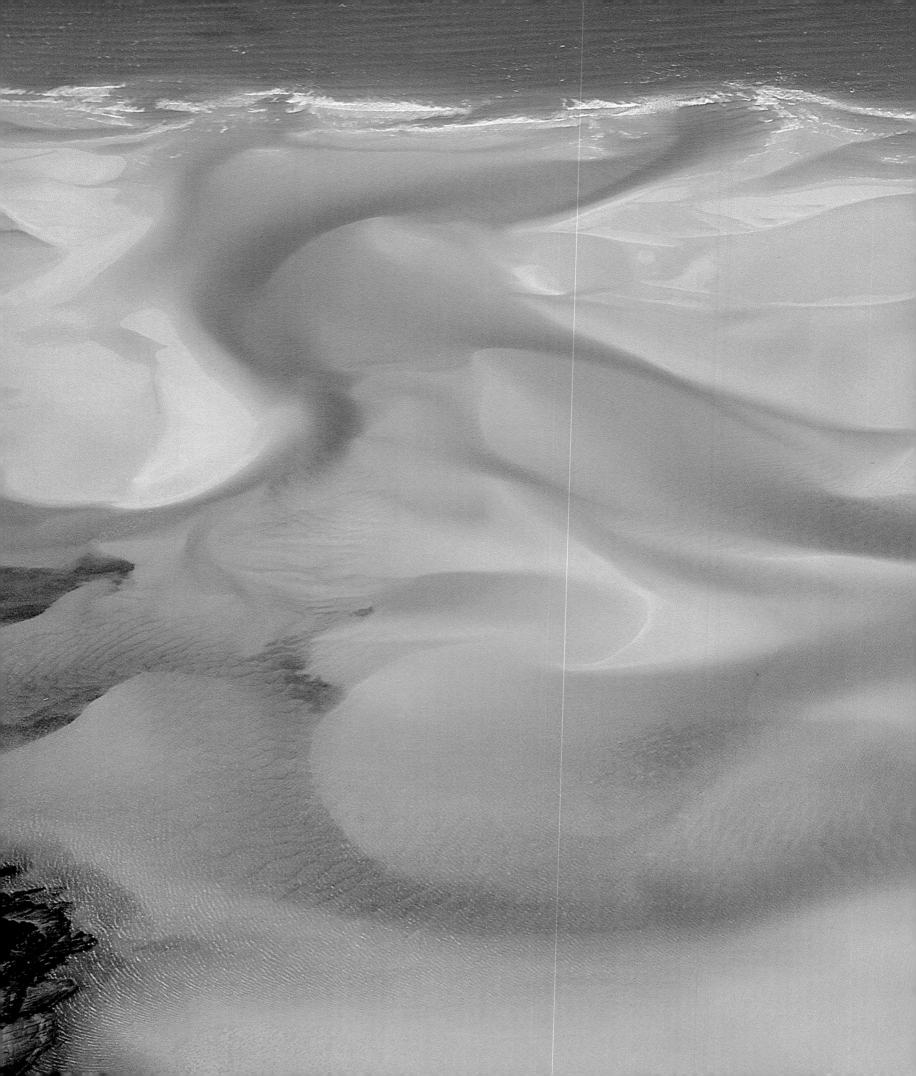

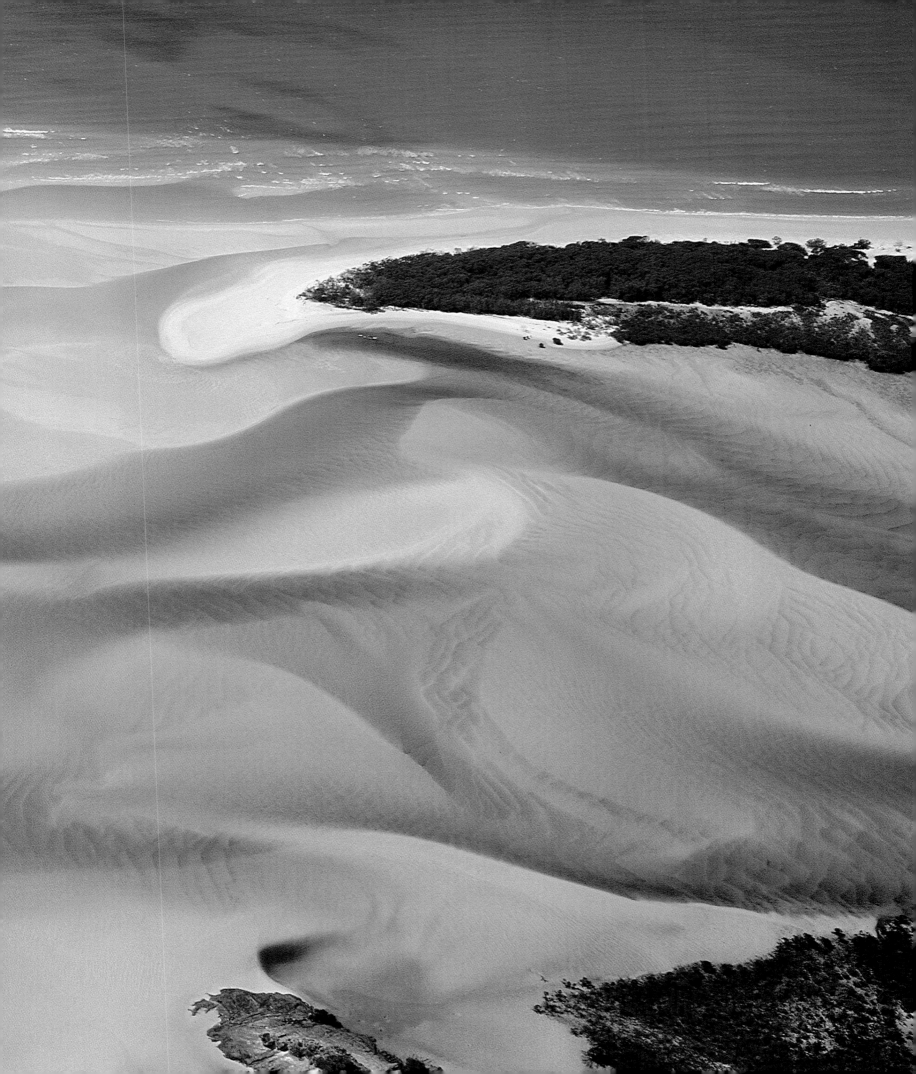

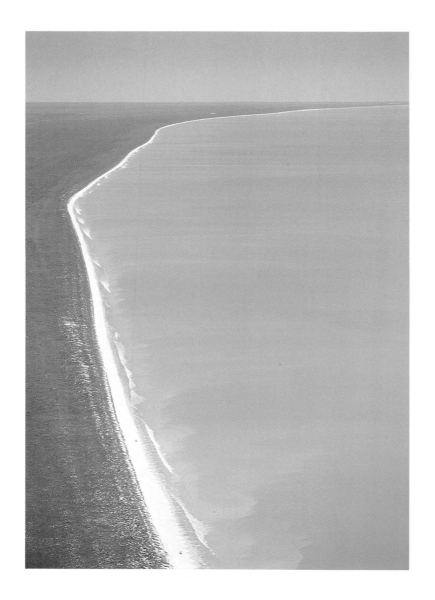

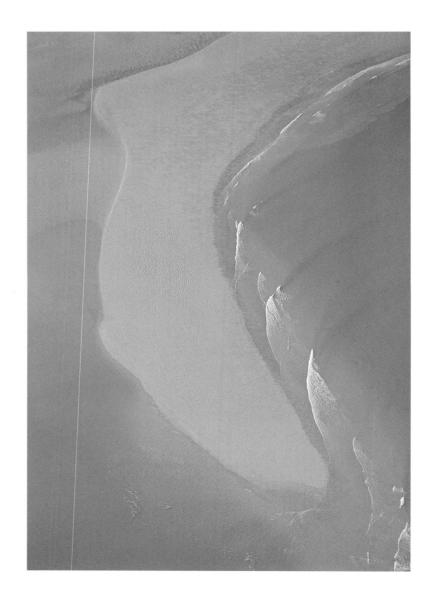

Left: Eighty Mile Beach, north-west Australia. Very wide, flat and gently shelving beaches of fine sand under a steady onshore wind produce these repetitive wave themes.

Right: Eighty Mile Beach. A hooked sandspit, known as a cuspate spit, is the result of a battle between sand removalists: the wind-generated waves on the right and the outflow of currents on the left. At present the currents are winning, though the waves are moving the sand along the beach.

Previous page: Coastline, Whitsunday Island, Queensland. Sculptured sand forms created by the combined actions of wind, waves and tides.

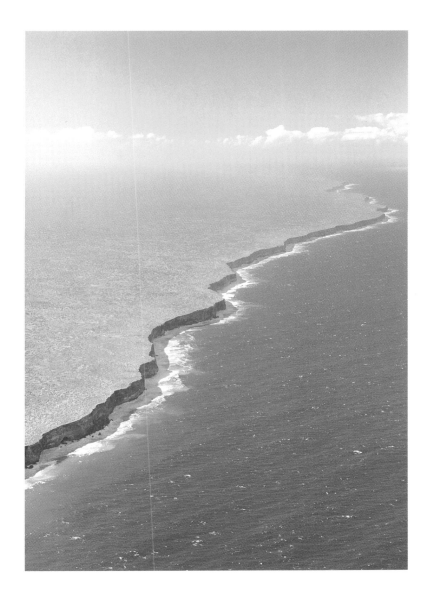

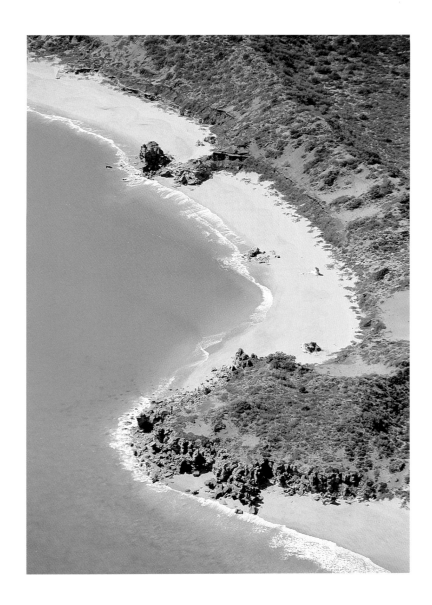

Left: Not a tree breaks the vastness of the Nullarbor Plain. Waves of the Southern Ocean are cutting away these young rocks of the Eucla Basin to form the 200 kilometre long cliffs of the Great Australian Bight.

Right: Rock outcrop along Eighty Mile Beach, between Broome and Port Hedland, nesting place for trans-continental migratory birds.

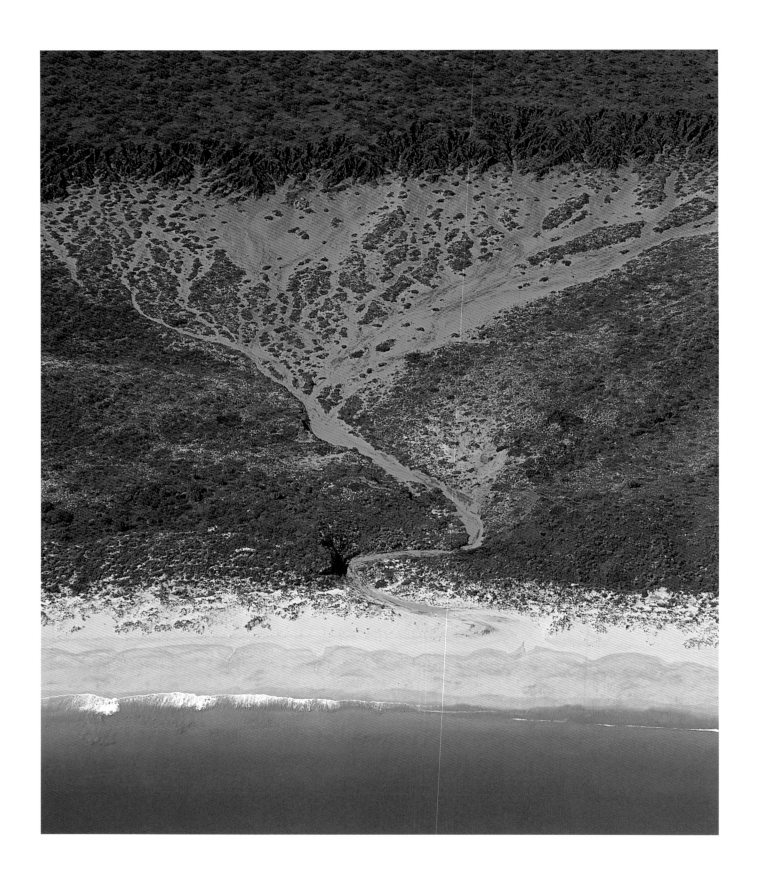

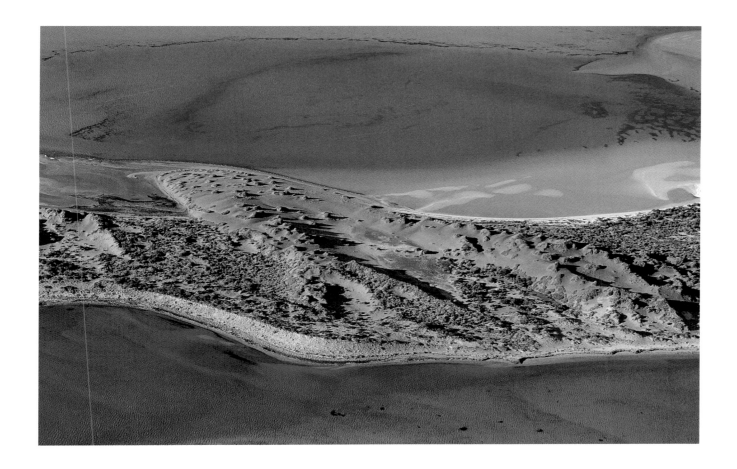

Coastal dune at Big Lagoon, Shark Bay.

Opposite: As wet season storms saturate the south-west Kimberley region, water drains off the edge of the scrub-covered red country, dissolving it. This scrub is called pindan or bindan by the Bardi people. Bardi land is centred on the sea's edge, their country and Dreaming tracks stretching under the sea to reefs and sandbars, probably tied into their cultural memory of a time when those reefs and sandbars were hills, with the sea's edge many kilometres to the west, and when the people camped and were active there.

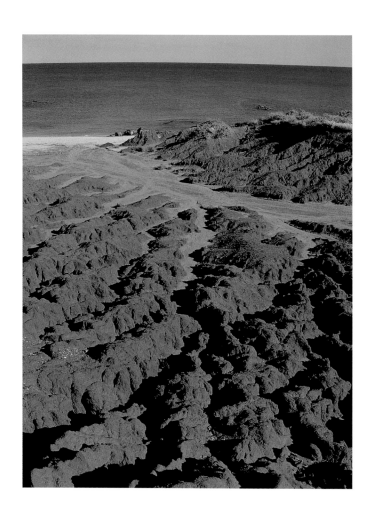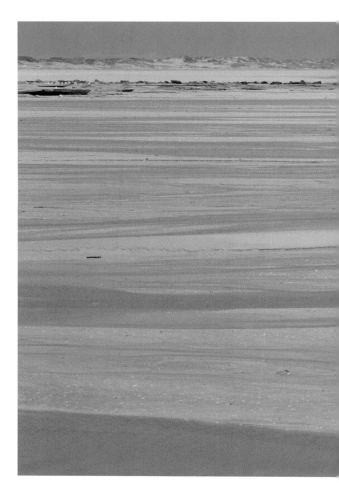

Pindan formations created by the eroding of the
compacted fine red soil.

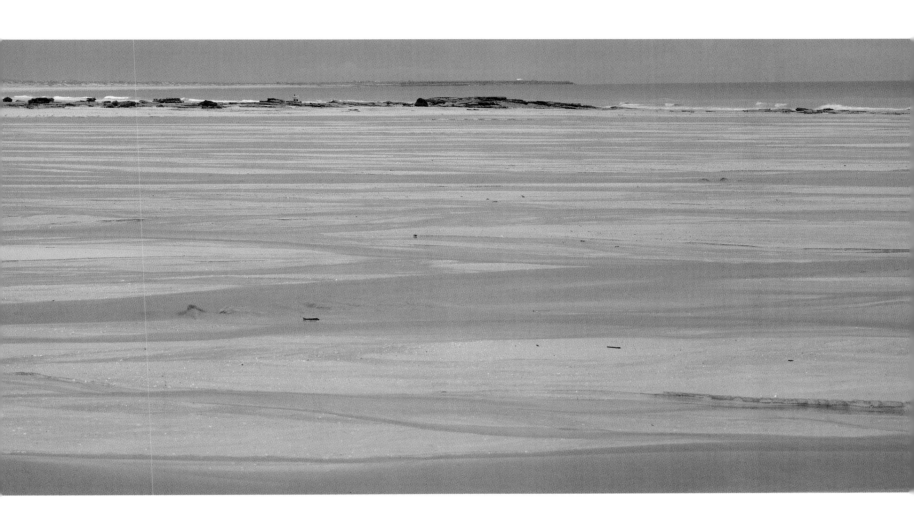

Water sheeting and scouring across Cable Beach, Broome, after a period of heavy wet season rain.
Eroded pindan soil streaks the beach.

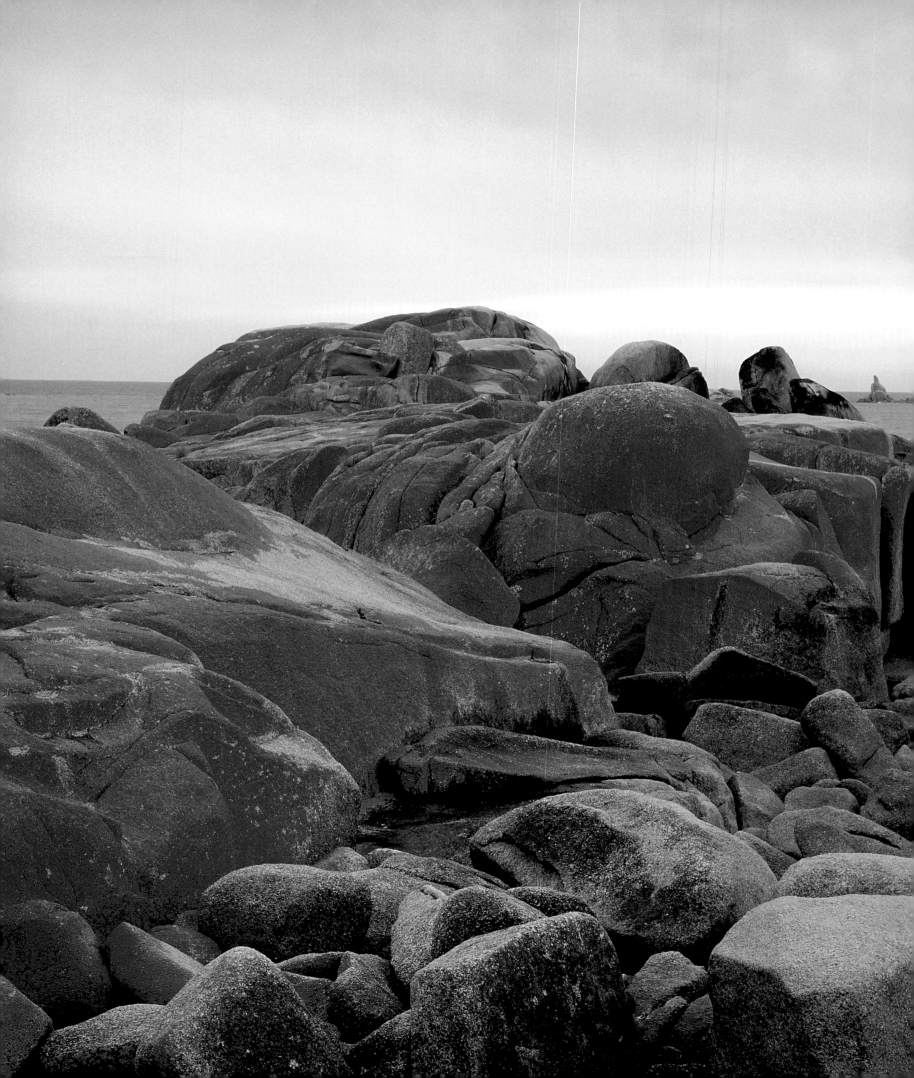

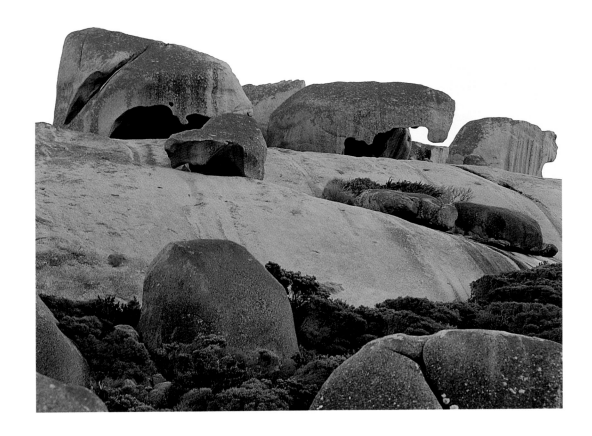

Lichens are the explorer's compass. These windswept Remarkable Rocks, great granite tors on Kangaroo Island, are lashed on the south-west faces and tops by salt-laden showers. These are the faces painted by the red lichen. The granite here is not broken by joints, cracks created by cooling, so the tors are very large. The caverns are being actively eroded by moisture, salt and swirling winds. The permanently shaded ceilings and walls are not suitable for the growth of lichens.

Opposite: Lichen sets the granite coast on fire near Eddystone Point, Bay of Fires, north-east Tasmania.

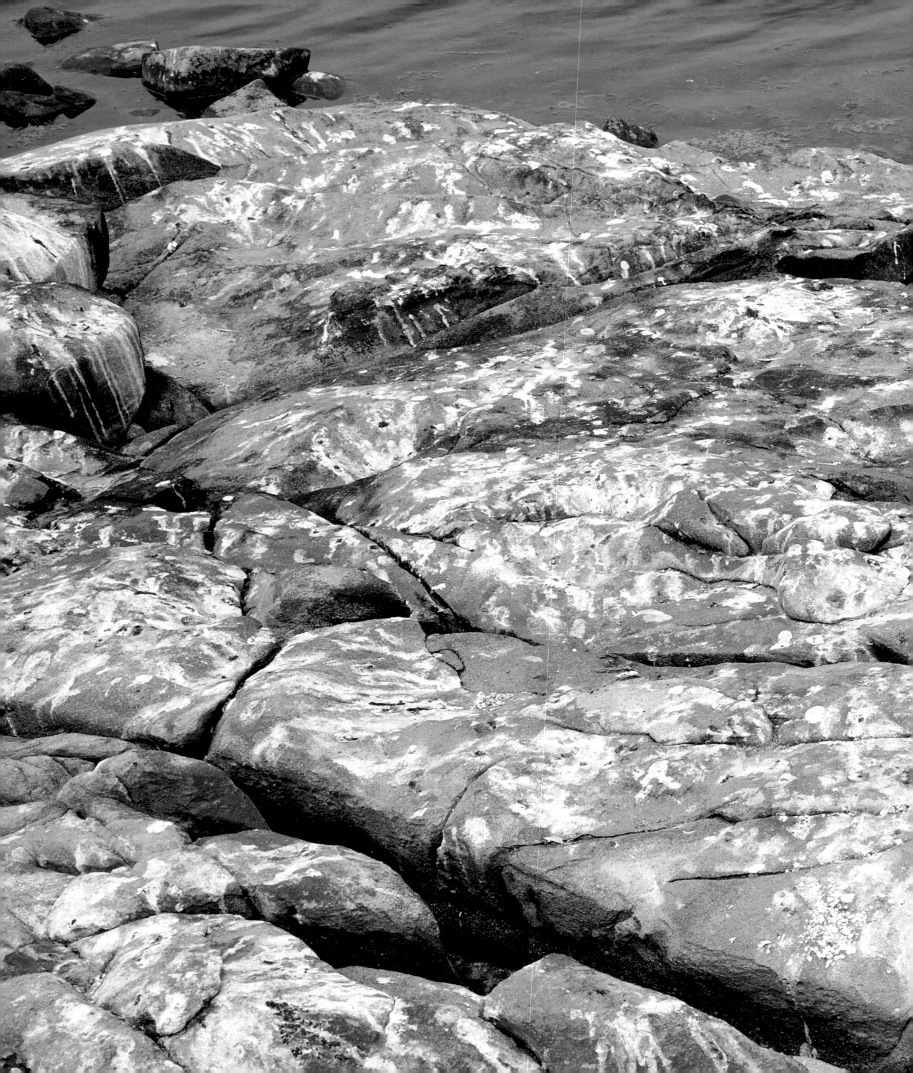

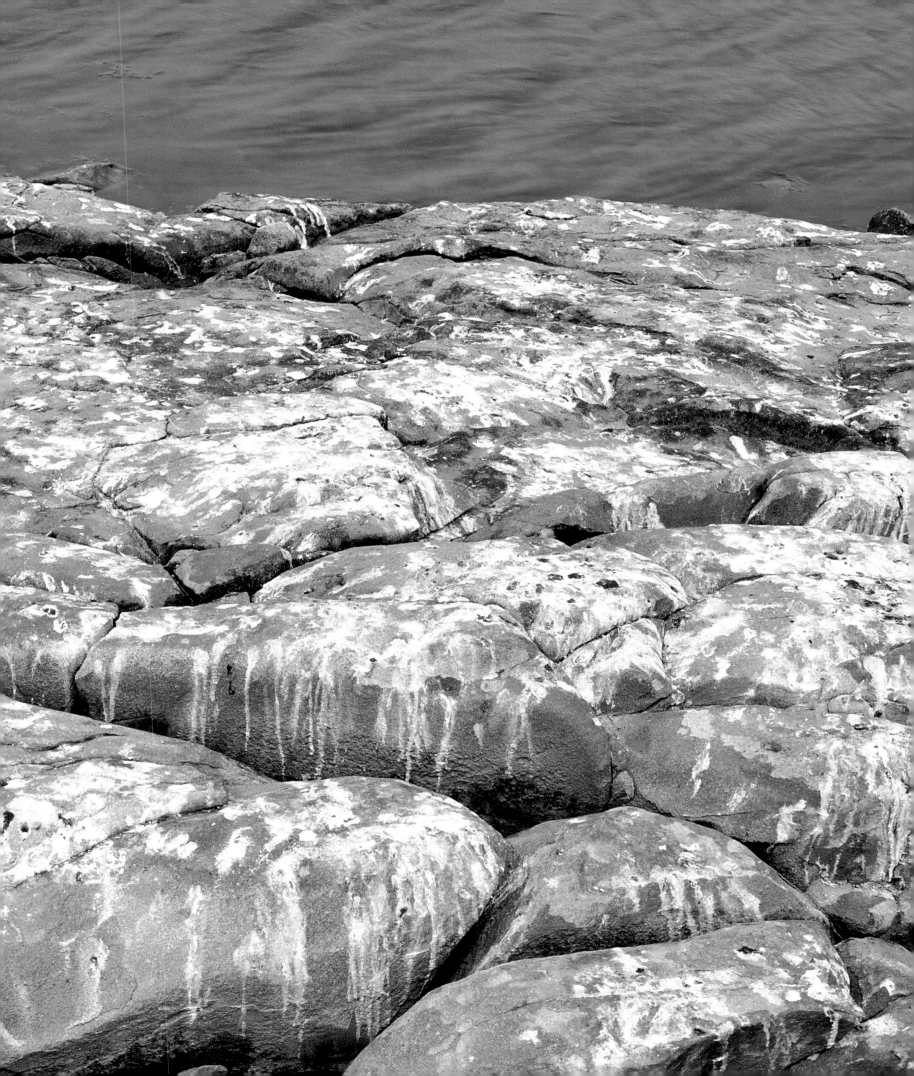

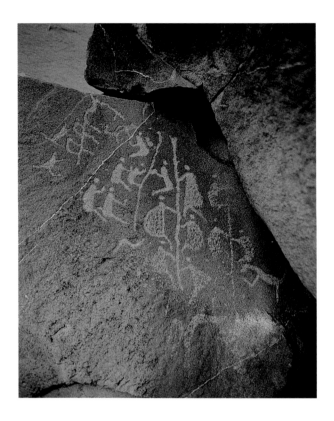 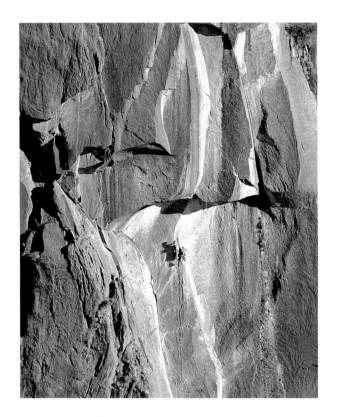

Left: 'Climbing Man Site', Burrup Peninsular near Dampier, Western Australia. Aboriginal people have lived on this continent for more than 60,000 years. In many places the ancestors have scratched, painted, chiselled and ground their stories of existence.

Right-hand side & opposite: Mt Buffalo, Victorian Alpine National Park. Rock climbers emphasise the scale of Mt Buffalo's cliffs. The granite here has been given its sheer-walled nature by a fault line and by cooling fractures or joints. Mt Buffalo's immense eastern walls of granite are a challenge to hang gliders who share the air space with Australia's version of the Golden Eagle, the Wedge-tail Eagle.

Previous page: Wilsons Inlet, Denmark, in Western Australia's south-west, favourite nesting place for a great variety of seabirds.

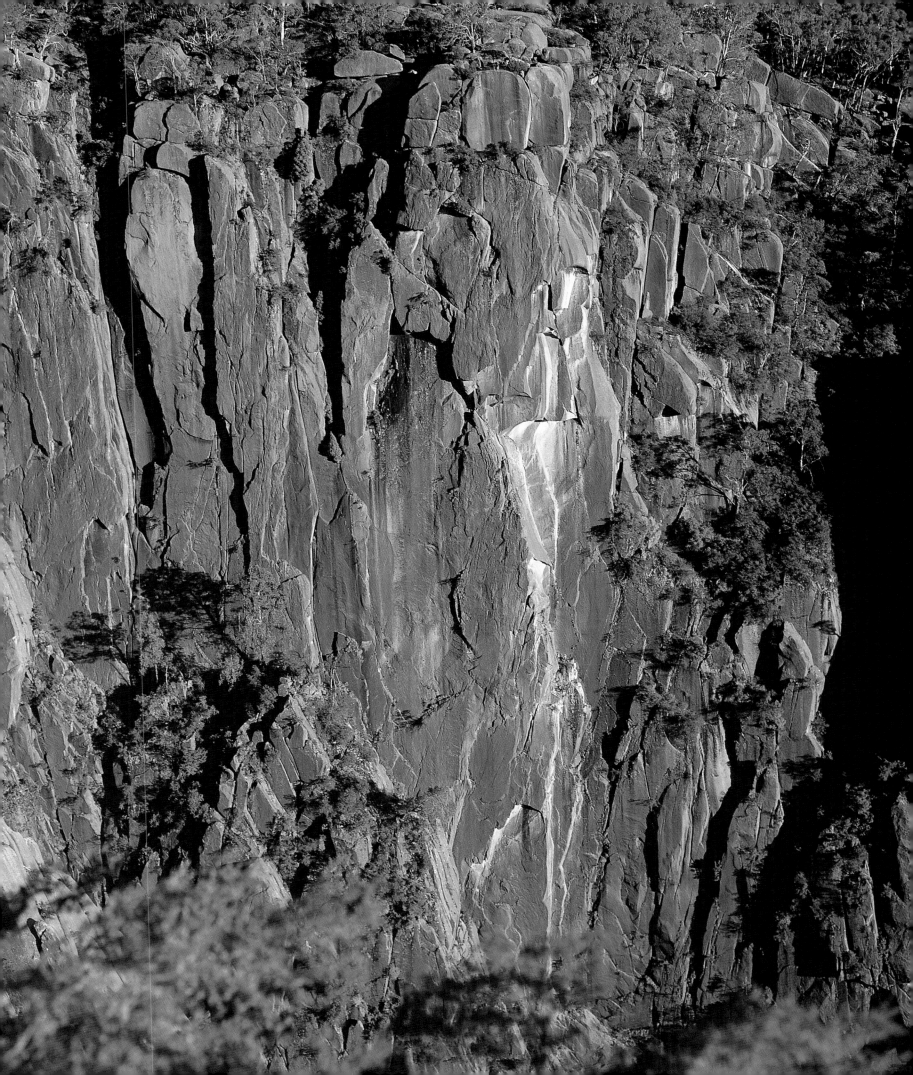

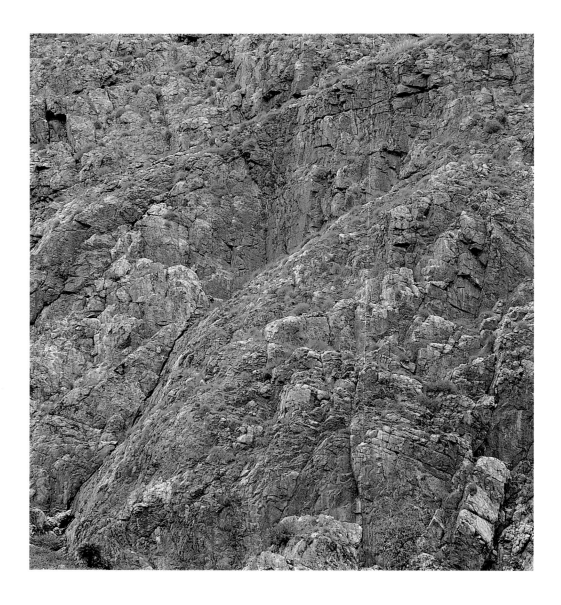

The fractured quartzite of the north wall of Ormiston Gorge, West Macdonnell National Park, Northern Territory, shows the impact of the convulsions of its genesis. Heat and rain from violent storms shape the crumbling surface, while roots of spinifex and Ghost Gums prise open the ruptured surface — gravity carries away the boulders and rubble as the wall retreats.

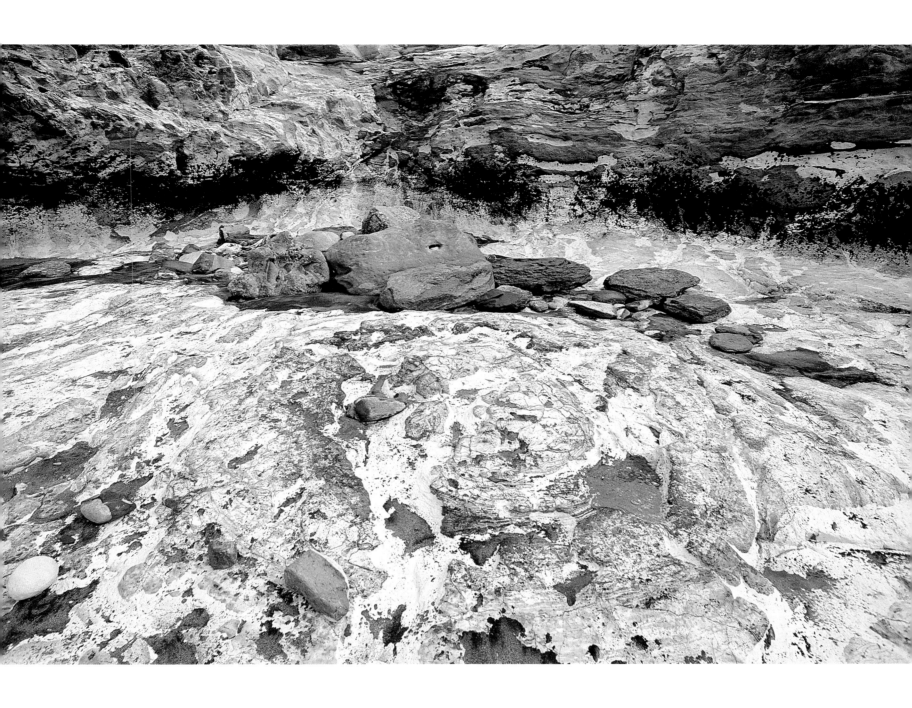

The coast near Darwin: a young clayey sandstone through which water charged with minerals such as iron oxides has moved, leaving behind the staining colours of their passage. Waves, driving sand and loose boulders have cut and swept this bench of stone, and ground out the notch behind the boulders.

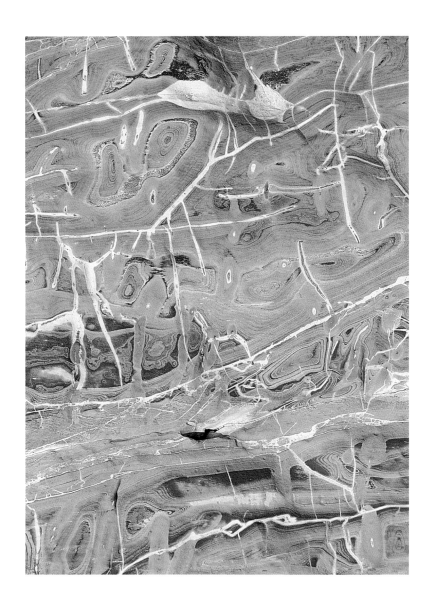

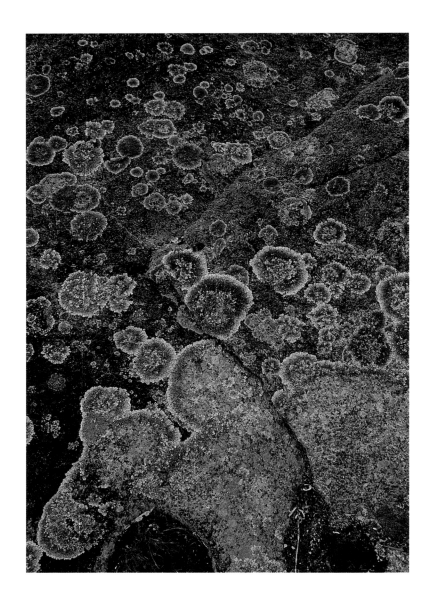

Left: Detail of Darwin's sandstone foreshore.

Right & opposite: Lichens, the pioneers, paint the rocks with colours ranging from vermilion, through dashes of golden sunlight to star bursts and bullseyes of greys, greens and blues.

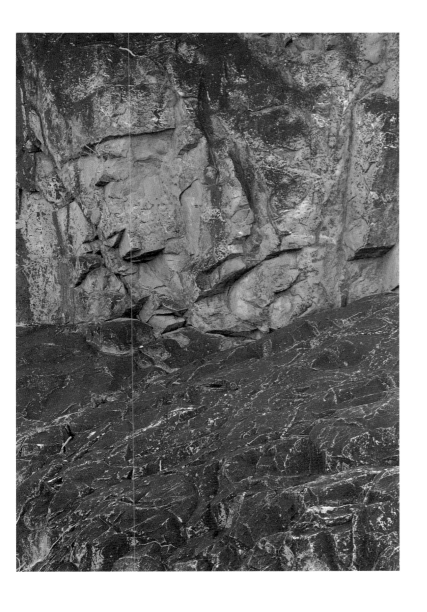

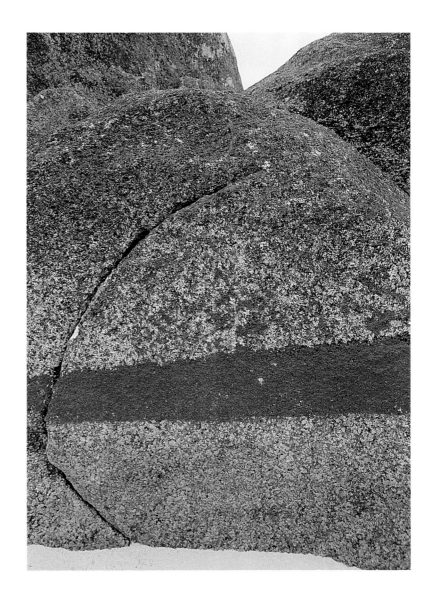

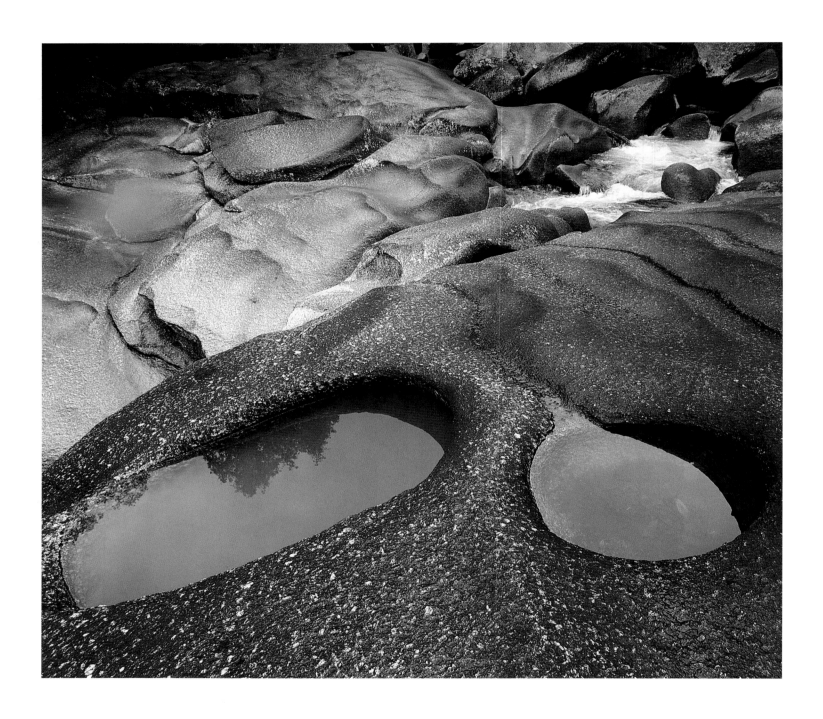

Creek polished granite, darkened by algae where it is not under regular attack by the water. A rainforest creek, north Queensland.

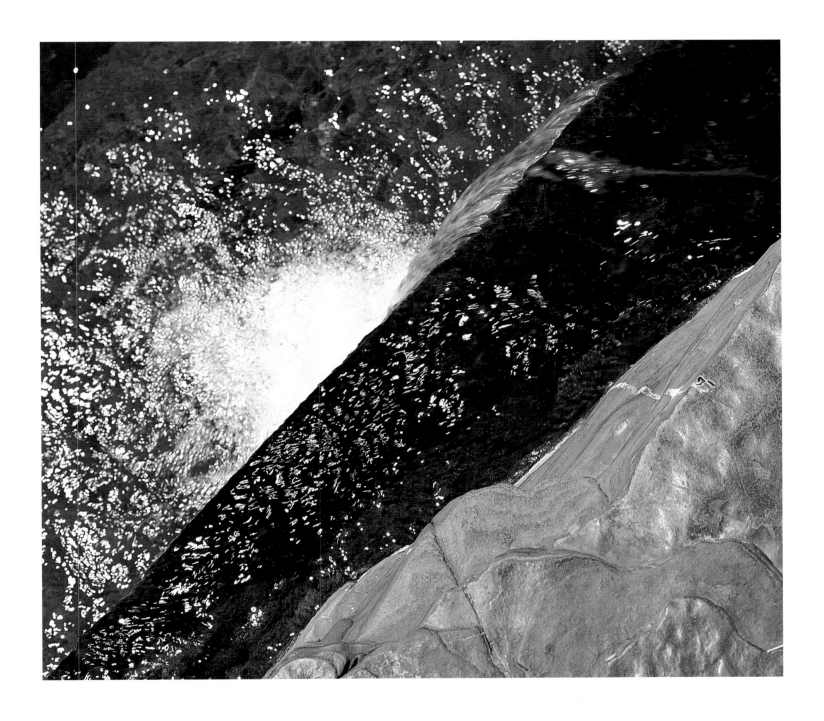

Hamersley Gorge in the Pilbara is a place of wonder for amateur or professional rock enthusiasts. Rich in iron, concentrated in bands by algae when the world was young, the walls of the gorge have been folded and twisted. The stream has found a series of steps on its way to join the Fortesque River.

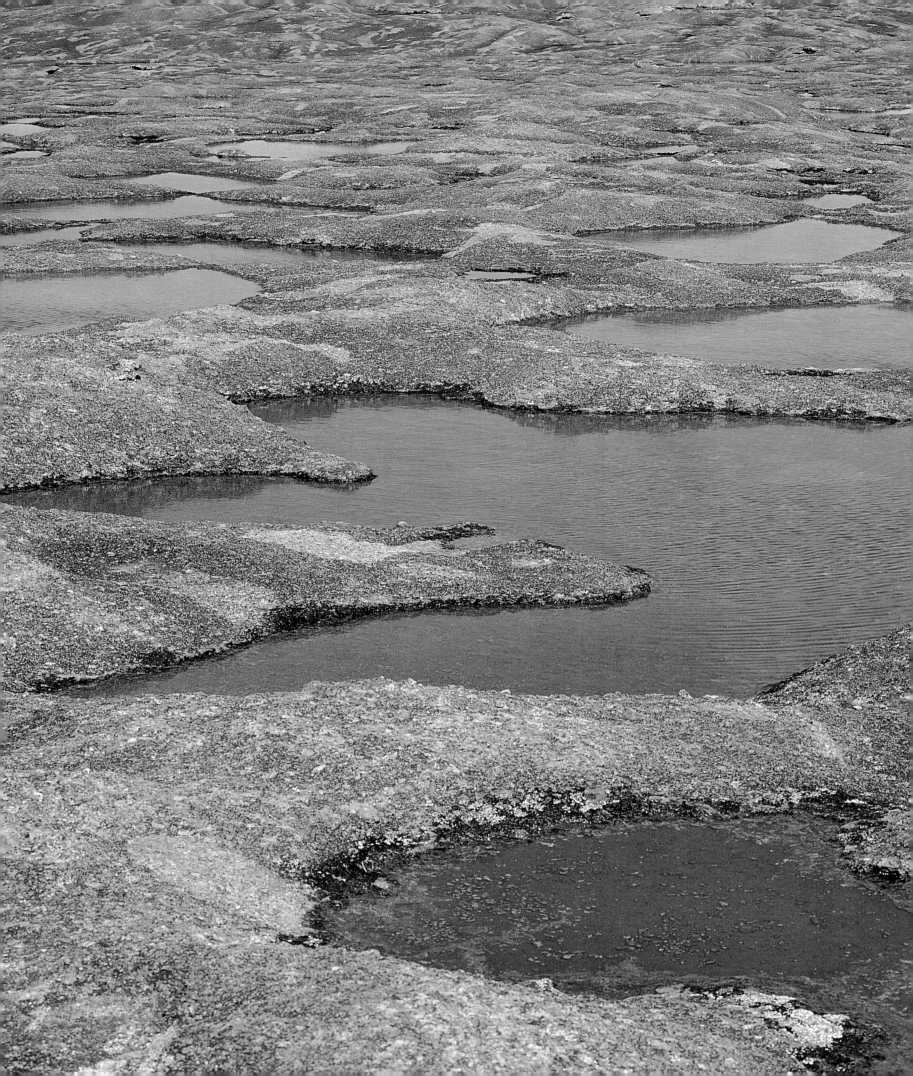

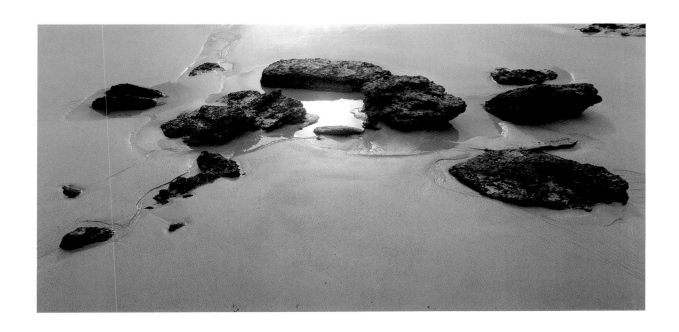

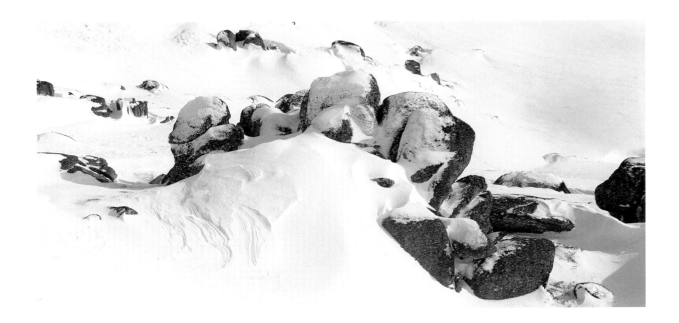

Top: Waves and the many tidal changes convert rock to sand, part of the continuing cycling of the earth's surface.

Bottom: Winter among the granite tors at Blue Cow, Kosciusko National Park, New South Wales.

Opposite: Gnamma holes on Wangara Rock near Lake Moore, Western Australia. These occur in granite when small depressions hold runoff water which promotes weathering, particularly of calcium and aluminium compounds (feldspar) and mica. Rotten patches of surface granite then develop which are scoured out by wind and water. The gnamma hole becomes deeper and wider. Algae grows on the damp, cooler, undercutting surfaces, producing acids which further attack the rock.

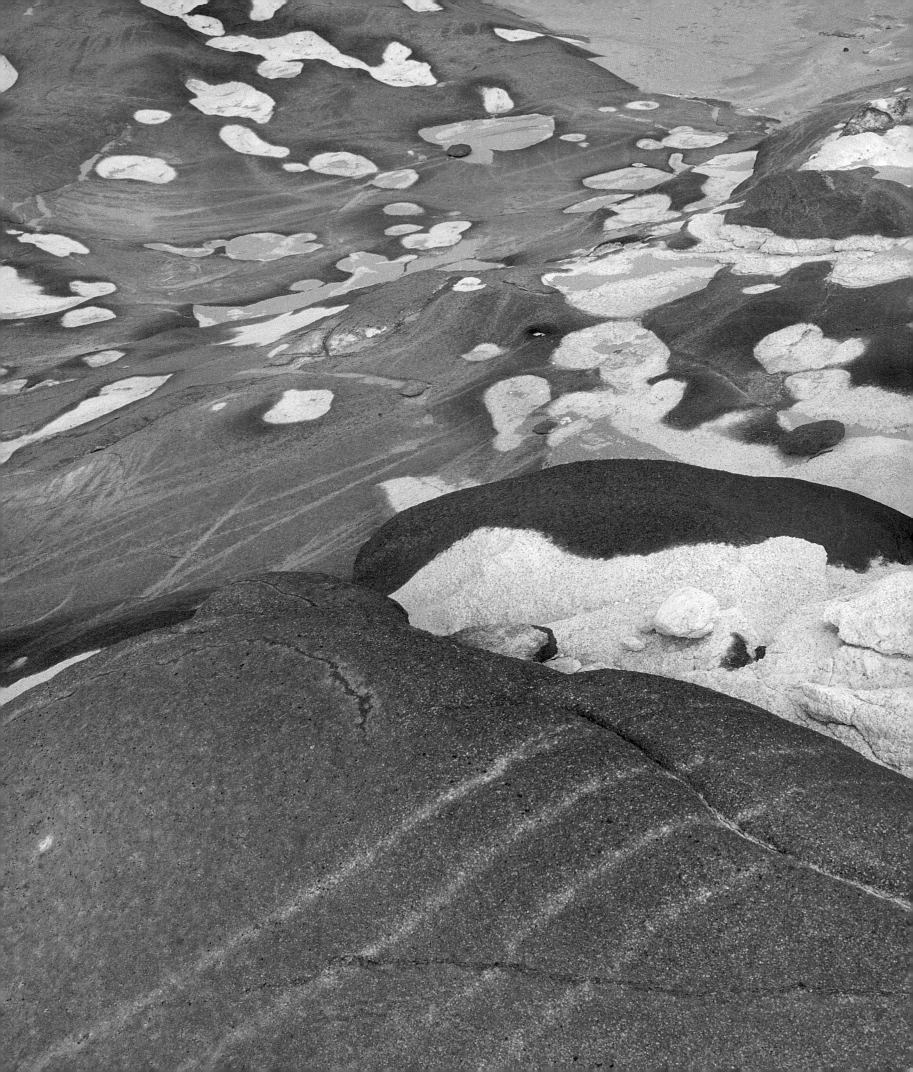

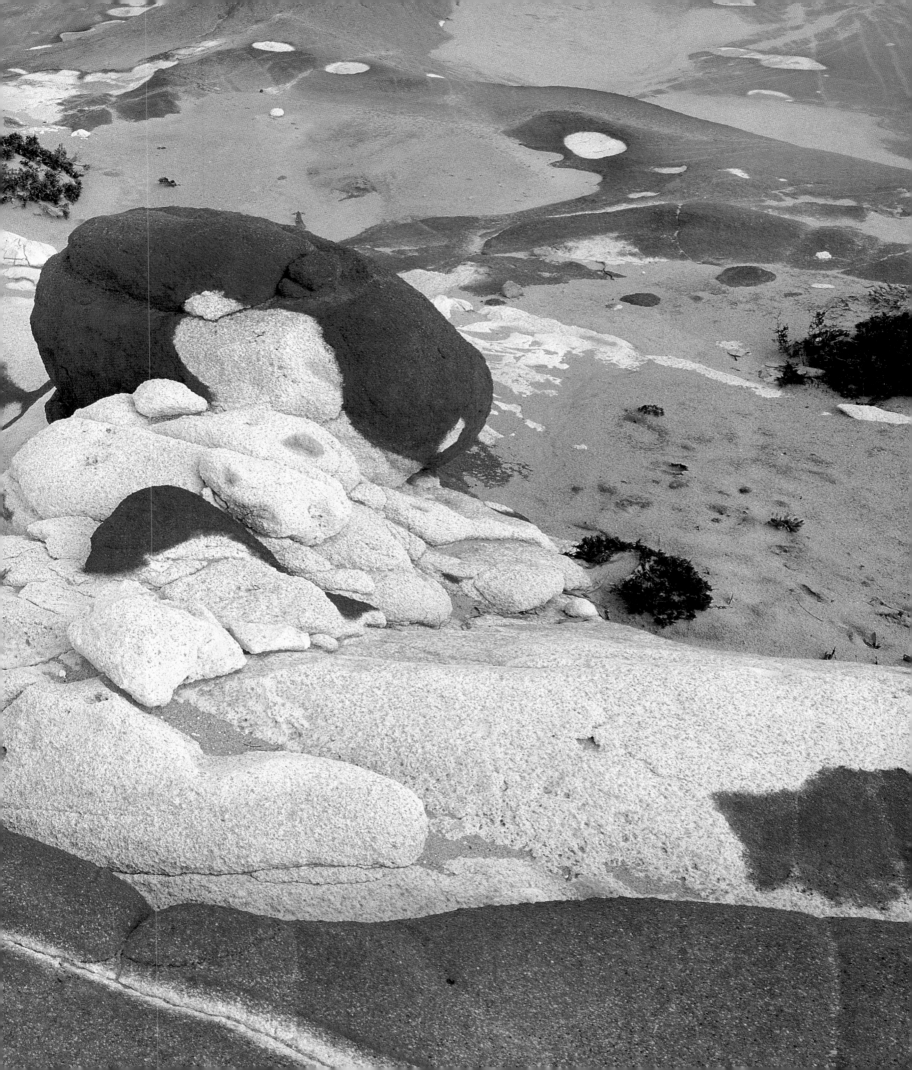

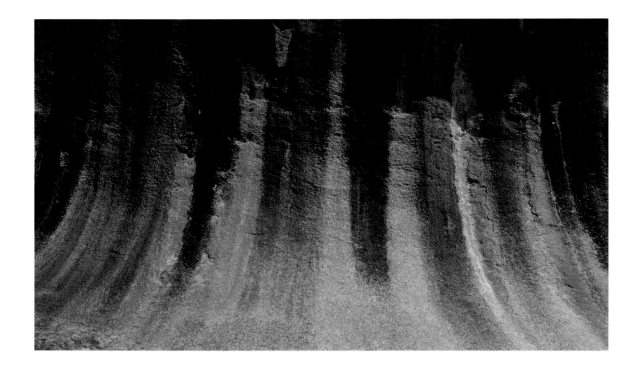

Wave Rock, at Hyden in Western Australia, is the top of a granite mass. The sweeping flow lines of dark organic slime, algae and lichen accent the smoothly undercut edge. It is believed that the soil level was once above the top of the curve and that water running off the Rock kept wet, chemically active soil against the granite. This caused the weathering or rotting of the granite. Since then, the soil level has dropped many metres, resulting in the clays and grit from the rotted granite coming away, sculpting the wave form.

Opposite: From time to time, as here at Paynes Find, Western Australia, granite rotted by weather and organic matter is swept away. The remaining algae on the raised strips carries on doing its work shaping the rock, before being swept away at a later time. But the earlier cleaned strip is once again carrying young algae. So the granite dome is slowly reduced to clay and sand.

Previous page: Near Lake Cowan, Norseman, Western Australia. The sandstone rock depicts a past upheaval of red and white mud, blending into a solid image.

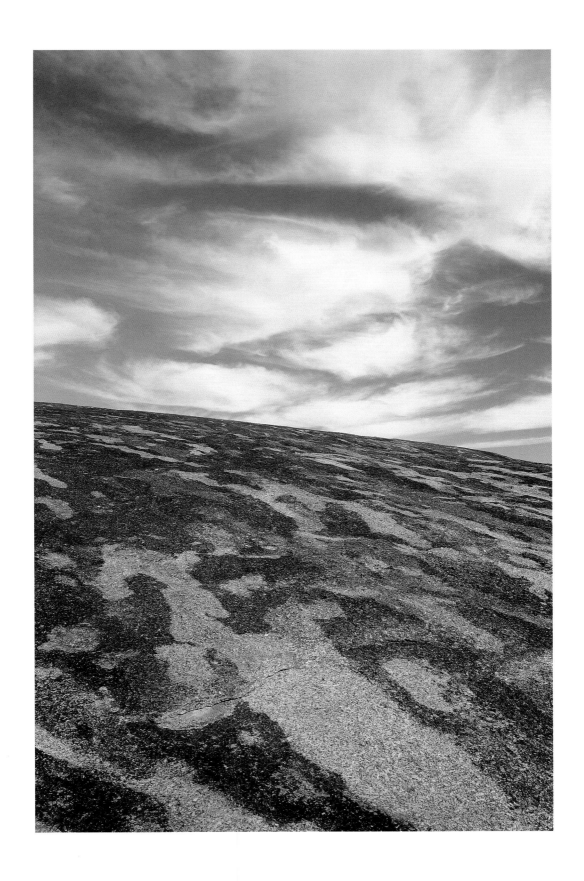

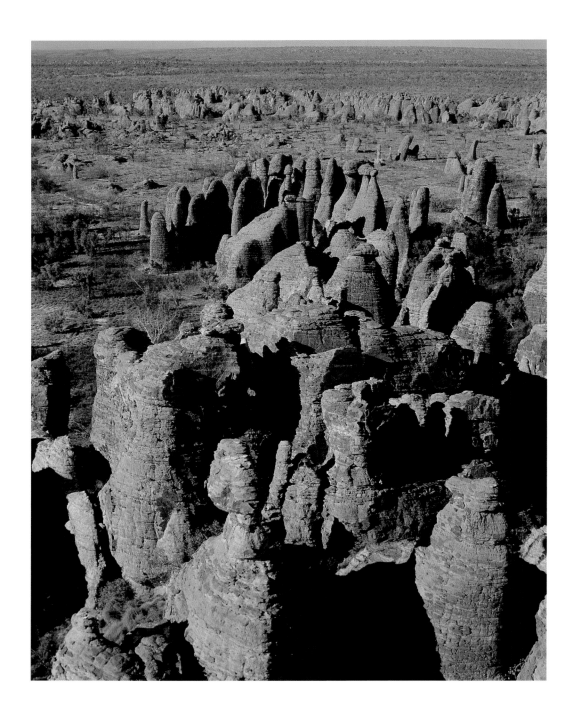

The 'Lost City' at Cape Crawford, west of Abner Range, Northern Territory, seems an appropriate name for this place. Ancient, finely jointed sandstone in the Abner Range to Nathan River region have weathered deeply along the joints. Erosion has opened these gridded gaps, thus isolating thousands of 'skyscraper' remnants, a hundred metres and more high.

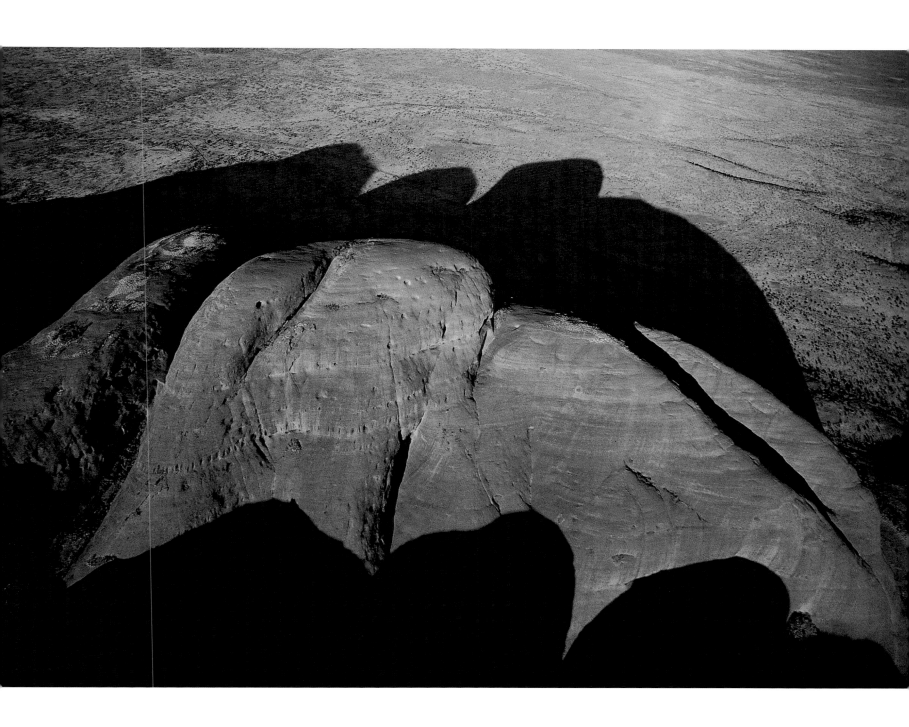

Mt Olga (above), half as high again as Uluru (Ayers Rock) is one of 36 domes of coarse
conglomerate which cover 40 square kilometres. The Valley of the Winds (foreground) is in
the deep shadow of early morning, buffeted by cold winds sucked in by rising air warmed
by yesterday's heated domes.

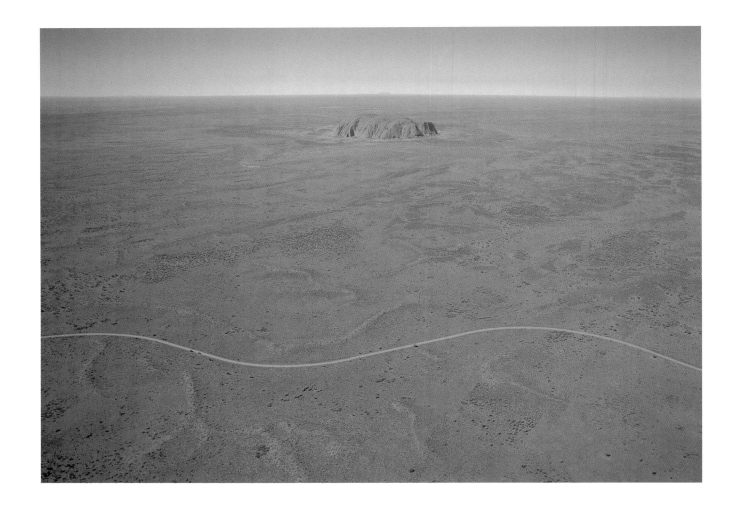

Uluru, the 300 million year old stump of a once great sandstone range pressured up from the southern edge of the Amadeus Basin, is home of Wonampi, the great serpent which looks after the water in the desert. The highway, named after Lasseter, the luckless prospector who refused Aboriginal help and died of thirst and hunger, imitates the writhing of Wonampi.

Opposite: In the beginning, according to the Tjukurrpa of the Anangu Aborigines, Uluru had been a great featureless dune. A series of sagas involving the ancestral creators had their movements over the dune petrified into gorges, gullies, hollows and caverns. Uluru is permanent reminder of the significance of land to all people. It gives the Anangu connection with the ancestral past and a spiritual link with all other living things, providing shelter, water and food.

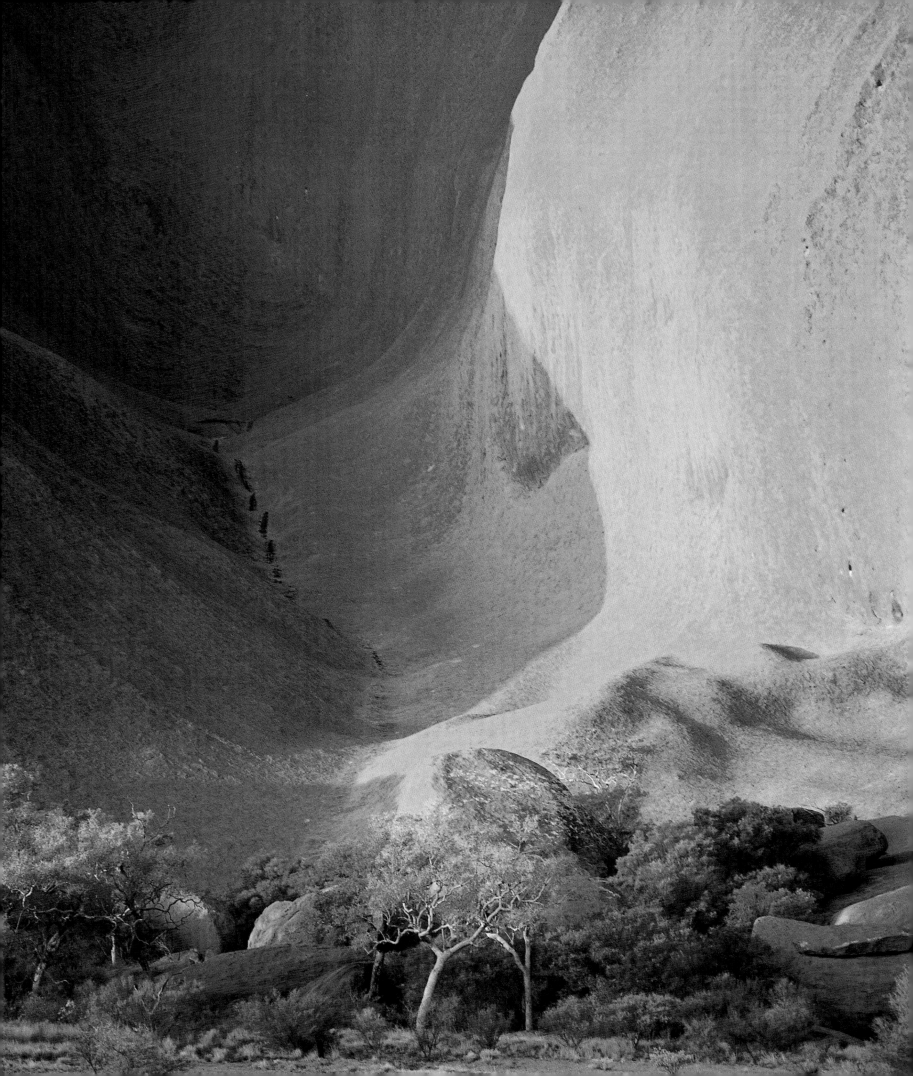

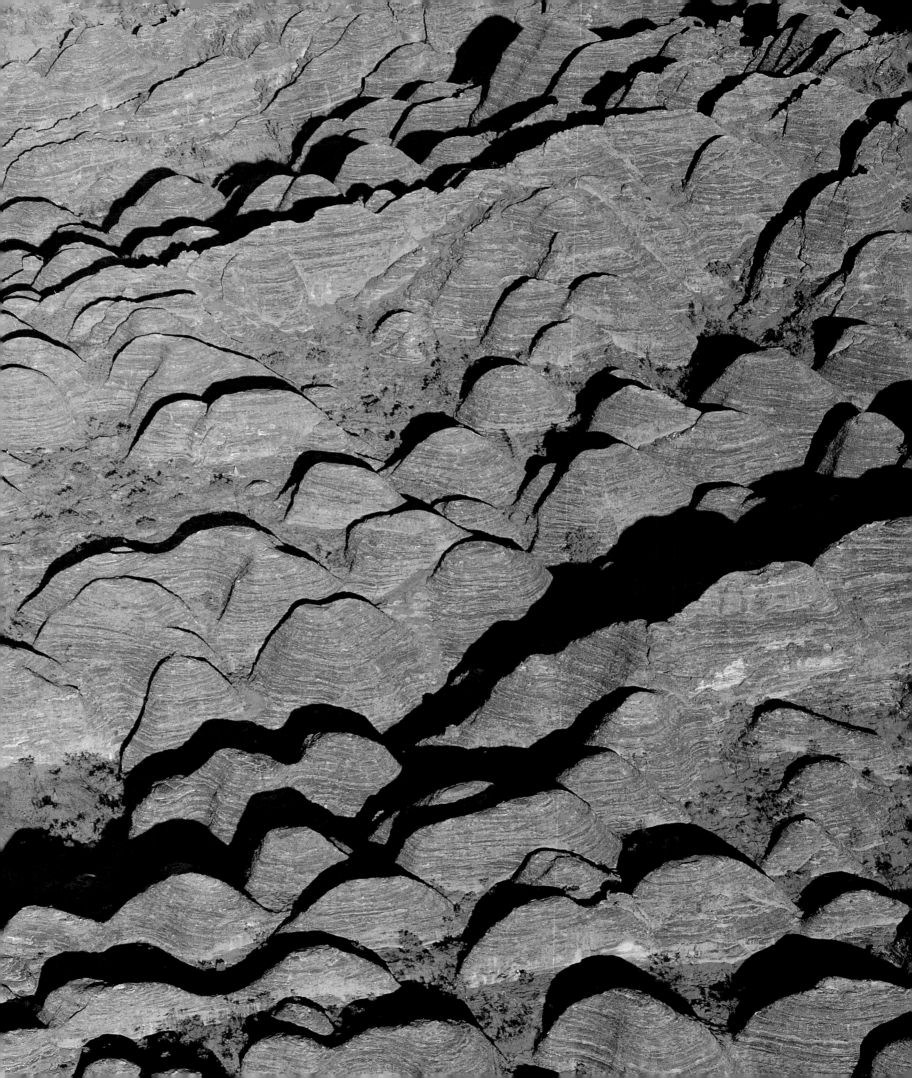

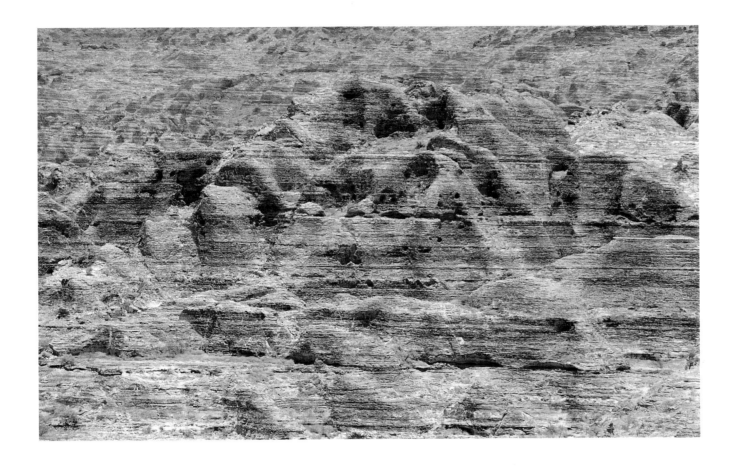

Above & opposite: The Bungle Bungles in the East Kimberley are layer upon layer of sandstone and conglomerate which were uplifted about 250 million years ago. The regularity and homogeneity in the fine layering produces the symmetrical slopes and the exquisite erosion forms. Water and wind have opened up the checkerboard joint patterns.

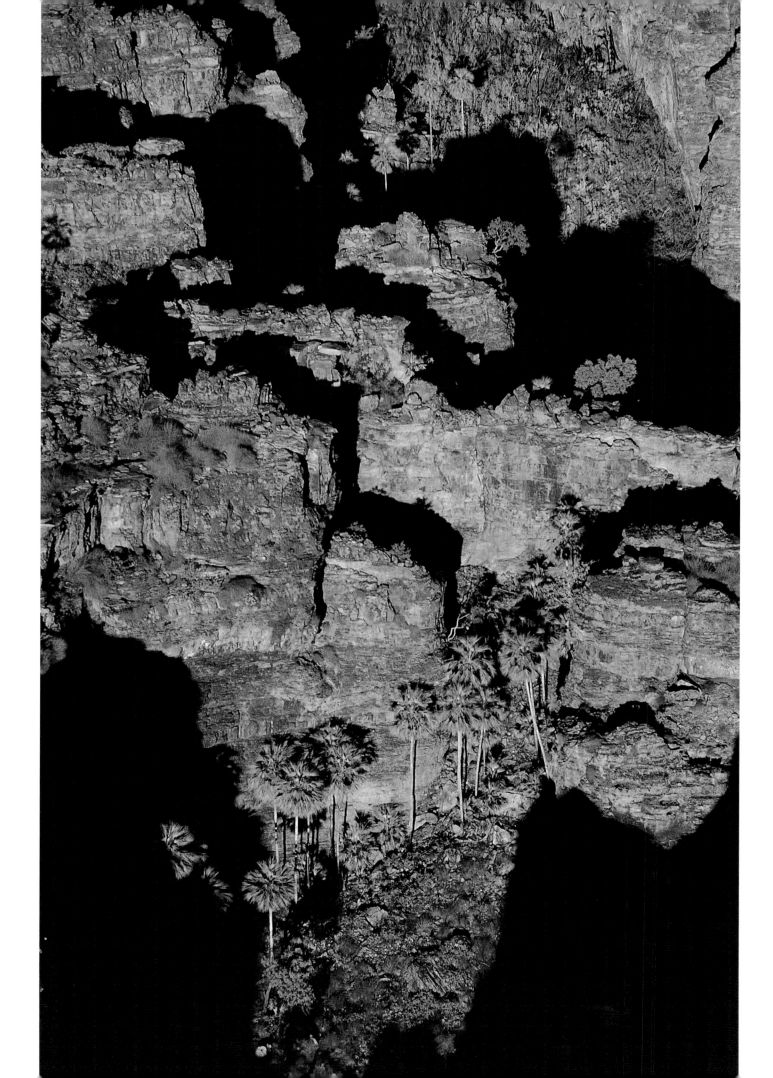

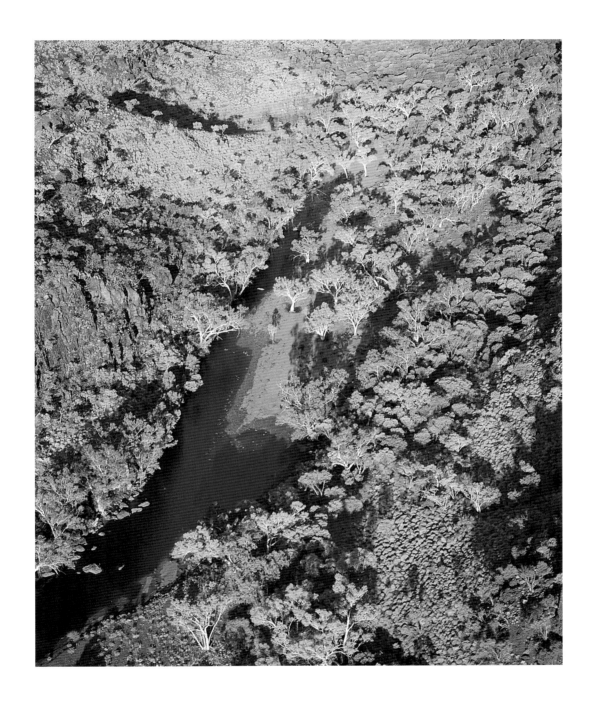

Gorge, eastern end of the Hamersley Range in the Pilbara.

Opposite: The sandstone gorge of the Keep River National Park near Kununurra is allied to those of nearby Mirima National Park. Both areas were very significant spiritual places for the Miriuwung people.

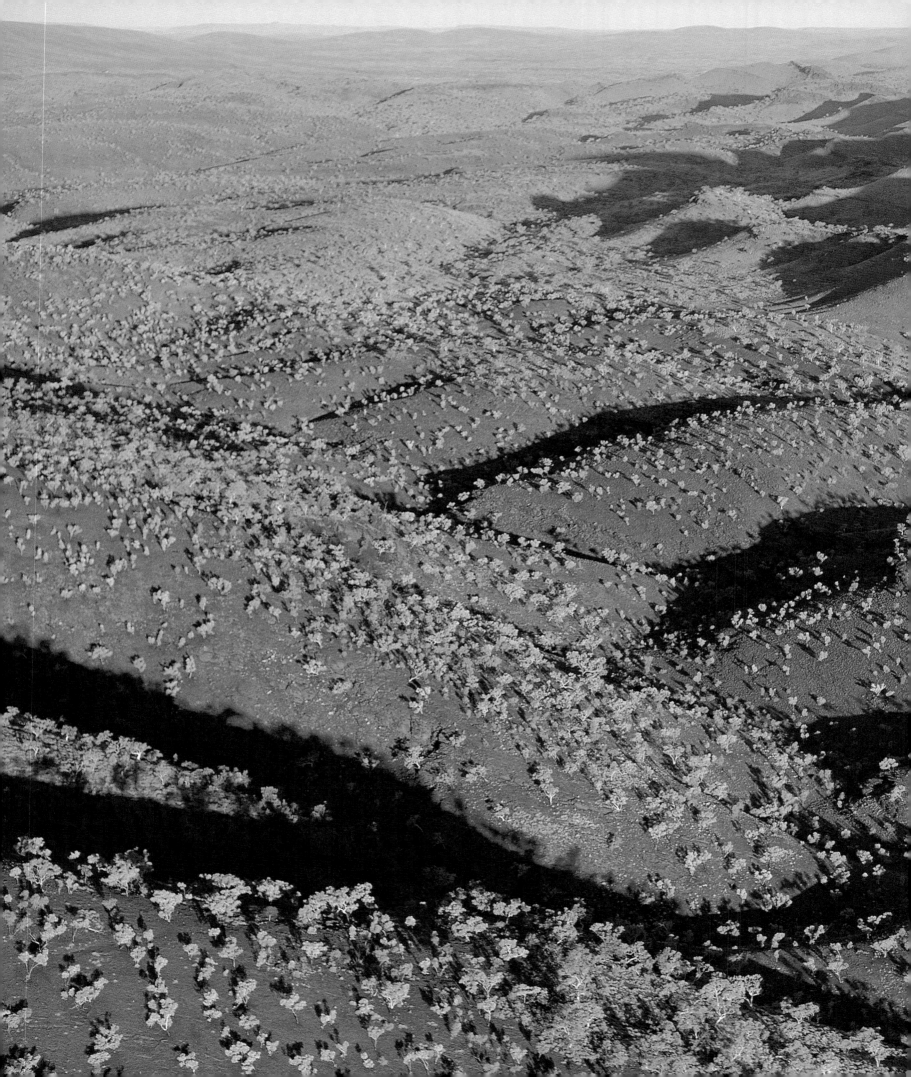

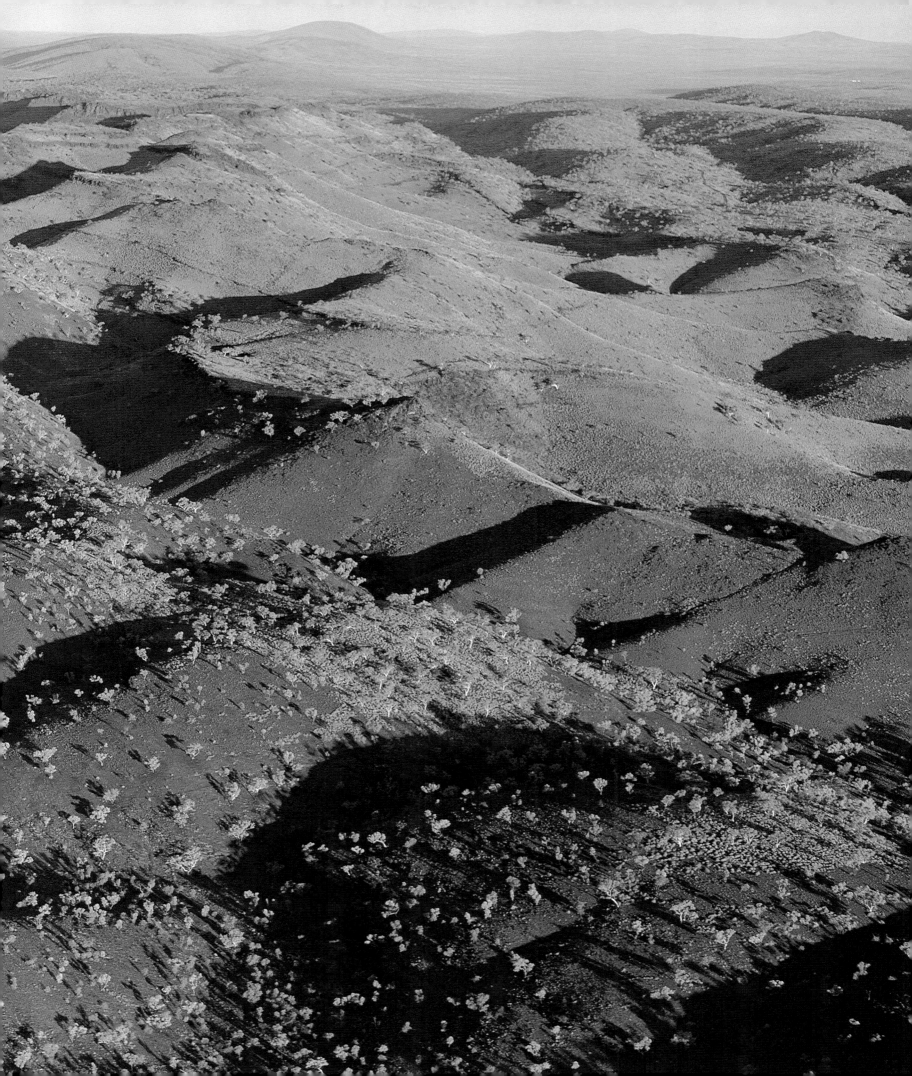

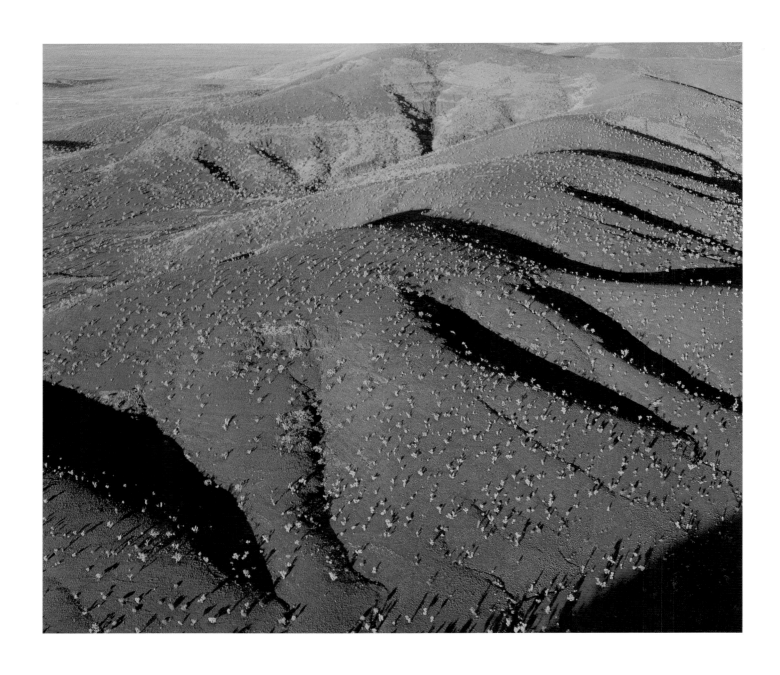

Above, opposite and previous page: Evening light over the Hamersley landscape
near Mount Meharry, Western Australia.

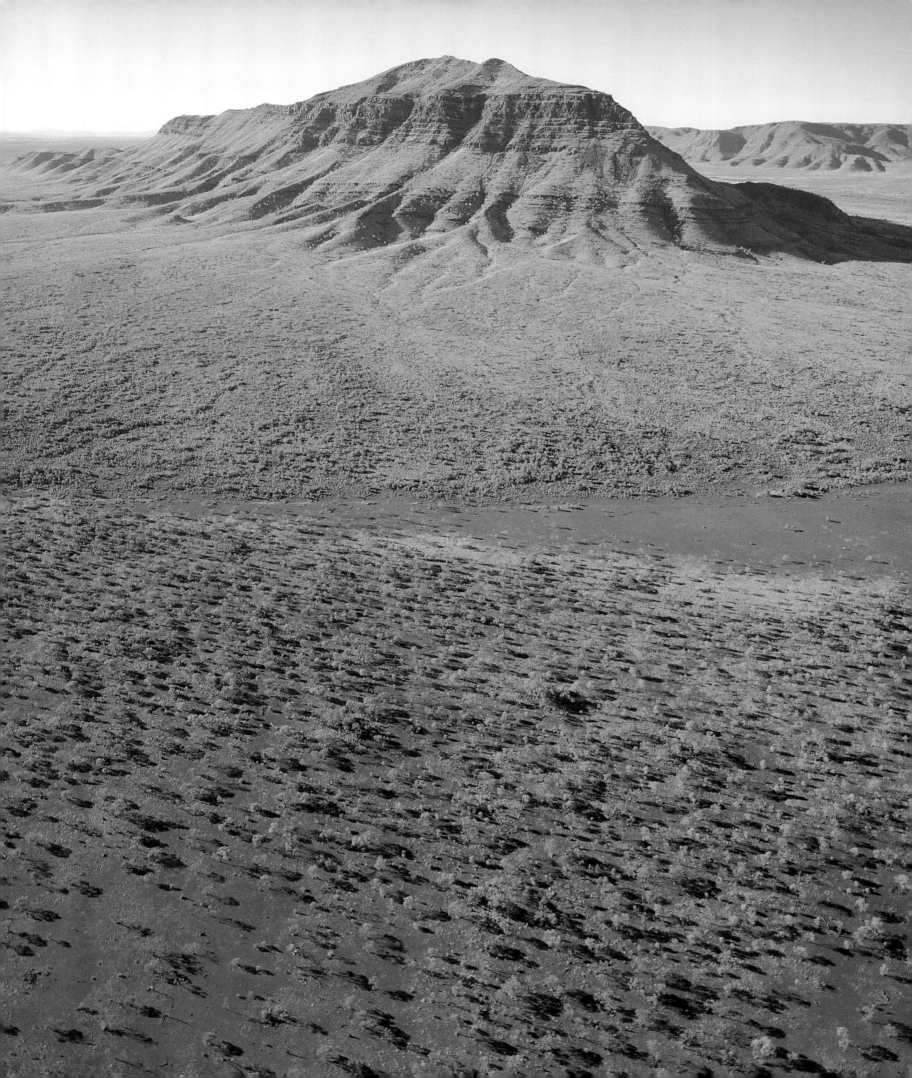

Above and opposite: Hamersley Range, Pilbara. Different species of spinifex
create their own design on the landscape.

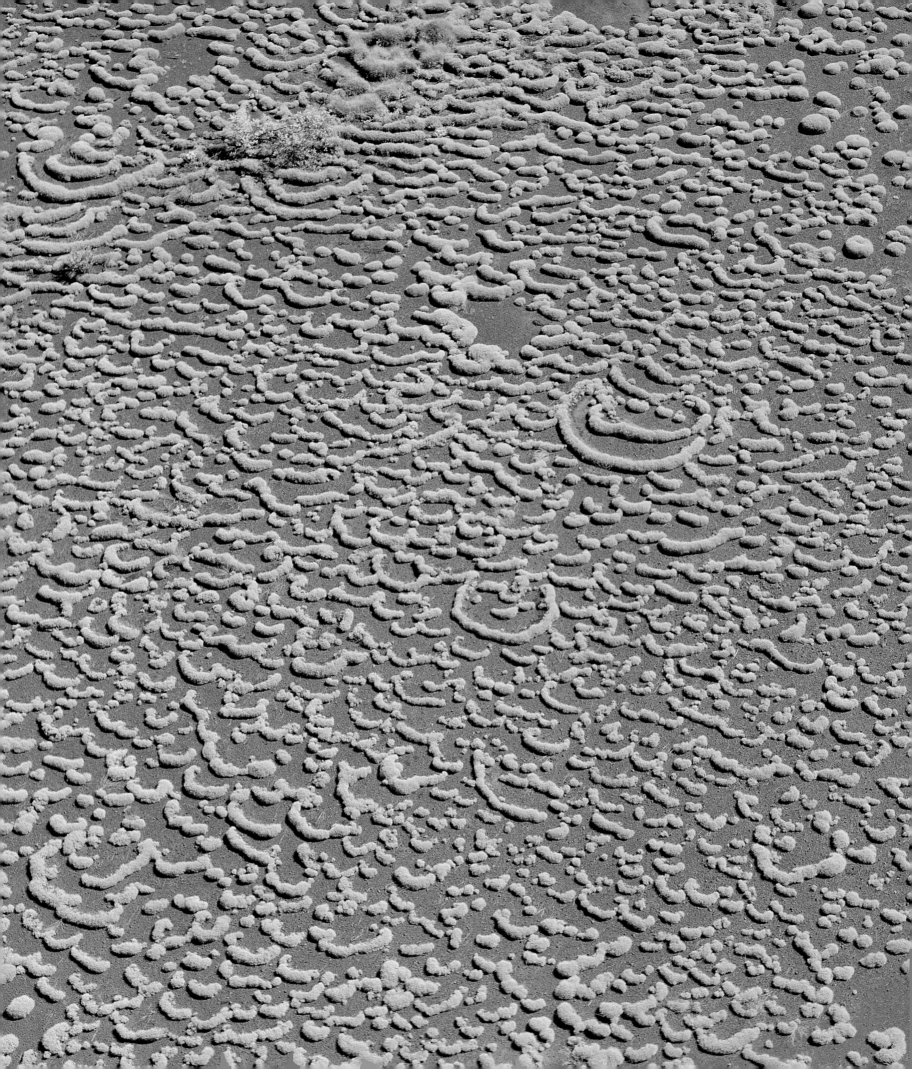

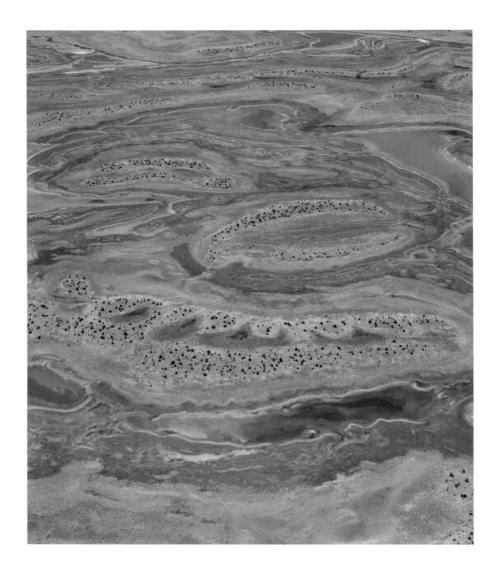

Lake Austin, near Cue, Western Australia, a true wilderness of dunes, salt pans and arid scrub. After the rains come, these dunes become blankets of white and golden wildflowers.

Opposite: About as full as Lake Austin gets these days, usually from a summer tropical cyclone which drifts inland to become a rain depression which fills lakes, gullies, rivers and waterholes.

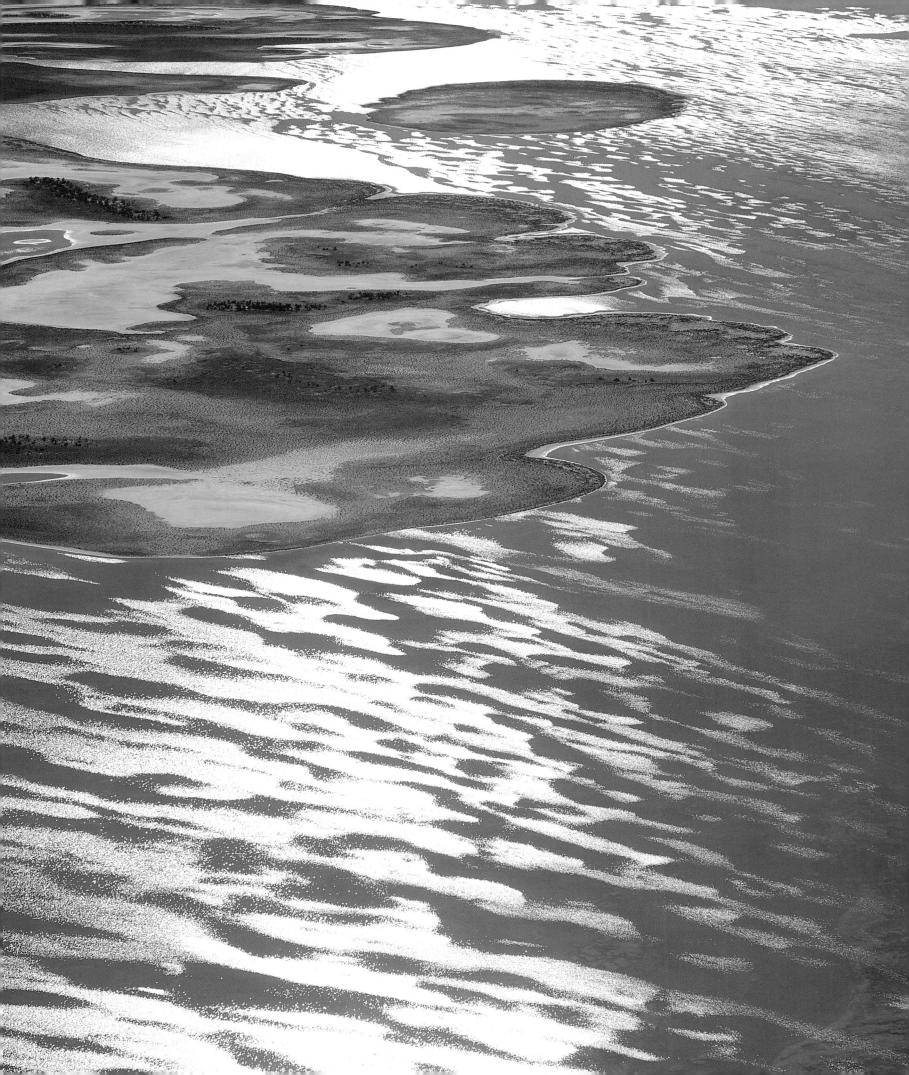

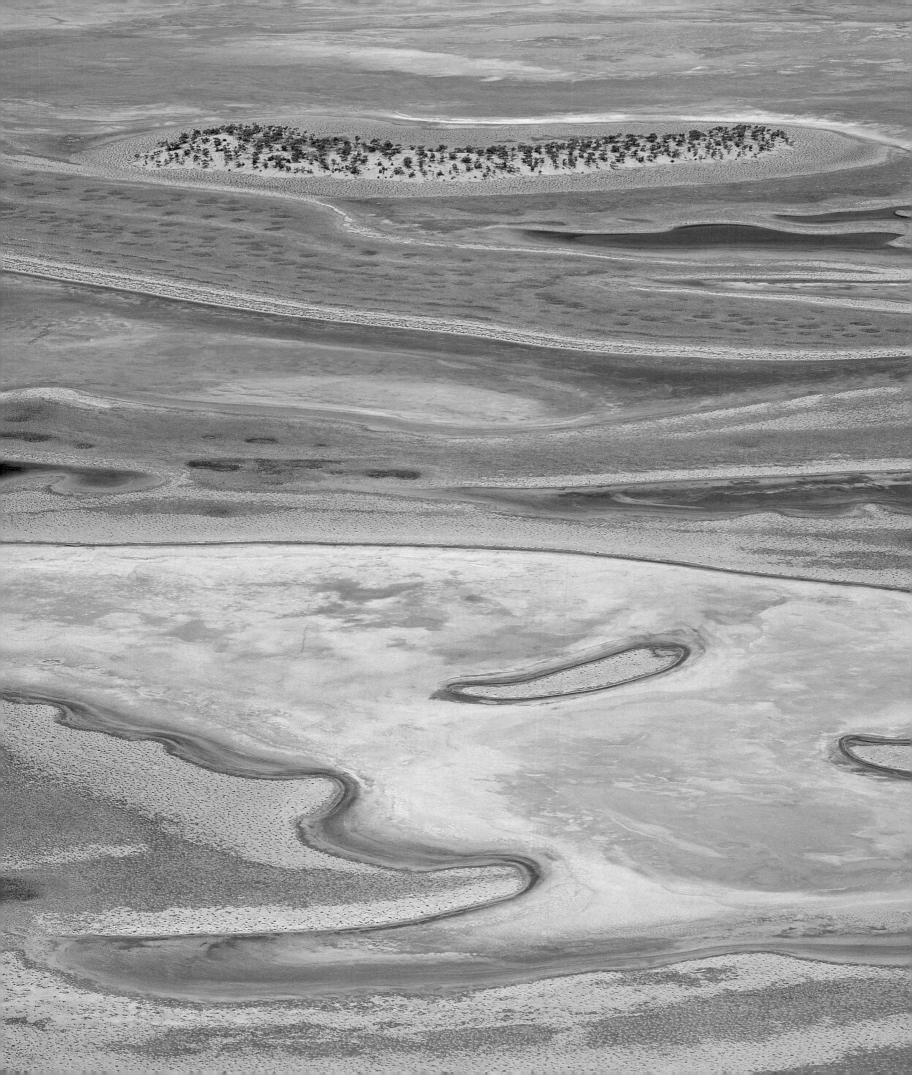

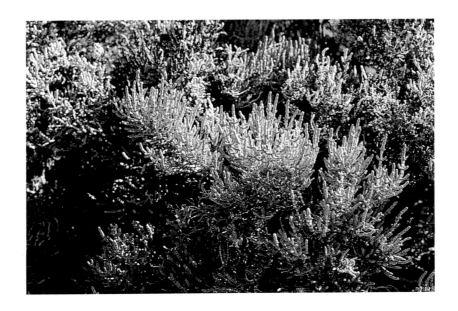

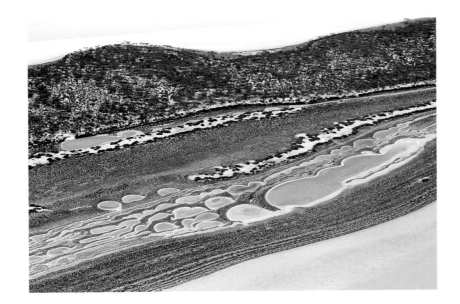

Top: Samphire is a group of succulent plants superbly adapted to be tolerant of extremely high levels of salt. Wherever they are seen, whether by salt lakes or behind coastal mangroves, they indicate extreme salt levels.

Bottom: Near Lake Grace, Western Australia. Linear patterns by the lakes in the foreground are like plimsoll marks on a ship, marking the times when these lakes reached various levels. Seed collects along stable water levels, then germinates producing the lines.

Opposite: Natural salt lake landscape, Lake Moore.

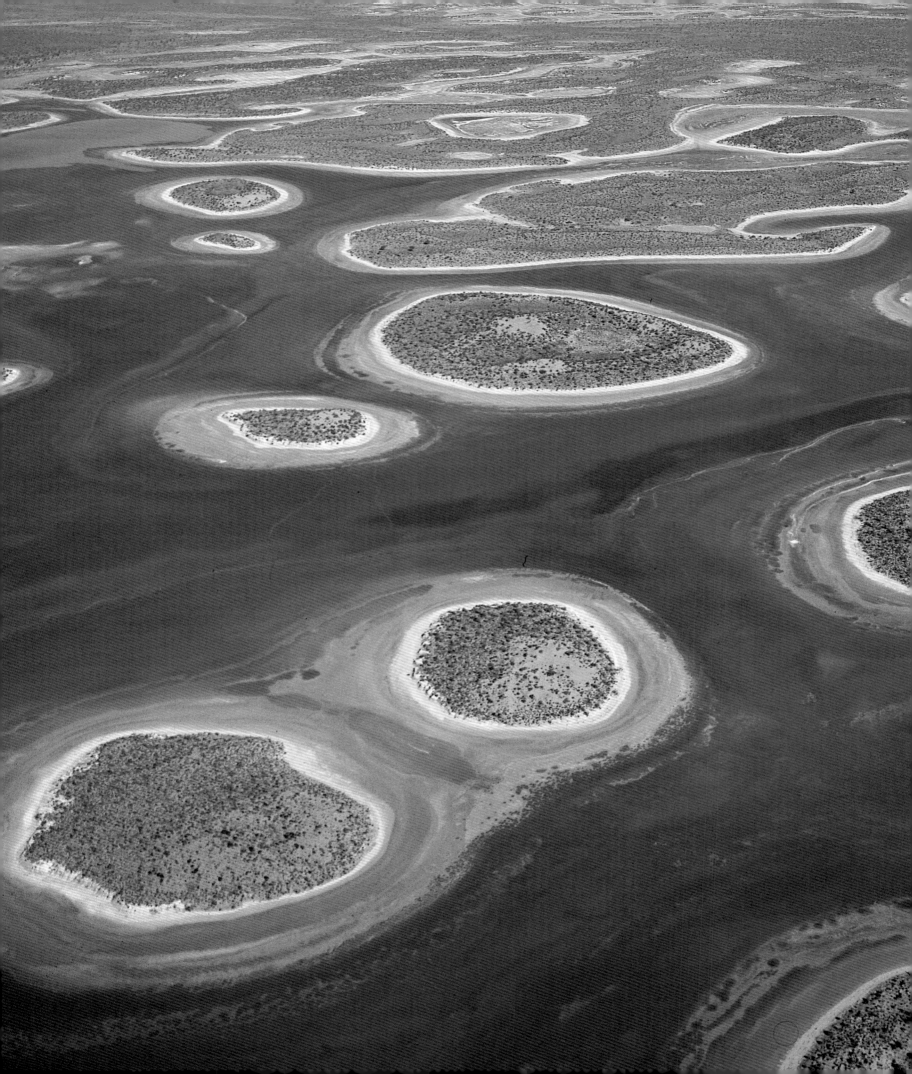

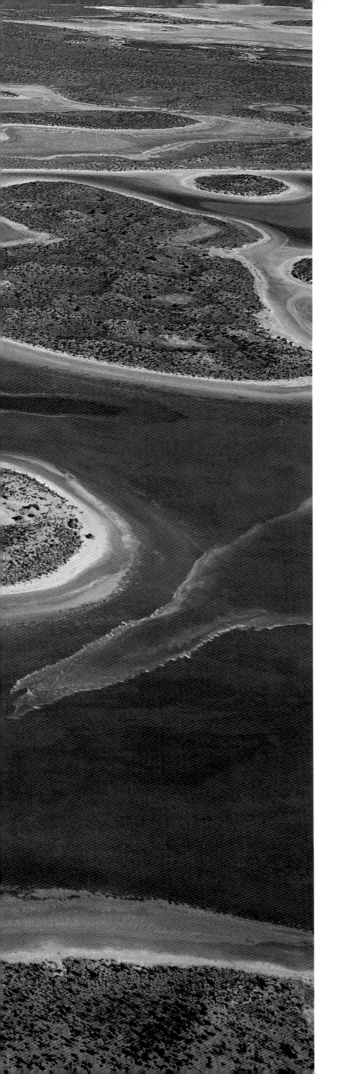

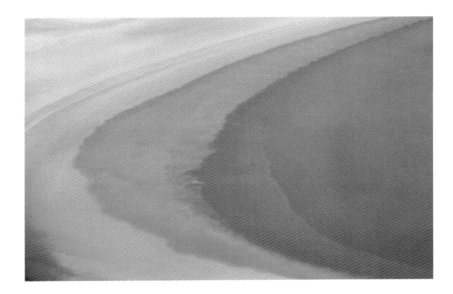

Lake Moore, south of Paynes Find, Western Australia. Like other broad shallow desert salt pans, it holds water for only a brief time after rain. Wind will move water across the shallow pan, causing it to drift away from the shore. At other times the water evaporates rapidly day by day. Each process leaves 'tidelines' marking the timing of the event.

Opposite: Lake Amadeus, north of Uluru, is a 120 kilometre long salt lake filling the valley of a once major tributary, if not the main stream, of the Finke River, which became blocked off by drifting dunes (also the source of the islands).

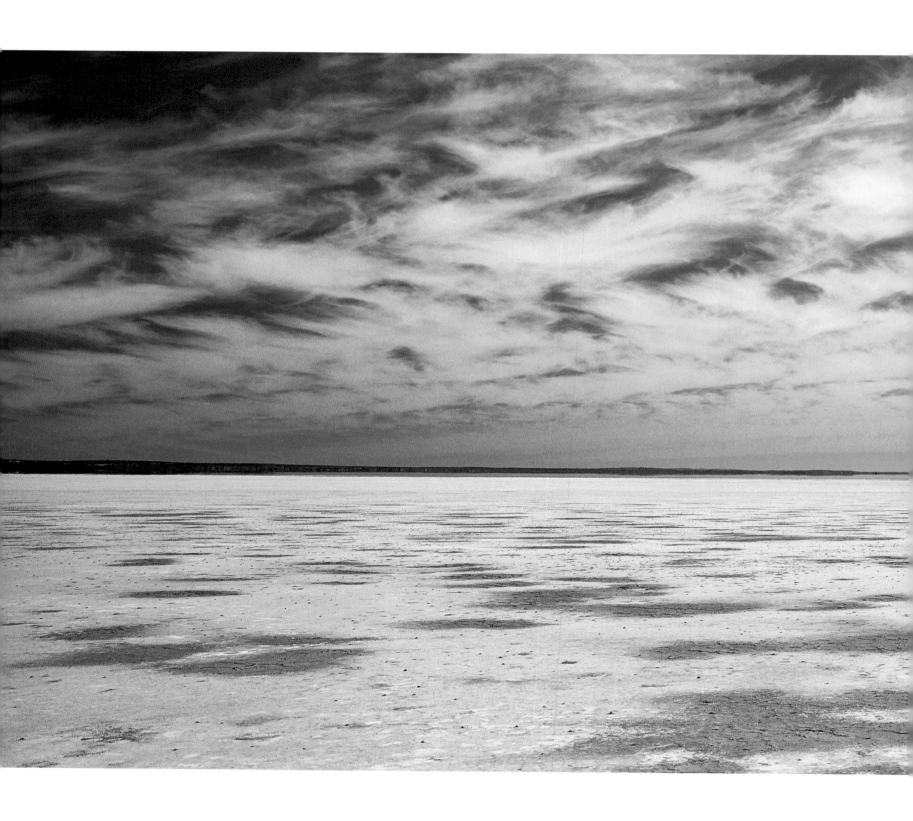

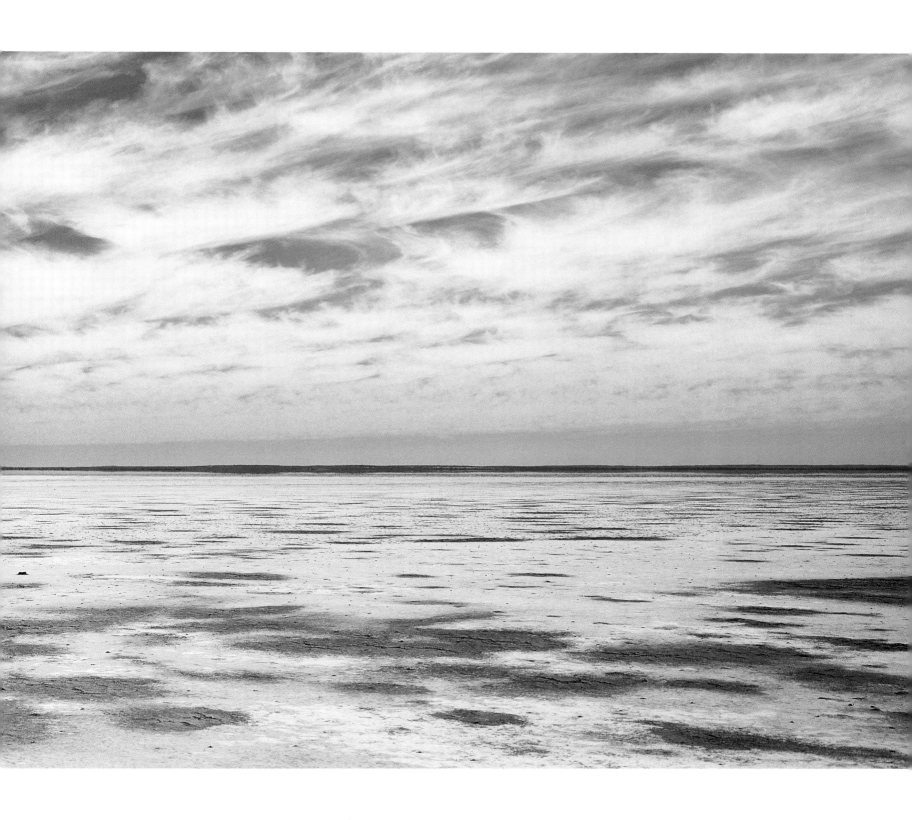

Lake Moore is a conglomeration of claypans, salt pans and salt lakes. Like many of the salt lakes of inland Western Australia they mark the courses of ancient rivers, ten and more million years old, which have accumulated salt from millions of years of drainage.

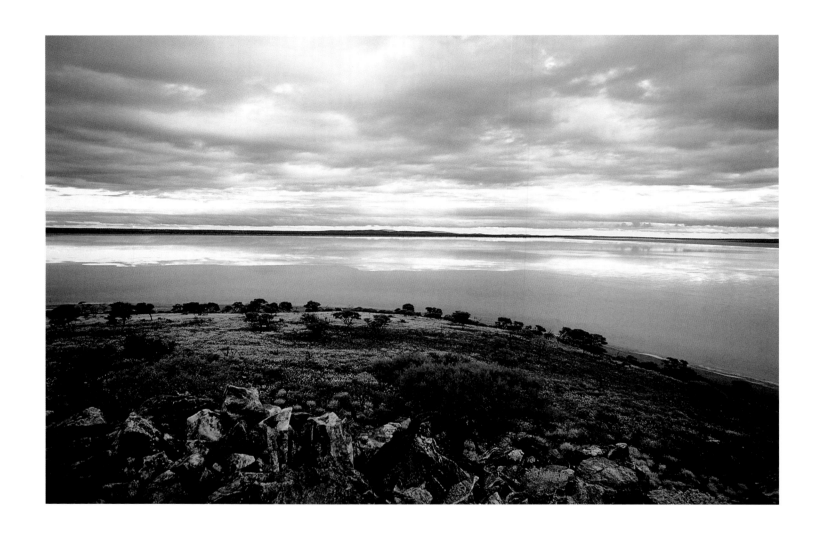

Mongers Lake, south-west of Paynes Find, Western Australia.

Opposite: The rains have come to Lake Austin.

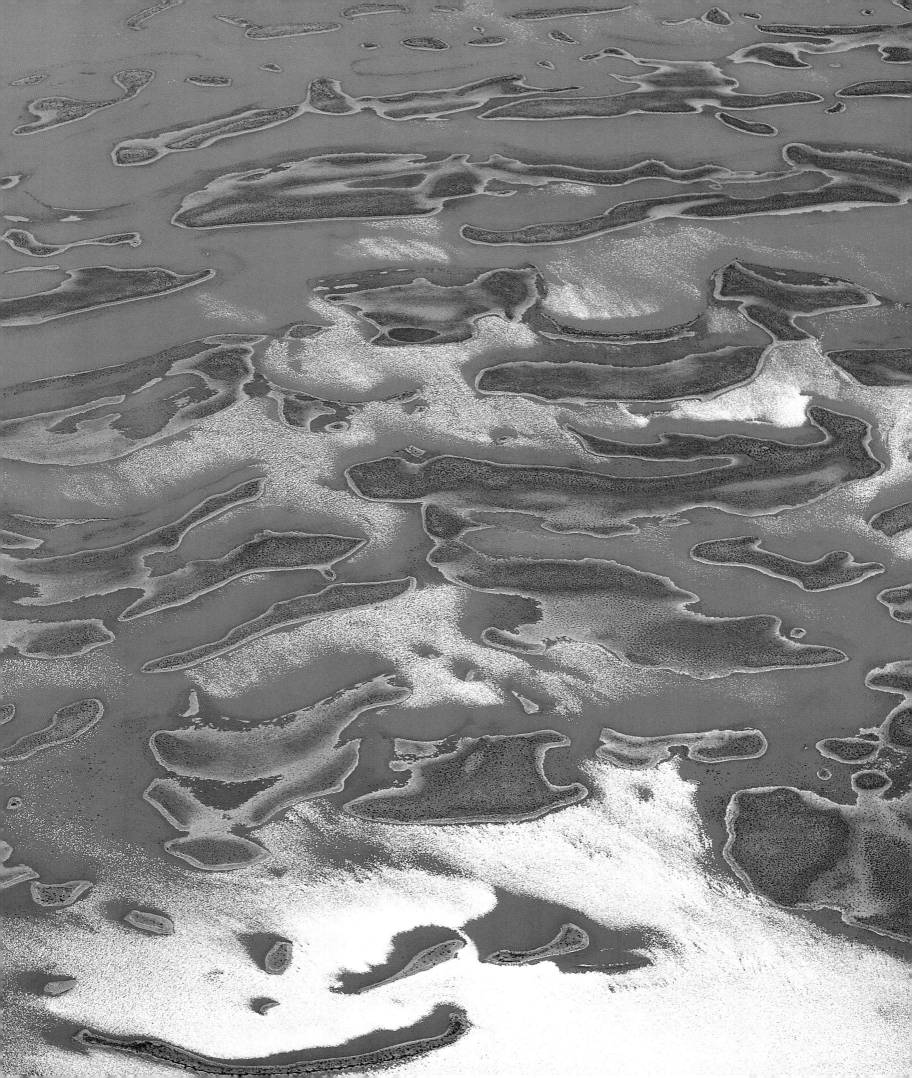

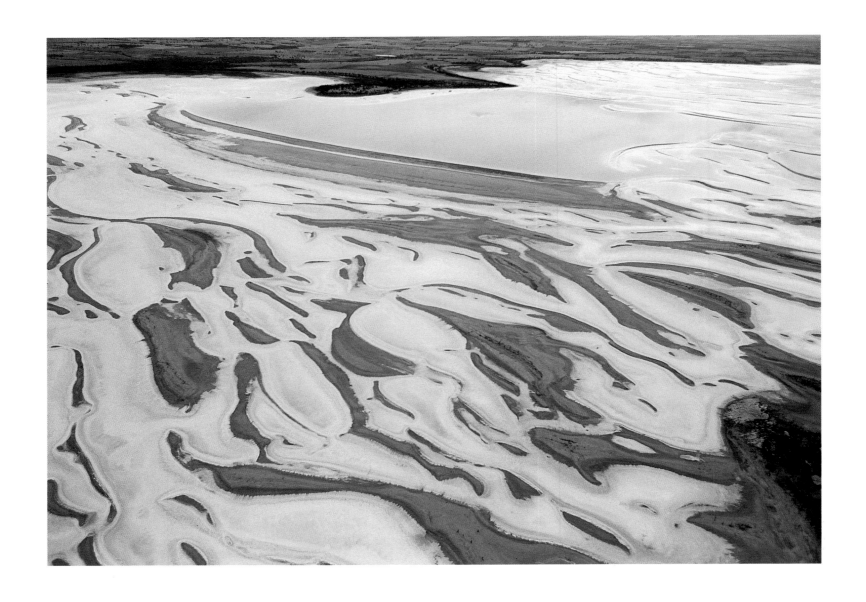

Above and opposite: Dumbleyung Lake, 70 kilometres west of Lake Grace, Western Australia — a large salt lake with patterns created by water and wind movement.

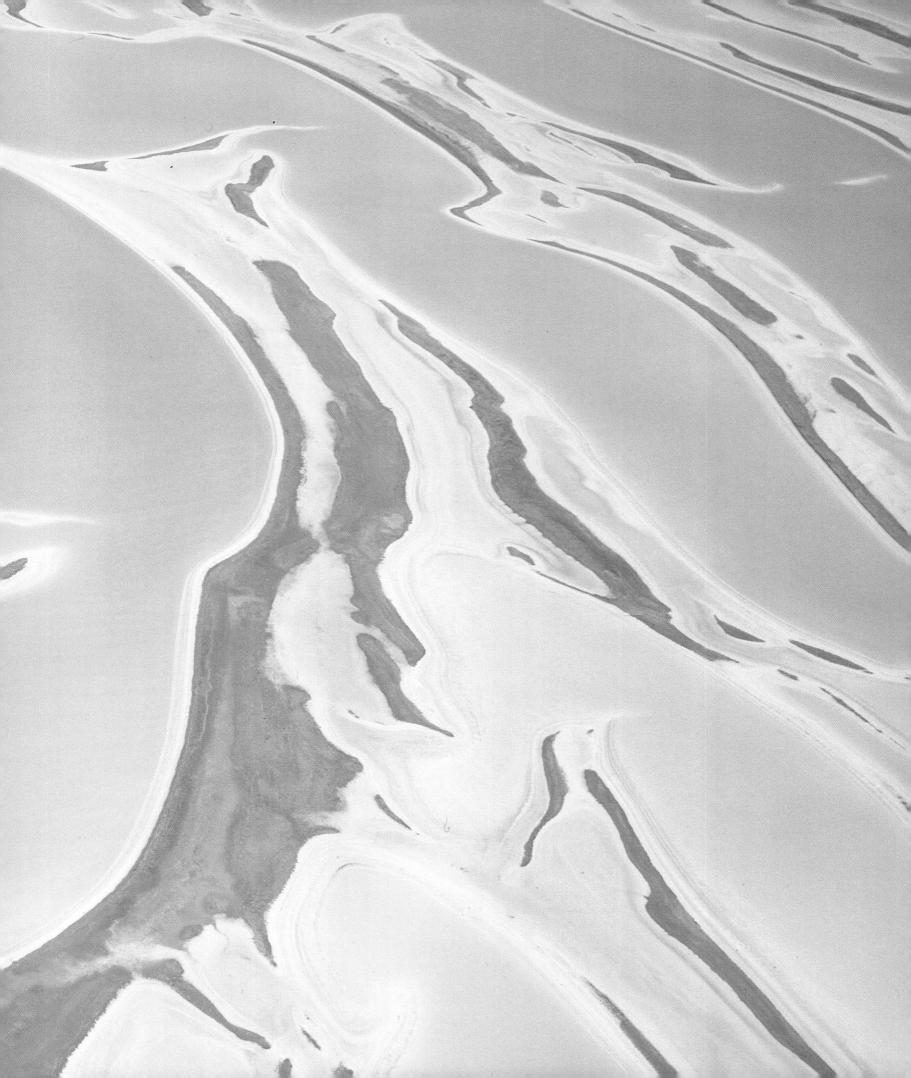

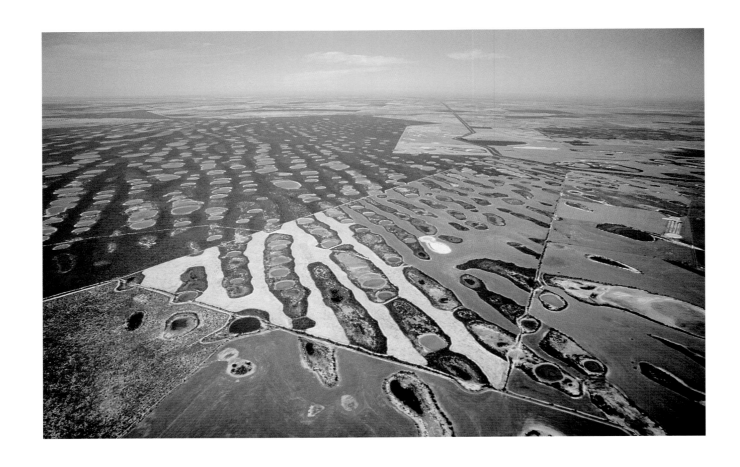

Fence lines are the first phase of wilderness breakdown. Dune and salt lake country, 70 kilometres north-east of Esperance.

Opposite: A little arable land surrounding salt lakes, north-east of Esperance, is sufficient for planting crops.

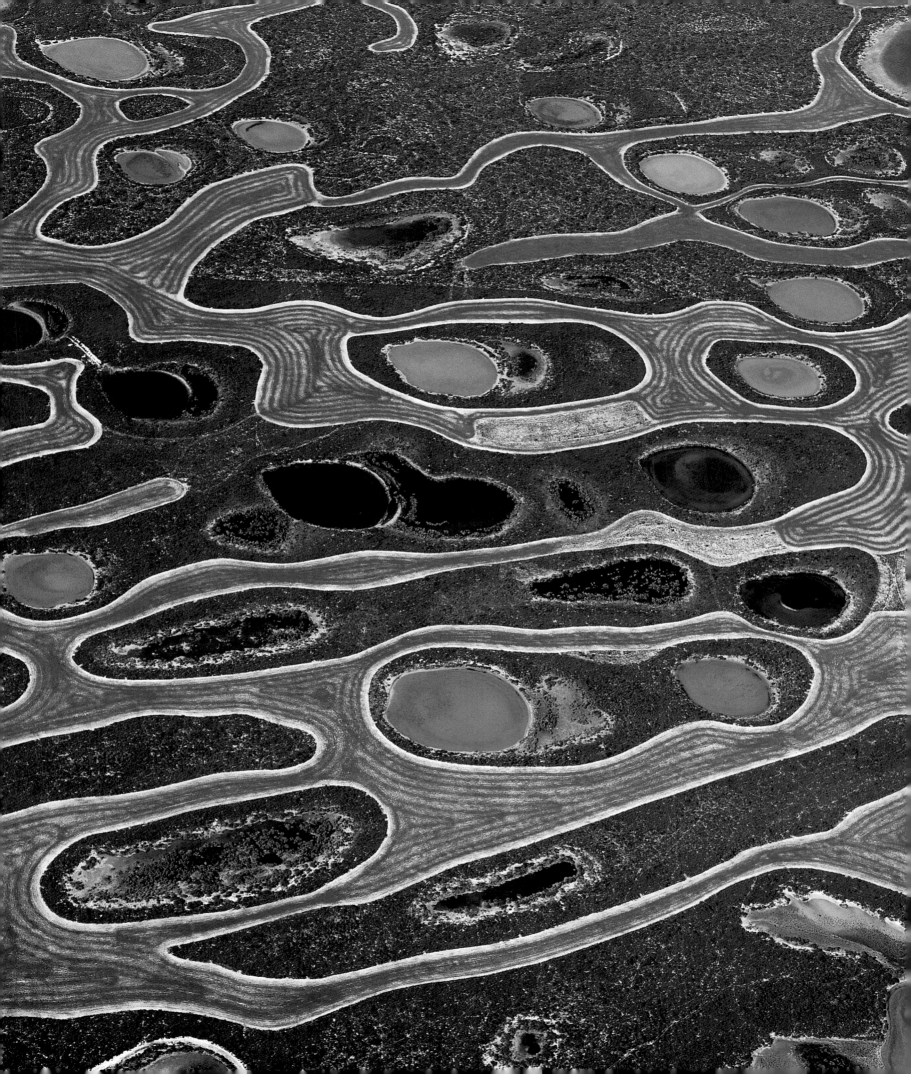

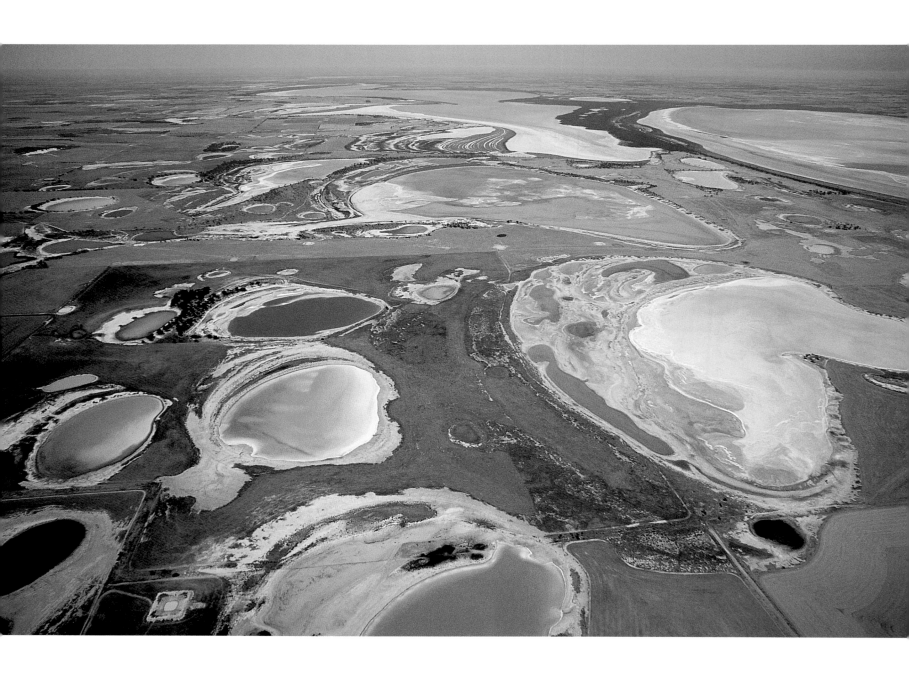

Salt lakes at Lake Grace serve as a 'litmus test' on land use. The coloured lakes in the foreground are adjacent to farming, while the blue lakes are not. Where these messages in colour may lead is not yet understood.

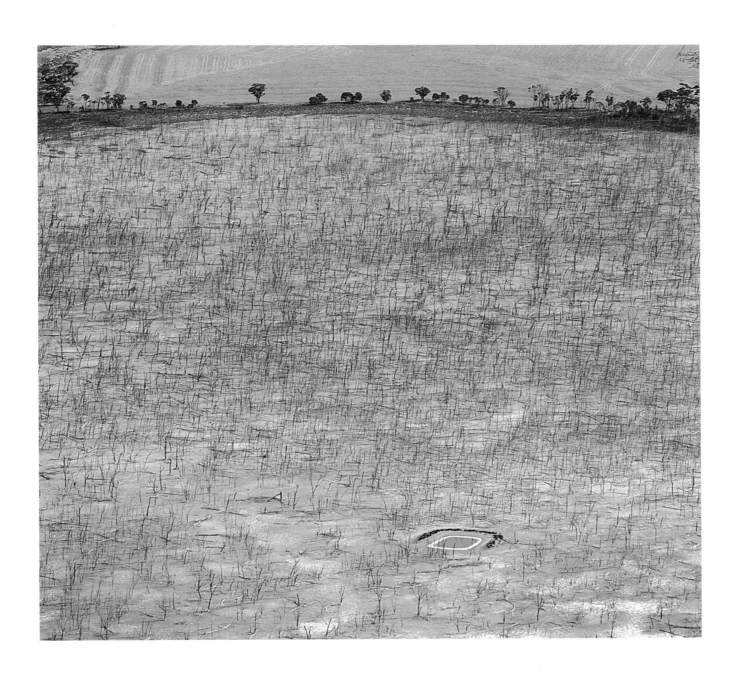

Saltwater affected dam and mallee scrub due to overclearing of the surrounding countryside.

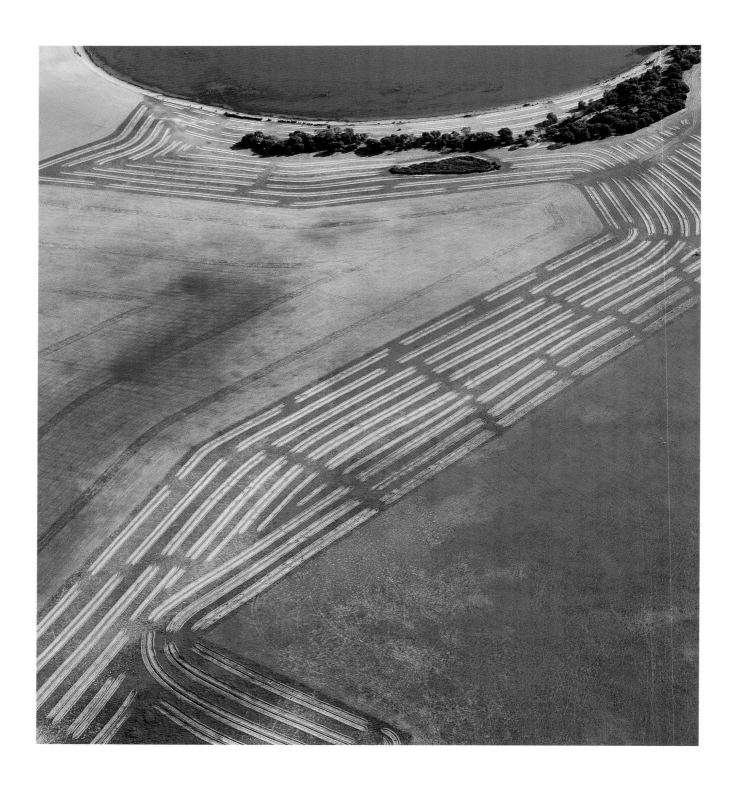

Tree replanting around salt lake to reduce the spread of salt.

Opposite: These strange patterns are on the claypans and bare areas around Alice Springs airport. Cuts have been made through the clay to allow water to enter the ground, and the trenched surface assists in catching wind blown and water transported seed. These projects have been successful in covering scalded ground.

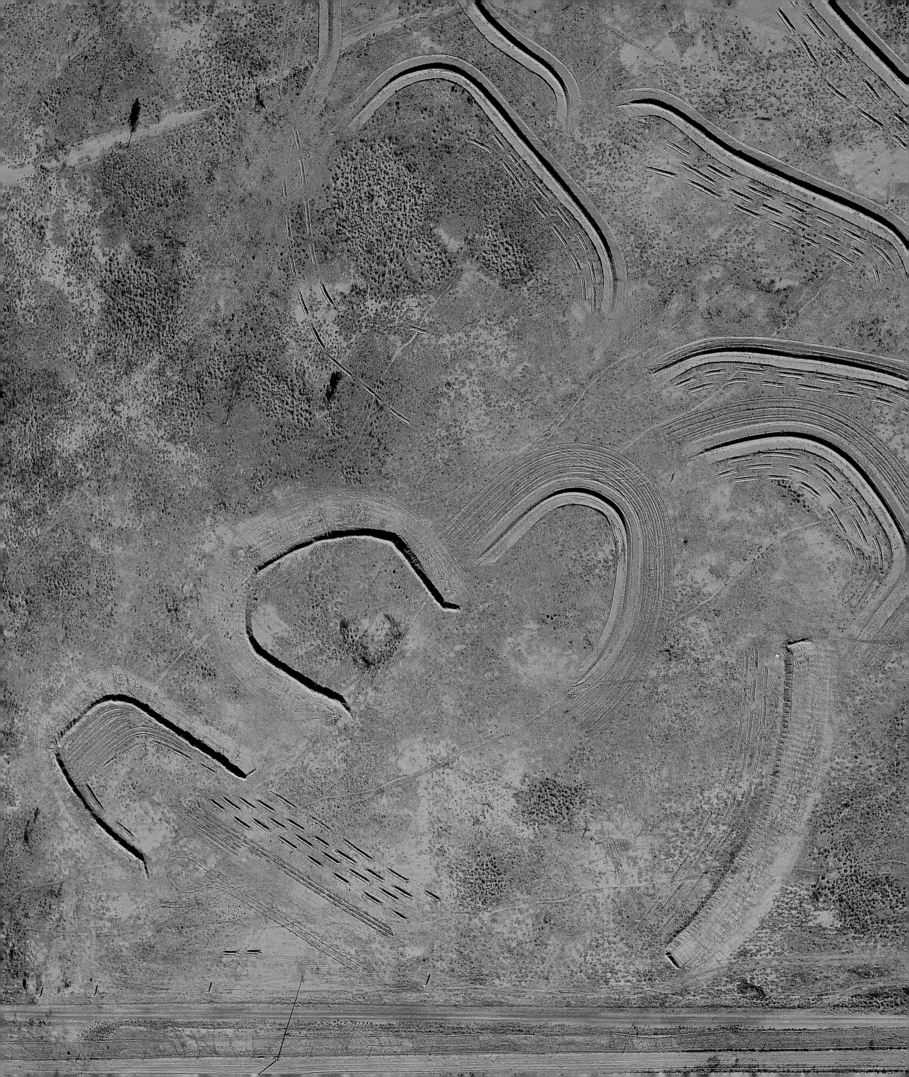

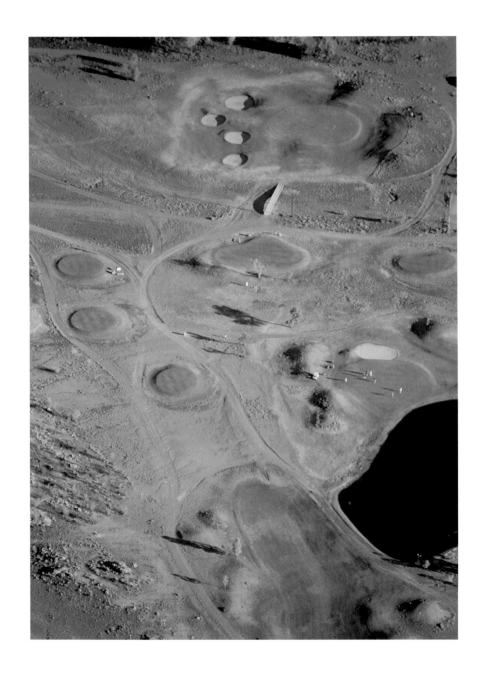

Alice Springs golf course. Golf courses in the desert are a lavish use of the most precious resource, water, unless it has been recycled after other uses.

Opposite: Near midday, cattle camp under whatever shade is available, and in Central Australia as near to water as possible. Their daily streaming backwards and forwards to watering points wears out the country near water. Such radiating damage, as found here north-east of Alice Springs, can be seen from space and is called a 'piosphere'.

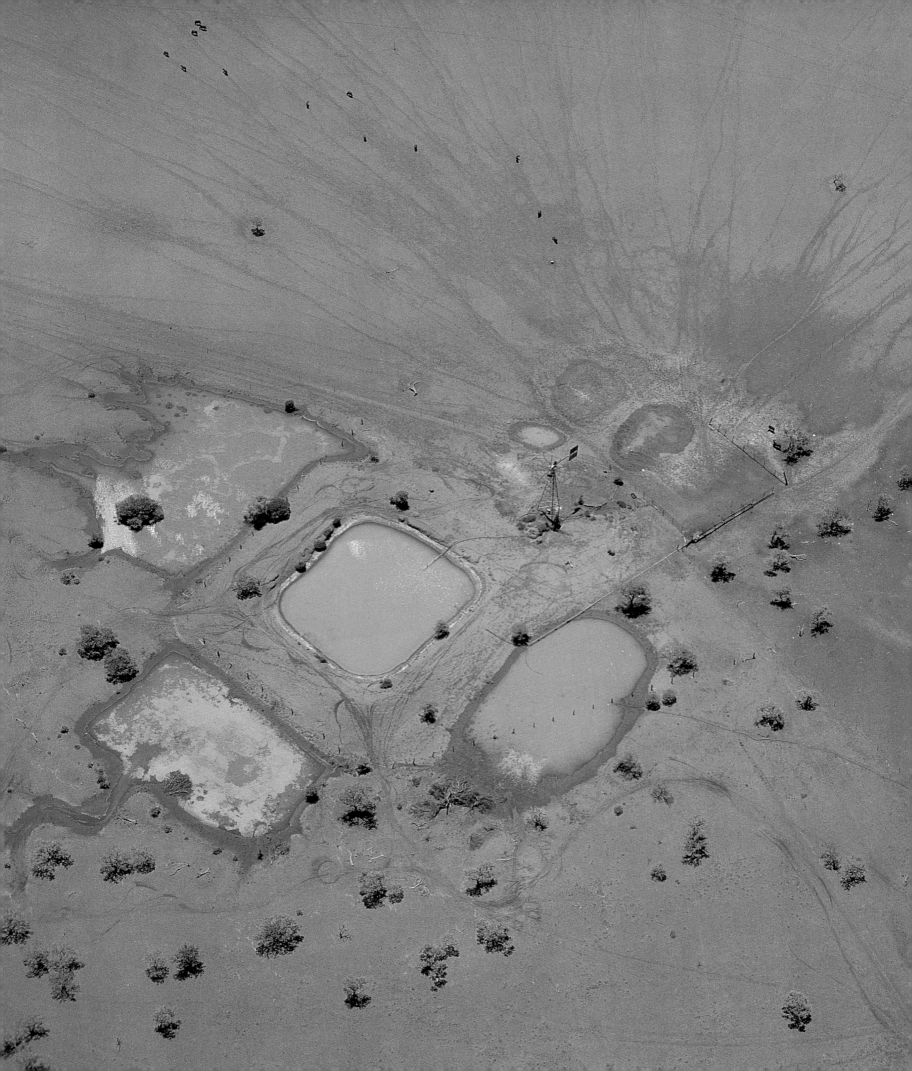

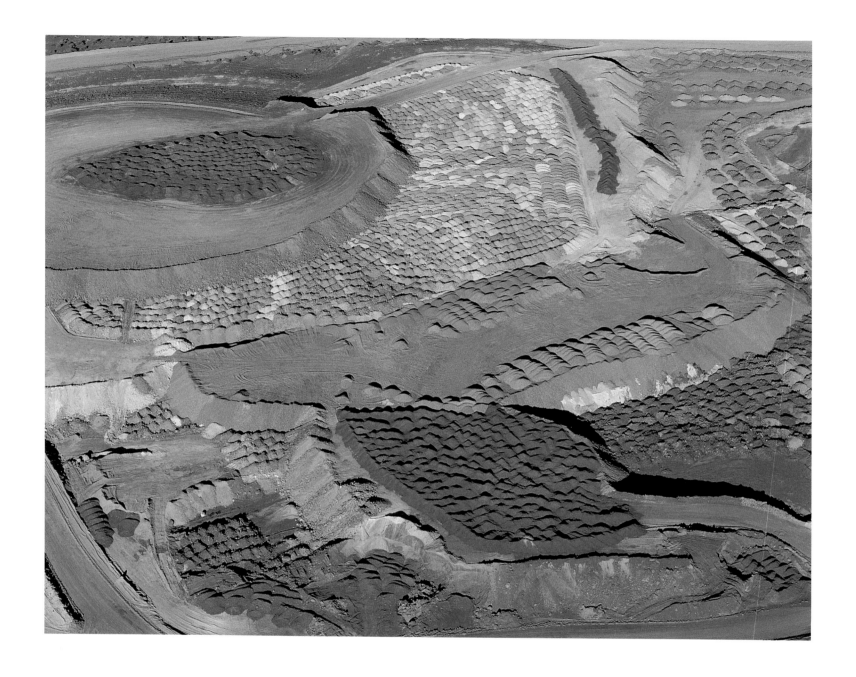

Part of the vast deposits of tailings from mines at Meekatharra, Western Australia. Gold accounts for a very tiny proportion of the minerals in rock. The variety of colours is indicative of the complexity of rock in the area.

Opposite: Bauxite mining tailings, Northern Territory. The darker areas are created by water from sprinklers, used to prevent wind erosion.

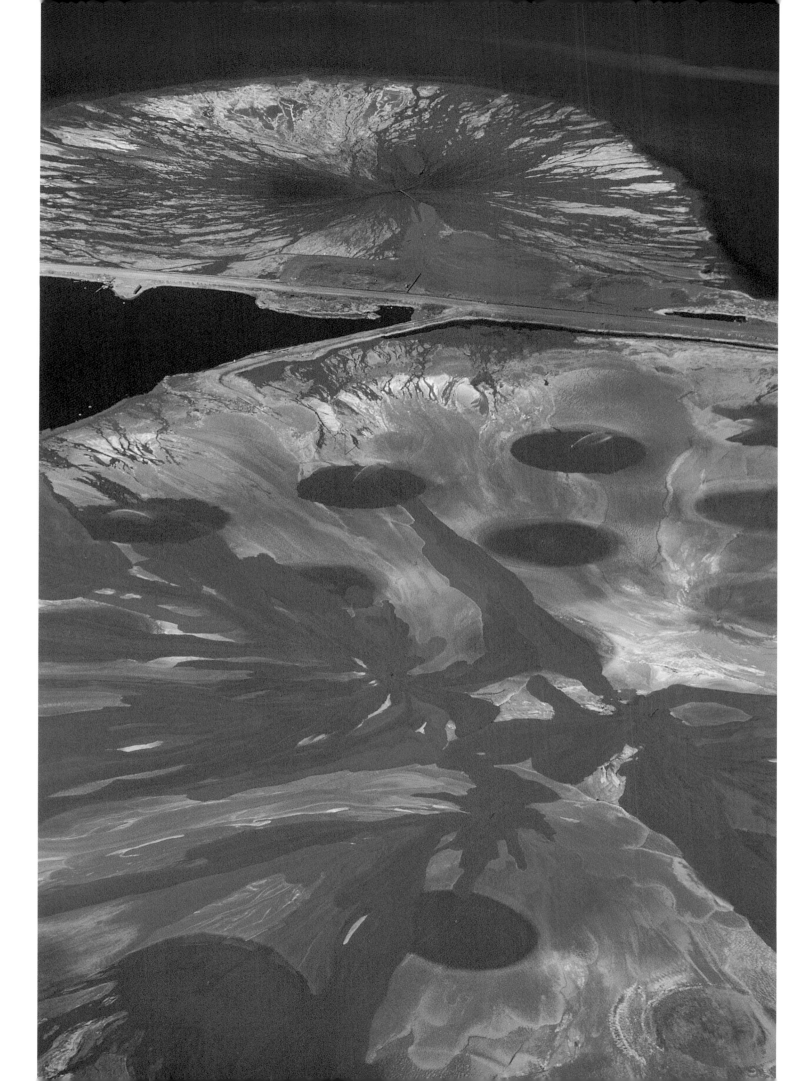

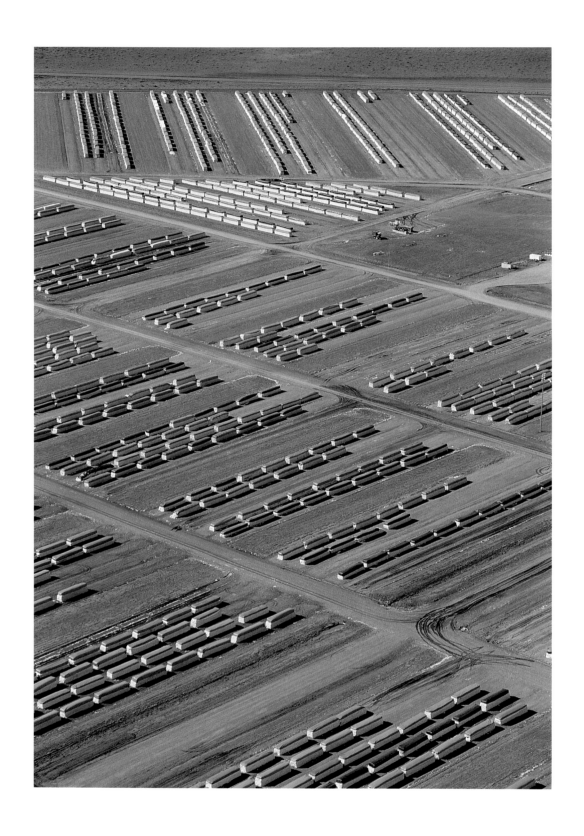

Cotton modules awaiting processing at Moree, New South Wales.

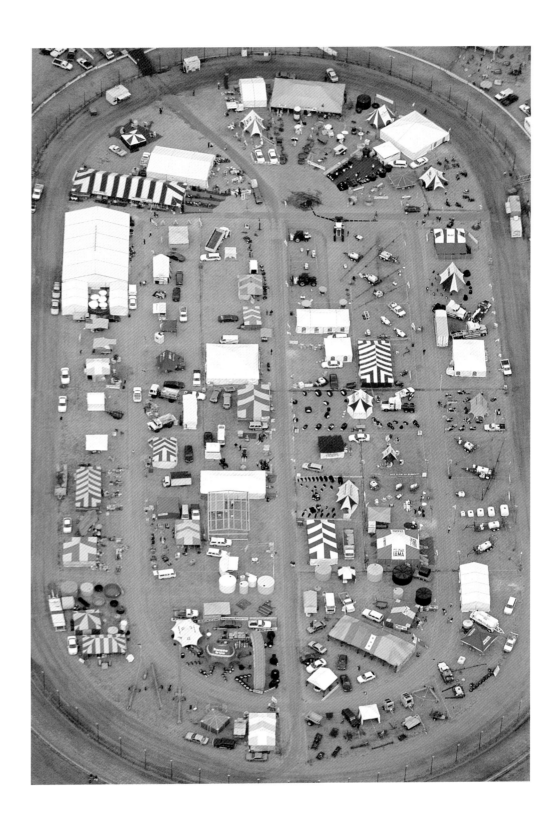

The Darling Downs, one of the most fertile and prosperous farmlands of Australia, can be guaranteed to stage one of the country's largest exhibitions of agricultural and pastoral stock and machinery, as evidenced at this show near Toowoomba, west of Brisbane, Queensland.

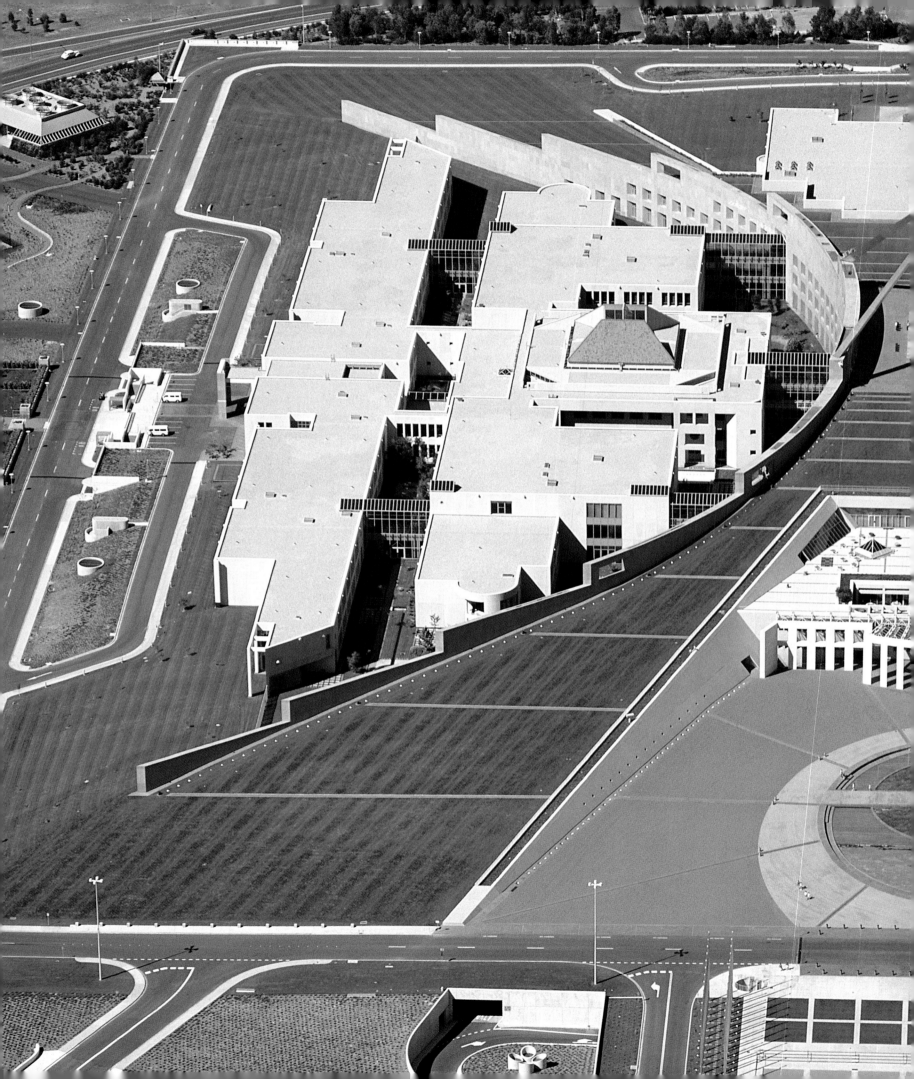

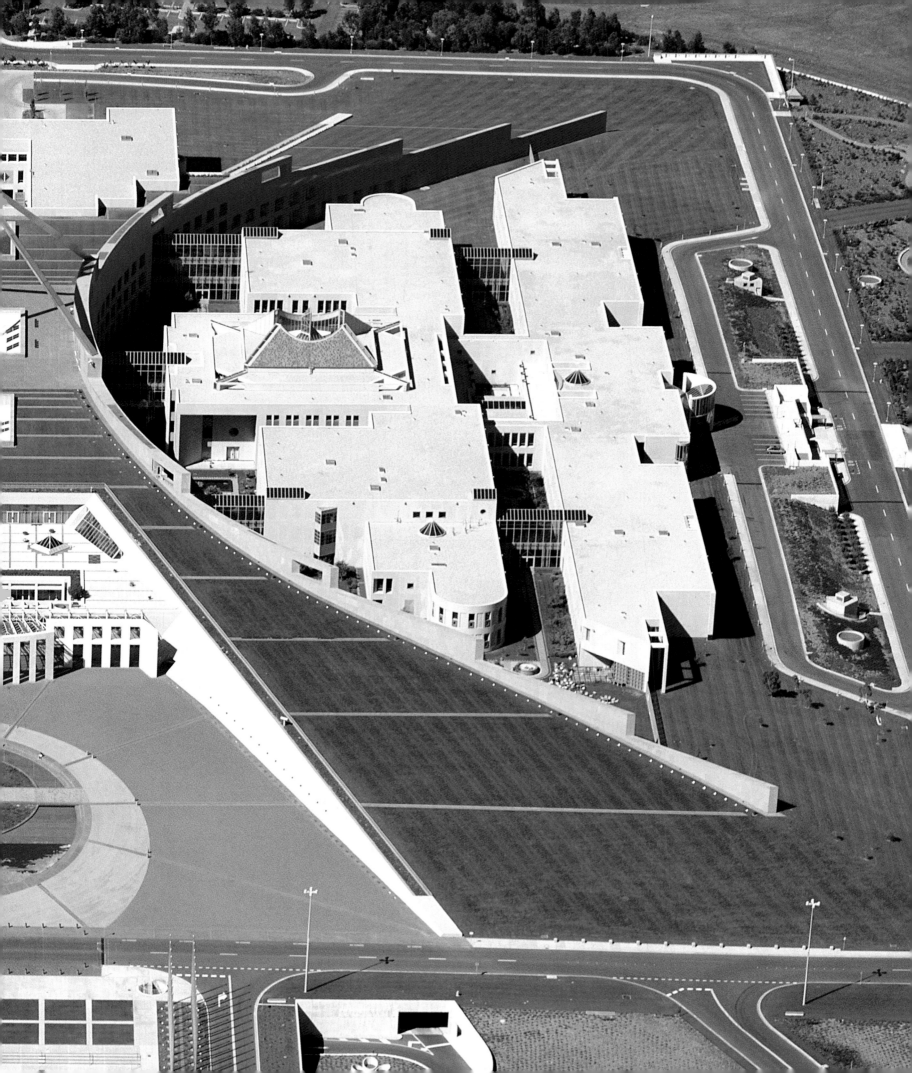

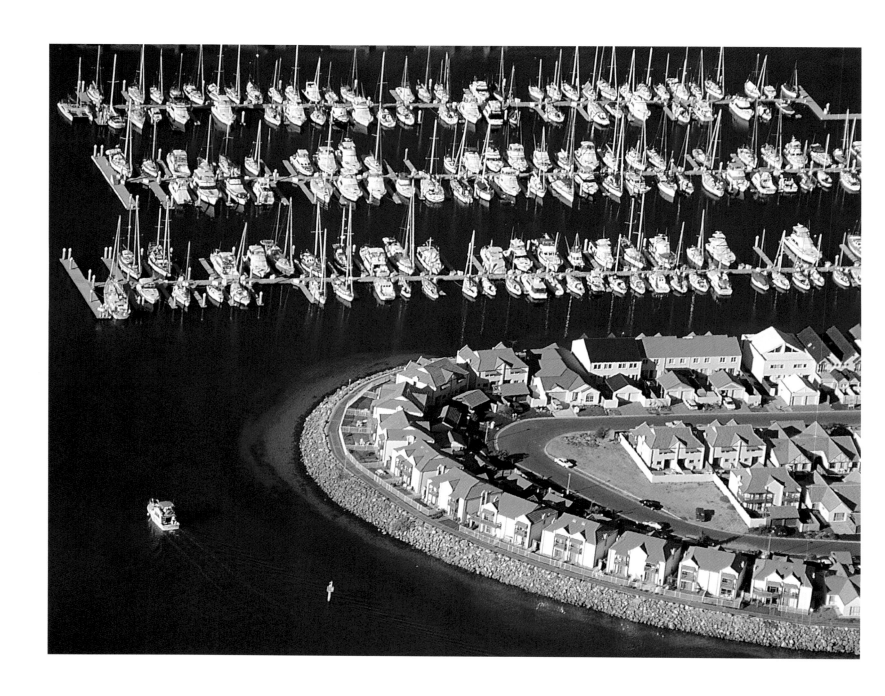

Gulf Point Marina north of Adelaide, totally man-made.

Previous page: The stunning symmetry of Australia's national parliament building. Closeted in the great curved granite wall to the left is the 'Lower House', the House of Representatives, while on the right is the 'Upper House' or Senate. Some 2,000 rooms and halls and two large parking areas lie within the contours of what was Capital Hill.

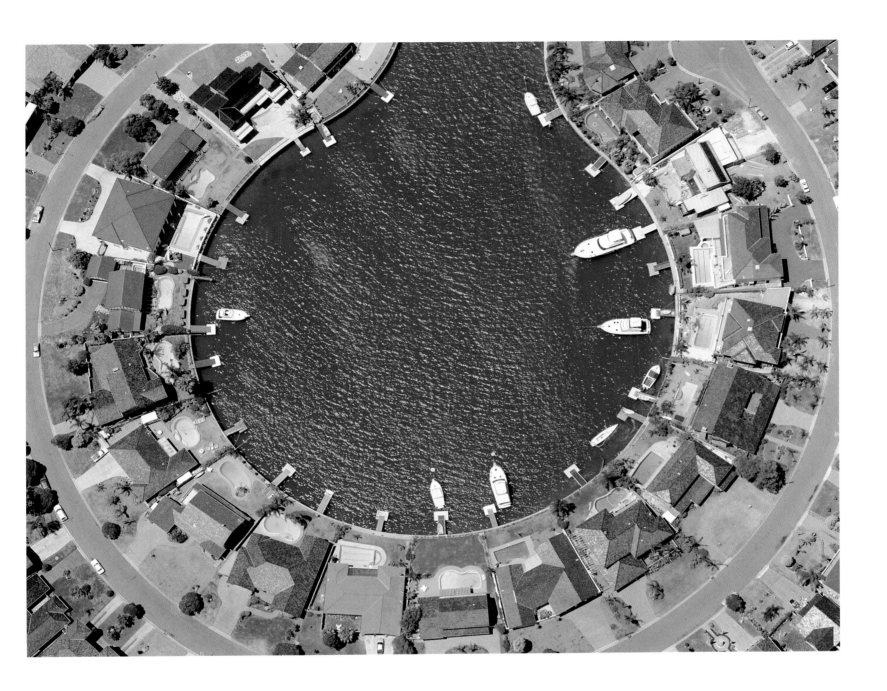

Gwawley Bay was a rich mangrove and estuarine habitat for oysters, fish and crustaceans only forty years ago. The irony is that the houses in this development on the artificial James Cook Island, Sylvania Waters, perhaps the first keys development in Sydney, require their own swimming pools. It has also been found that many of the homes now sit on concrete rotted by sulphuric acid generated in the old mangrove mud.

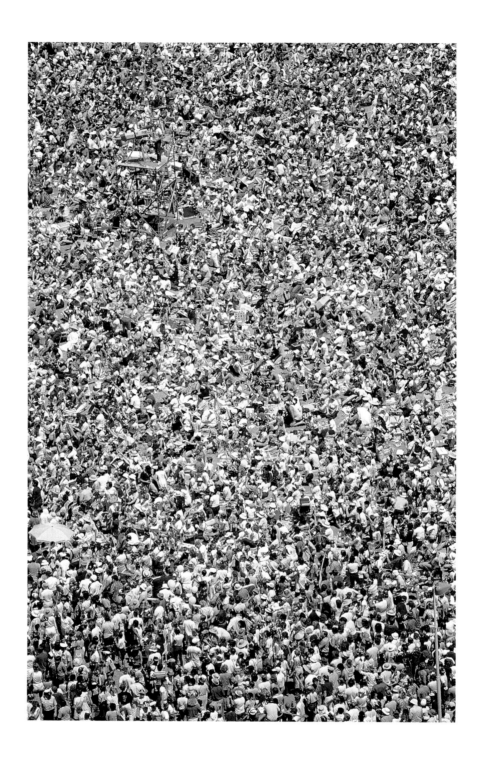

This festive display is illustrative of the universal desire to congregate.

Opposite: Southbank, Brisbane, is brilliant use of a derelict area for public use, given original impetus by a world fair. The area includes the State Library, Queensland Art Gallery, the Performing Arts Centre and, in this image, the Entertainment Piazza, art and craft stalls, swimming area, gardens, the Gondwana Exhibit and restaurants.

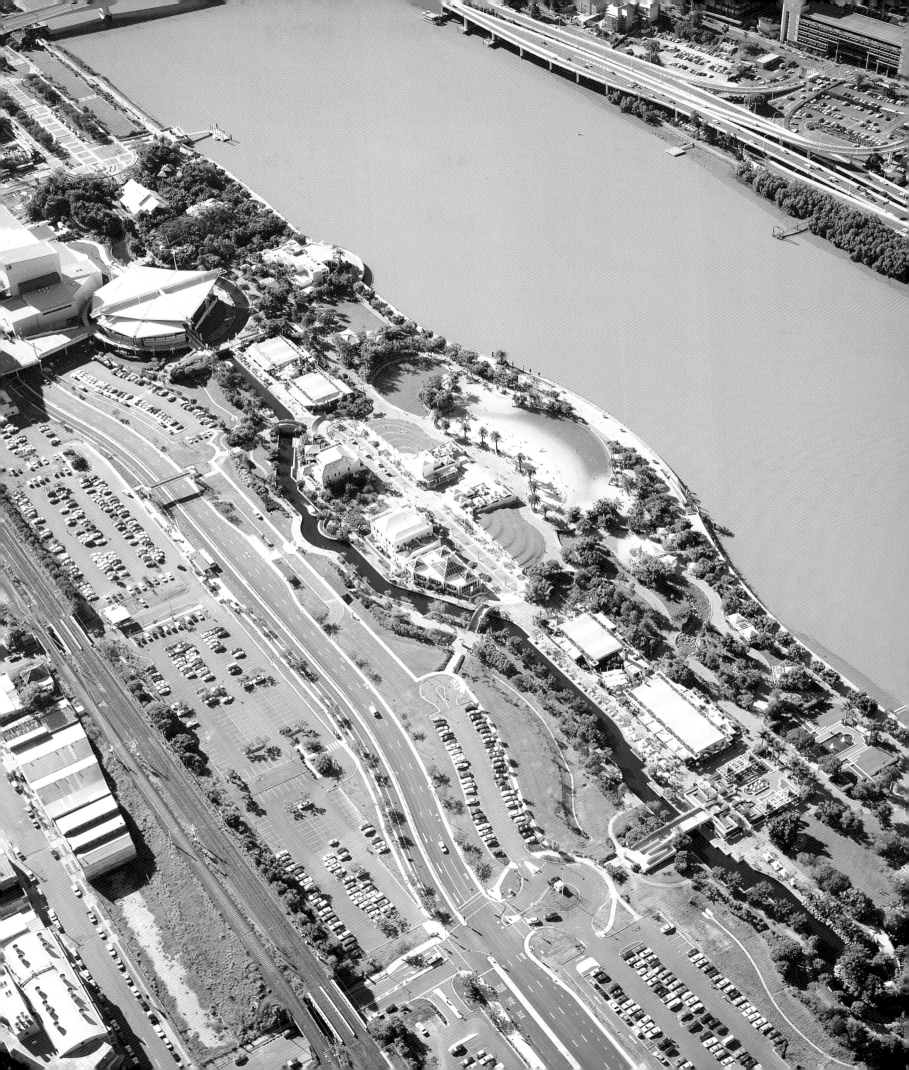

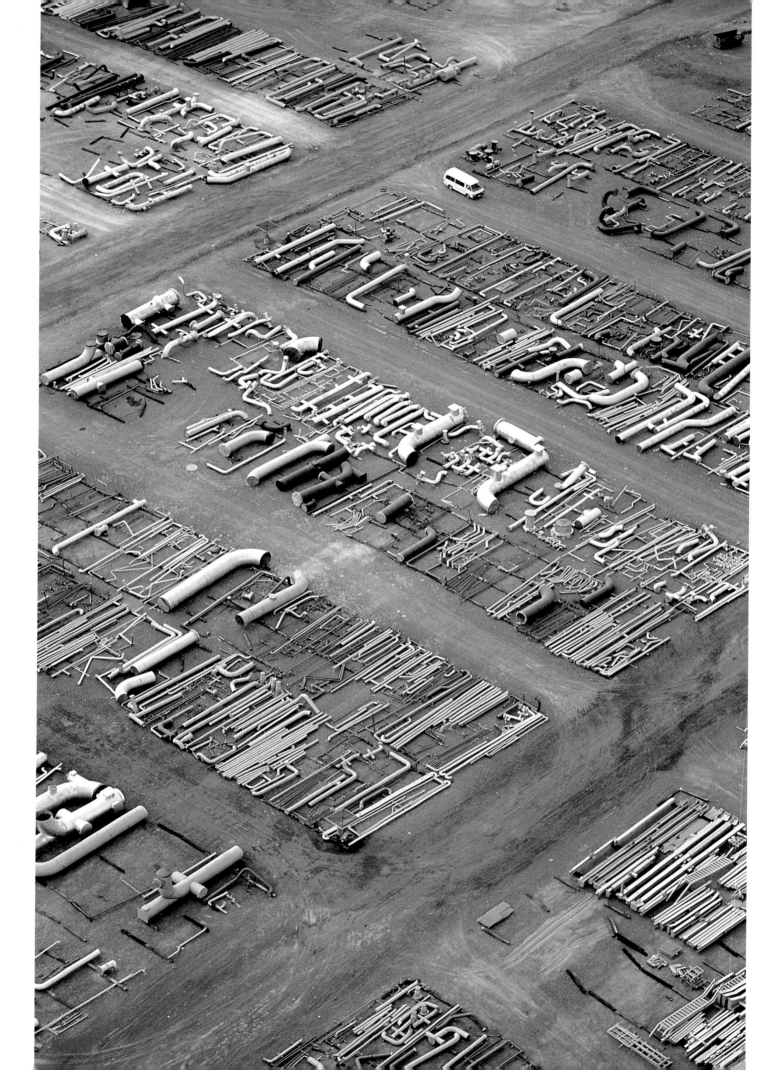

Solar salt ponds, north of Carnarvon, Western Australia, created for the commercial mining of salt.

Opposite: The Lilliputian bus puts these pipe fittings into perspective. Pipe supply yard for offshore drilling rigs, Burrup Peninsula, Dampier, Western Australia.

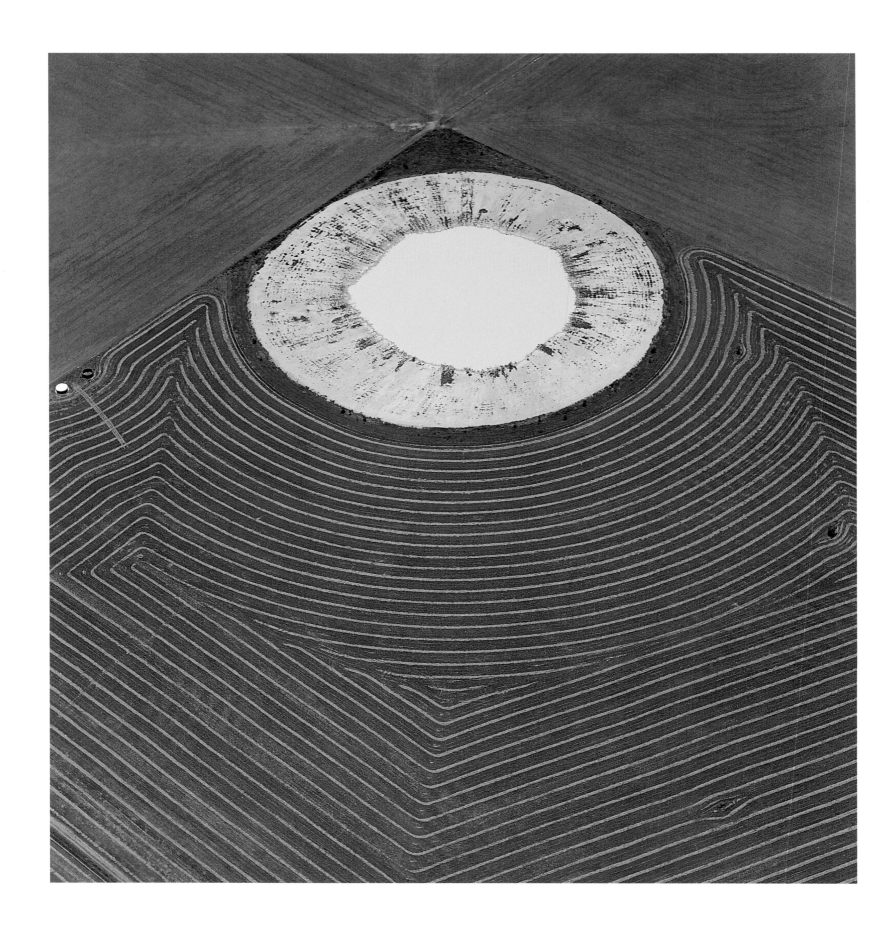

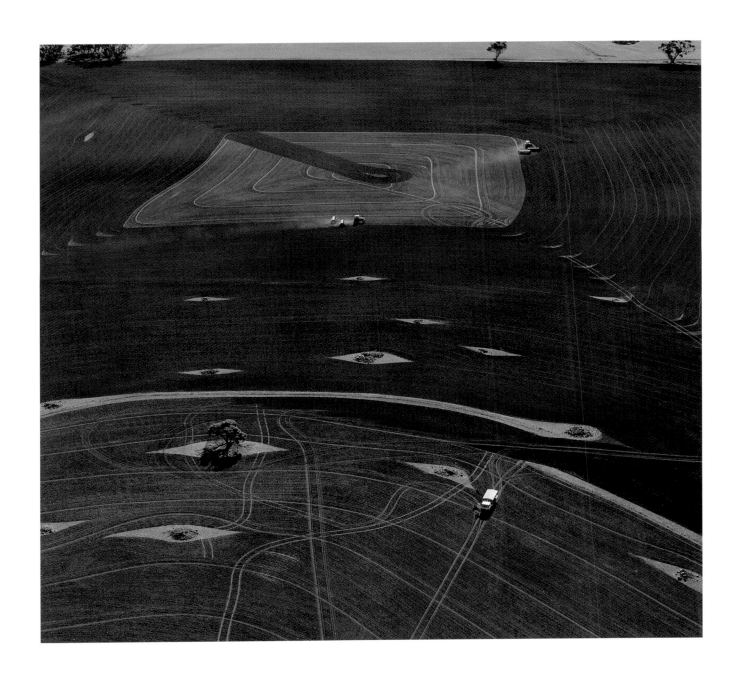

Chocolate coloured soils in the Western Australian wheatbelt, east of Perth.

Opposite: Turkey nest dam at Newdegate east of Lake Grace, Western Australia, cut into the fabric of the earth.

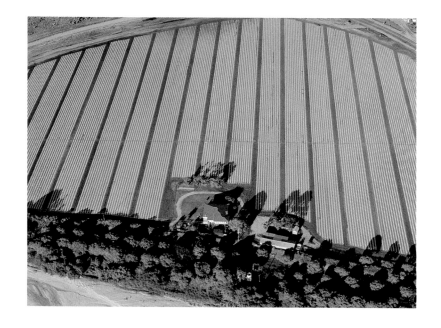

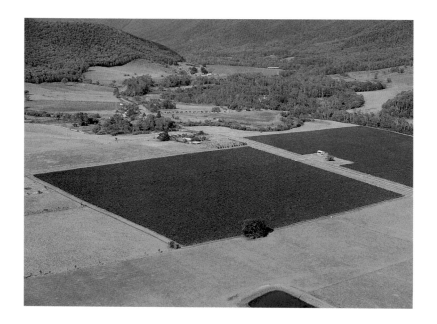

Top: Tomato fields with plastic liners at Bowen, Queensland.
Plastic liners allow economical use of water and reduce weed growth.

Bottom: Farmland at the foot of Mt Buffalo, Victoria.

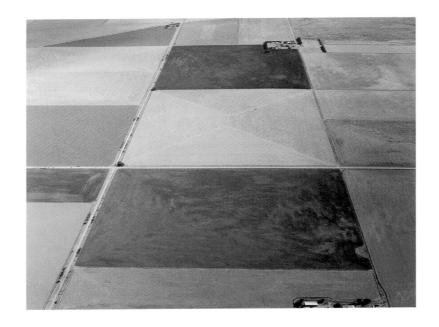

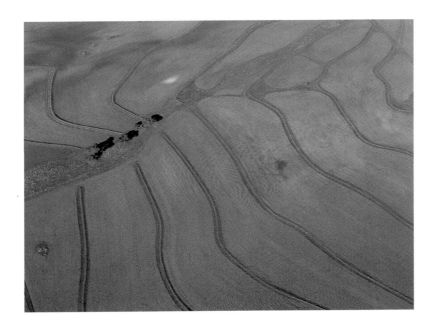

Top: The simple symmetry of wheat fields south-west of Clare on the Adelaide Plain.

Bottom: Contour farming, the beginning of a healthier relationship with nature near Northam, Western Australia.

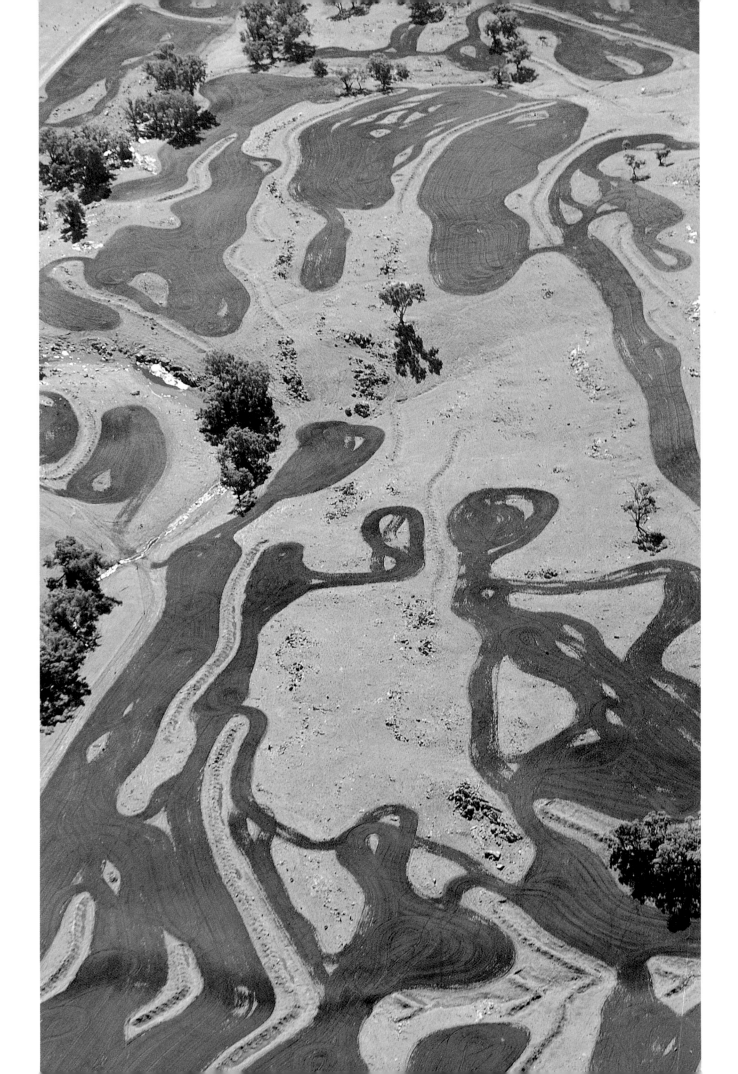

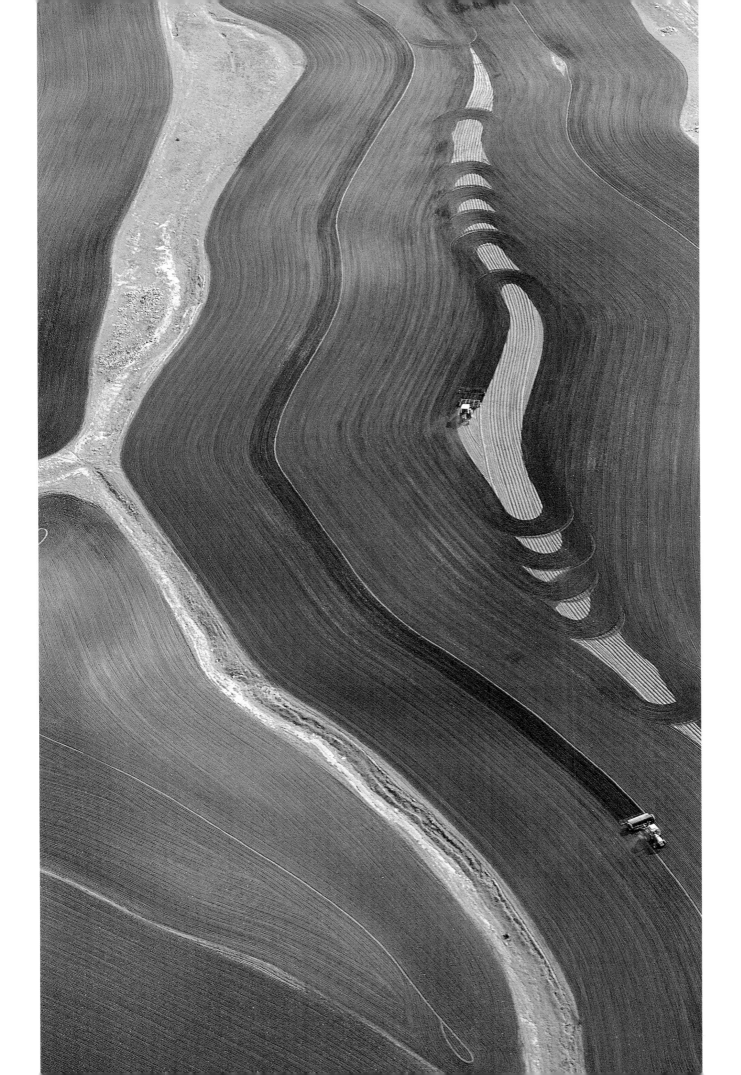

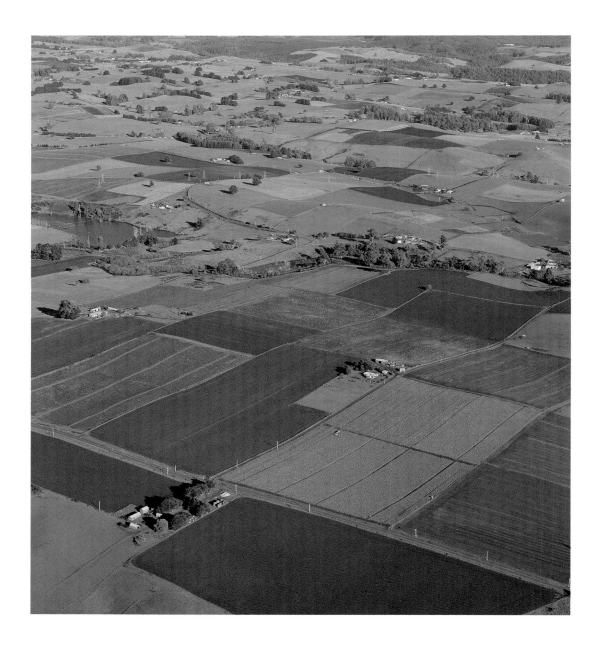

Above: Some of Australia's richest crop land stretches across northern Tasmania on well-watered basaltic soils, as here near Wynyard, west of Devonport. This fertility is reflected in the small size of the farms. Crops such as potatoes, cereals, vegetables, opium poppy for medicinals, cut flowers and hops are typical.

Opposite: Looking towards the Bass Strait at farmlands near Devonport which have sustained farmers since 1804.

Previous pages: Scratching a living from the land in country with a shallow veneer of soil over ancient rocks, Northam, Western Australia.

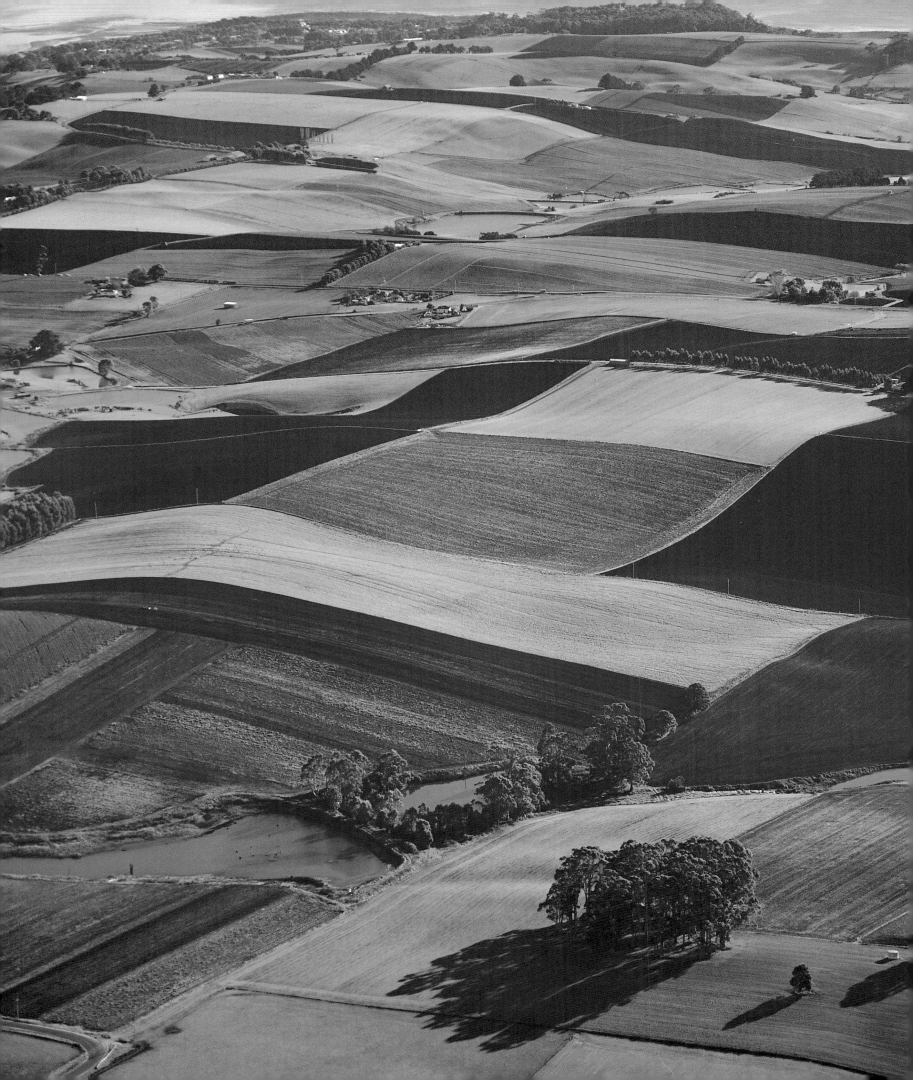

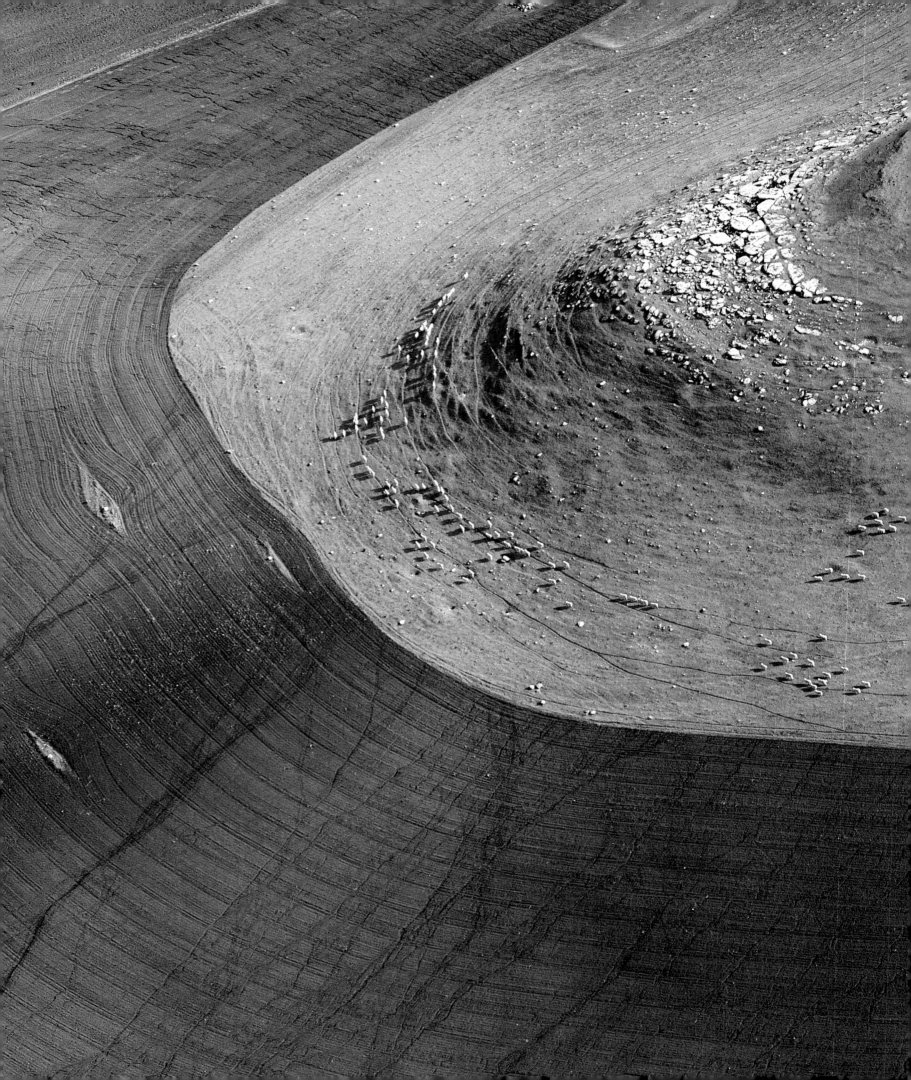

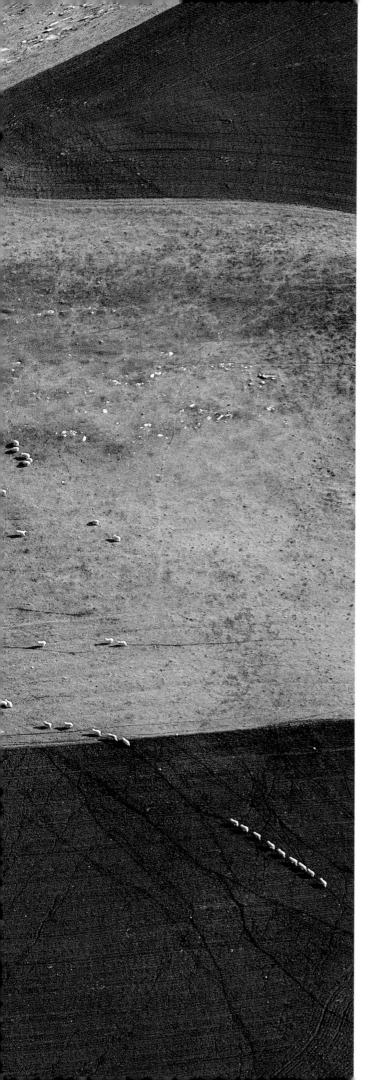

In some parts of Australia the stock routes have been called the 'long paddock'. Not so important in these days of road trains, in the past they were the routes to far away markets for the cattle and sheep drover, and provided drought pasture for others. They also restricted travelling stock from feeding on somebody else's land. This remarkable picture is of a stock route in inland Western Australia.

Opposite: Limestone caps on hills can act like an impervious roof shedding water downslope. Sheep avoid the grade by following the contour, as does the plough. But run-off is still strong enough to have moved thousands of tonnes of soil downhill via the rills.

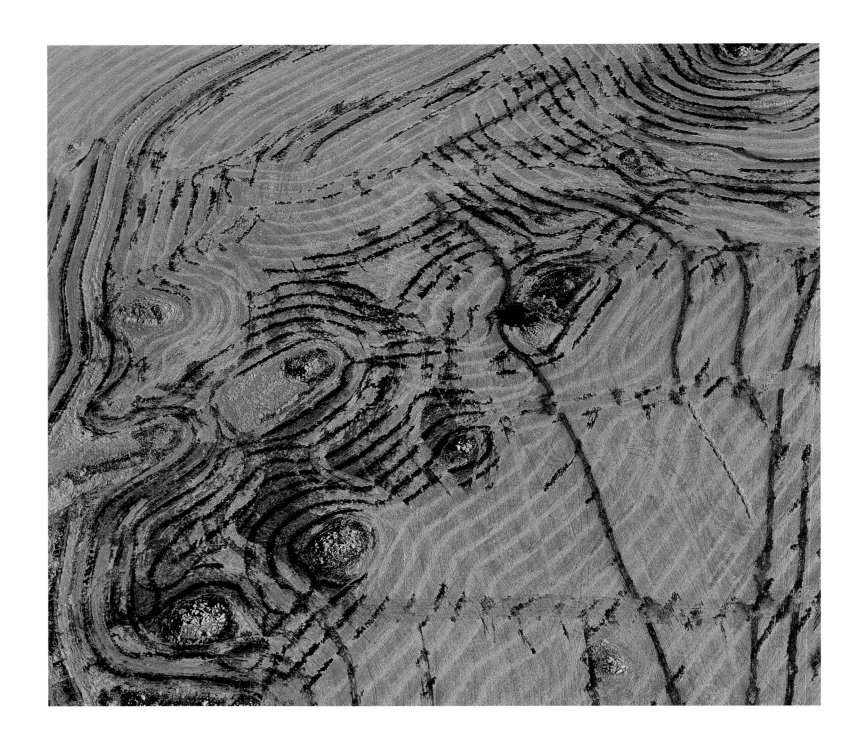

Burnt wheat stubble pattern. Stubble is burnt after harvest by some farmers with the view to returning nutrients to the soil.

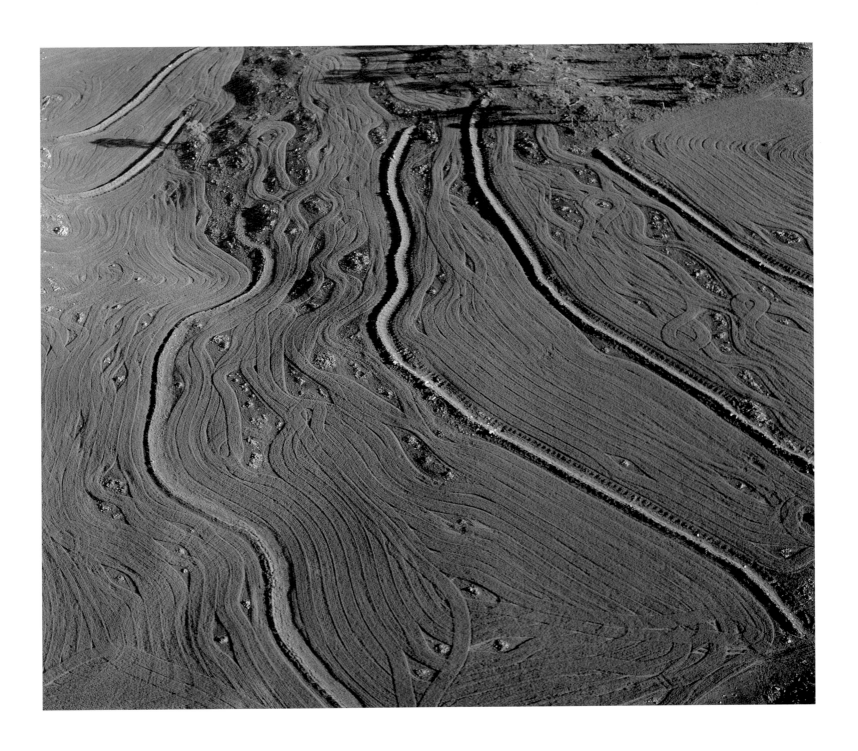

Granite country is very prone to erosion. Here a Toodyay farmer on the Avon River headwaters, 70 kilometres north-east of Perth, has controlled run-off with contour banks, and between them has planted skeins of cereal crop.

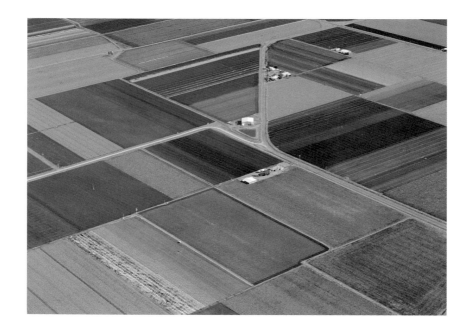

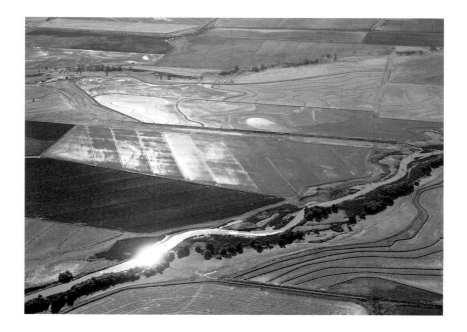

Top: The rich volcanic soil between Toowoomba and Brisbane produce a great variety of crops.

Bottom: Irrigated rice fields near Griffith, New South Wales. Well over a million tonnes of rice is produced under irrigation in the Murrumbidgee Irrigation Area each year.

Opposite: Rain falling on the Murray River headwaters 1800 kilometres upriver waters these lush vineyards at Mildura. By summer's end tens of thousands of tonnes of sultanas and raisins will be drying here.

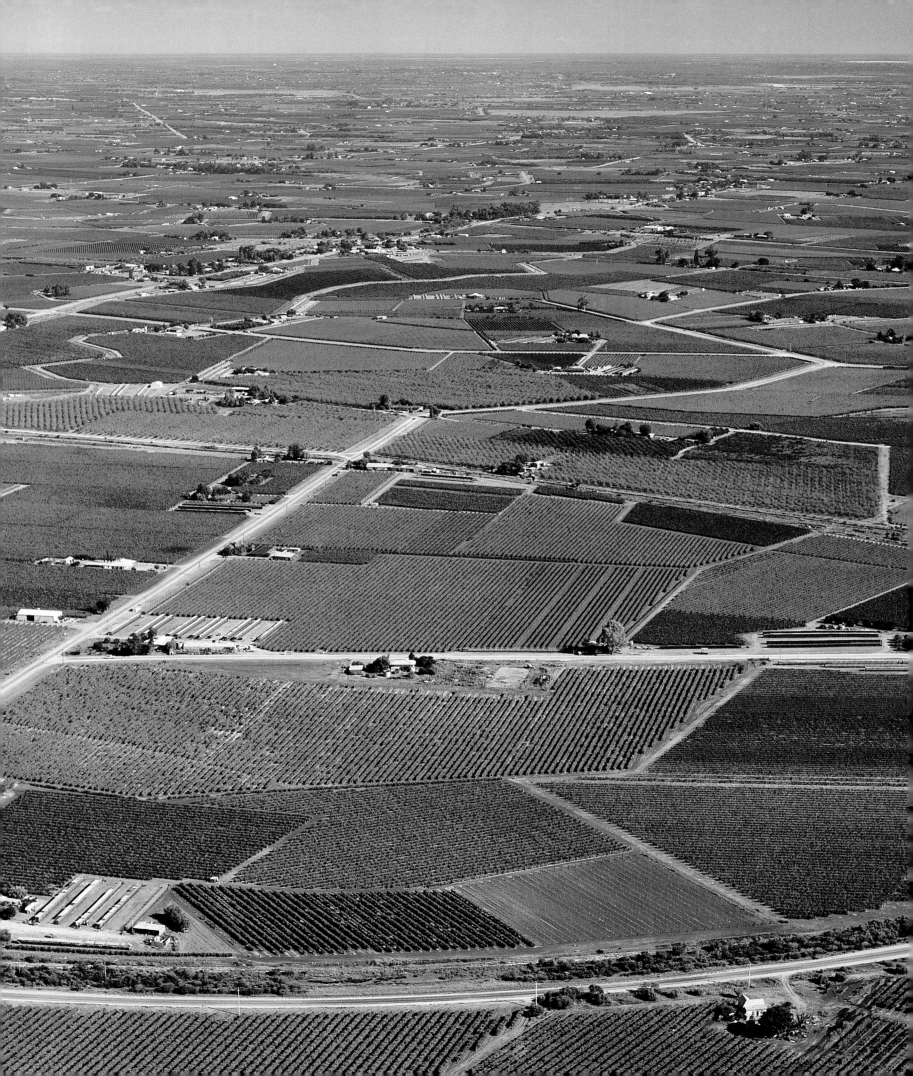

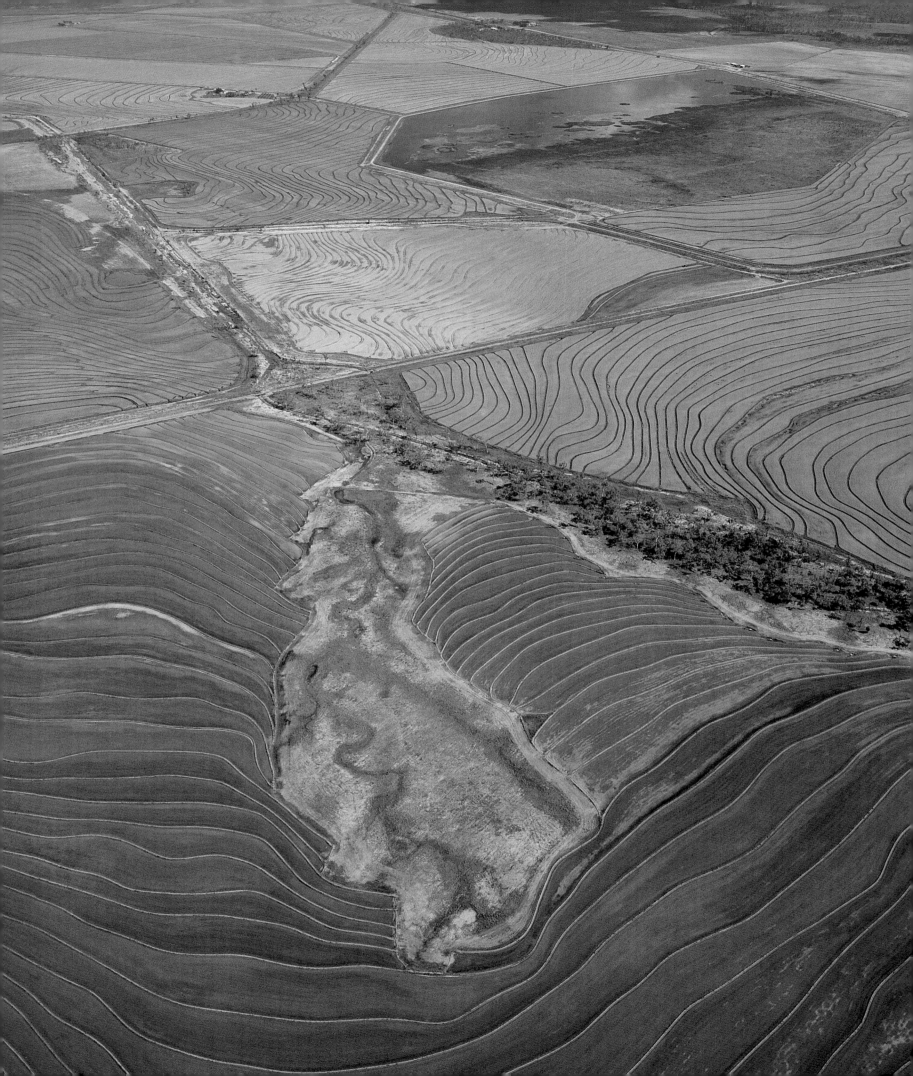

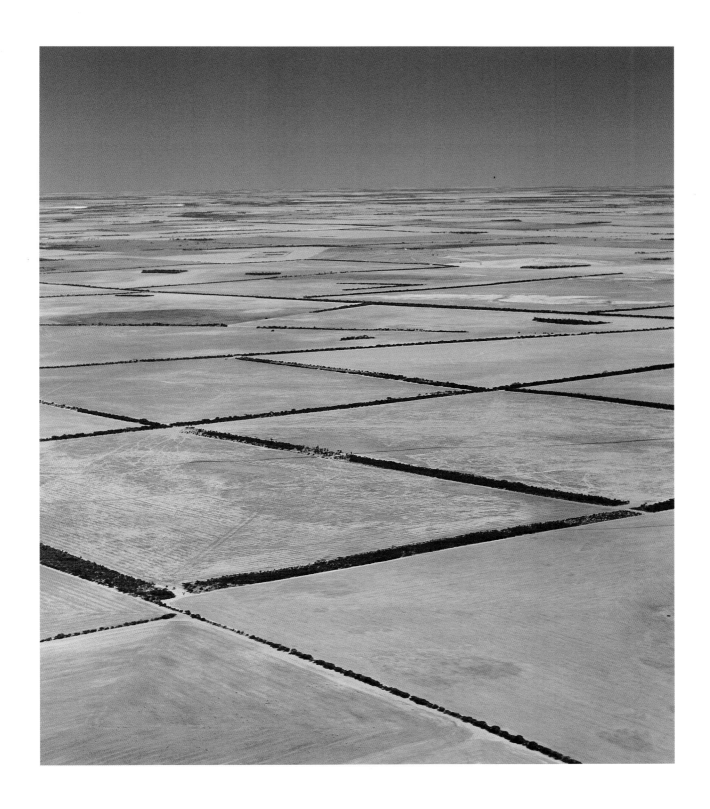

The pattern of Australian wheatfields — excessive removal of natural vegetation to create endless wheat plains —
has placed the land under threat from erosion and rising salinity levels.

Opposite: Earth contour banks provide pondages for rice growing at Mareeba,
Atherton Tableland, north Queensland.

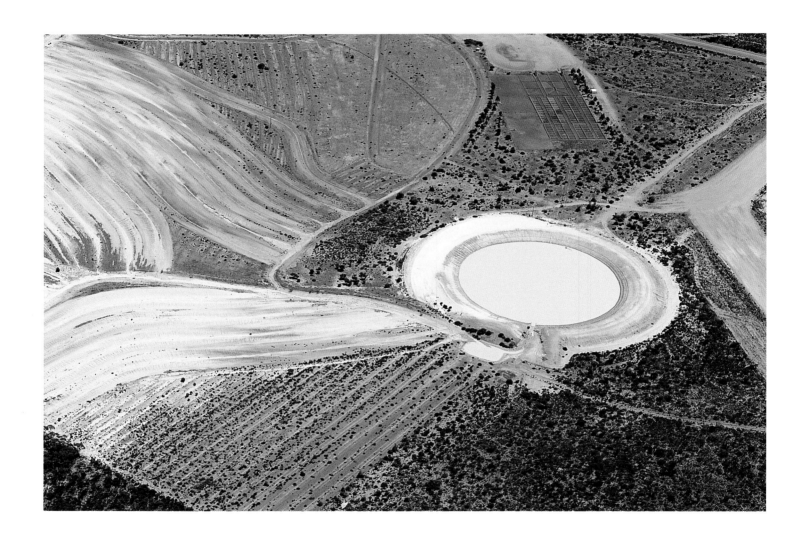

Excessive earth workings — Turkey nest dam and its catchment replacing semi-arid woodland, Newdegate, east of Lake Grace, Western Australia.

Opposite: Newly ploughed rocky, undulating country, Northam, Western Australia.

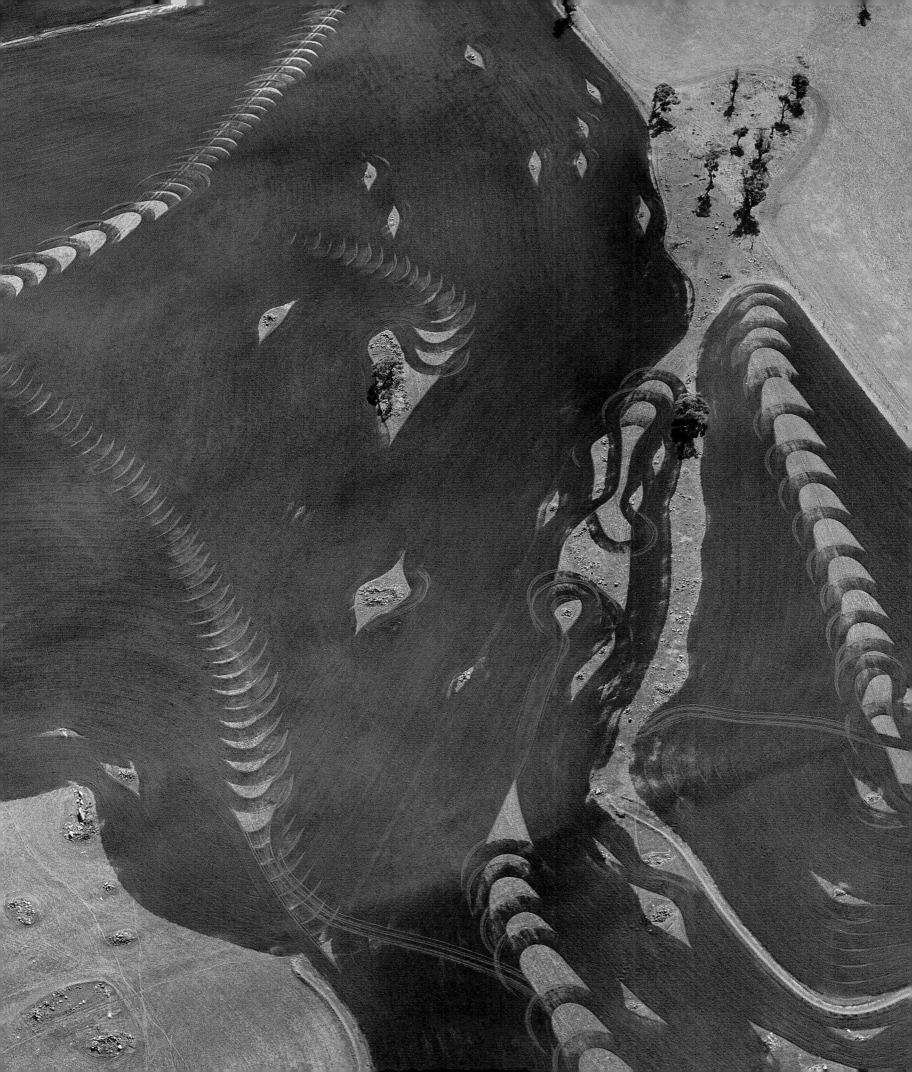

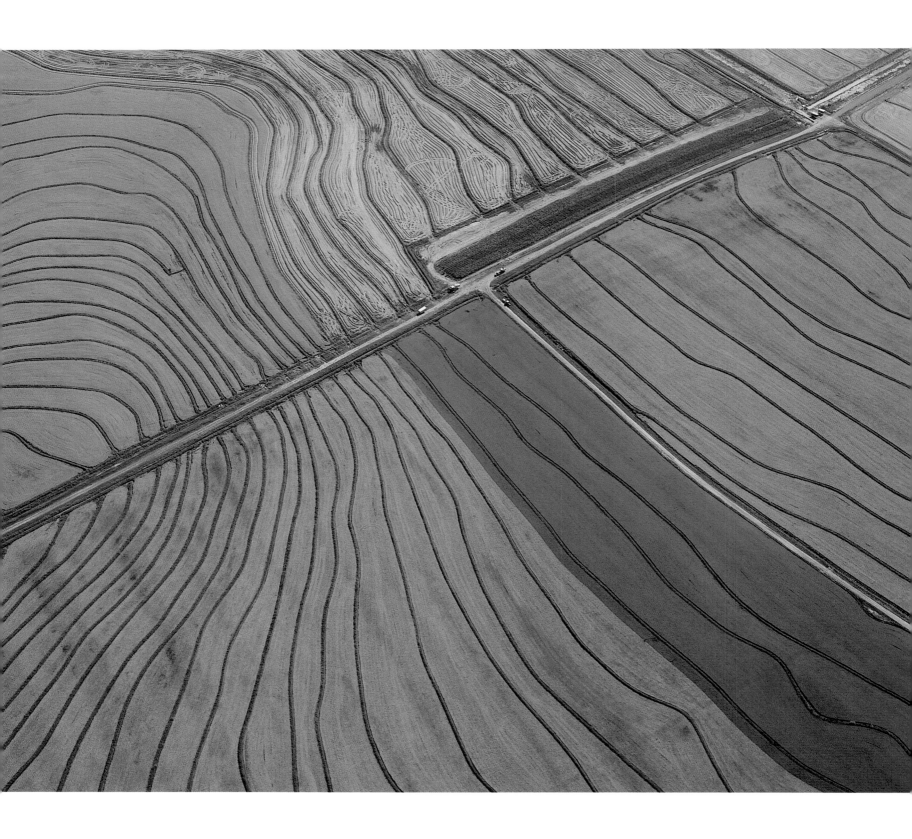

Mechanised rice harvesting near Mareeba, Queensland. Design created by gravity feed irrigation.

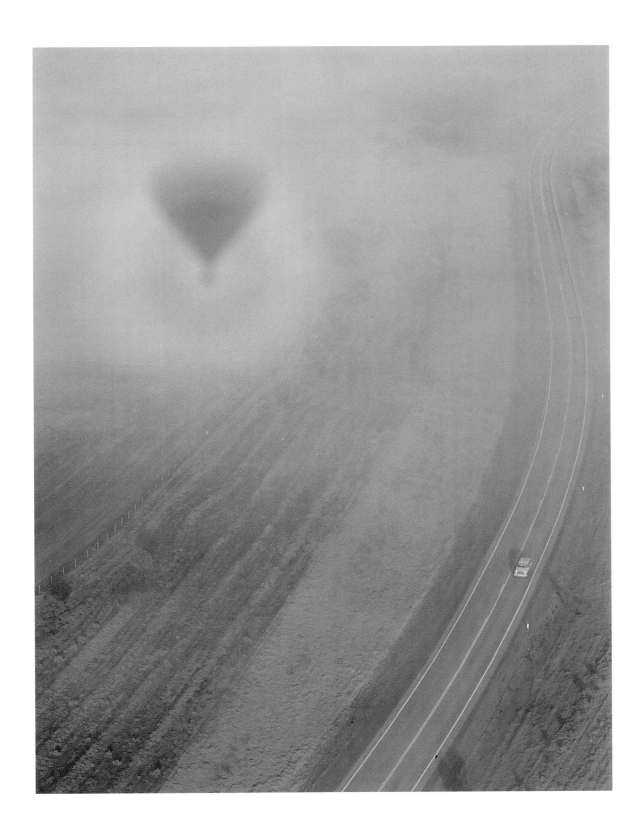

Hot air ballooning on cool spring mornings produces a serene floating sensation, the silence accentuated by the occasional roar of the burners. It also provides the perfect photo 'tripod', with no sudden movements, just the slow rotation, and below, the shadow within a circular rainbow in the mist.

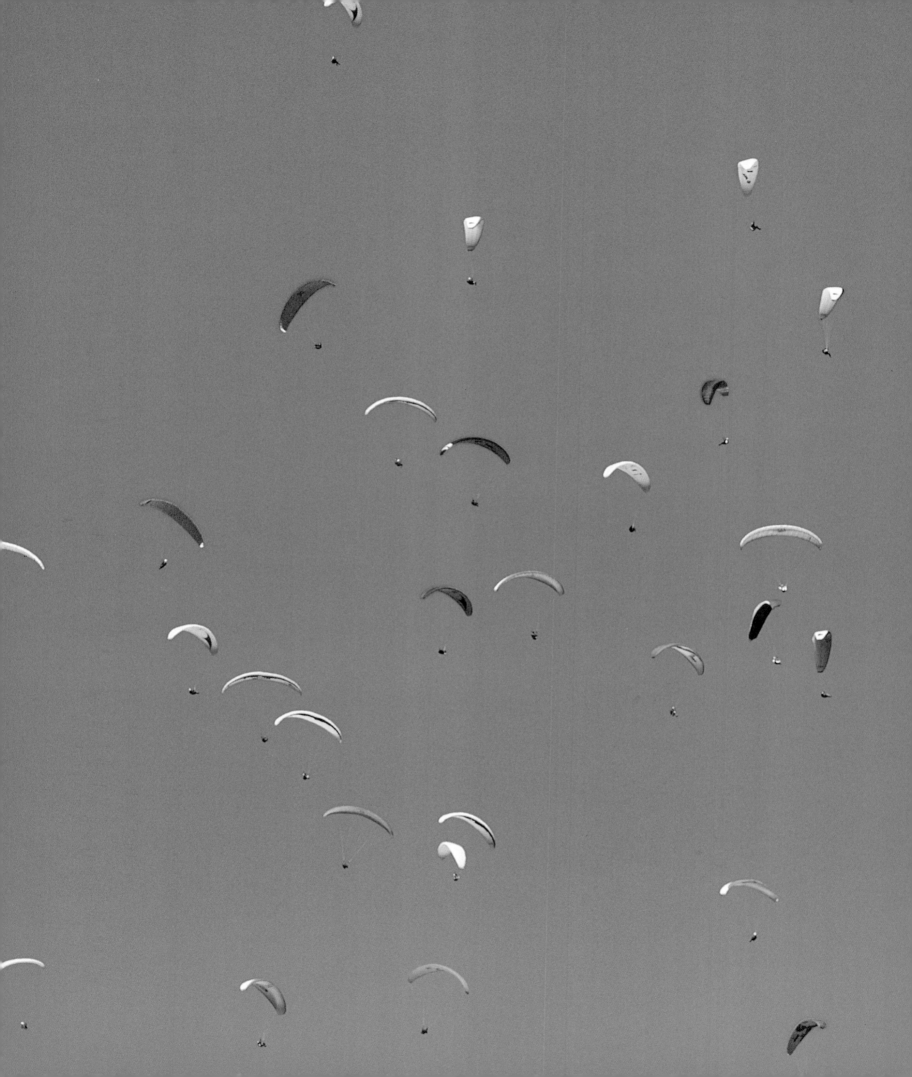

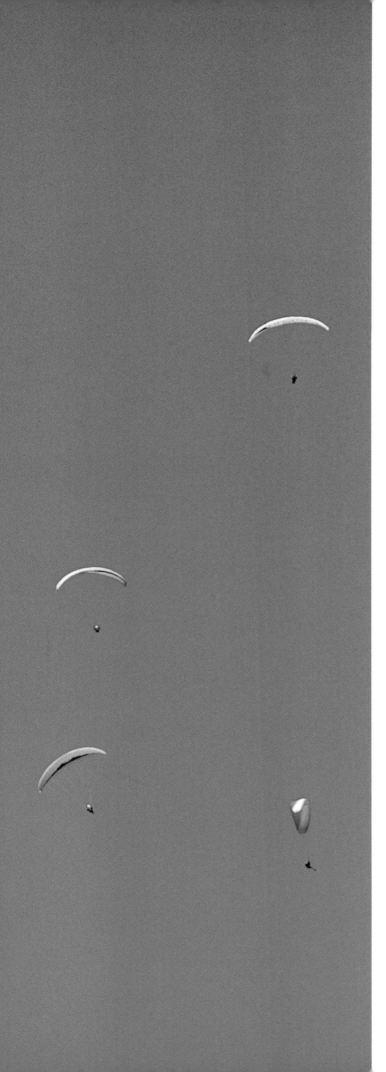

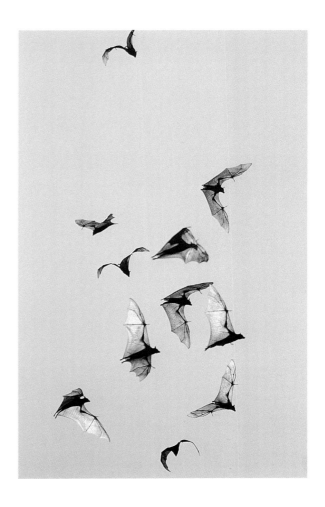

Fruit bats returning to their roosts in the paperbark trees along the Leonard River after a night among the fruiting figs, Windjana Gorge, 130 kilometres east of Derby, in the Kimberley.

Opposite: Bright, one of Victoria's delightful country towns, lies by the Ovens River, set in the shadow of the soaring granite cliffs of alpine Mt Buffalo; ideal conditions for hang gliding and parasailing, as the numbers of participants here show.

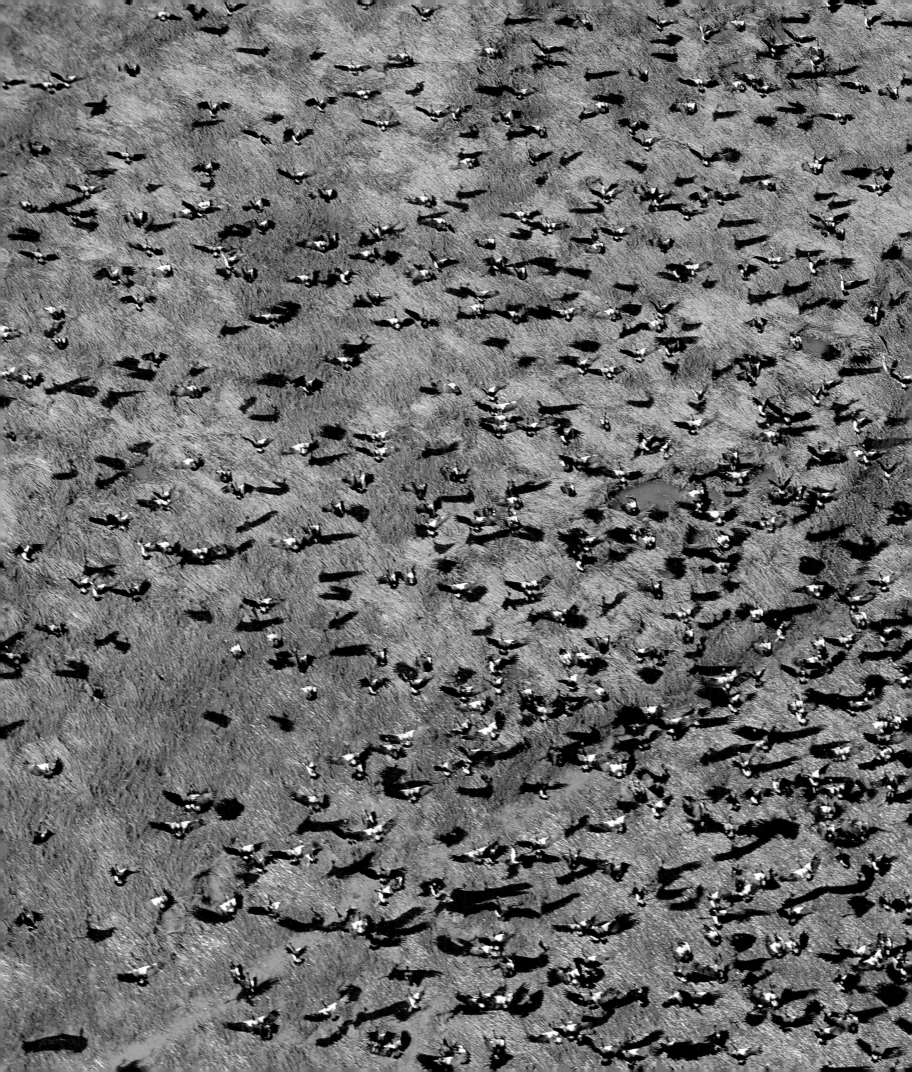

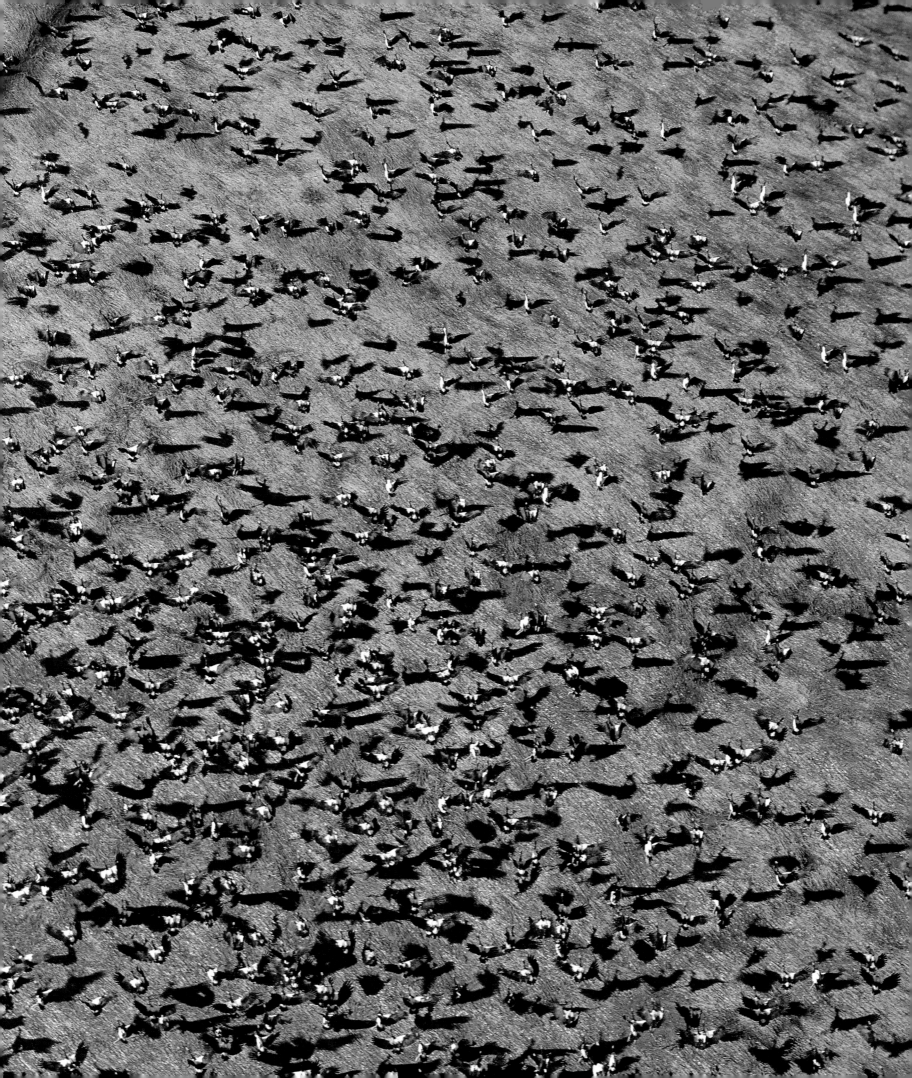

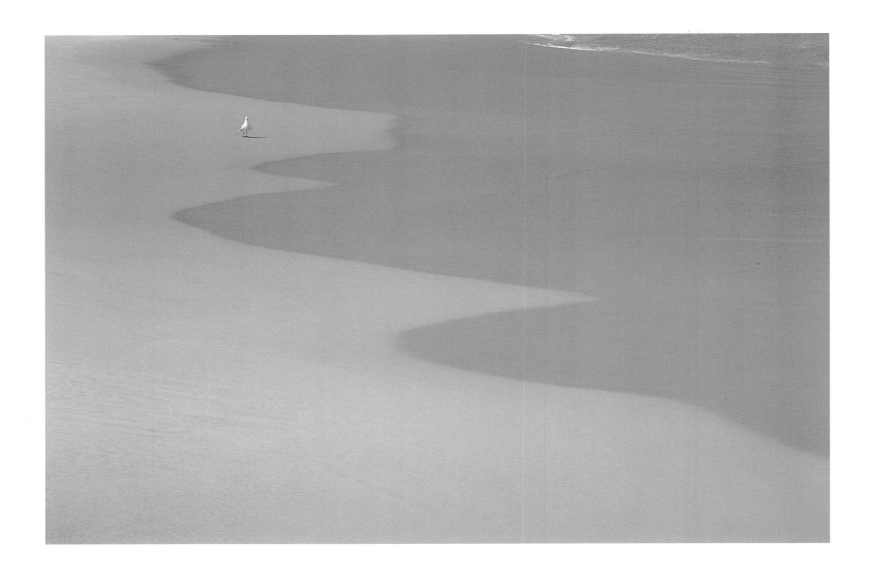

The simplicity of the beach quietly reflecting the blue sky in the receding water, with one of the ever present seagulls.

Opposite: Eighty Mile Beach, south of Broome, is a stopover for migratory birds from as far away as Siberia.

Previous page: A large flock of Magpie Geese above early dry season sedgeland. Nesting takes place when this country is flooded in the Wet. In excess of 350,000 geese inhabit the wetlands of Kakadu National Park.

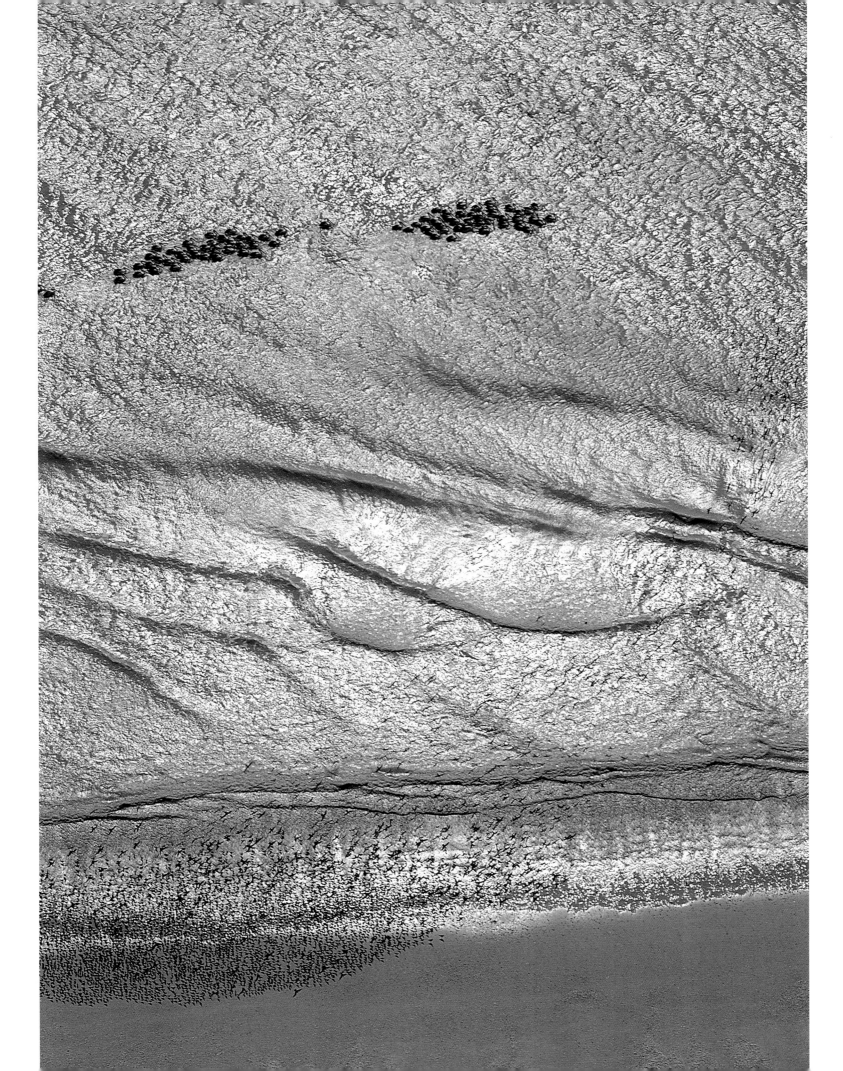

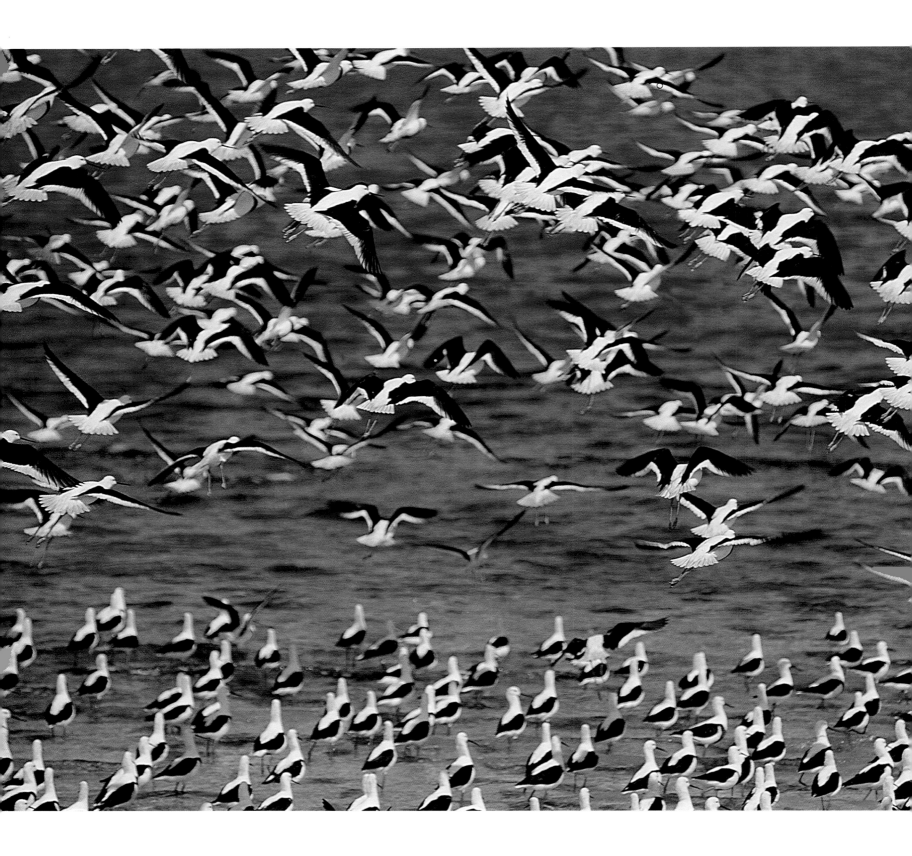

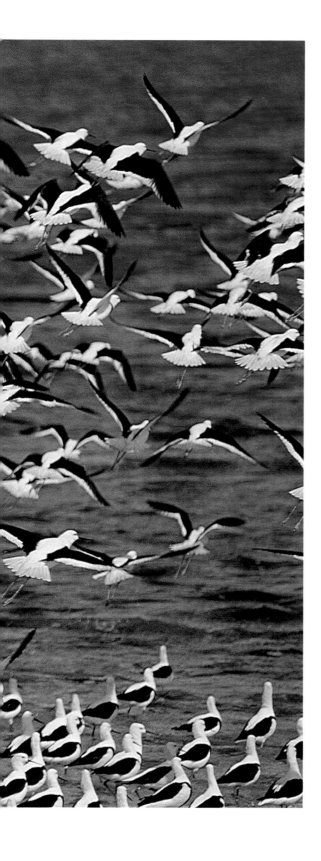

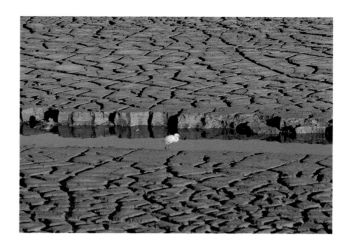

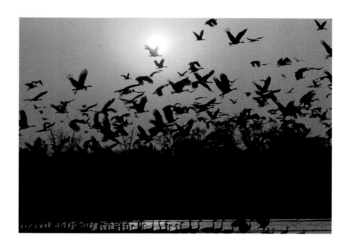

Top: A Little Egret and the geometry of cracked
mud in the backwater of a reservoir.

Bottom: Magpie Geese on the Ord River, near
Kununurra in the Kimberley.

Opposite: A congregation of Banded Stilts, a highly
nomadic bird which wades or swims in saline and
hyper-saline waters, feeding on brine shrimps and
other invertebrates, wanders throughout the
south-west of Australia.

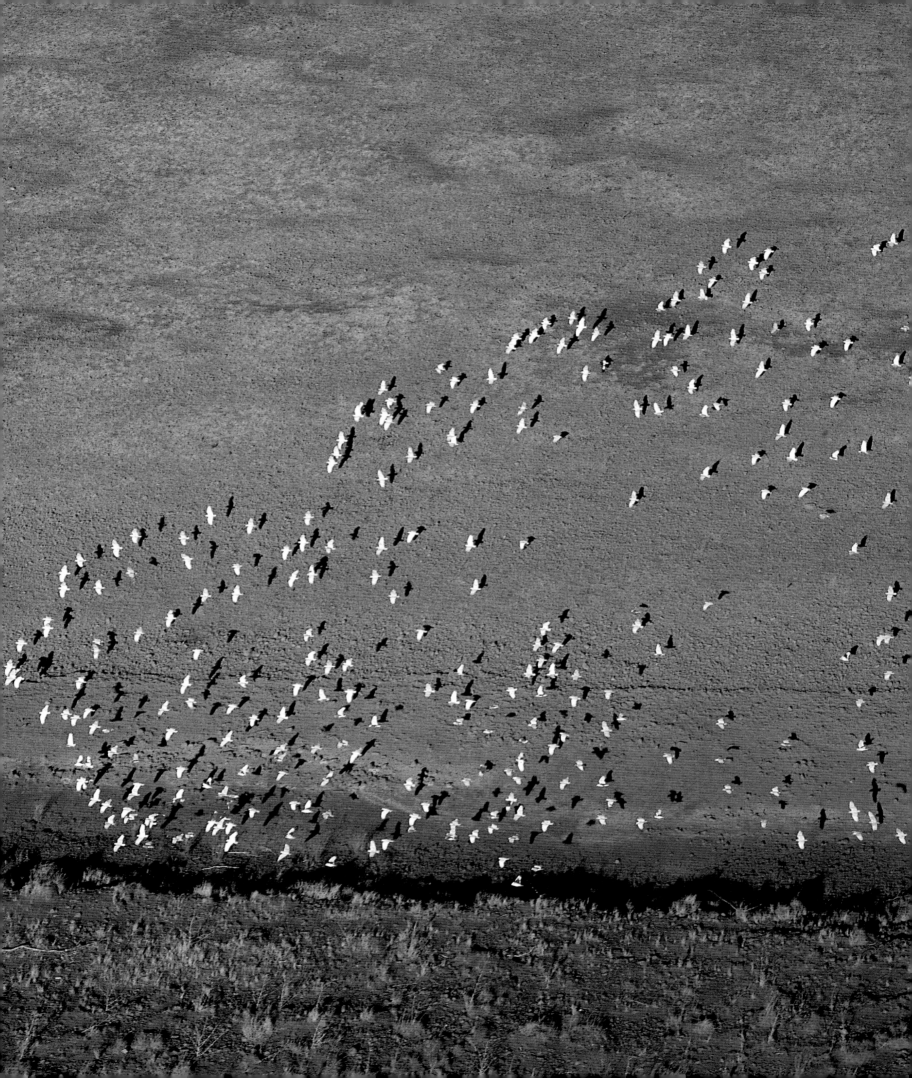

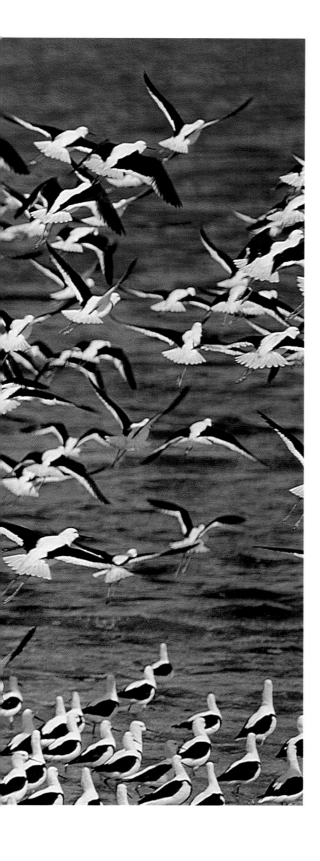

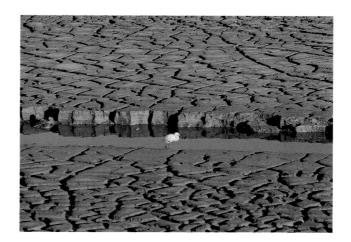

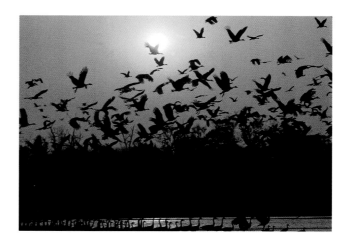

Top: A Little Egret and the geometry of cracked mud in the backwater of a reservoir.

Bottom: Magpie Geese on the Ord River, near Kununurra in the Kimberley.

Opposite: A congregation of Banded Stilts, a highly nomadic bird which wades or swims in saline and hyper-saline waters, feeding on brine shrimps and other invertebrates, wanders throughout the south-west of Australia.

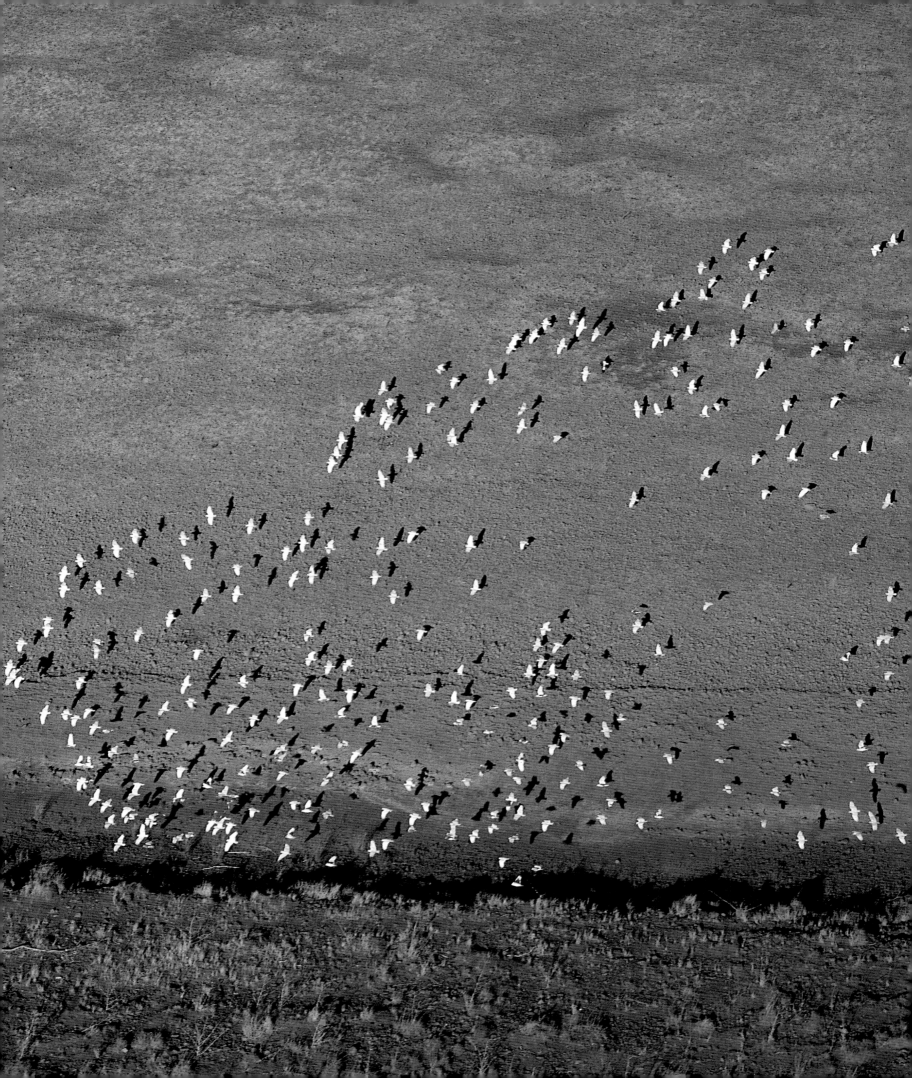

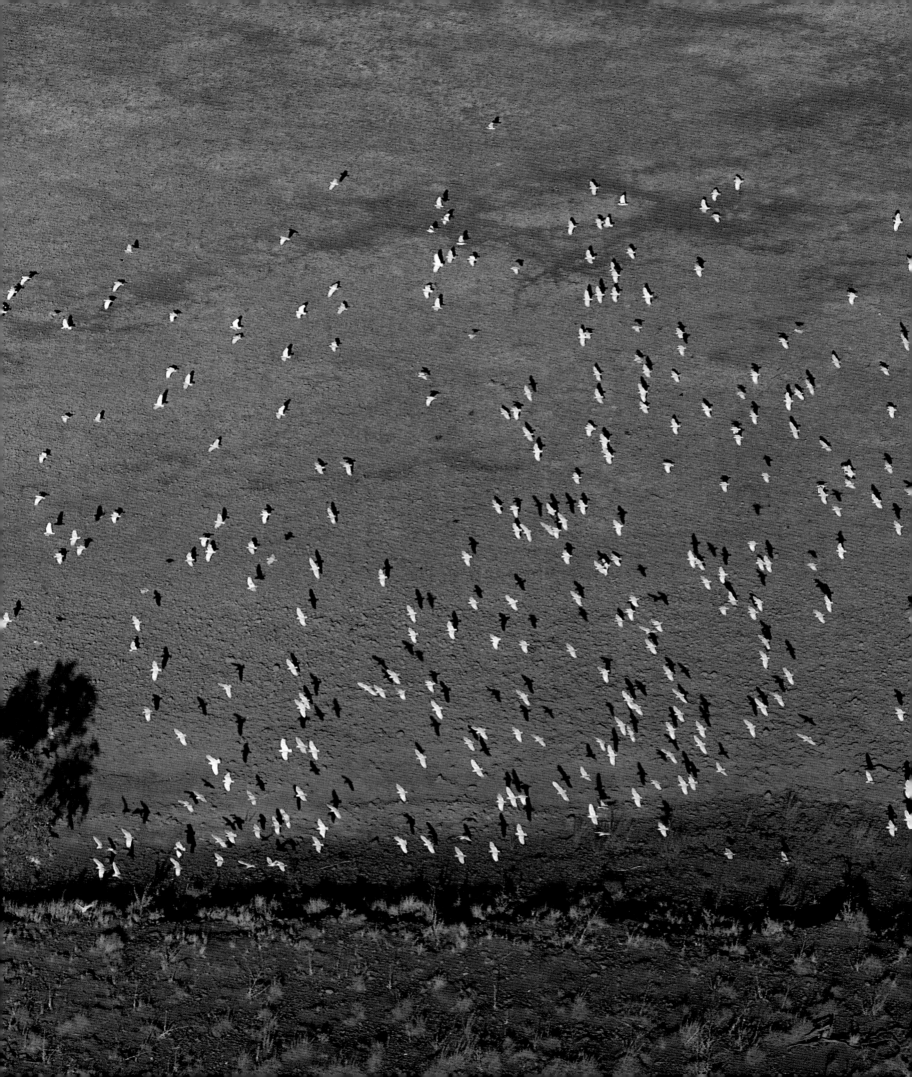

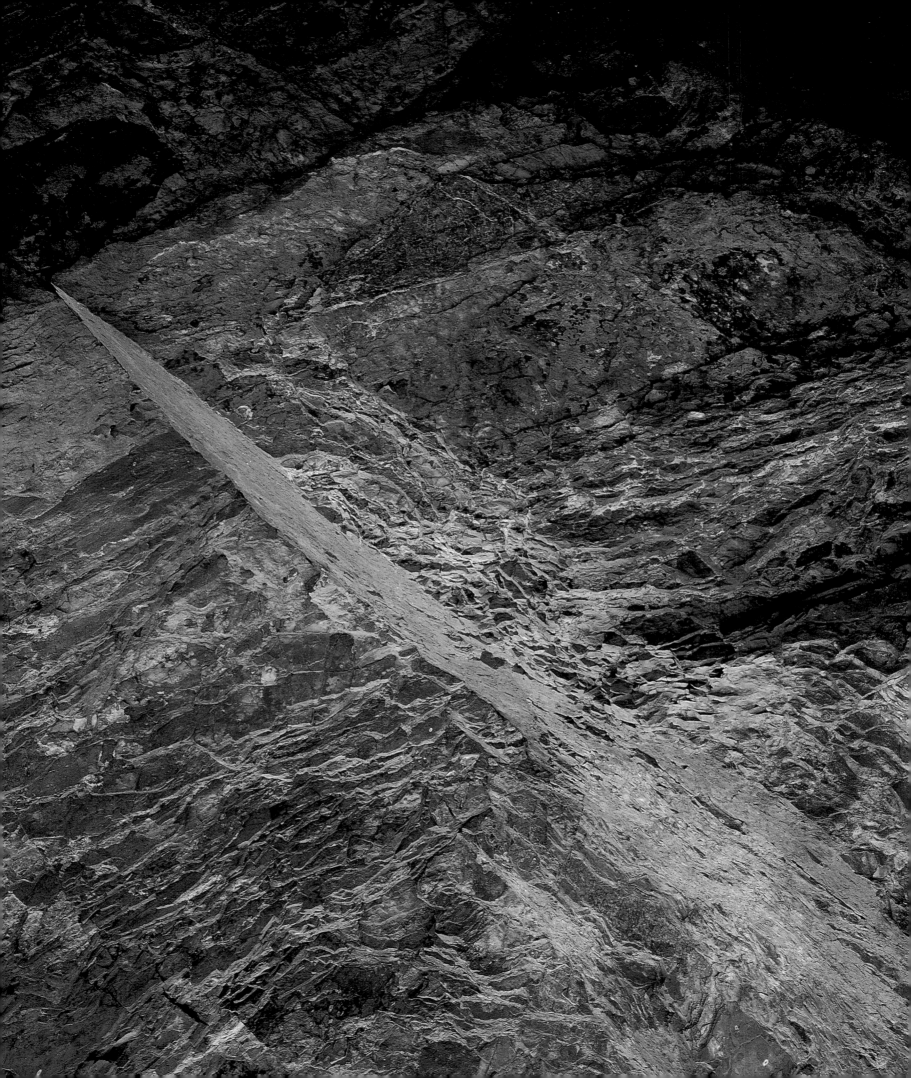

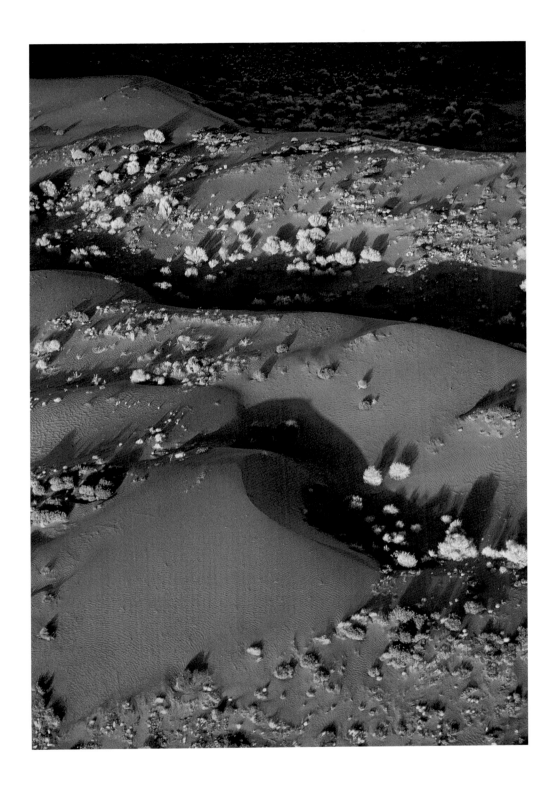

Trees, Strzelecki Desert, north-east South Australia.

Opposite: Ceiling of a rock overhang showing the diversity of rock and colour near Yandicoogina River, 170 kilometres south-east of Port Hedland, Western Australia.

Previous page: White Corellas flying over a dry river bed in the Pilbara.

Uluru detail, Northern Territory.

Opposite: Evening light on the wandoo forest west of York,
Western Australia.

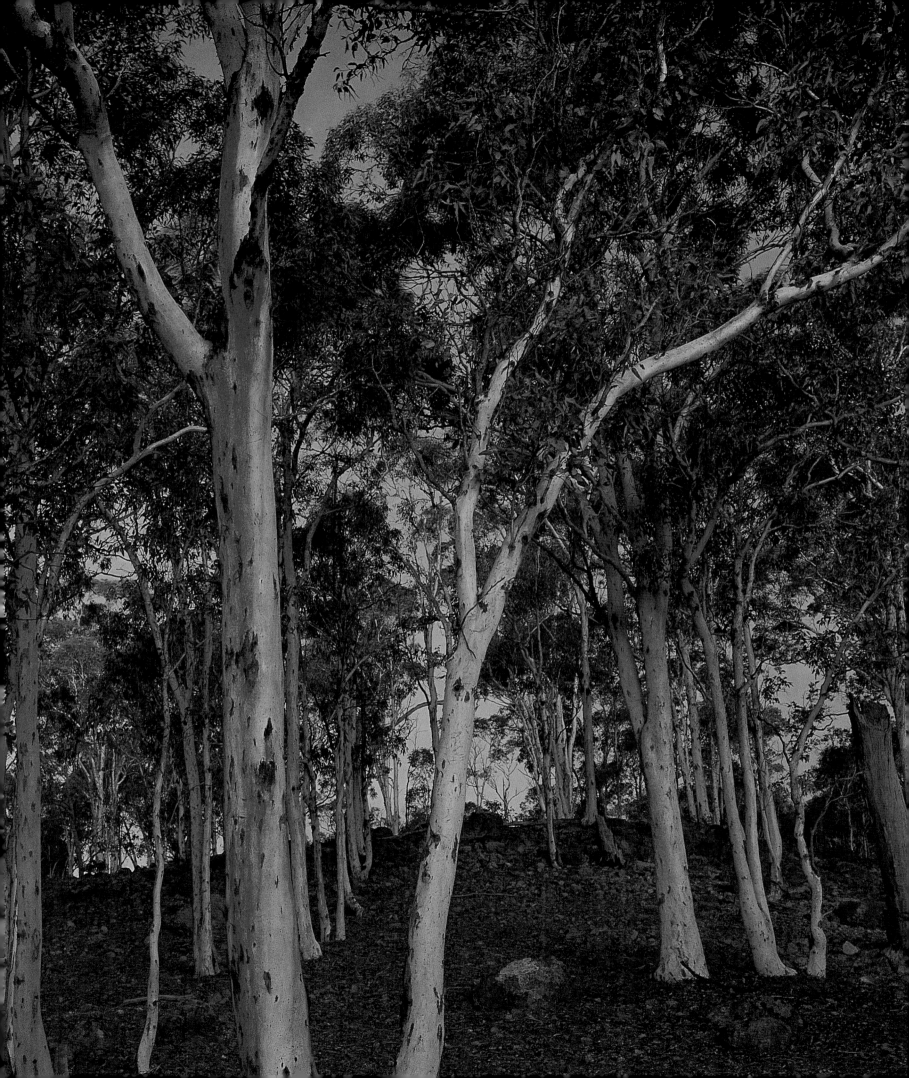

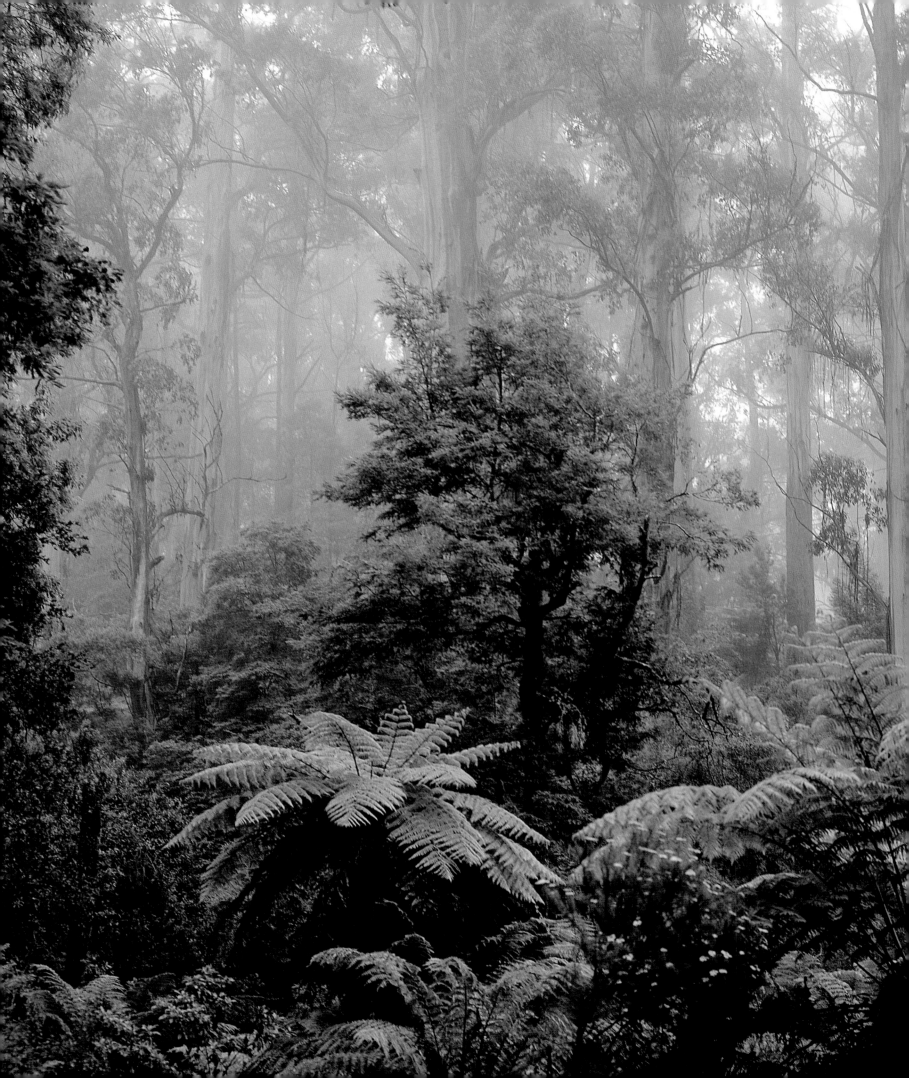

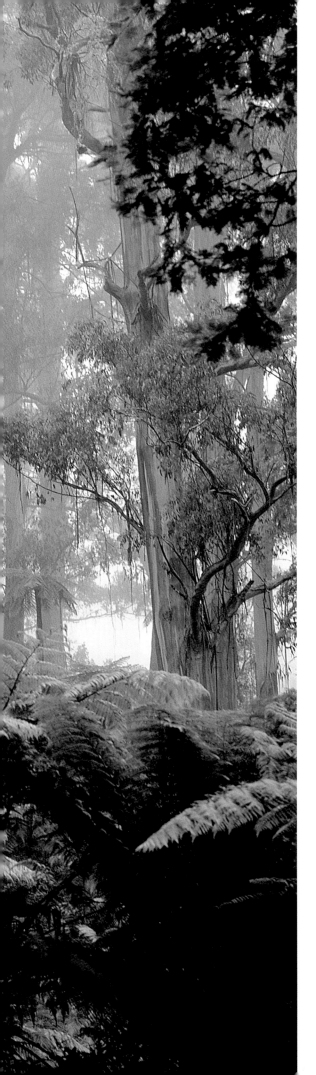

A Curtain Fig near Yunguburra on the Atherton Tableland. These rainforest plants frequently begin life above the ground, where pigeons may have dropped the seed into a damp, litter-filled tree hollow. They drop roots to the ground and can continue to do so from their branches as they grow. The tree beneath is smothered.

Opposite: Bulla Bulla National Park, Victoria. Remnant rain-forest near Yarram, south-east of Melbourne.

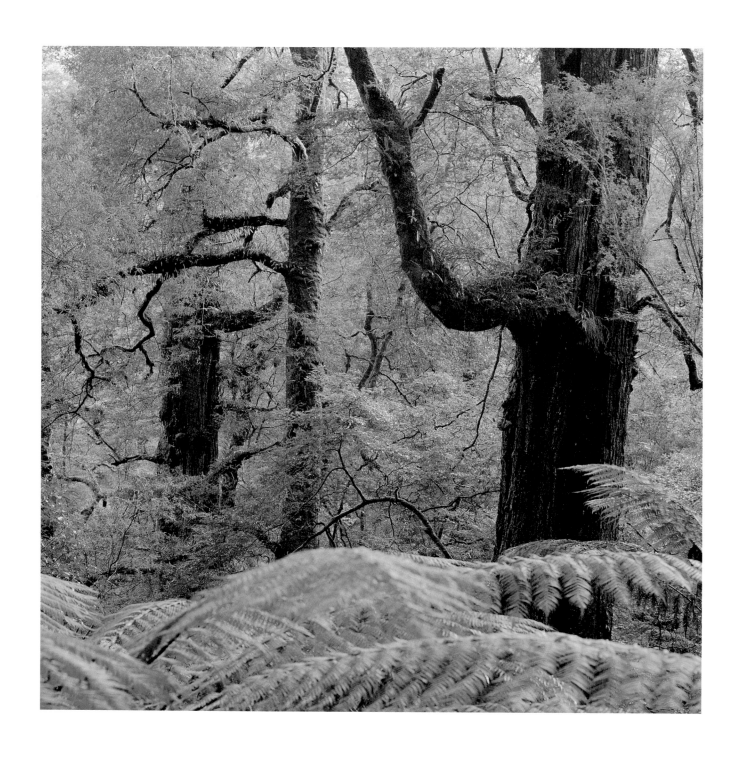

Forest in the Otway Ranges north of Port Campbell, Victoria.

Opposite: Detail of tree trunk, Otway Ranges.

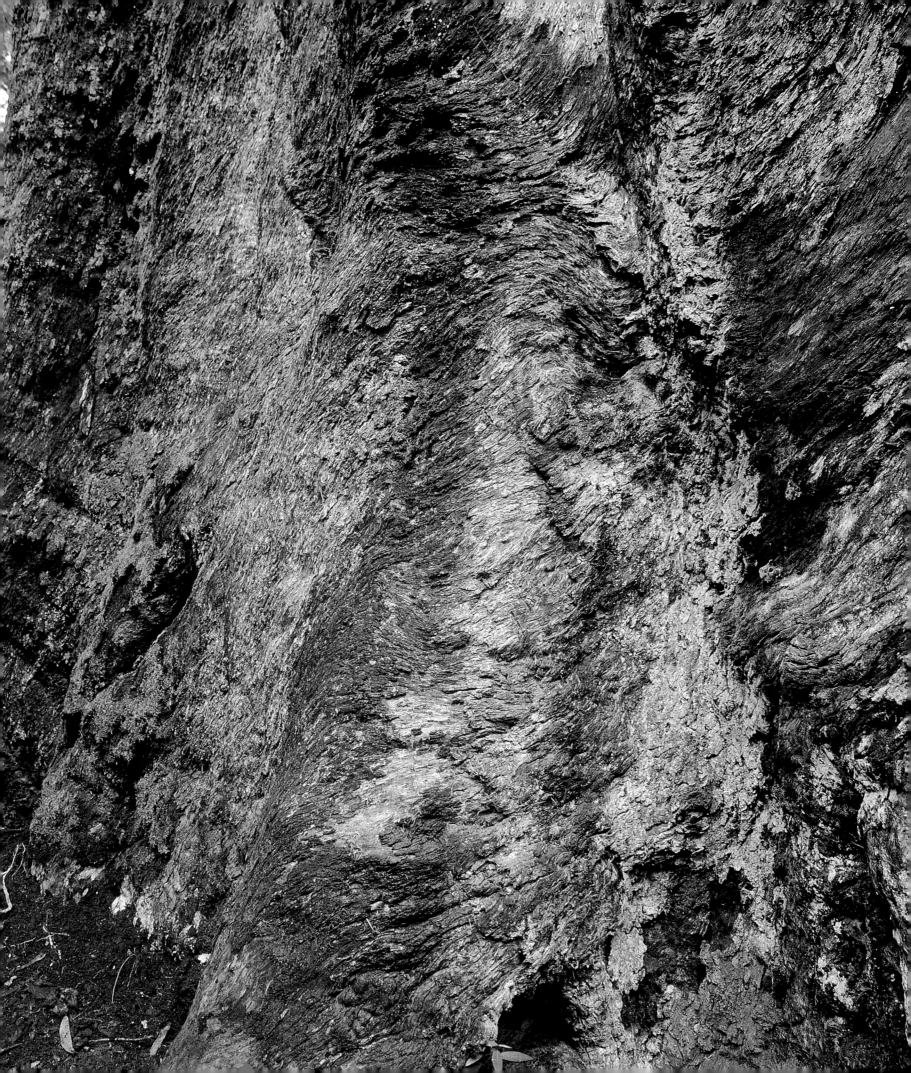

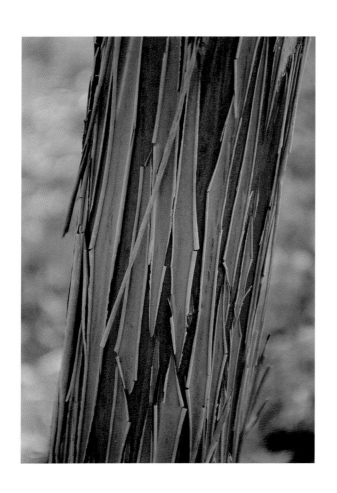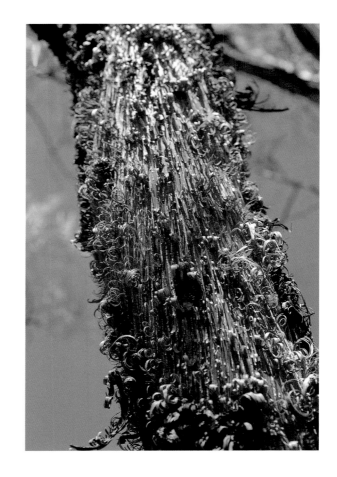

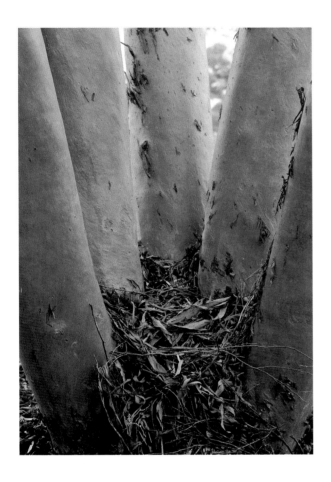

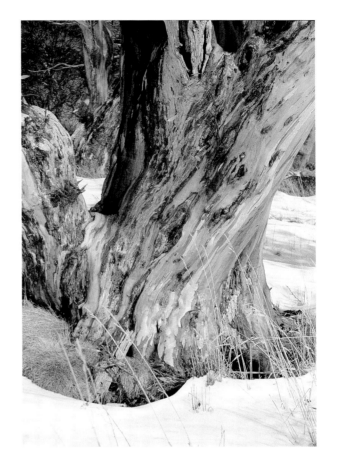

Above and opposite: Seasonal variations in the evergreen Australian eucalypts are revealed in their bark.

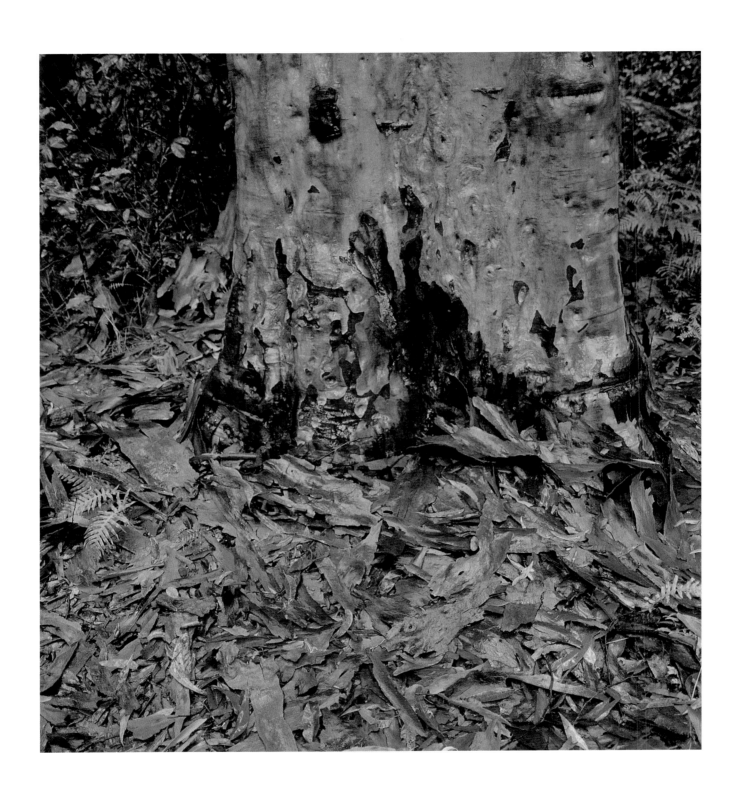

Shedding bark, New South Wales forest, south of Bega.

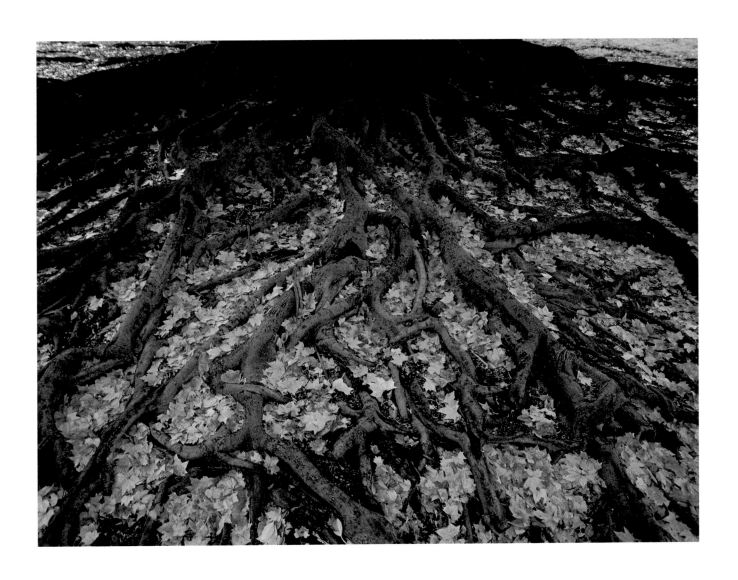

Root system of a Moreton Bay Fig, highlighted by autumn leaves.

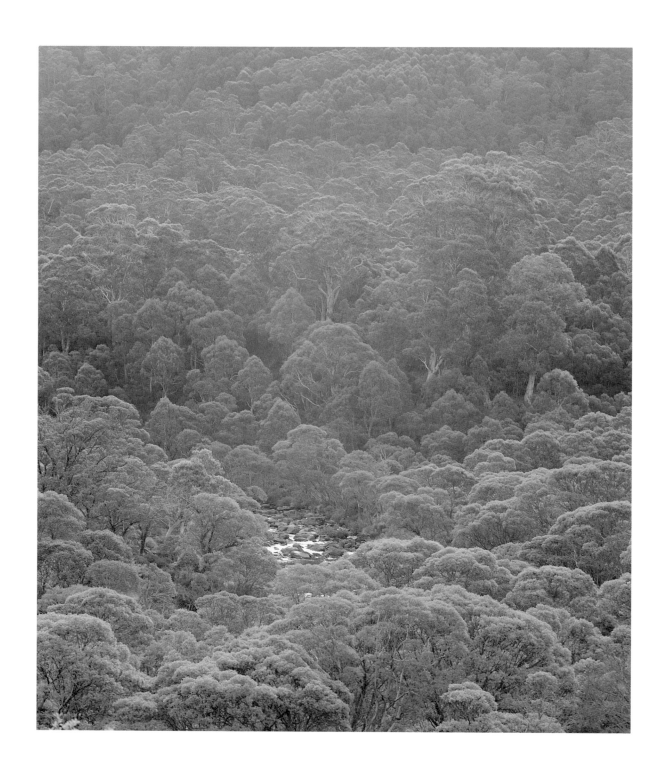

A creek running through the forest near Thredbo, south of Mt Kosciusko, New South Wales.

Opposite: Baron Falls, west of Cairns, Queensland, after heavy monsoonal rains.

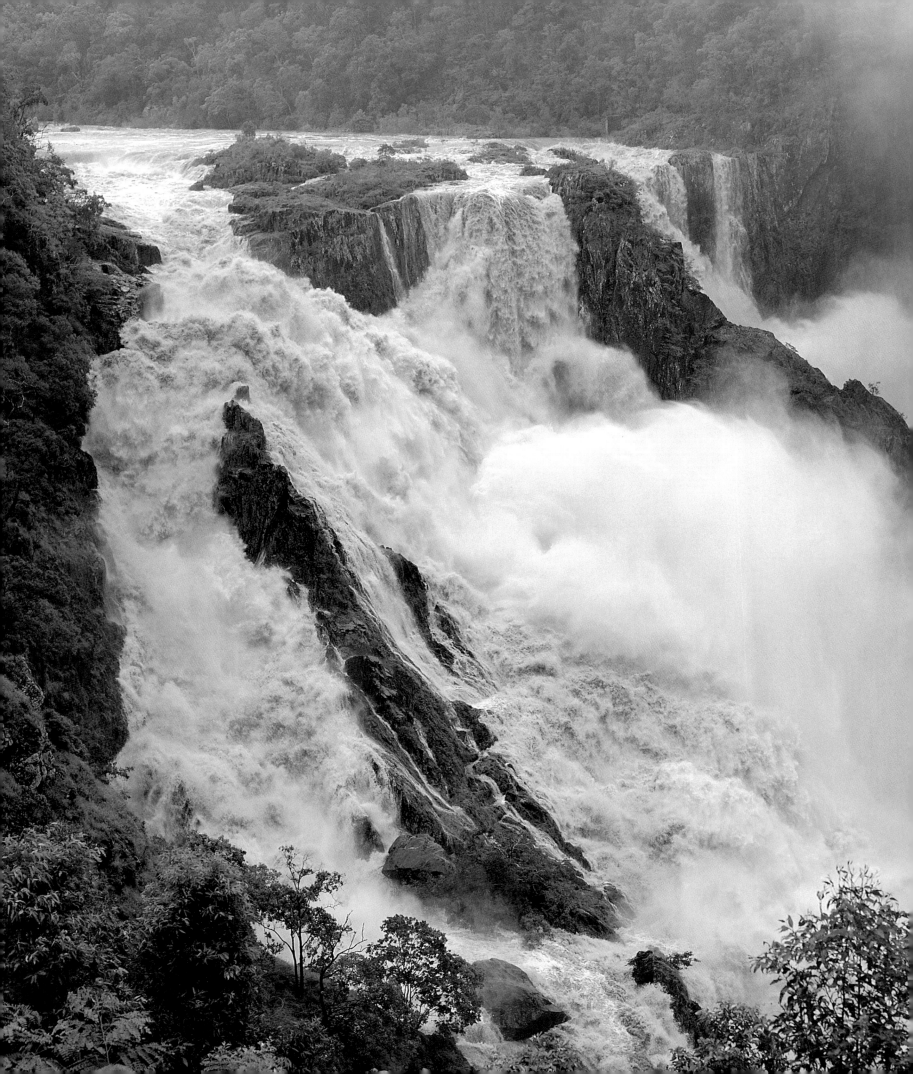

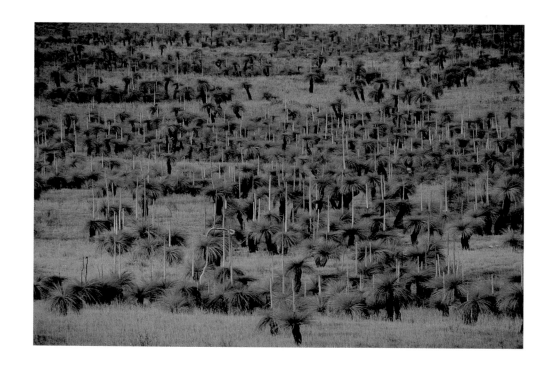

Grasstree forest north of Lancelin, Western Australia.

Opposite: The amazing uniformity of forest growth near Charleville, Queensland.

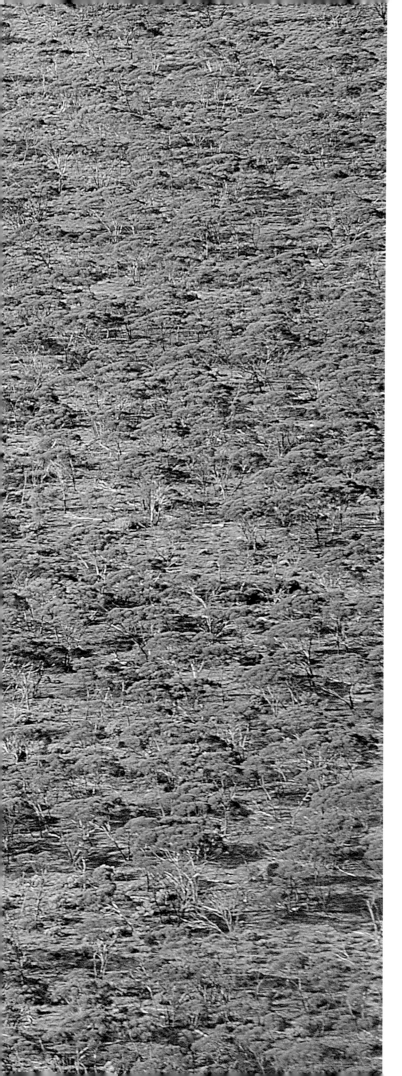

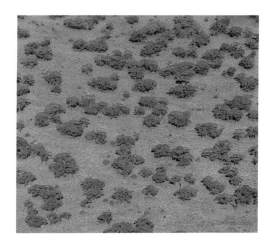

Saltbush and Salmon Gum near
Norseman.

Opposite: Forest east of Norseman,
Western Australia at the beginning of the
Nullarbor Plain.

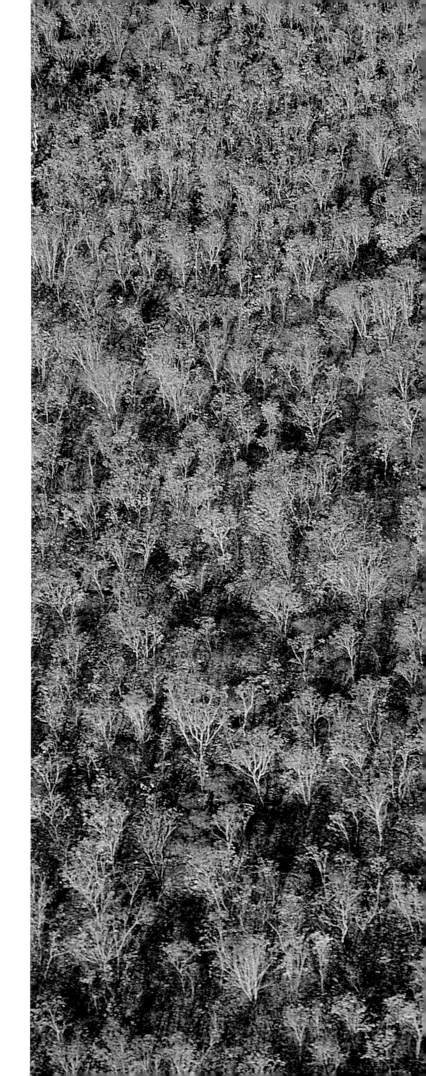

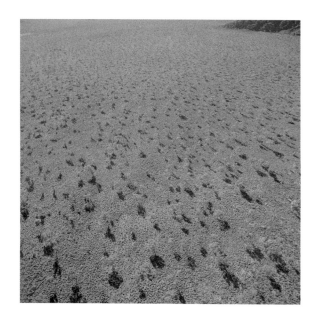

Kimberley landscape, west of Ragged Range and
south-west of Kununurra.

Opposite: Forest west of Oskar Range, Kimberley.

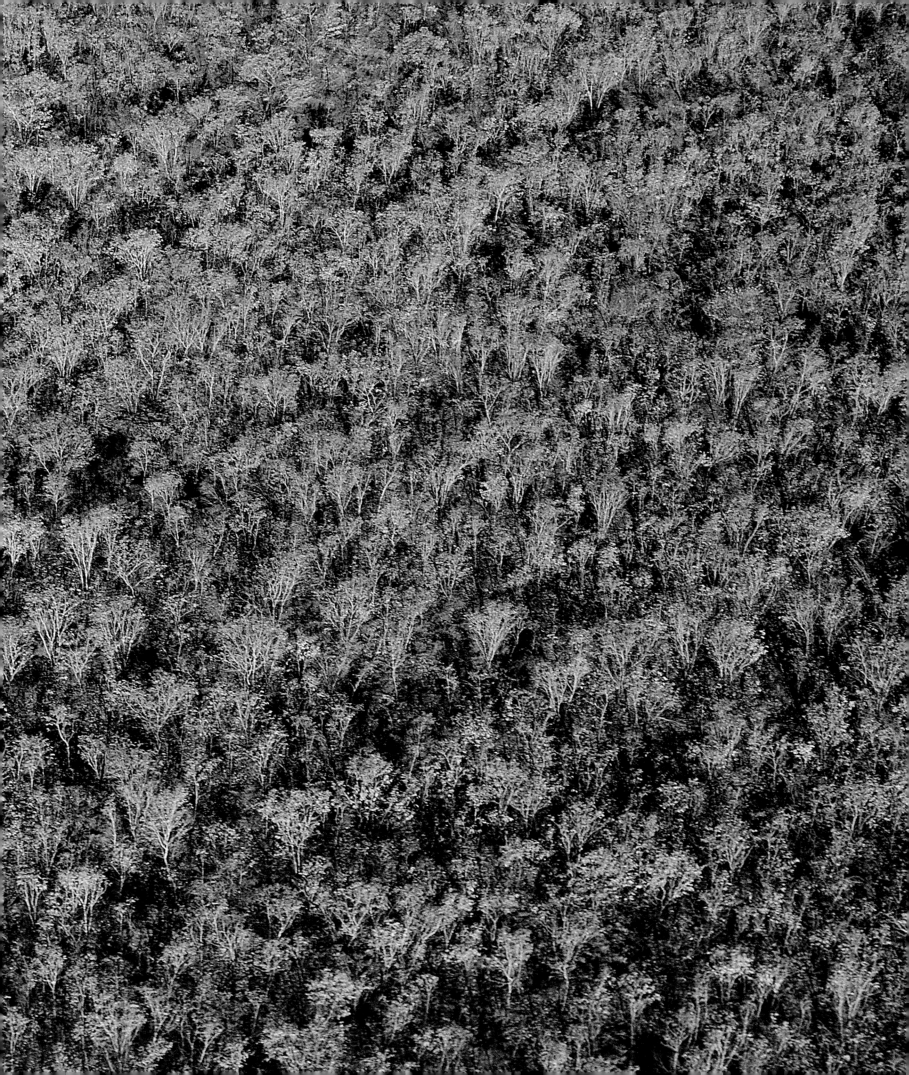

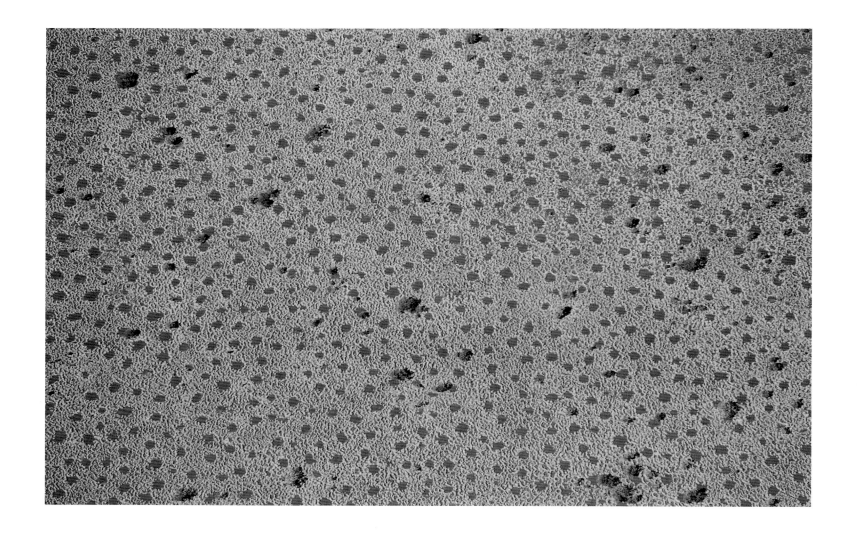

Top: Not raindrops but bare patches in the spinifex created by a species of termite living totally underground and feeding on spinifex leaves cut to about a centimetre and stored in underground cells. Without these desert recyclers the desert would die ... it would literally 'run out of fuel'!

Opposite: Chichester Ranges, south-west of Port Hedland, Western Australia.

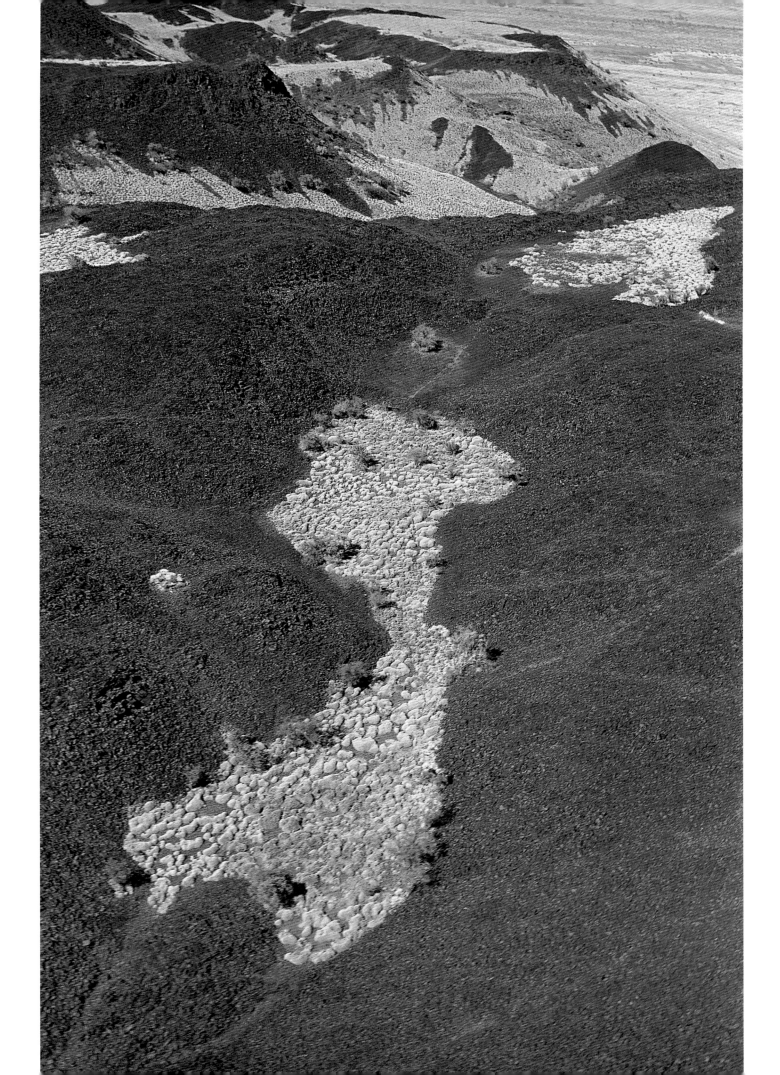

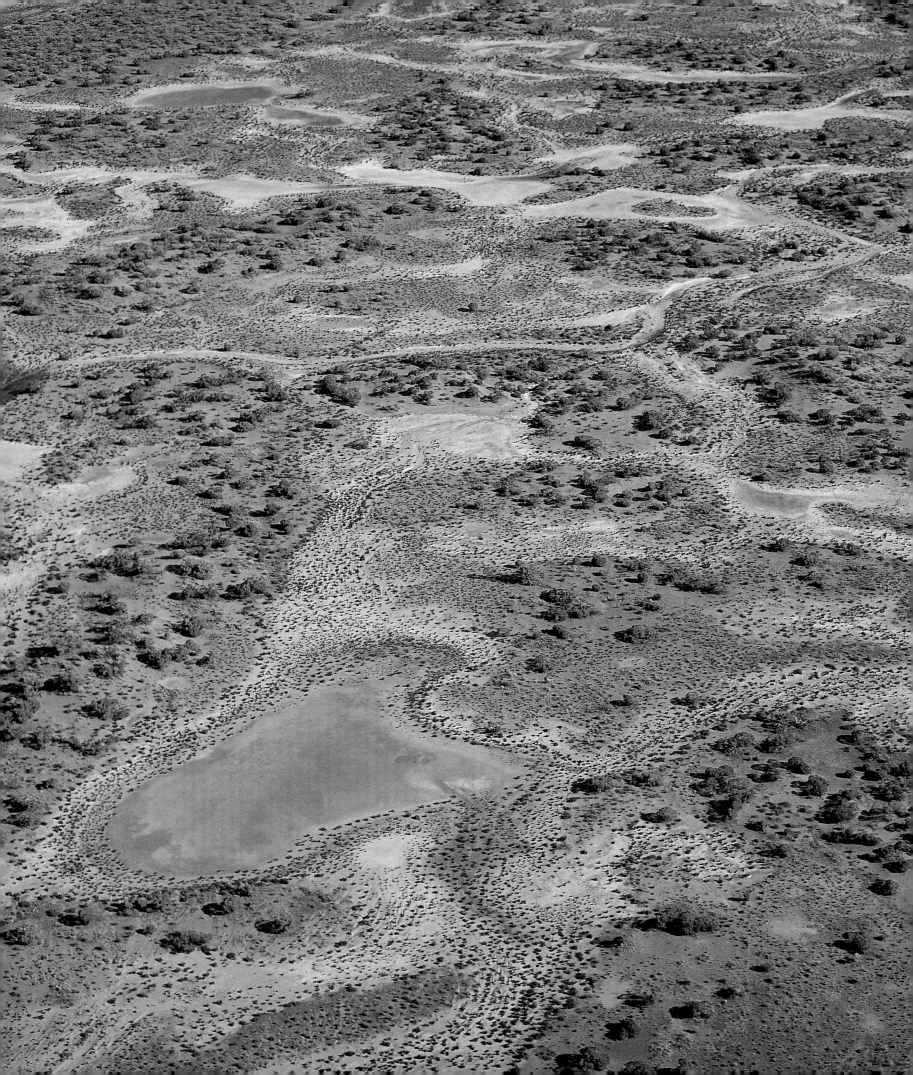

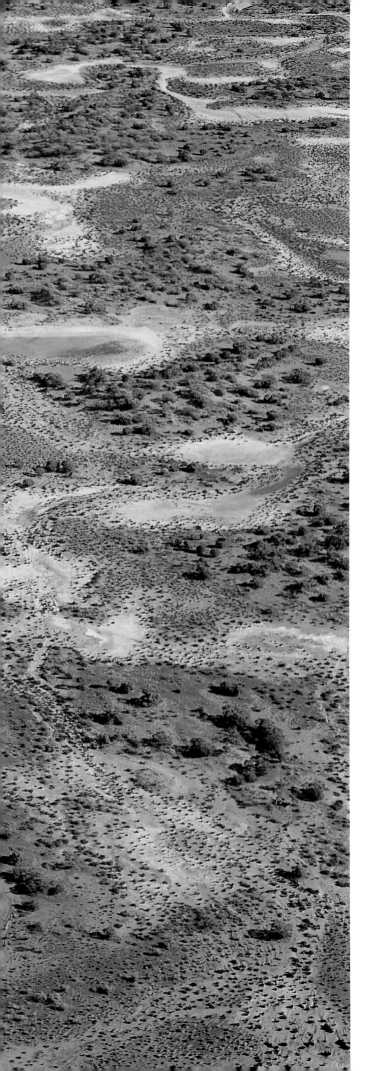

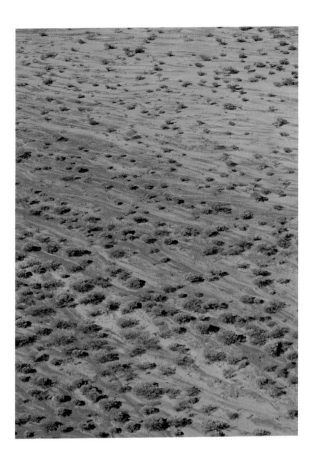

South of Meekatharra, Western Australia, the plains are awash in the rainy season. Scattered mulga and other acacias hold the country together as the water flows away.

Opposite: Near Byro Station, south-east of Carnarvon Western Australia. Much of the country in this area is covered with a veneer of sand. Winds have rippled and dimpled this surface, while thousands of rainstorms have washed the clays into the hollows, forming claypans. A rime of salt edges the pans. Only specially adapted plants can inhabit the salted places.

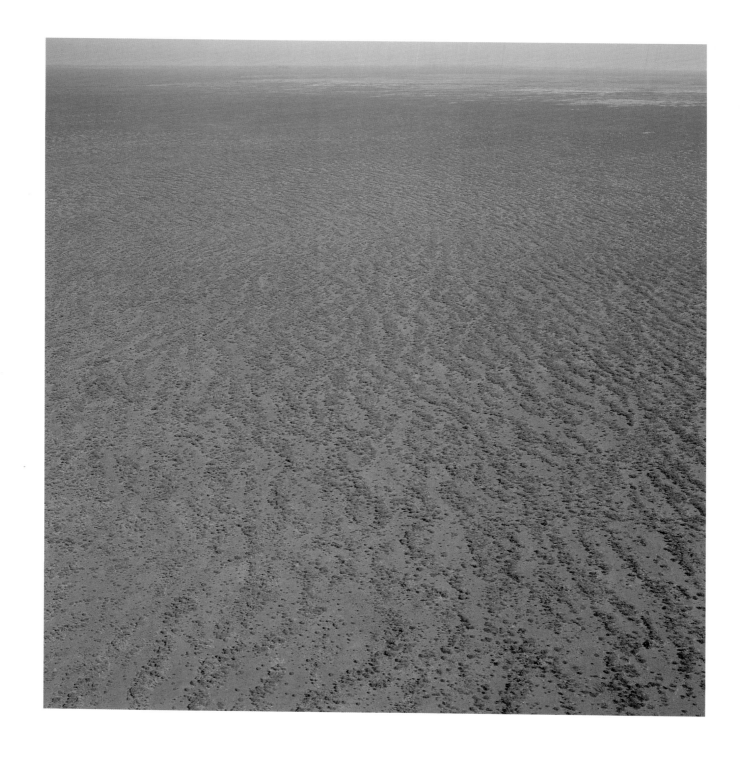

North of Alice Springs and the Macdonnell Ranges there are broad sand plains which, following fire, are swept by winds which throw up low ridges of sand, ash and mulga seed. These are accentuated as stormwater runs downslope. Mulga seed germinates in the ridges, which may be 5 to 20 metres apart, resulting in linear stands of mulga when seen from the air.

Opposite: Flood plain east of Lake Eyre, South Australia.

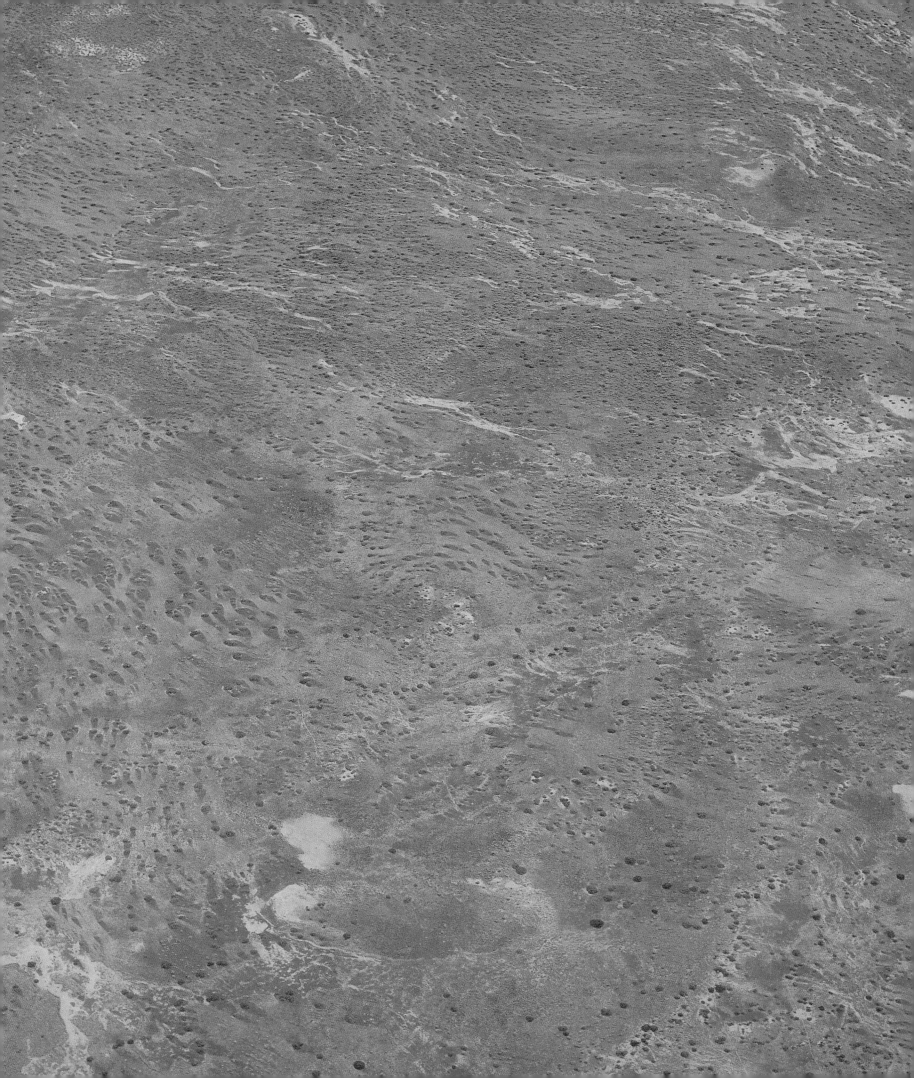

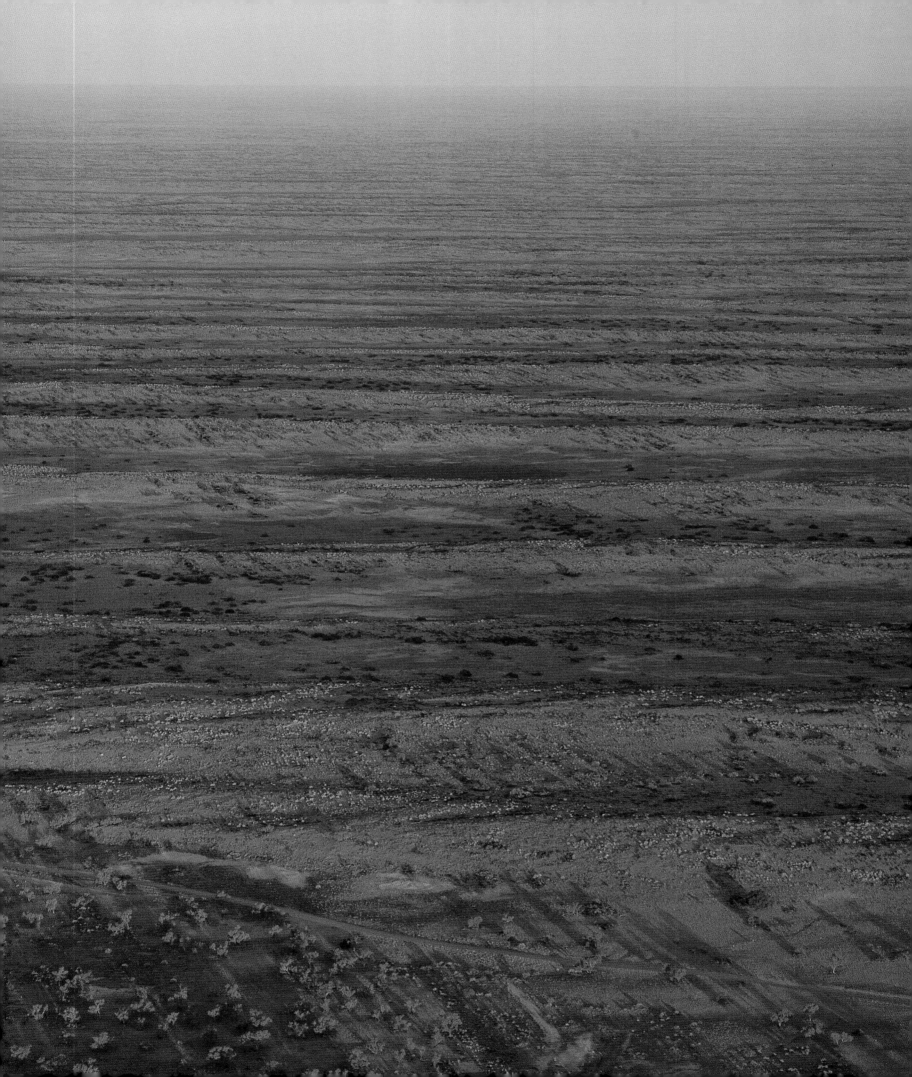

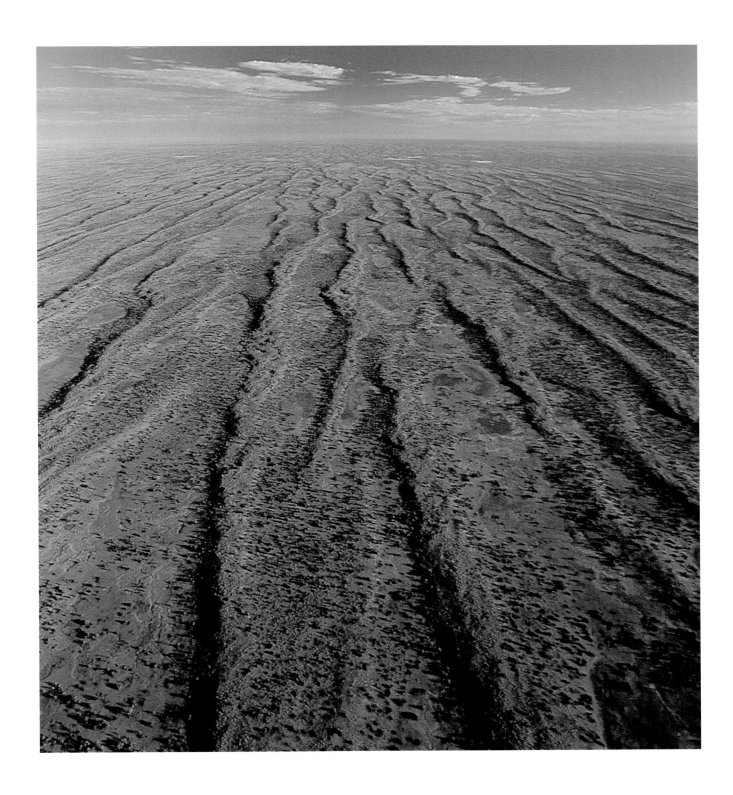

Above and opposite: Dunes, Strzelecki Desert, north-east South Australia. The dunes run predominantly north south.

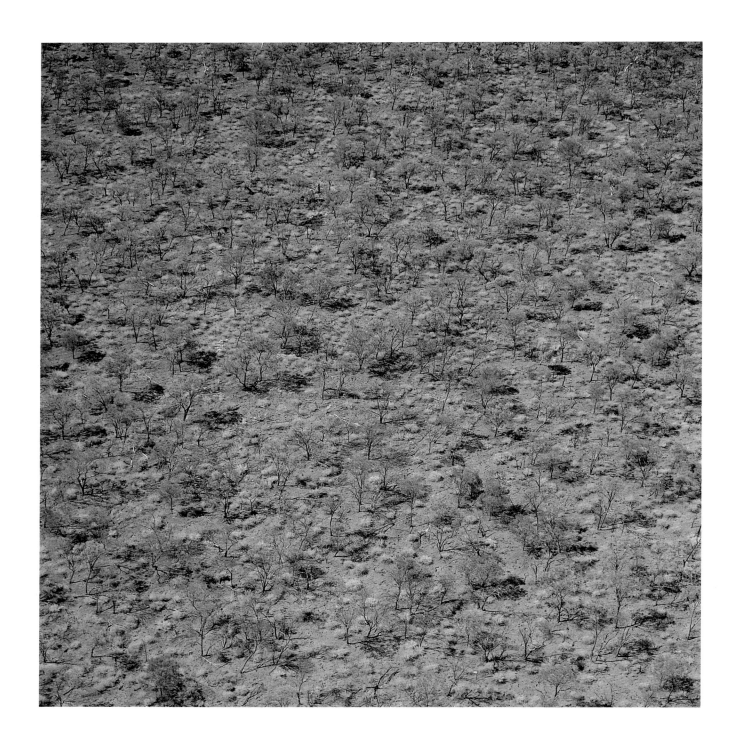

Forest pattern in the Pilbara near Mt Bruce.

Opposite: The Ragged Range, south-west of Kununurra, a land of 'all slopes', drains into the Ord River and Lake Argyle.

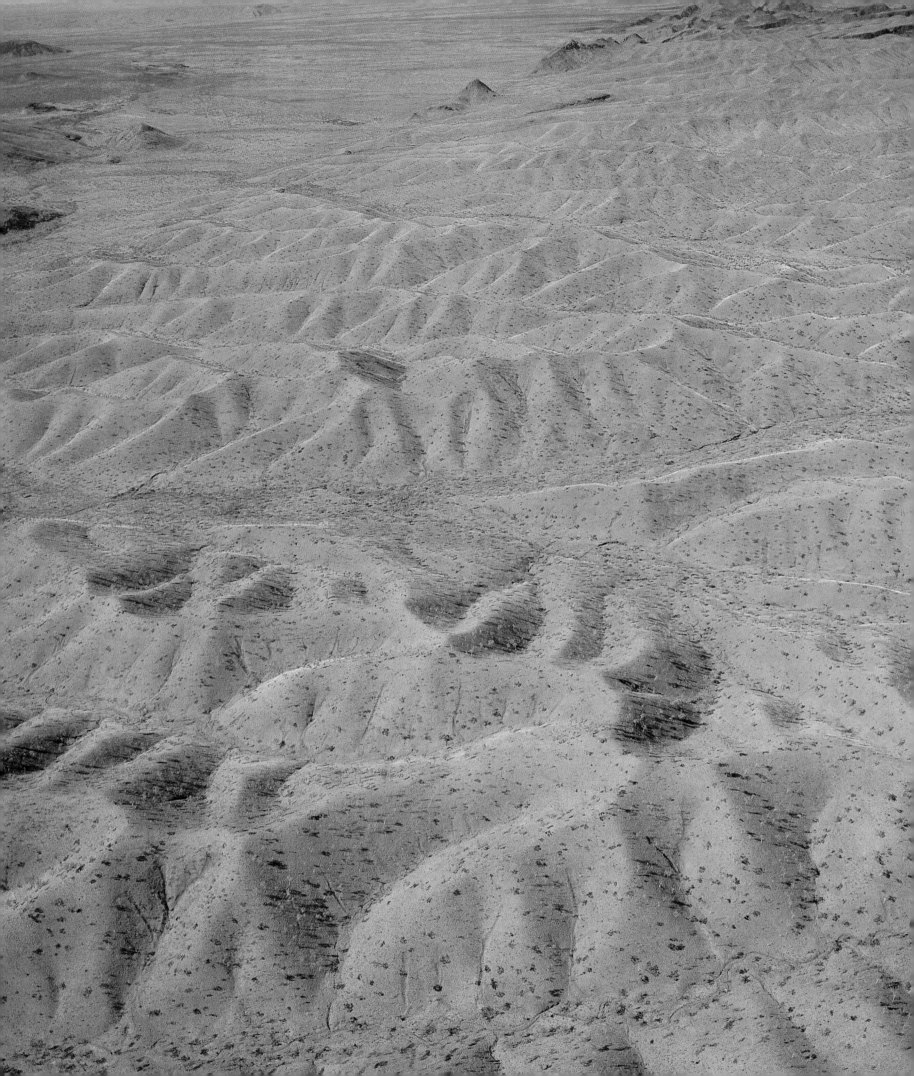

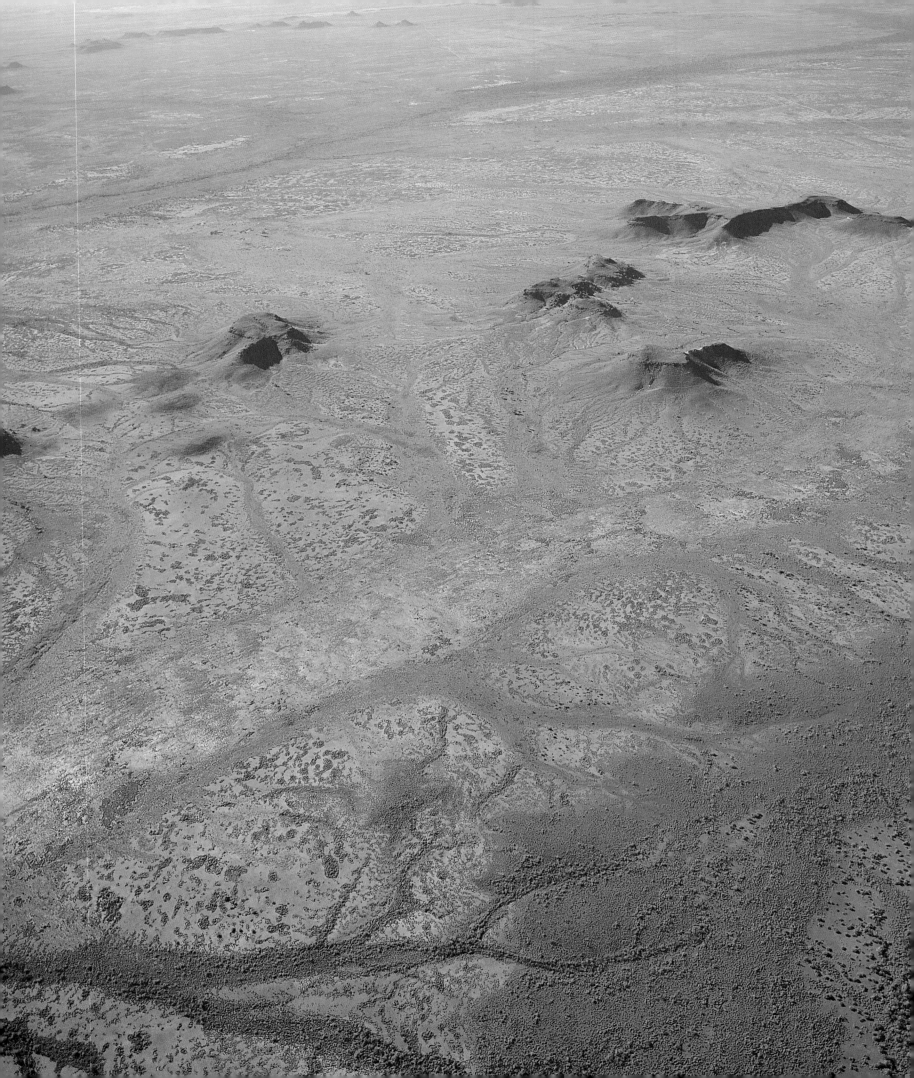

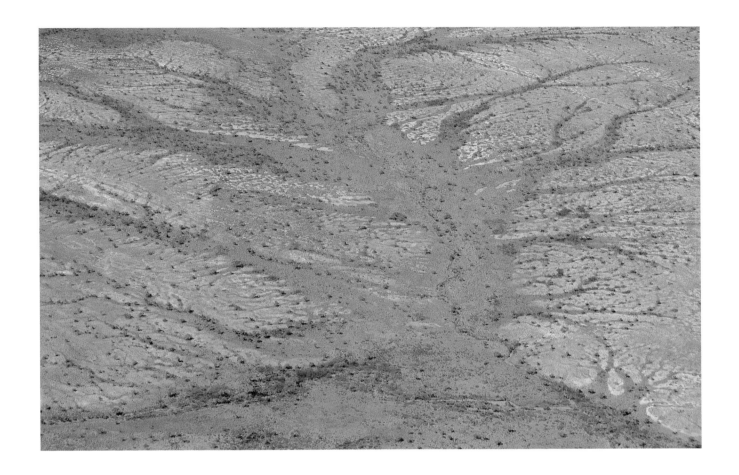

The Murchison River drains the Yilgarn Block, one of the world's oldest land surfaces. Many millions of years of exposure to weathering and erosion have levelled the area to rounded undulations of granitic rocks and ancient metamorphosed rocks. Mulga grows on the ridges, with River Red Gums on the damper areas of valley channels. The Murchison catchment of Western Australia is a land of absolutes, of extremes, dying of thirst one day, flooded the next!

Opposite: Hard-capped outliers of the iron-enriched Hamersley plateau, Robe River area, Western Australia.

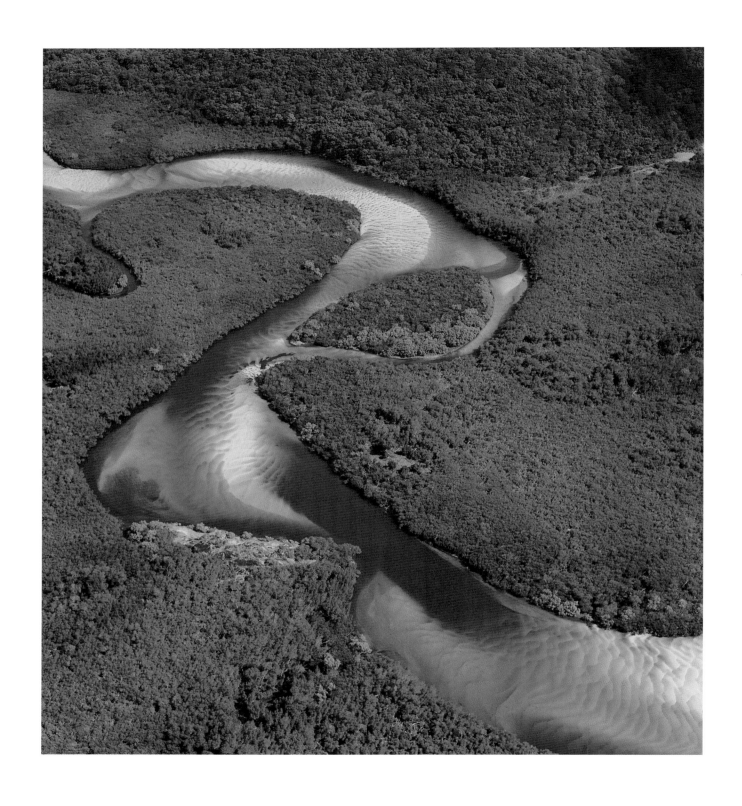

Creek north of Cooktown, Cape York Peninsular, Queensland.

Opposite: Lake Magenta, 200 kilometres north-east of Albany, Western Australia is a shallow freshwater lake. The varying water depths create a range of environmental conditions suited to different species of melaleuca. Each of the varying strips of green are a different species.

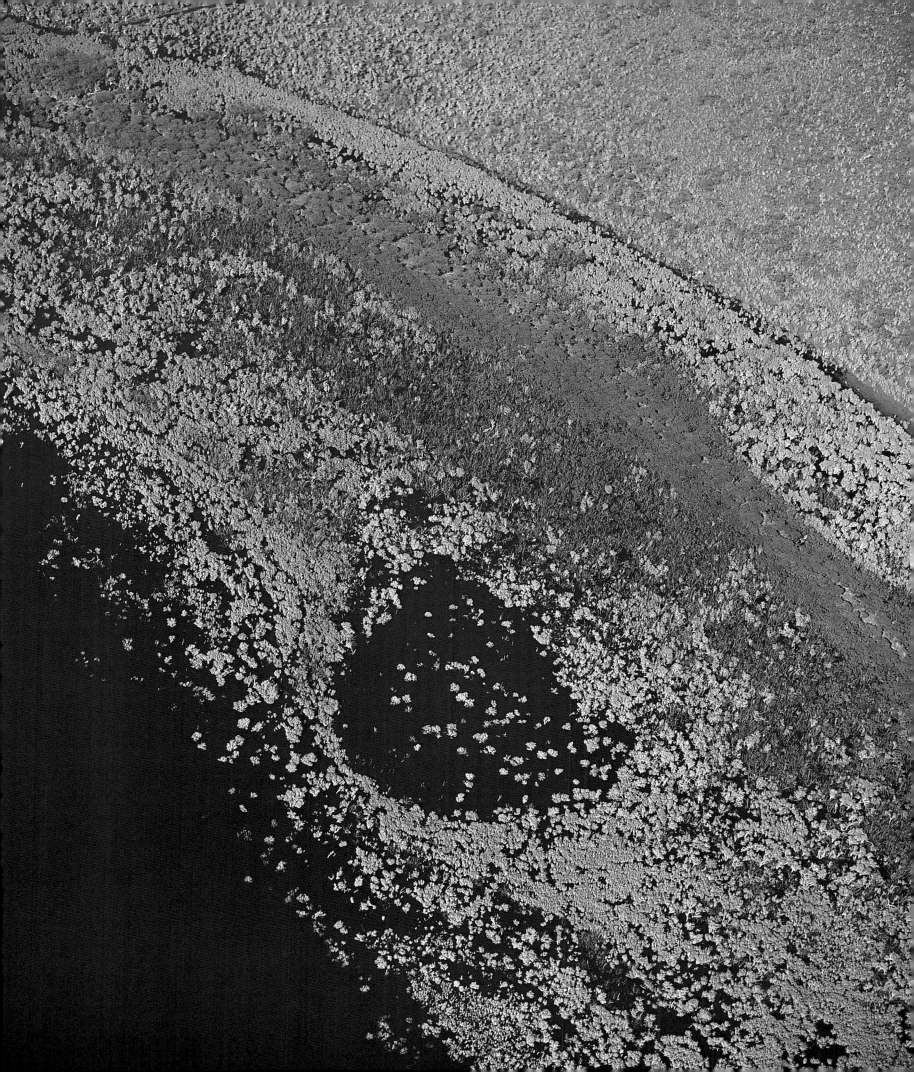

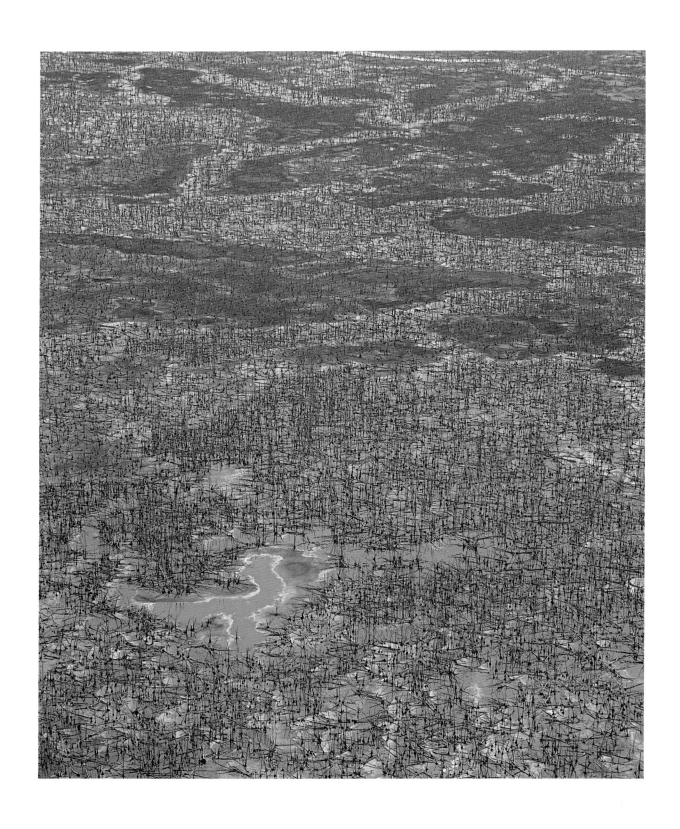

Drowned forest east of Adelaide River, 60 kilometres east of Darwin, Northern Territory.

Opposite: Remains of a drowned forest, Lake Argyle, Kununurra, East Kimberley.

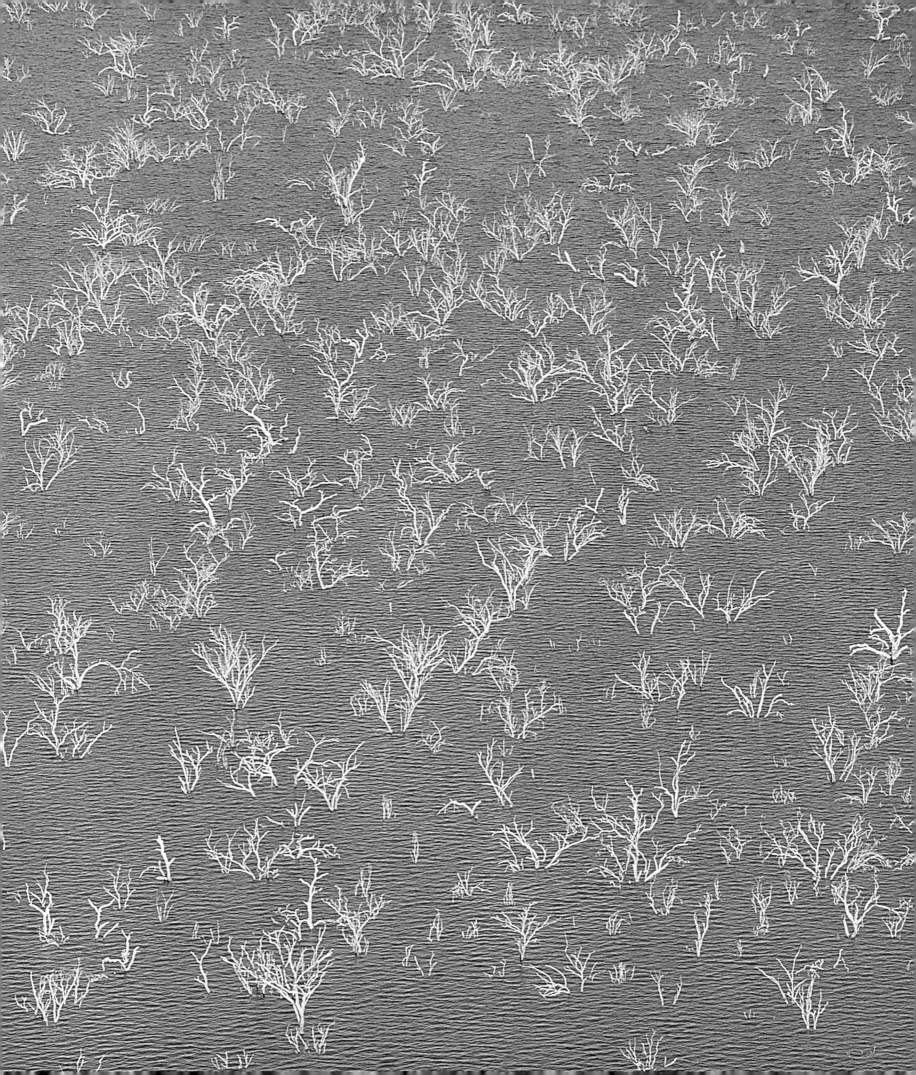

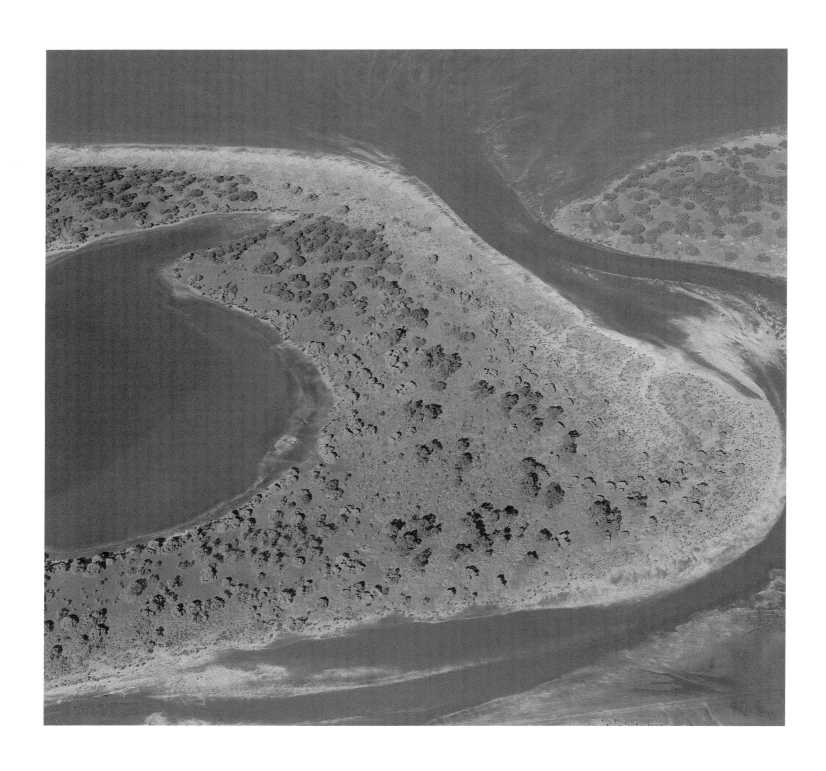

Lake Kambalda, south of Kalgoorlie, Western Australia, a sump for the
red soil filled run-off from the surrounding area.

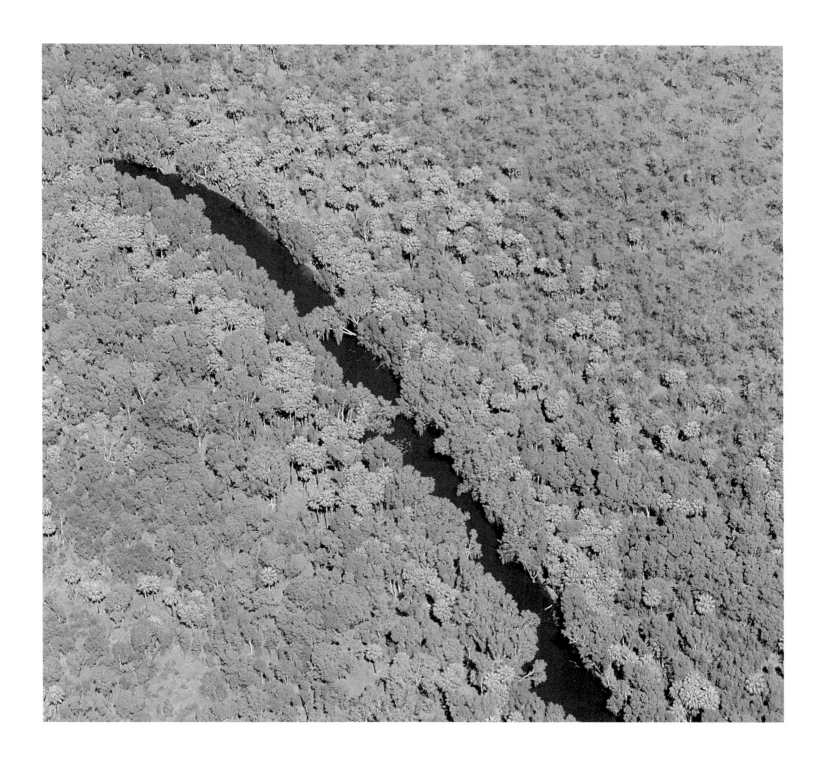

Artist Sir Arthur Streeton once described an Australian forest as 'an army of grey-green ants'. In this view of a waterhole on Batten Creek, Borroloola, Northern Territory, each strip or patch of colour represents a stand of a different species. Lining the waterhole, tall paperbarks and Barringtonia, then Swamp Bloodwoods and Darwin Stringybarks, Salmon Gums, the bluish Silver Leafed Box and bright green acacias, each species fitting its soil and water preferences.

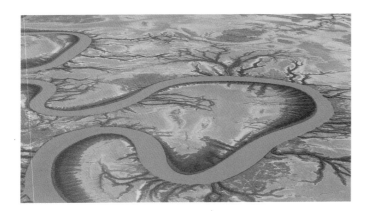

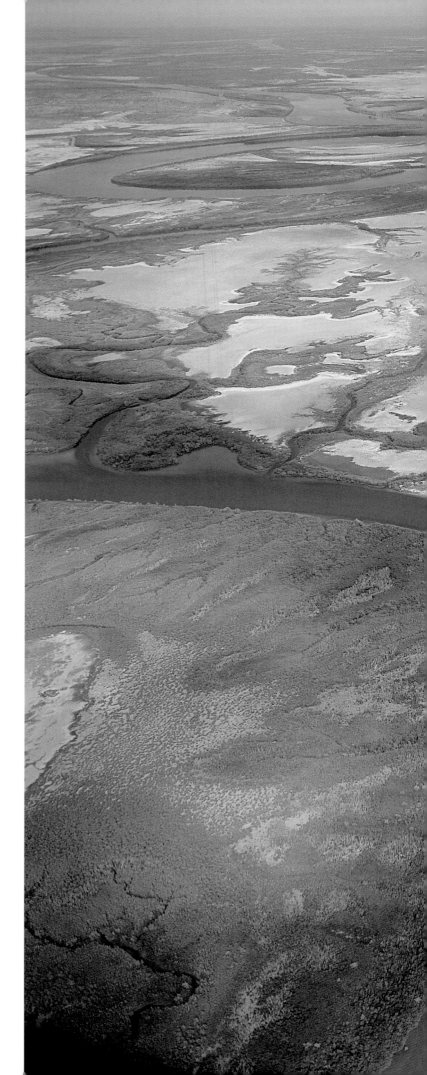

The Nicholson River near Burketown, Queensland. As if writhing in their last throes before death in the ocean, the rivers of the Gulf of Carpentaria meander their way across the tidal mudflats. A ten metre tide pushes water fifty kilometres or so up and down these estuaries, and frequently out across the mudflats via the side channels.

Opposite: The mangrove-lined drainage systems on the incredibly flat floodplain of the lower McArthur River as it runs into the Gulf of Carpentaria.

Overleaf: During a cyclone in the late seventies dugong from the sea-grass shallows of the Gulf of Carpentaria were swept across these McArthur River floodplains by a massive storm surge and had to be airlifted back to sea. The area becomes a vast freshwater sea in the wet season.

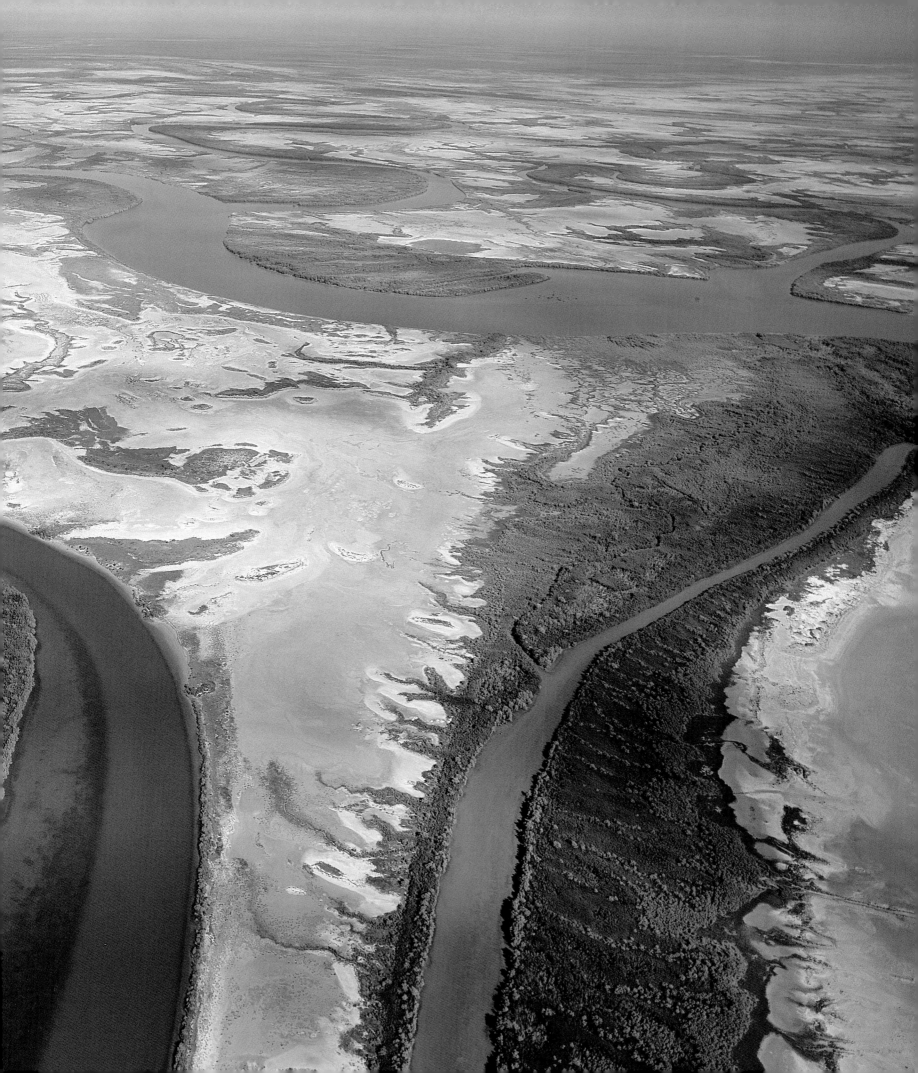

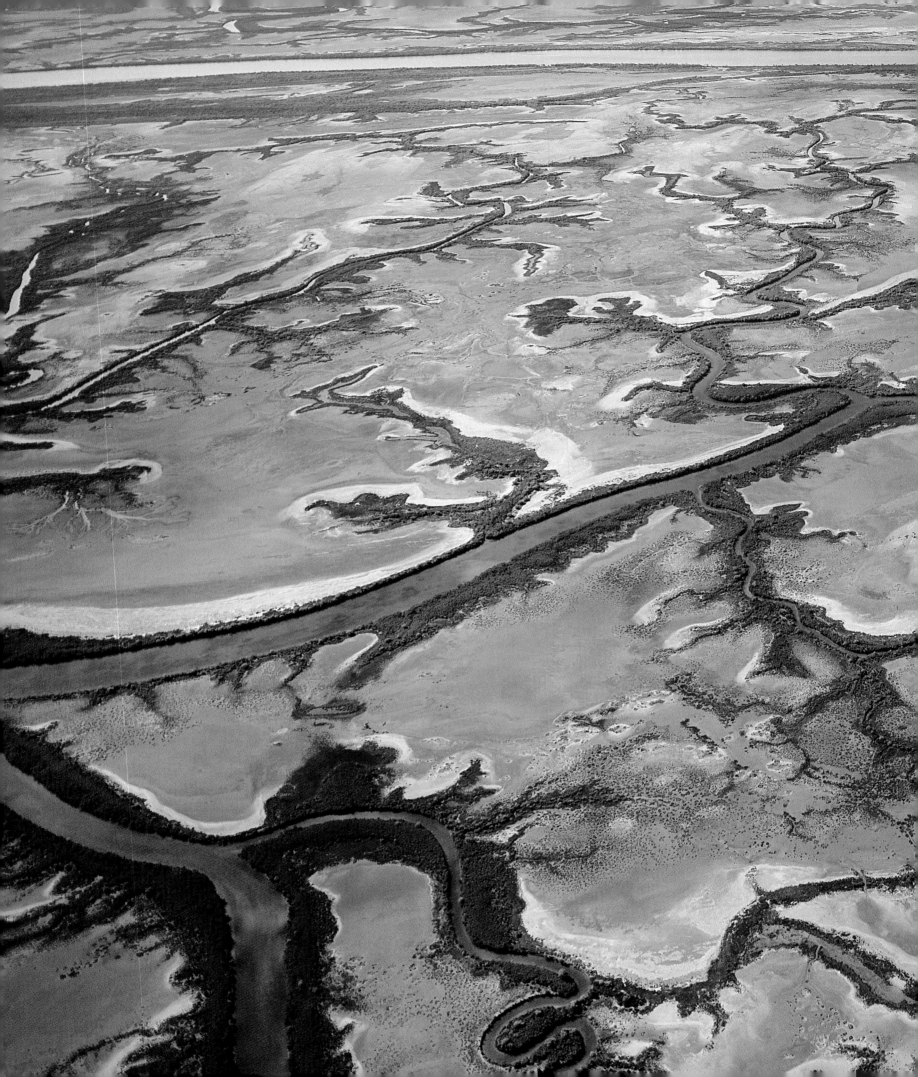

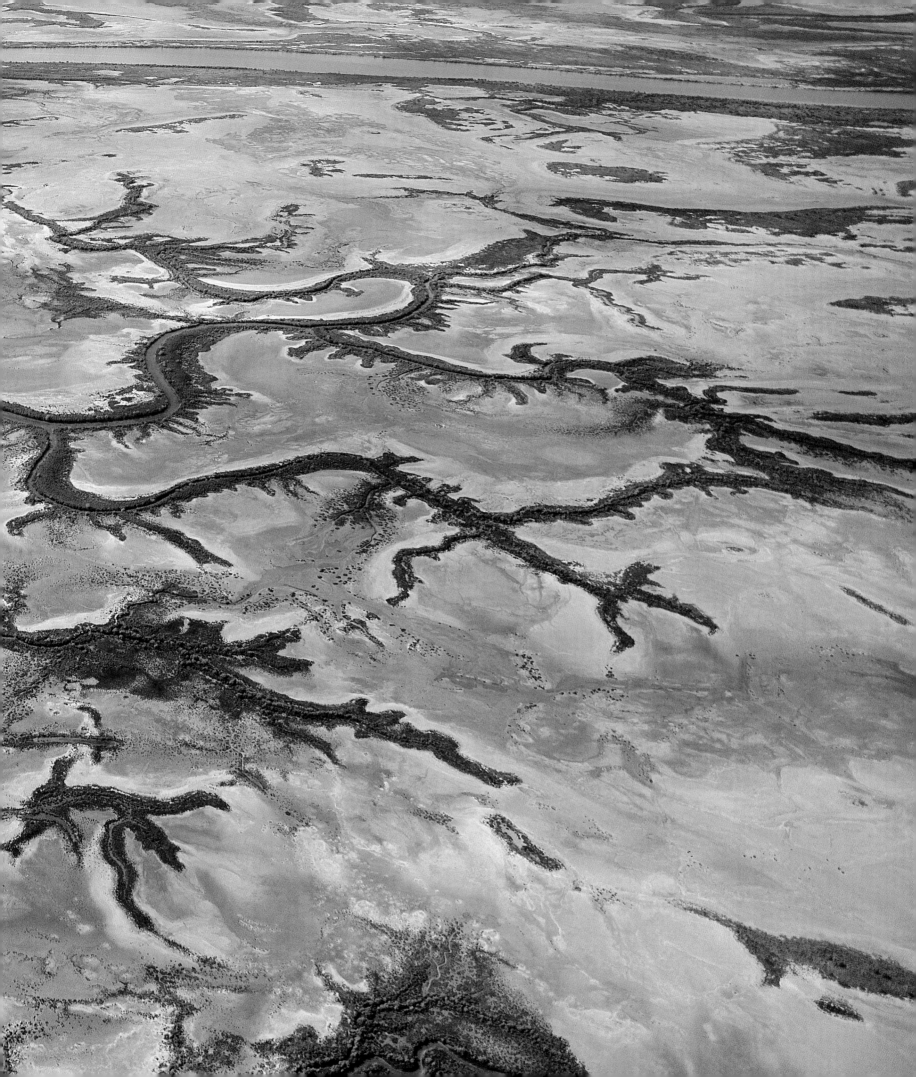

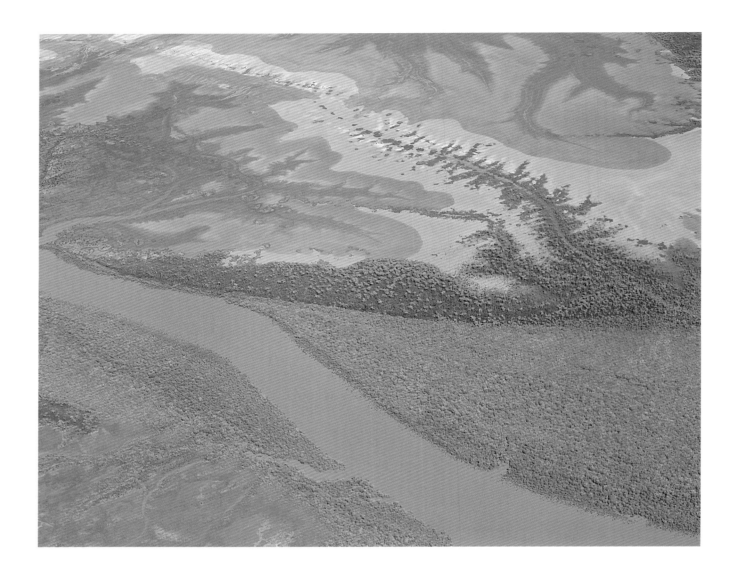

Tidal mudflats and mangrove swamps are common about the monsoon coasts of Australia. Extremely rich in marine and other fauna, such areas as this at the mouth of the Victoria River, 350 kilometres south-west of Darwin, Northern Territory, provided the Aborigines settling Australia more than 60,000 years ago with their first Australian food.

Opposite: Coast near Elcho Island, Arnhem Land. With a drop of about a metre over 70 kilometres, but with a difference between low tide and high tide of perhaps 6 metres and more, the northern rivers see long periods of mud-charged surging waters every day. These waters sweep the banks and mud islands on each incoming and outgoing tide, slicking the surfaces into wonderfully fluid forms.

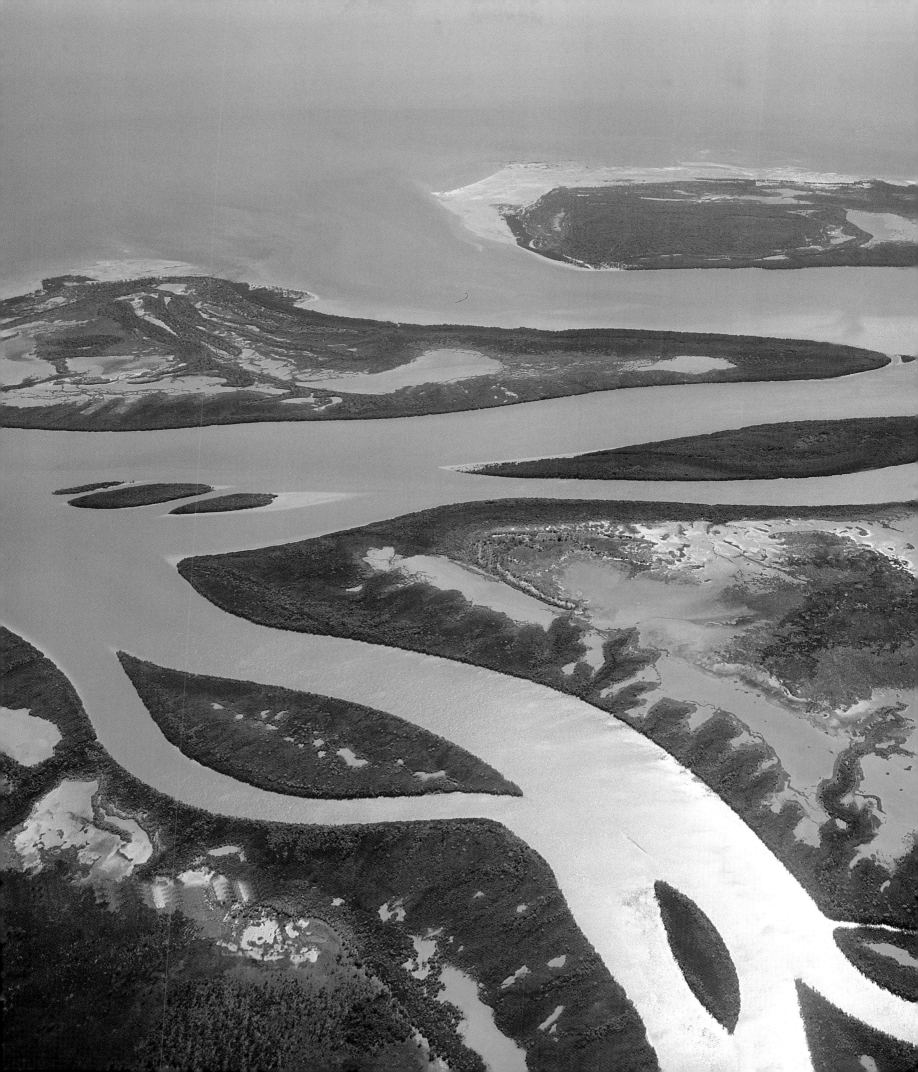

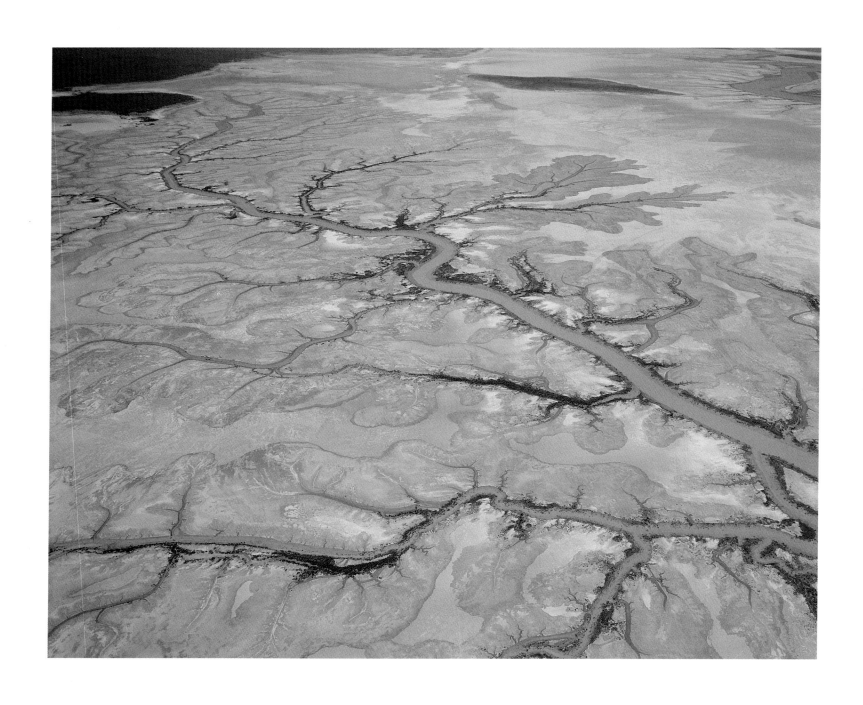

Above and opposite: Stokes Bay mudflats north of Derby, West Kimberley.
The gently sloping plains of fine, creamy mud and the intricately etched drainage systems of the deltas of northern
Australian rivers — masterpieces of water, mud and plants, impossible to perceive at ground level.

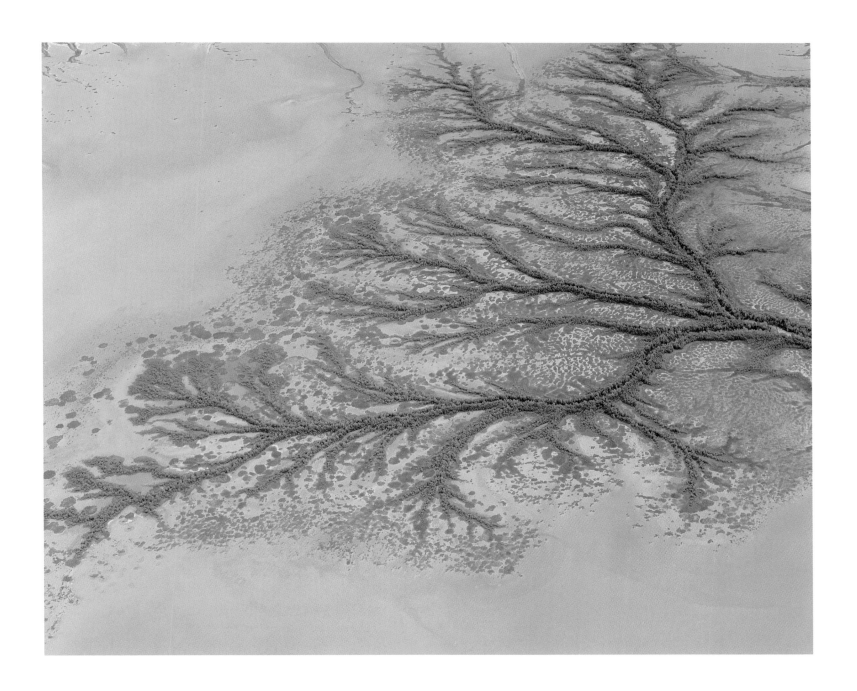

Overleaf: A patchwork mosaic created by a wandering river system in the late dry season: open river channel carrying 'white coffee'; fresh green, tidally irrigated mangroves by the active channels; bare, hypersaline clays; brown drying-off grass and shrublands; a charcoal grey area burned by the the first dry-storm lightning strikes.

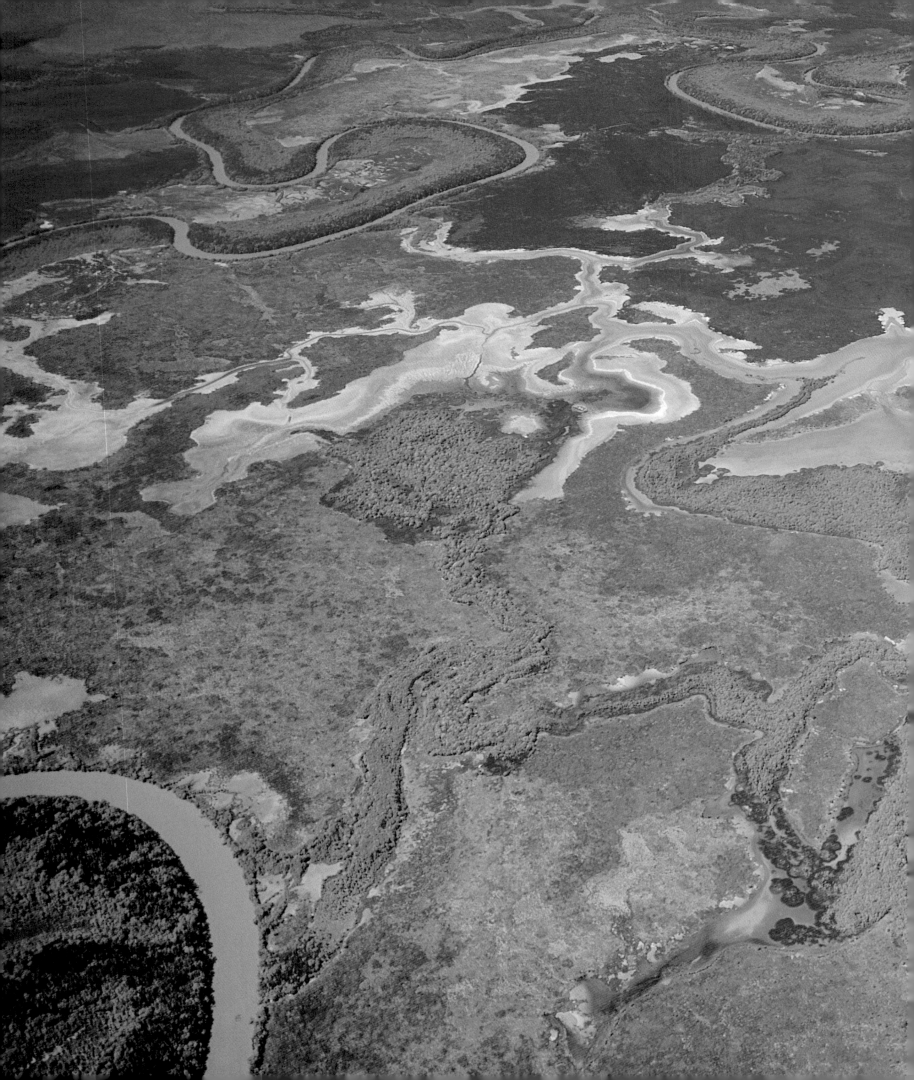

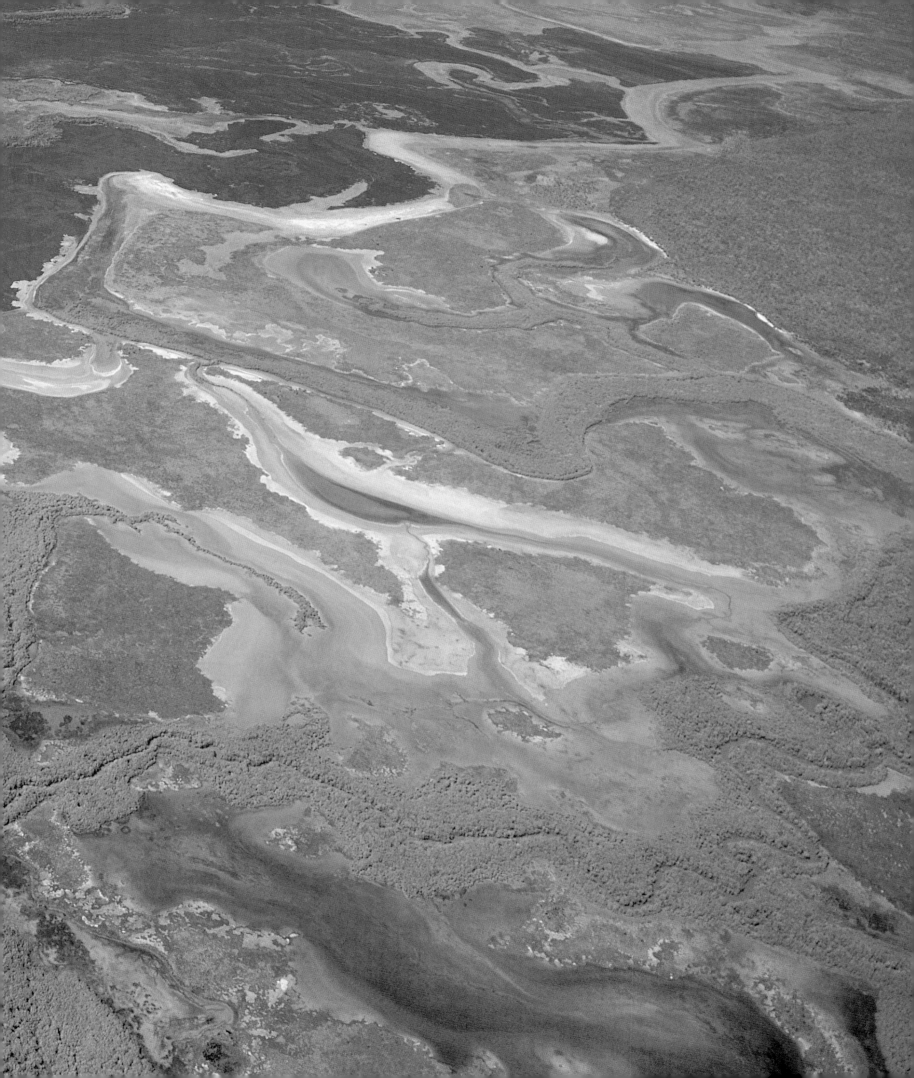

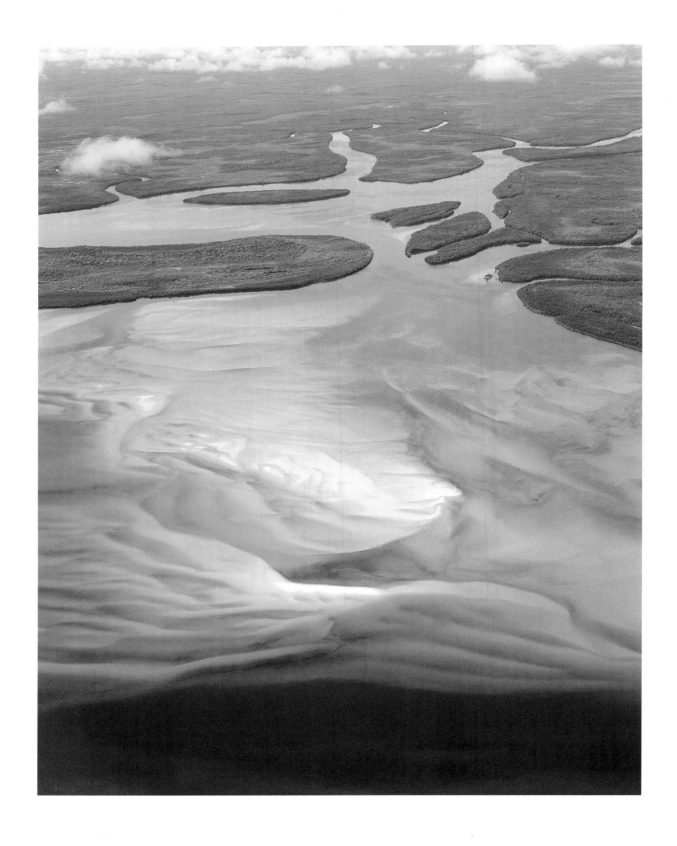

Kennedy Inlet, Newcastle Bay, tip of Cape York Peninsula, Queensland. The deltaic river mouth is choked with sandy shoals and underwater dunes formed by rapidly flowing water. Whiting, flathead, mulloway, bream and tailor are typical in this habitat.

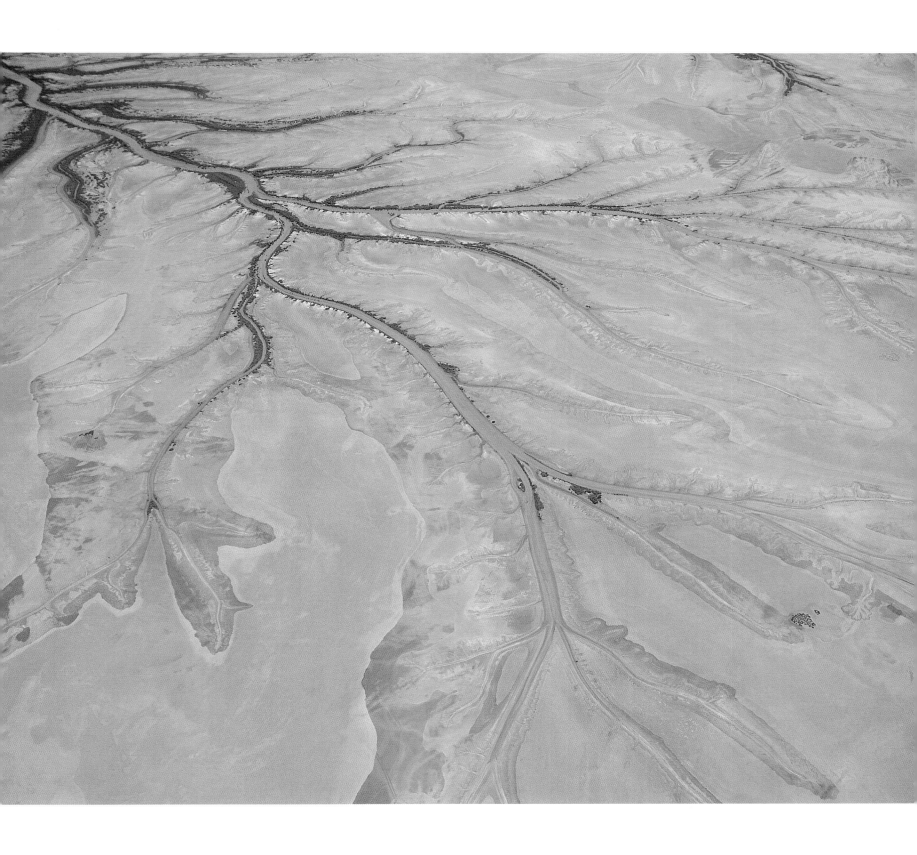

Saturated muddy high tide marks spreading out from the branches of the drainage tree which admit and dispose of the King Sound waters of Derby. Spring tides and storm surges cover this whole flat.

One of the boundless beaches of north-west Australia, with clays draining from the beach and being sucked out to sea. Tormented by massive seas of the summer cyclones, these beaches are cut and filled and parallel hind beach dunes may be created or destroyed.

Opposite: Part of the One Tree Island reef, Capricorn Group, east of Rockhampton, Queensland. Skeletons of the coral polyp and any other resistant part of reef plants and animals are the base of the current living reef which is battered, chewed, part digested and swept into piles on the reef crest to become a cay, to be colonised by plants, seabirds and turtles.

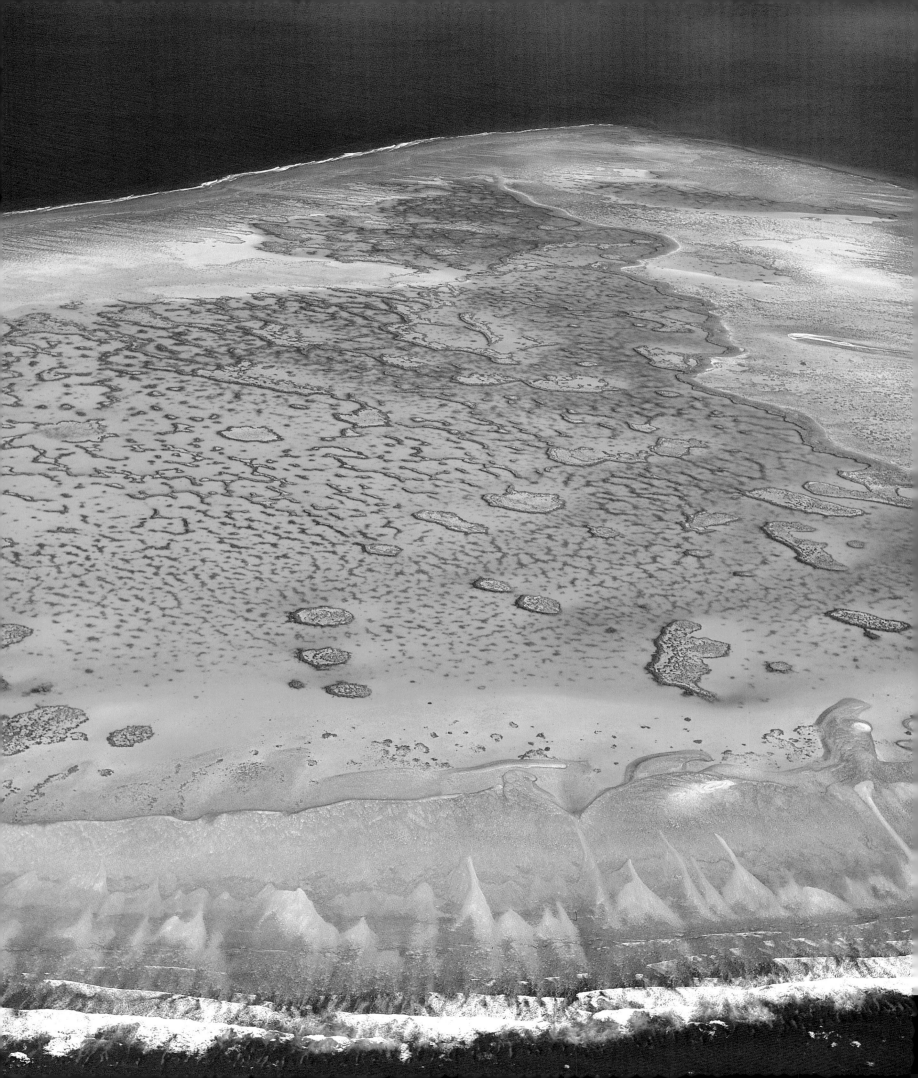

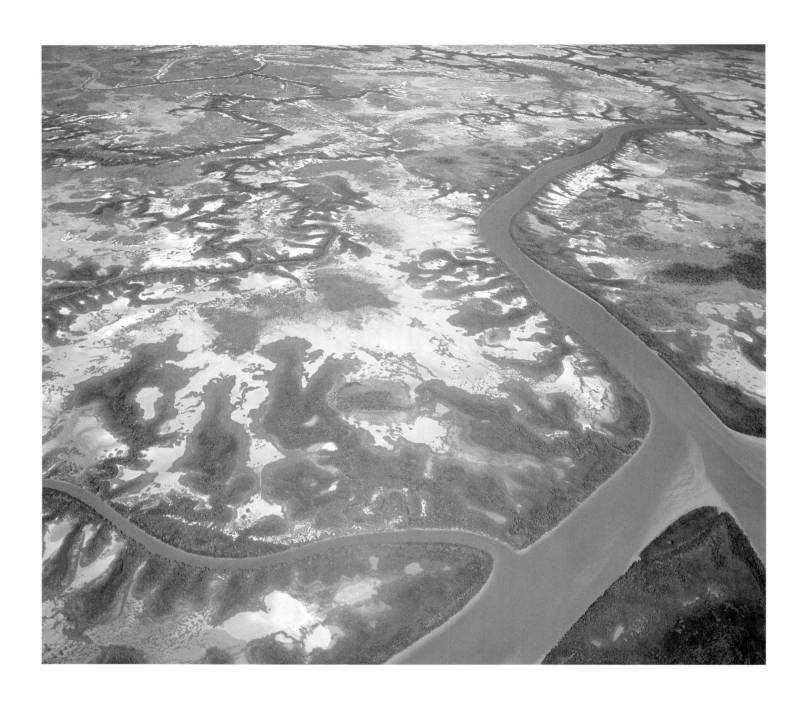

Tidal river sweeping inland, Van Dieman Gulf, north-east of Darwin, Northern Territory.

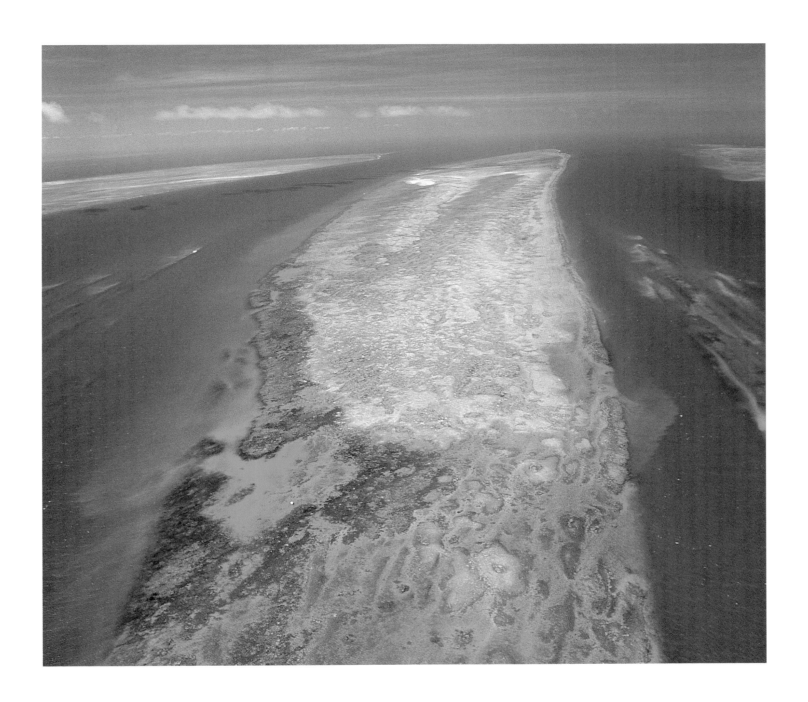

South Torres Reef flanked by Dayman and Simpson Channels, north of Thursday Island, Torres Strait, Queensland.

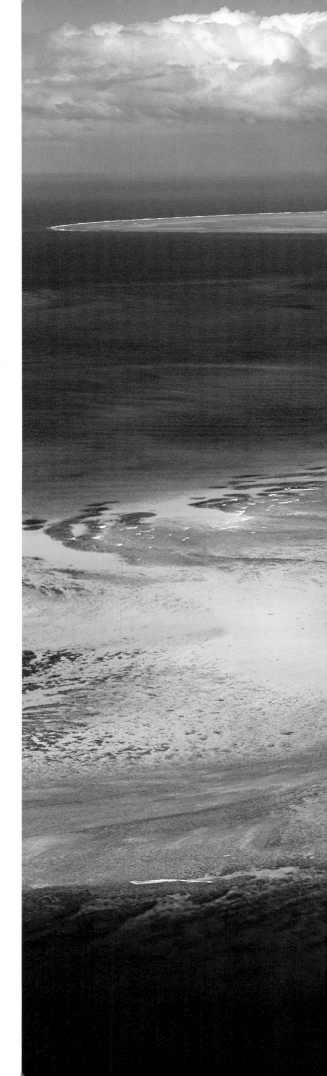

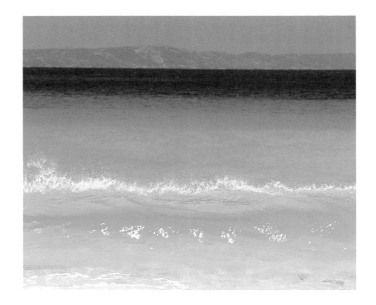

Symmetry of wave action, near Albany, south-west Australia.

Opposite: Polmaise Reef in the Capricorn Group, east of Rockhampton, is one of nearly three thousand reefs and about nine hundred islands which make up the Great Barrier Reef. The warm, clear, unpolluted waters of the Coral Sea have maintained one of the planet's most beautifully complex, dynamic and abundant living systems.

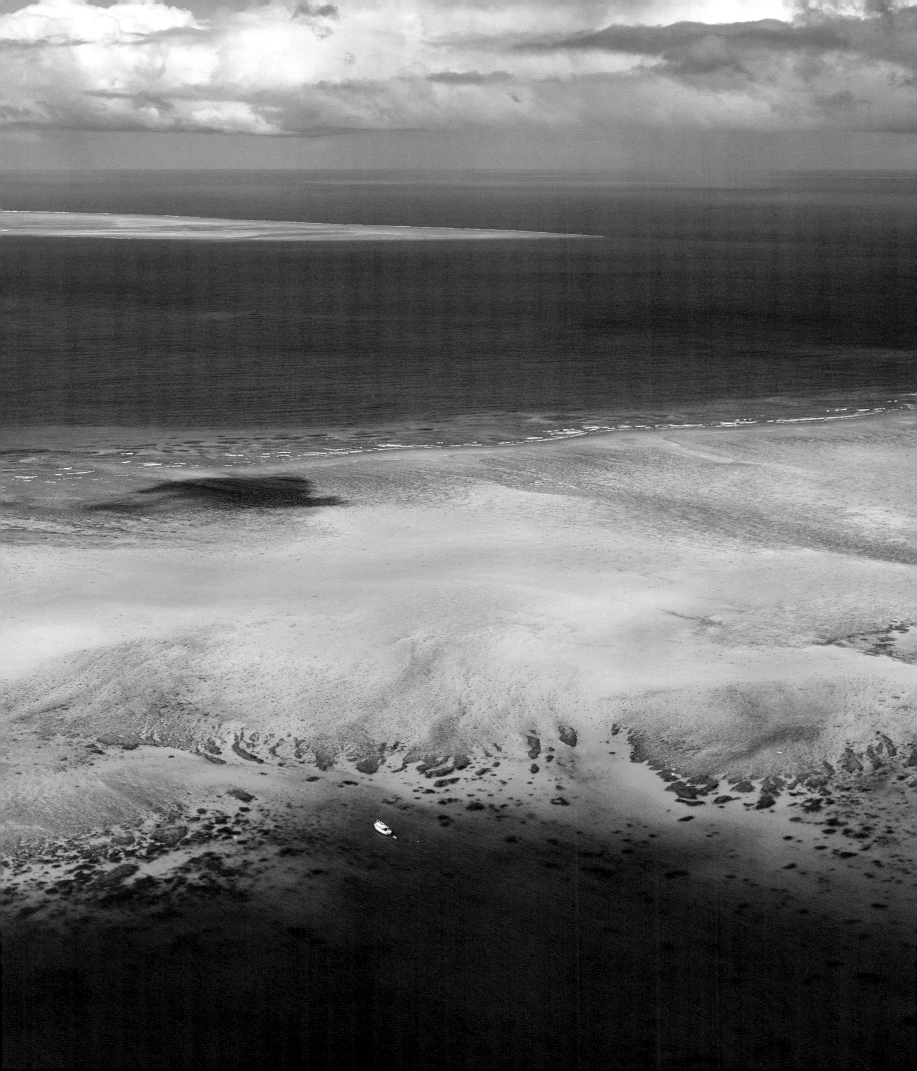

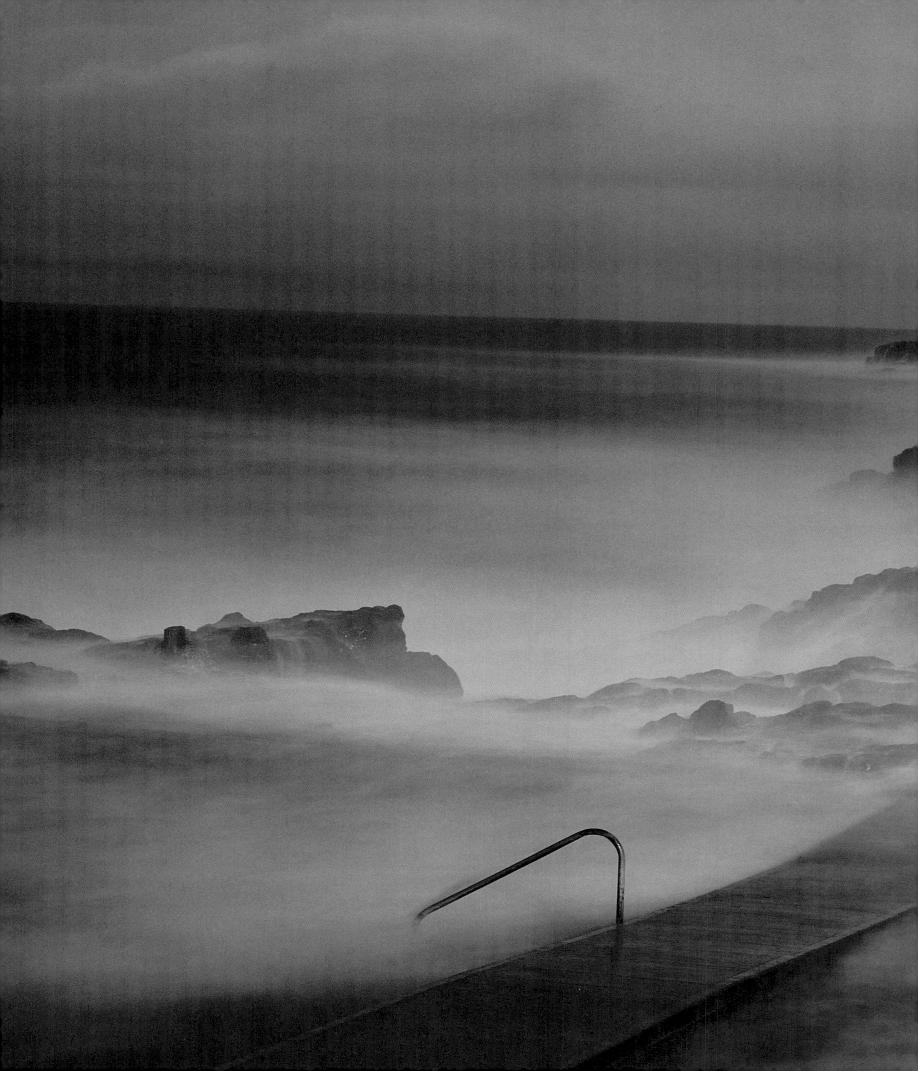

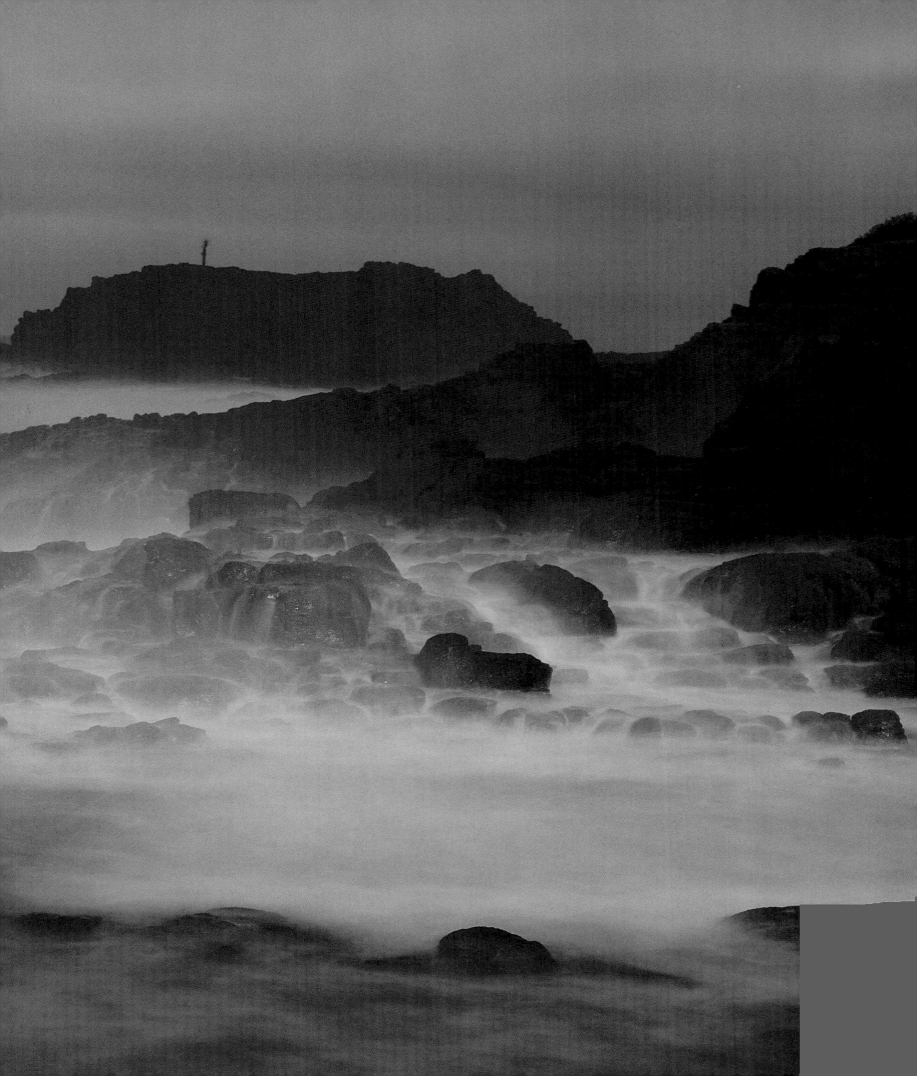

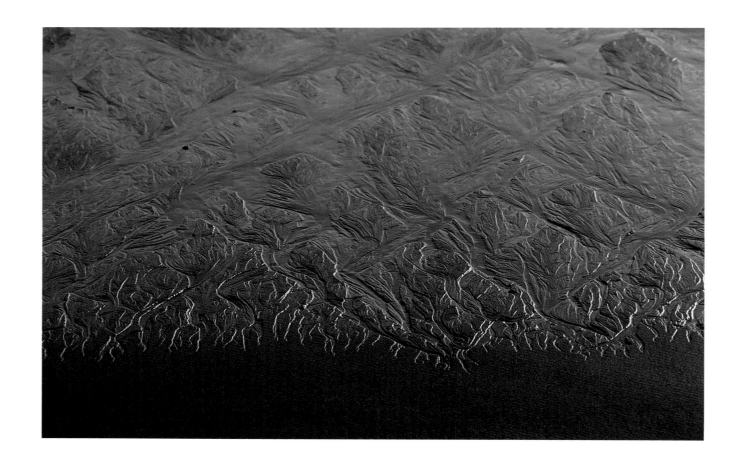

Is this chaos? A lacework of tiny channels form as water stored from a higher tide quietly drains back to the ocean; the timeless ebb and flow of land shaping processes.

Opposite: Waves of the Indian Ocean meeting waves of sand; the dunes near Augusta highlighted by the falling light of day.

Previous page: New South Wales coastline, near Narooma, 160 kilometres north of Bega. The restless sea came and went many times, dousing and draining from the shore, to form this creation in blues; fluorescent lights like shooting stars in the water, against the restless rushing of the sea.

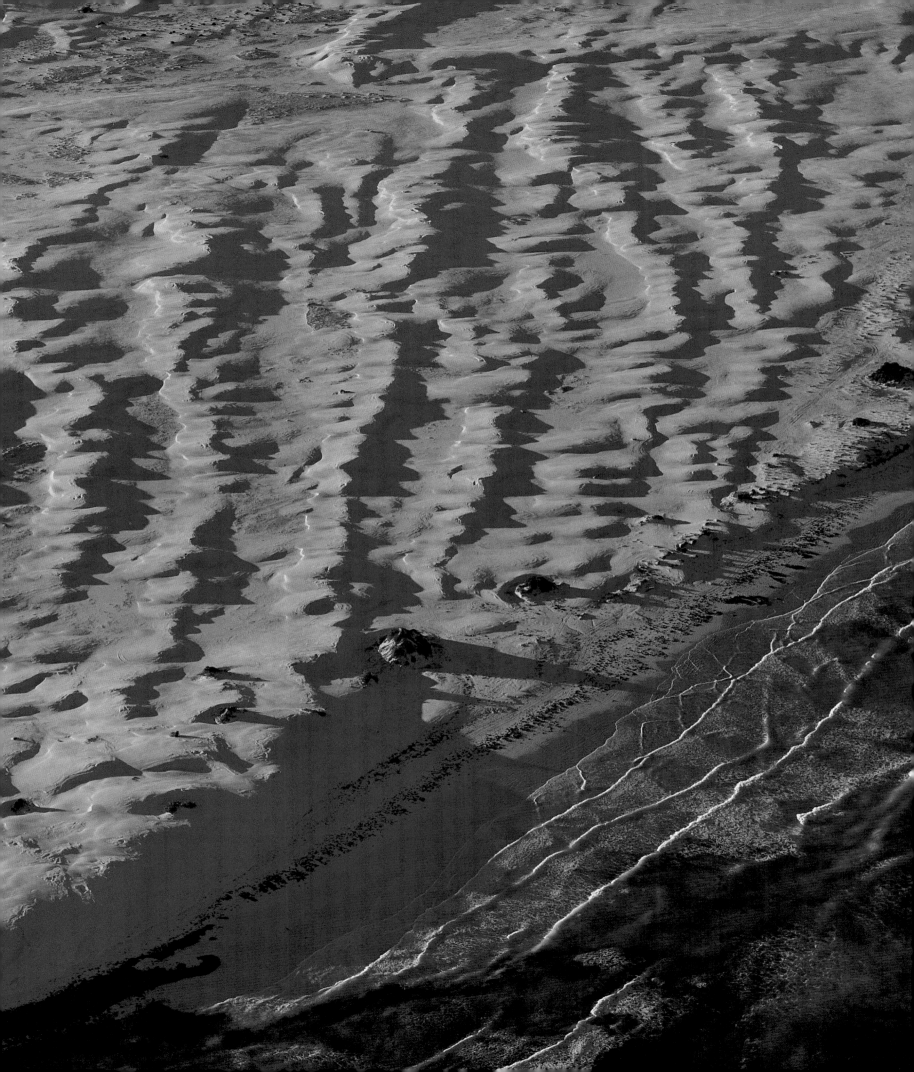

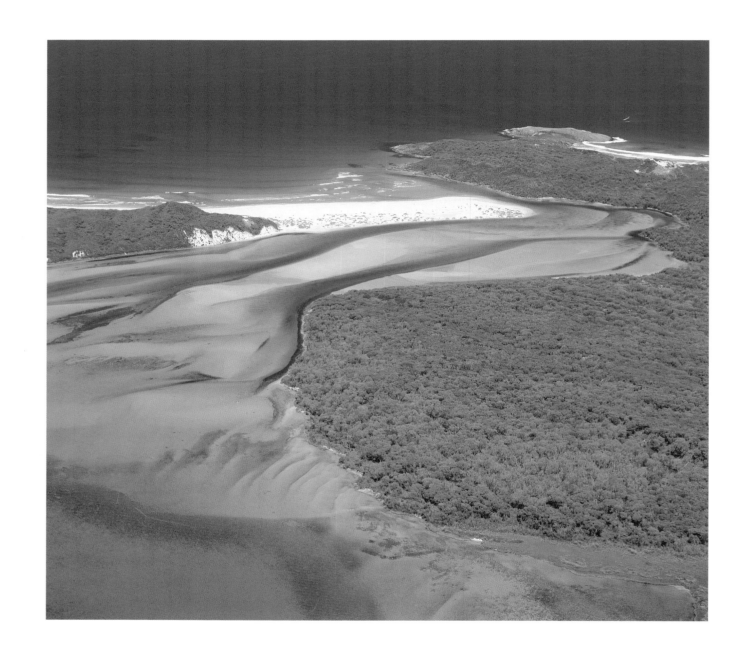

Walpole Inlet, west of Albany, where the Frankland and Deep Rivers meet the Southern Ocean.

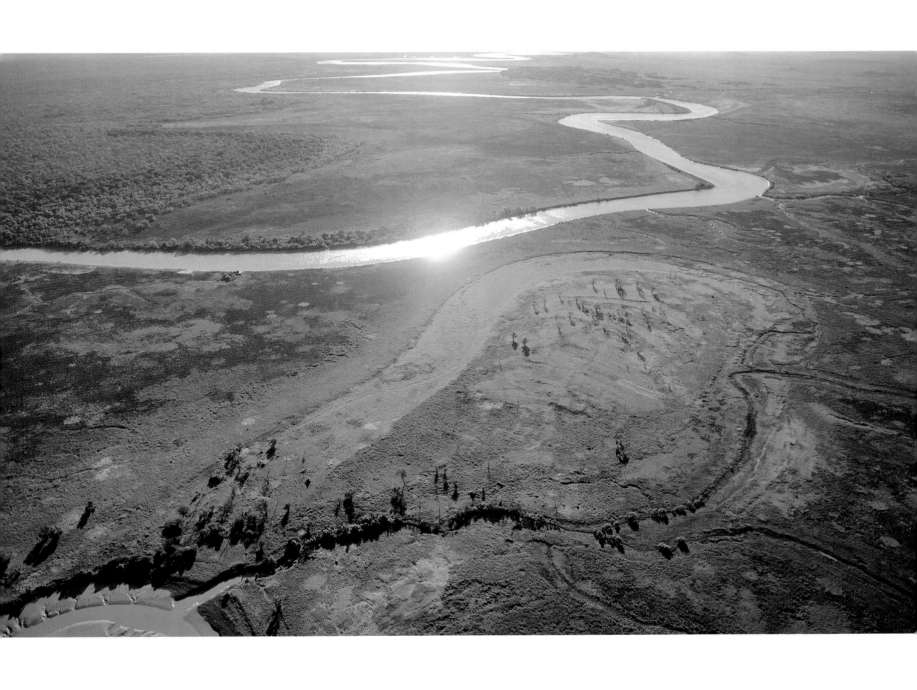

East Alligator River, Kakadu National Park, Northern Territory.

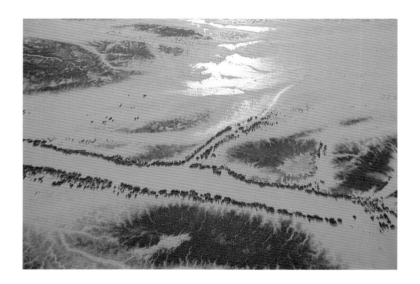

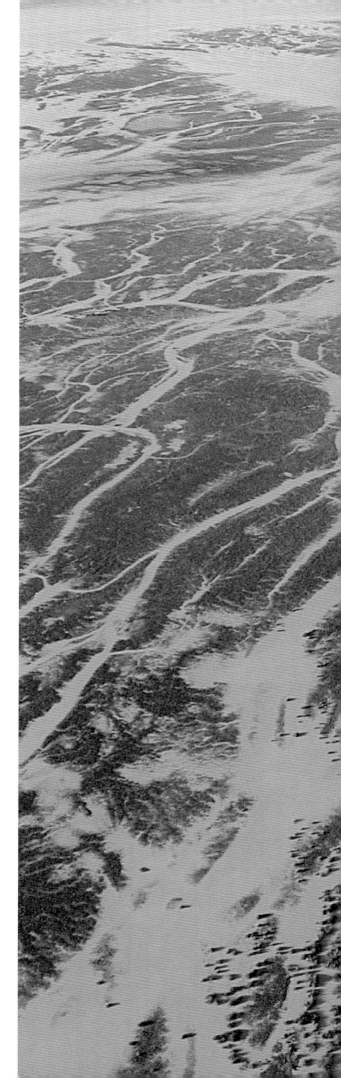

Diamantina River, far west Queensland, flooded by
torrential rains.

Opposite: The rivers of central Australia create Goyder Lagoon
before proceeding to Lake Eyre.

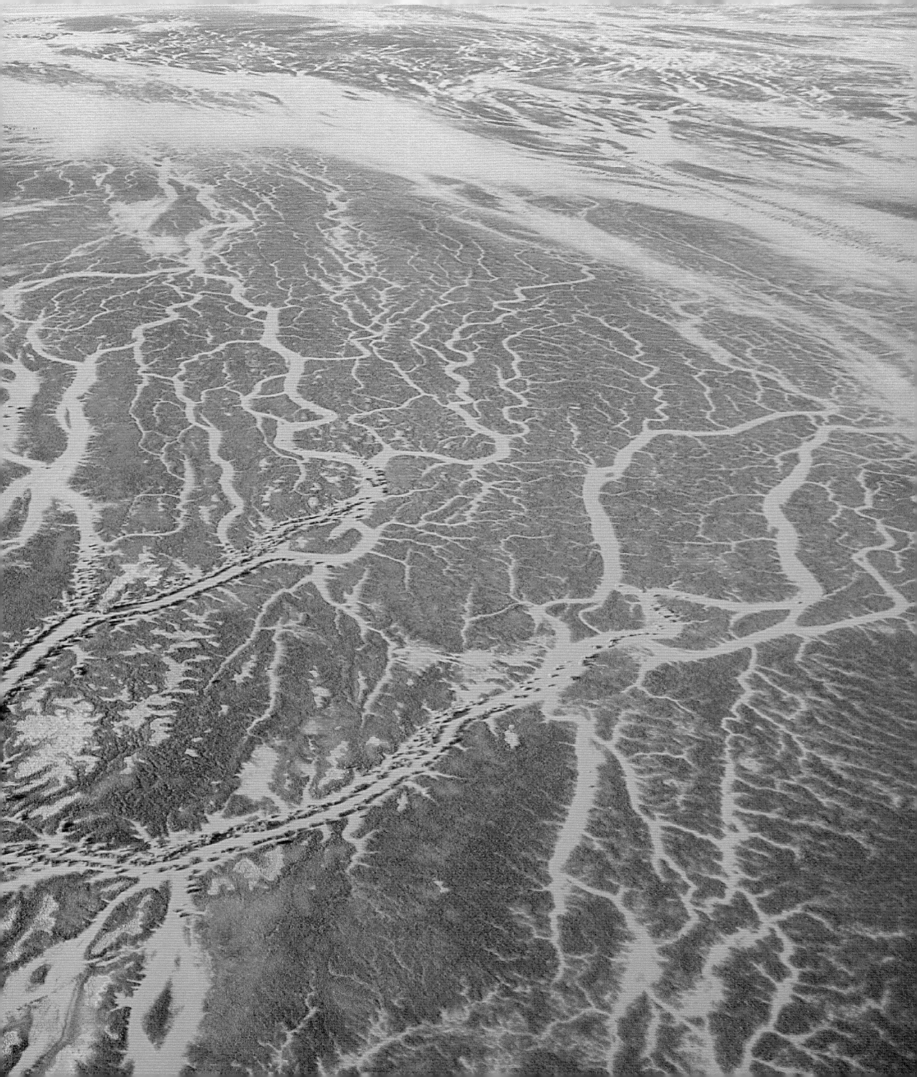

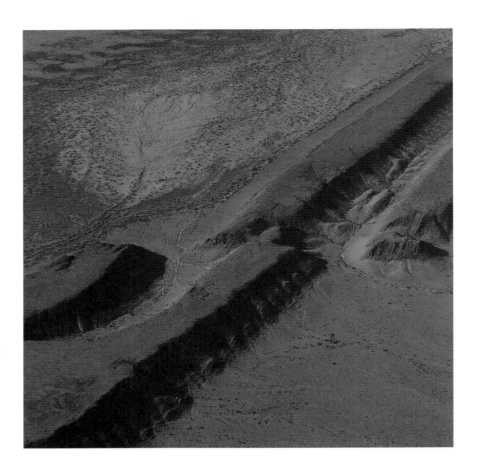

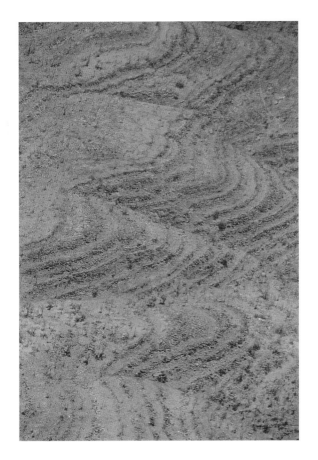

Left: Here the twin flat-topped ridges have been cut by a fault, then slipped along the fault away from each other. Such a break is useful for river development. See how the stream once ran straight down between the ridges. The left hand end broke left while the long valley and its stream has broken to the right.

Right: Alternating horizontal sedimentary rock strata in the Abner Range, south of Borroloola in the Northern Territory produce contour lines which clearly show the gully form.

Opposite: Near De Little Range, north of Boulia, Queensland.

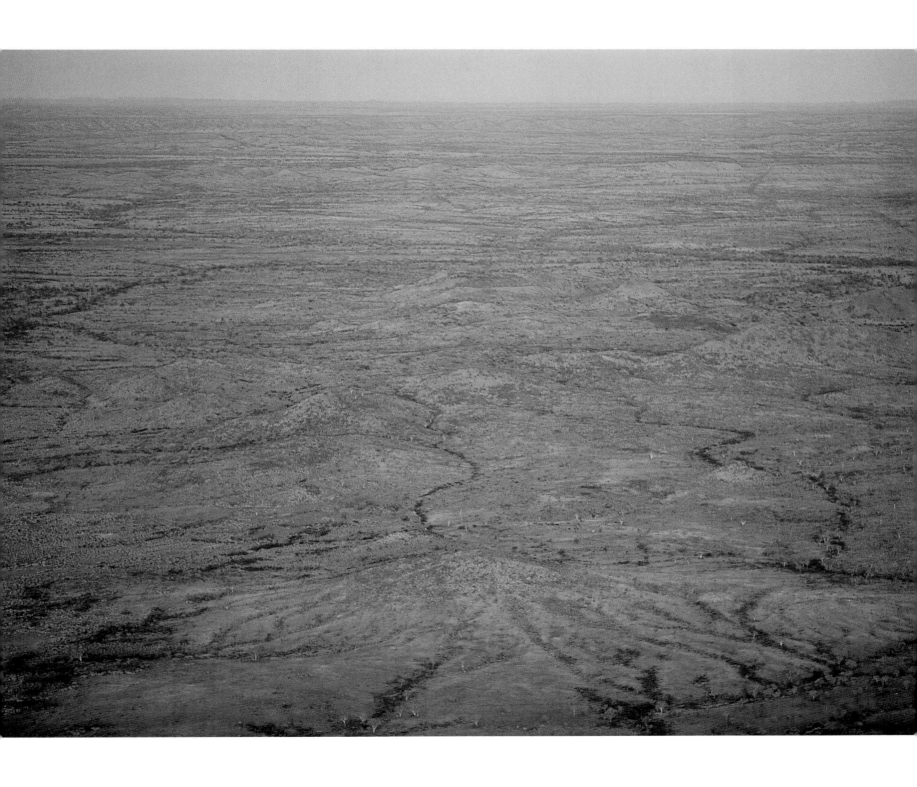

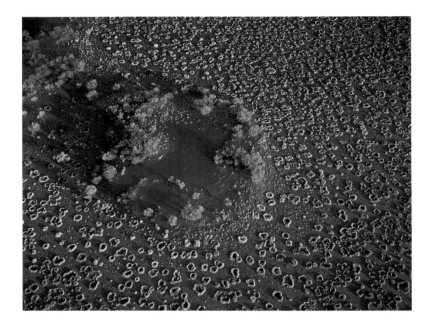

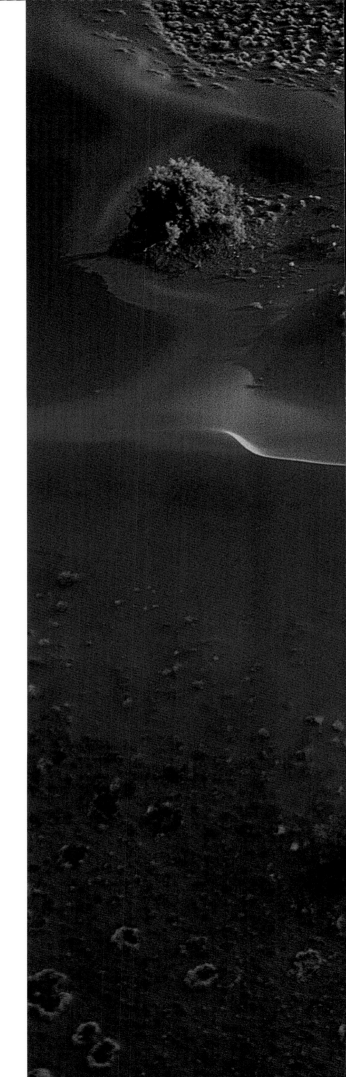

Old spinifex rings suggest blond smoke rings on the desert sands
near Windorah, south-west Queensland.

Opposite: Evening glow on the tactile dunes at Windorah.

Overleaf: Between Wills Creek and the Burke River north of Boulia,
Queensland. In 1861 Burke and Wills struggled across these mulga
and low gum covered hills on the first crossing of Australia
south to north.

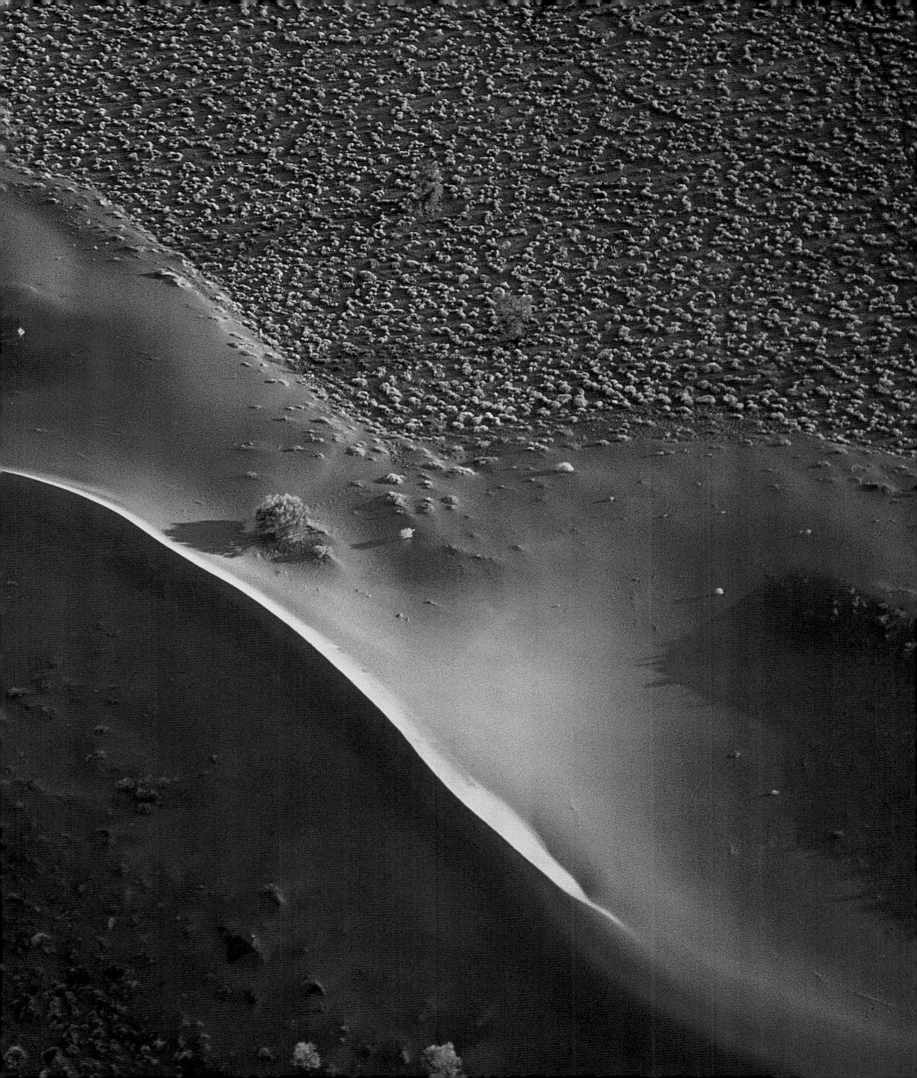

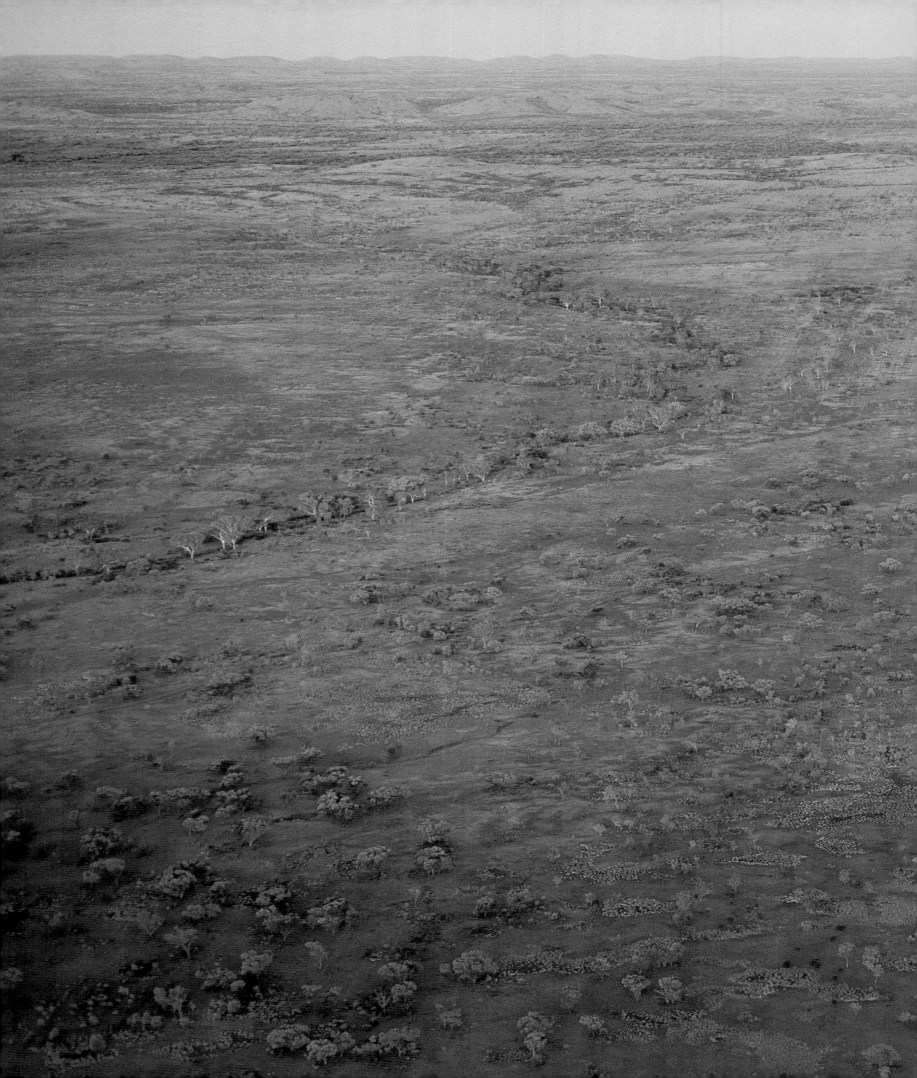

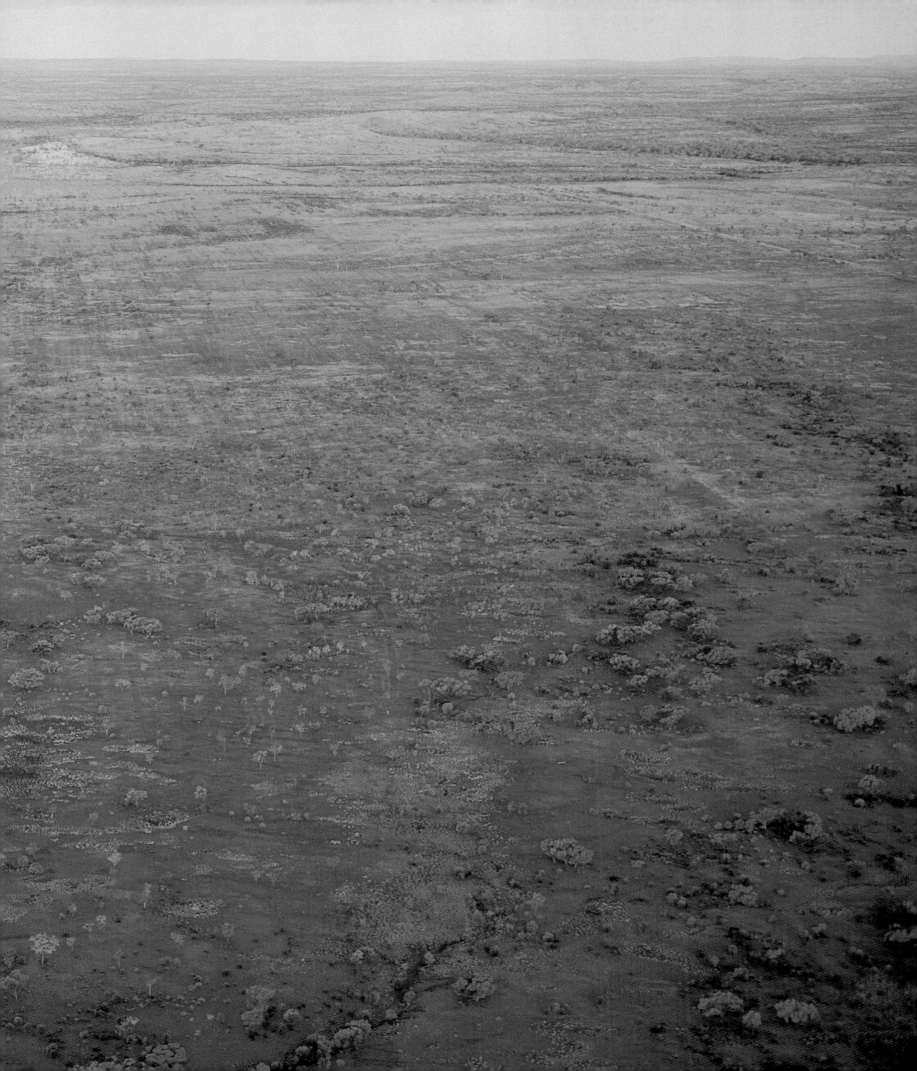

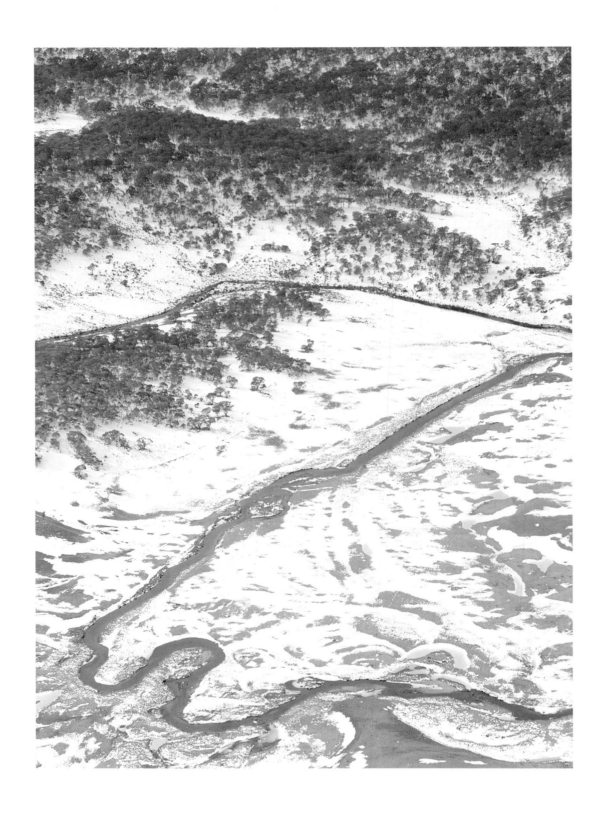

Winter in the Australian Alps, New South Wales. The Gungarlin River at Snowy Plain, south of Mt Kosciusko, shortly before entering the Snowy River.

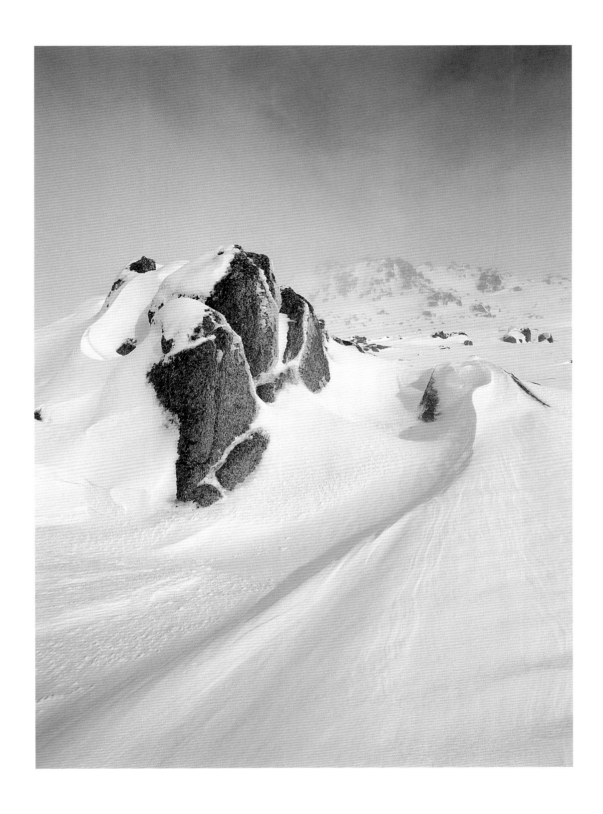

These granite tors on Crackenback Range below Mt Kosciusko, New South Wales, have passed
through many blizzards. Ultimately, extremely dilute acid rain, freezing temperatures, ice wedging,
hot summers, wind and water abrasion will remove these bumps from the range
and unearth yet more granite tors below.

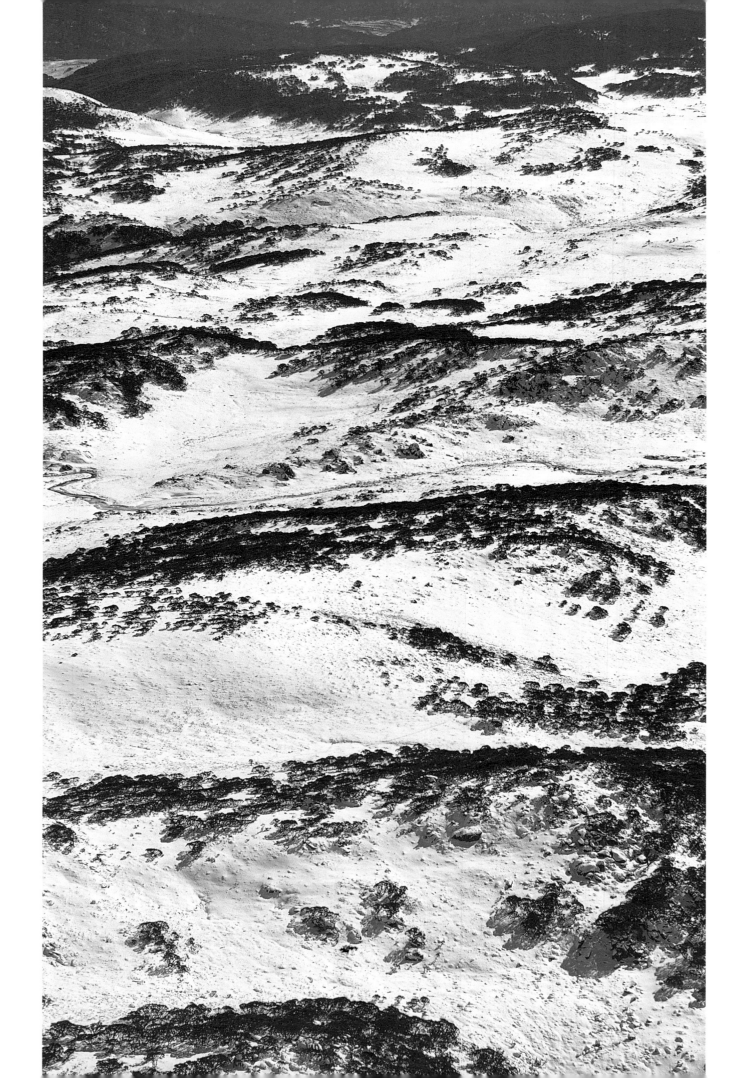

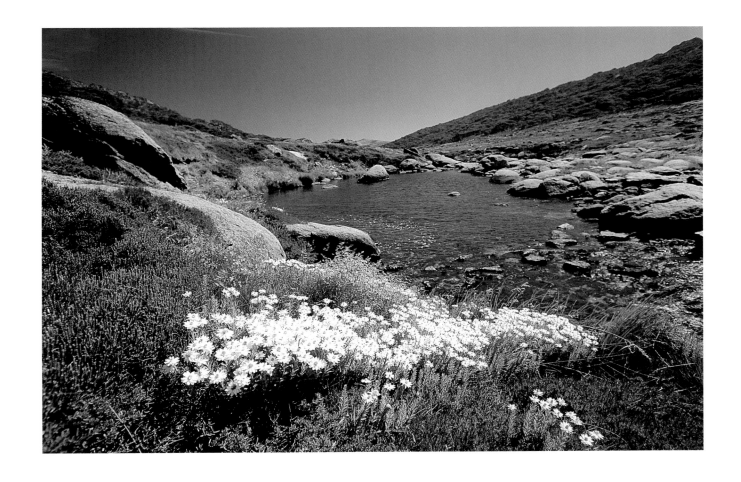

Paper daisies rustle by an alpine tarn, summertime, Charlottes Pass, Kosciusko National Park.

Opposite: Kosciusko National Park. In winter the undulating granite landscape of the Snowy Mountains is perfect for high class cross-country skiing; in summer it is a mecca for bushwalkers searching out wildflower meadows and stands of exquisitely formed and marked Snow Gums.

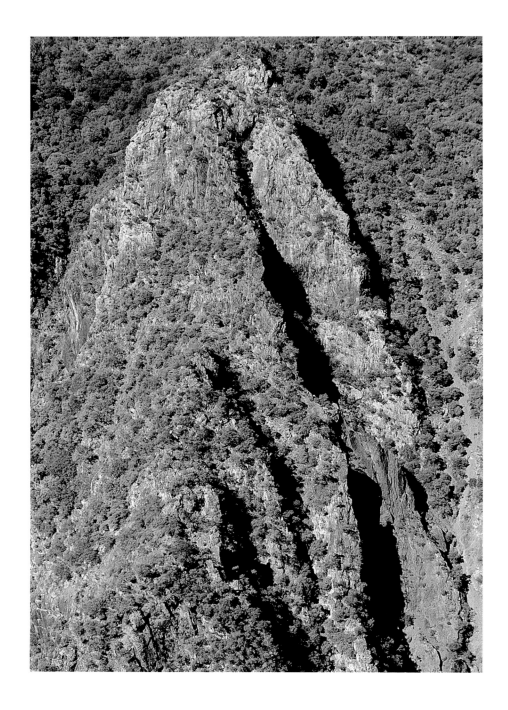

Wollomombi Falls near Armidale, New England, is evidence of the power of falling water as it cuts back along fault lines in the heat and pressure tempered slates. This massive gorge forms the edge of Wild Rivers National Park, New South Wales.

Opposite: The Hawkesbury Sandstone walls of the Blue Mountains were real walls to the early penal settlement of Sydney, defying any crossings until 1813. The high tops of the middle distance are all capped with basalt. Mounts Banks, Bell and Tomah are separated from the Katoomba line by the immense Grose River gorge. On the valley floor grows a stately forest of towering Sydney Blue Gums, while a thousand metres above, the heath and woodland is exceedingly rich in wildflowers, including the State Emblem, Waratah.

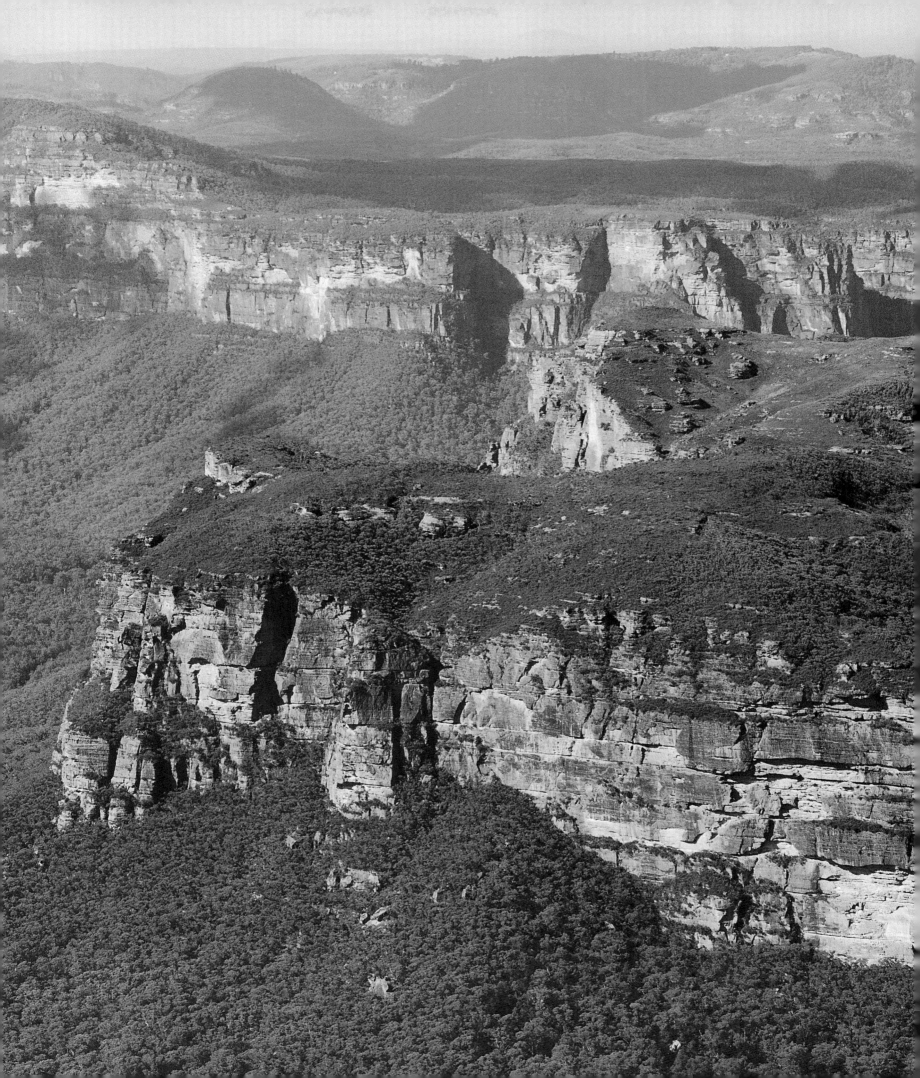

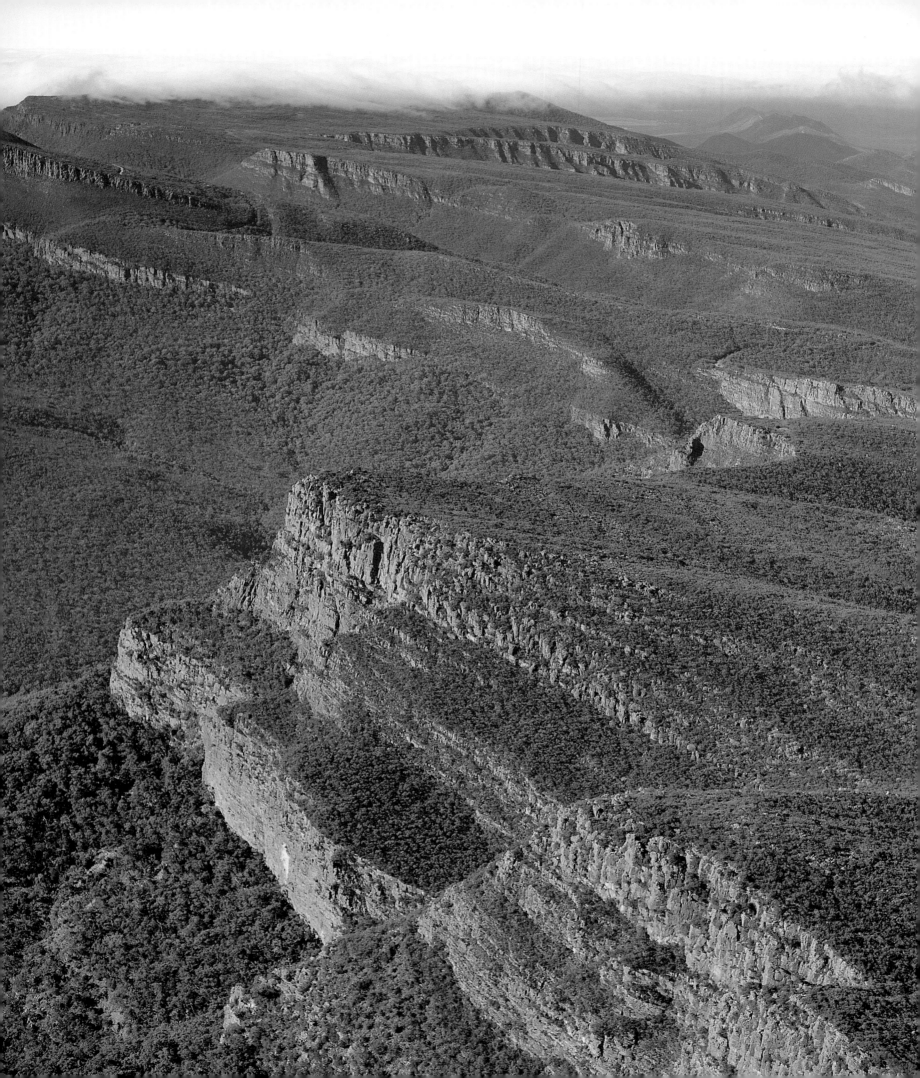

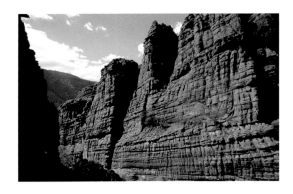

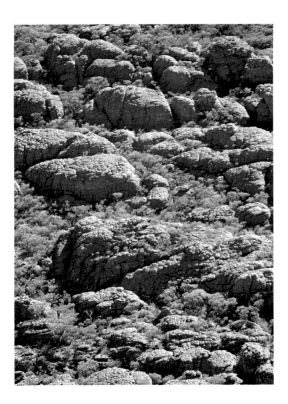

Top and bottom: The Grand Canyon along the Wonderland Track in the Grampians, western Victoria, is a weathered joint in the dipping sandstone which has been eroded out by a small creek. Etched into the walls are the layering patterns which record the way in which the original sand was deposited beneath shallow waters.

Opposite: The dipping sandstone of the Grampian Mount William Range forms the first cuesta range, the most eastern of four parallel ranges.

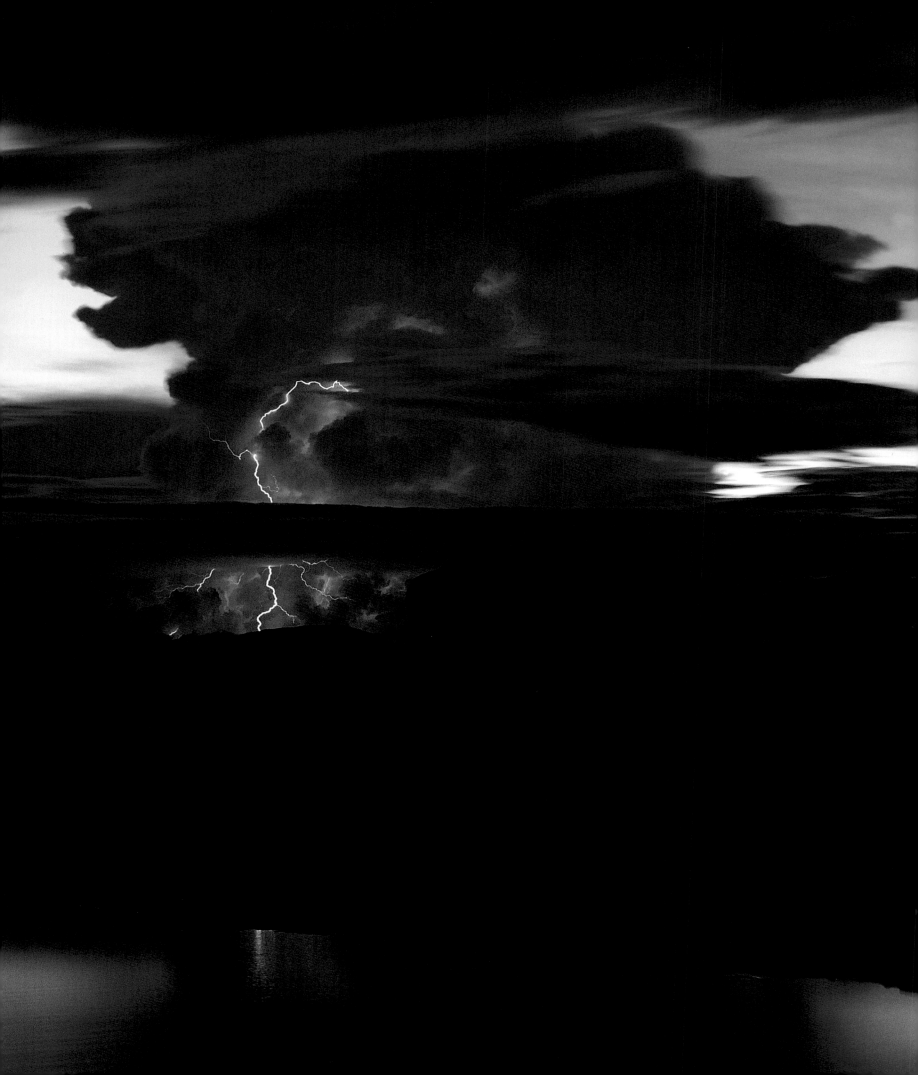

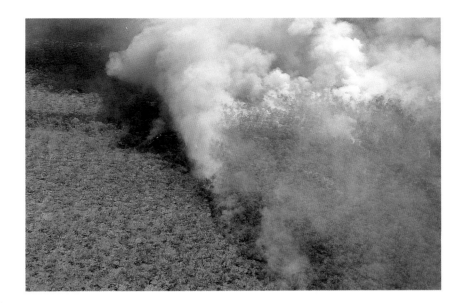

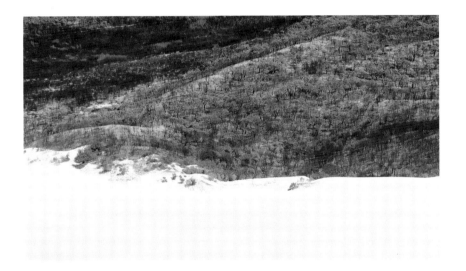

Top: Wildfire in the wallum and woodland of the frontal dunes along the
Queensland coast, if repeated too often, can initiate dune blow-outs
powered by the prevailing south-east winds, which send long tongues of
loose sand inland to engulf forest. Research has shown that significant
disturbance occurs to wildlife populations for some years after wildfire.

Bottom: Aftermath of bushfire in Northern Territory,
caused by lightning strike.

Opposite: Towering cumulus clouds of summer afternoon storms pack a
huge electrical punch, which in 1951, 1972, 1976, 1982 and 1997 caused
massive wildfires in Australia.

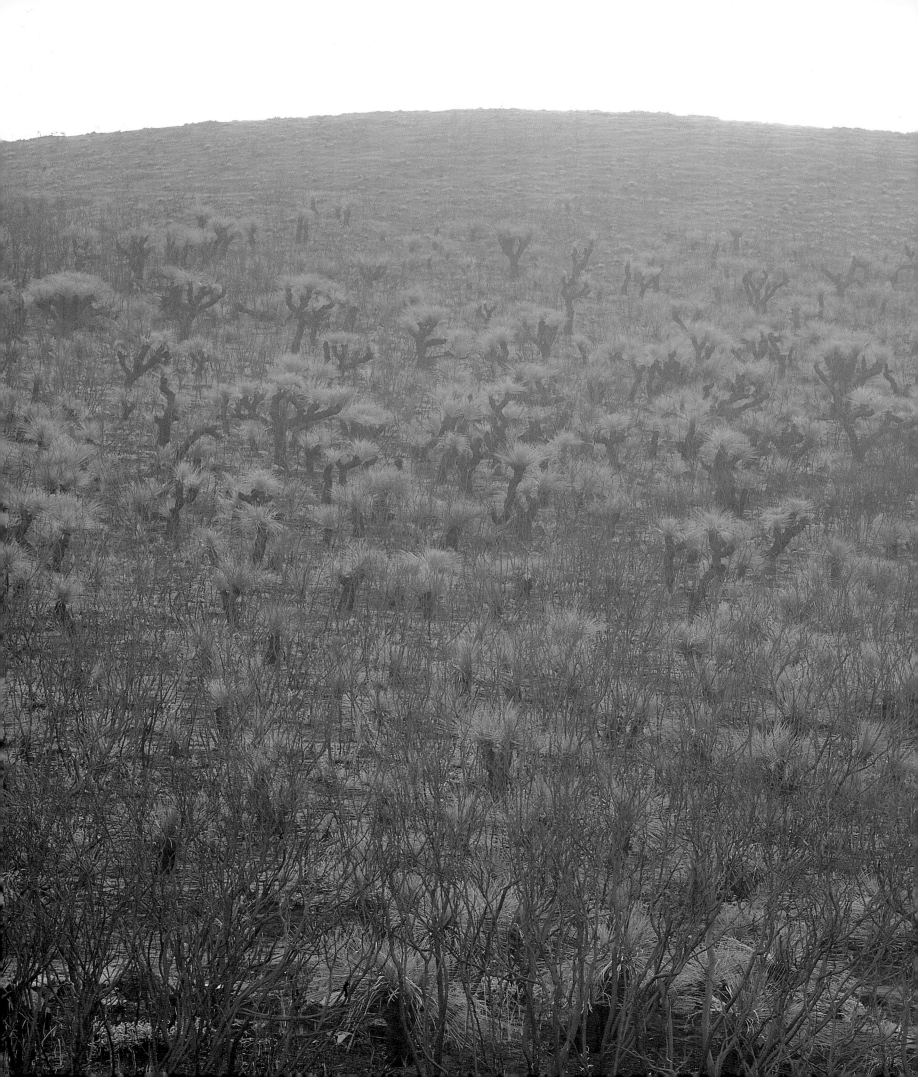

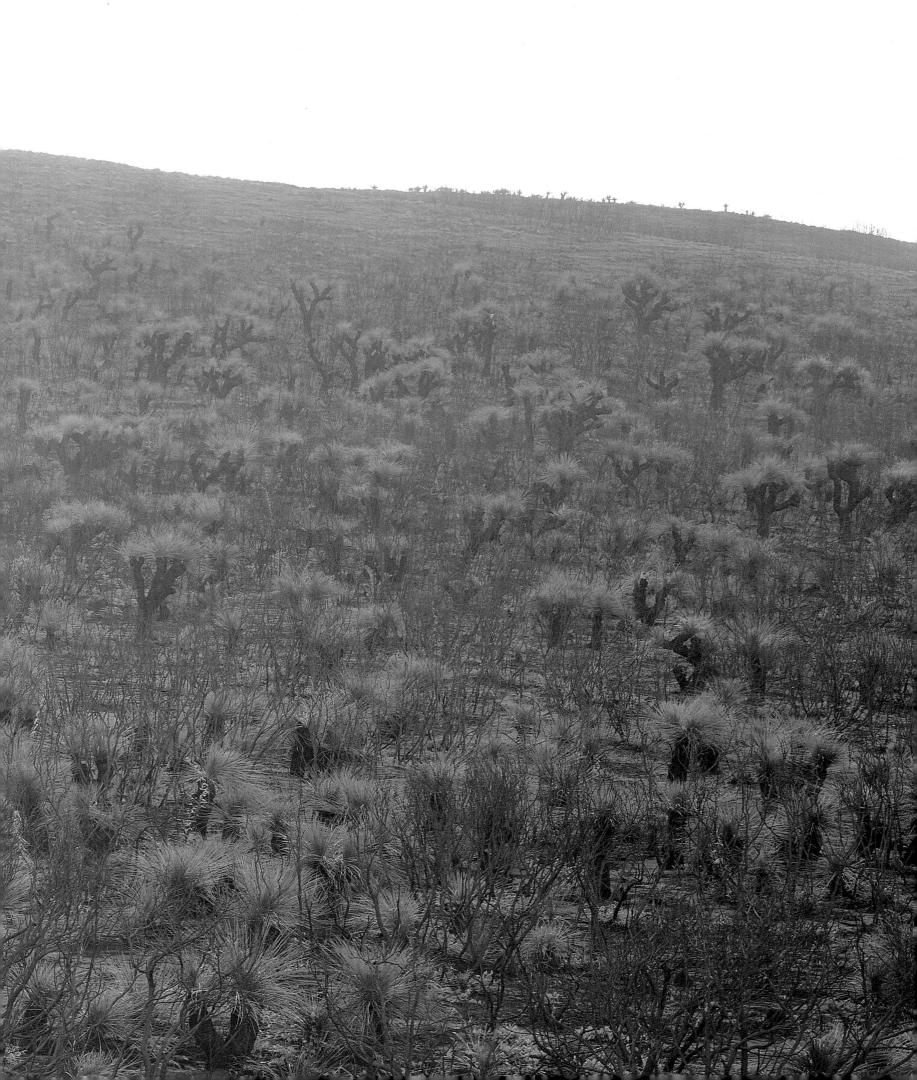

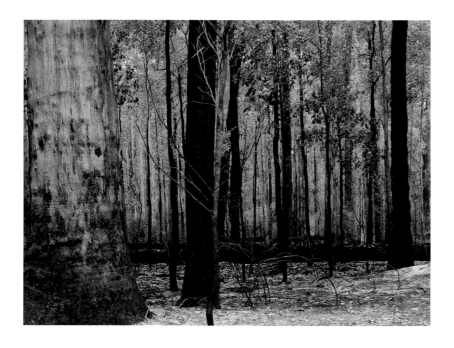

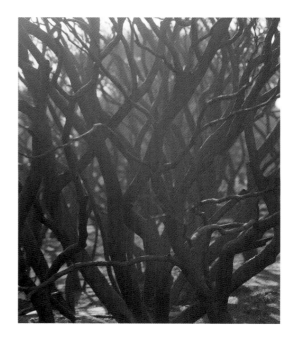

Left: The result of a cool prescribed burn in Karri forest, south-western Australia.

Right: Melaleuca and Leptospermum scrub, Cowarumup Bay, north of Augusta, Western Australia. The maze of blackened stems in the vague light of dawn, with a touch of sea mist, is inexpressibly haunting.

Opposite: Burned gullies in spinifex country near Dampier, in the Pilbara.

Previous page: Fire will not kill the environment; natural processes will continue, producing a living pattern to fit the new conditions.

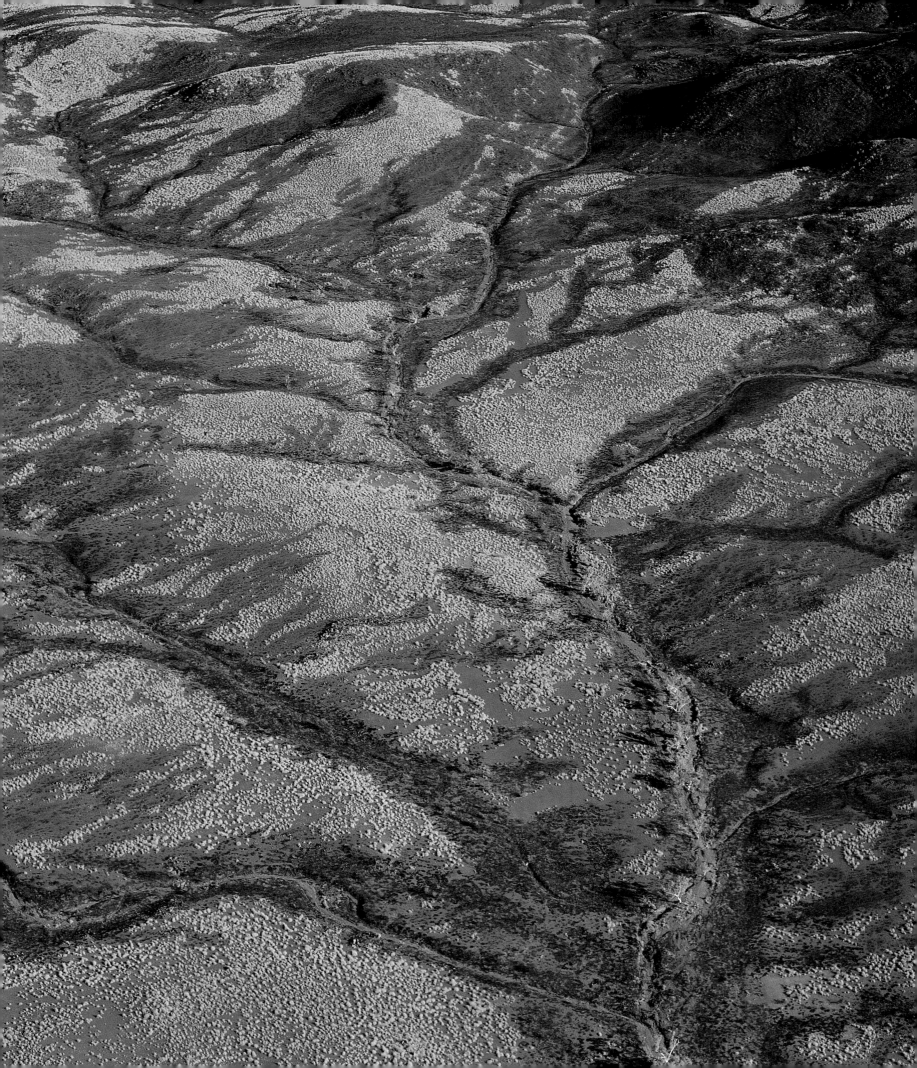

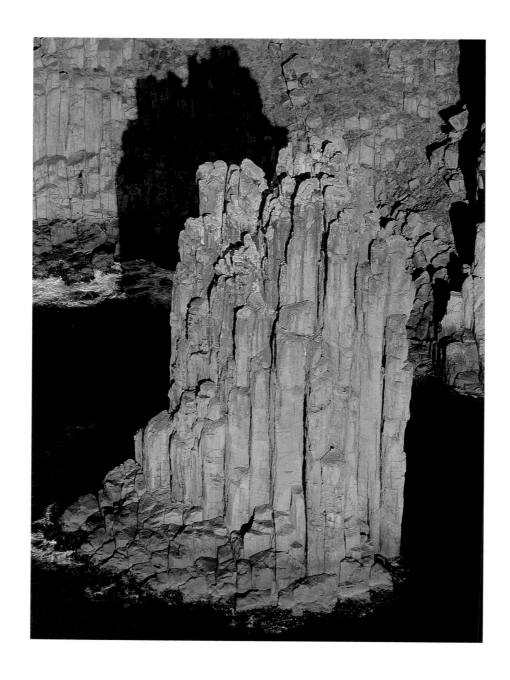

Above and opposite: The incredible dolerite columns, Cape Pillar, Tasman Peninsula, southeast of Hobart, Tasmania. About 160 million years ago extensive masses of a volcanic rock (sills of dolerite) were injected between layers of rock across much of Tasmania. These 450 metre thick sills cooled in the form of packed thick vertical columns. Since their cooling, many millions of years of erosion have removed the covering rock, and the sea, in places, has cut into the sill edges forming the spectacular Capes Pillar and Raoul and Tasman Island.

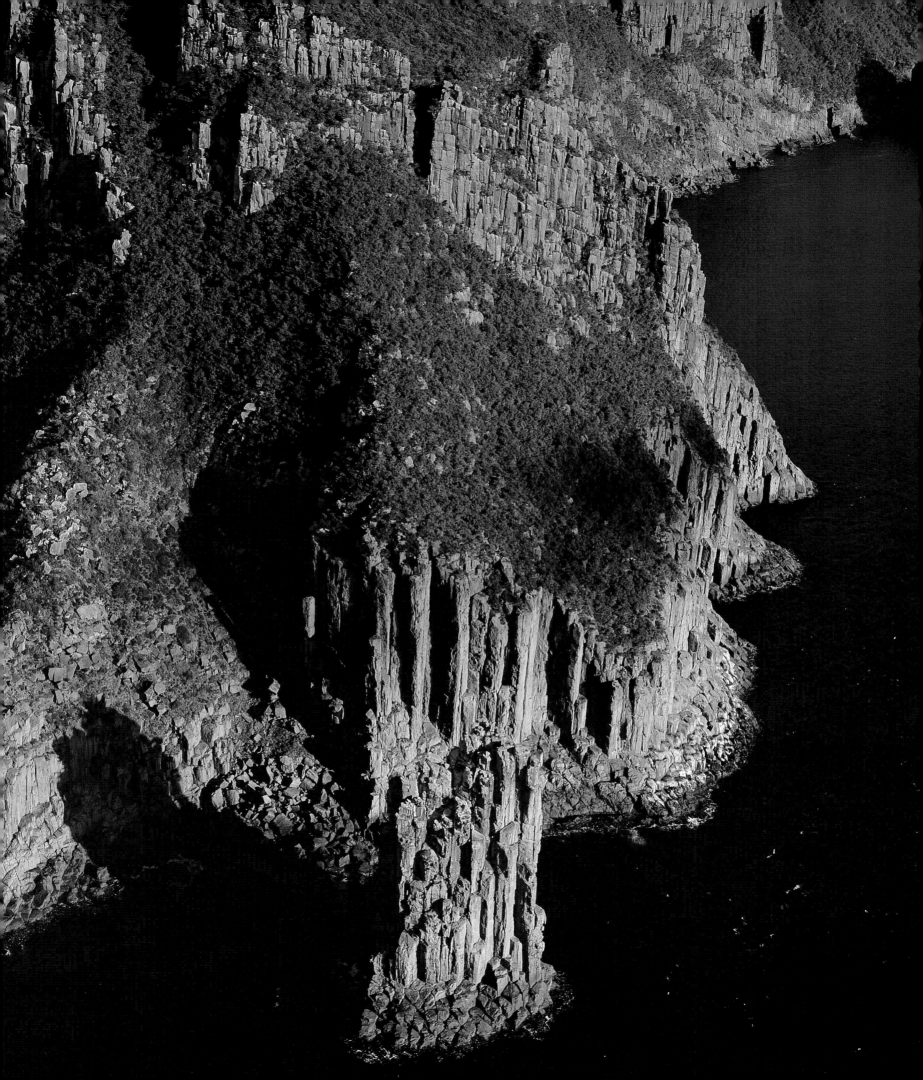

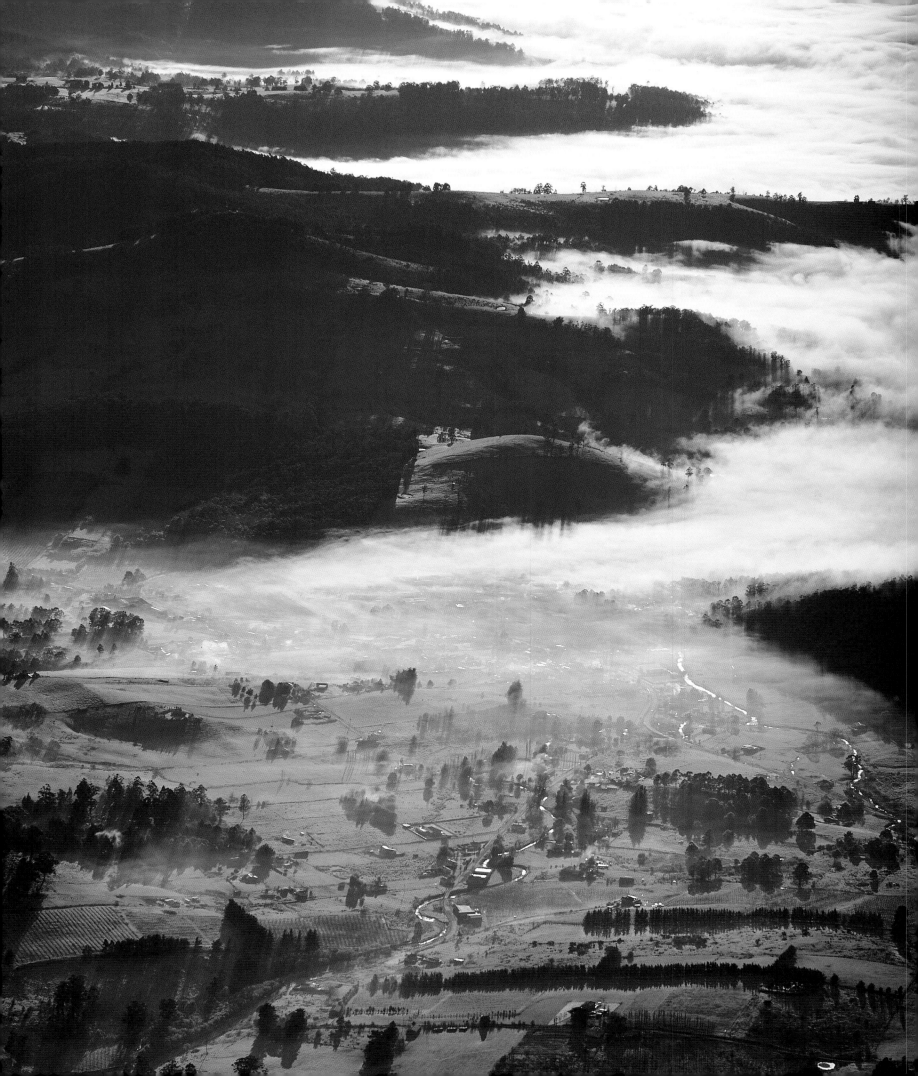

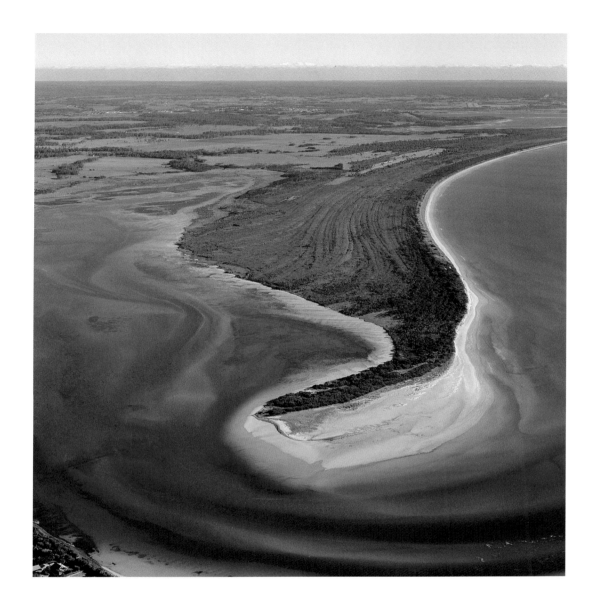

Perkins Bay, Stanley, northern Tasmania. When the sea level rose forming Bass Strait, islands stood out from the northern shore of Tasmania. But prevailing westerly winds swept waves and shoreline sand in an easterly direction, and eventually islands became joined to the coast by banks and spits of sand. Parallel lines on the scrub-covered spit show how sand ridge was built upon sand ridge.

Opposite: Mountains of the upper Huon, south-west Tasmania, rising from a sea of early morning mist.

Overleaf: The upper Huon, Tasmania.

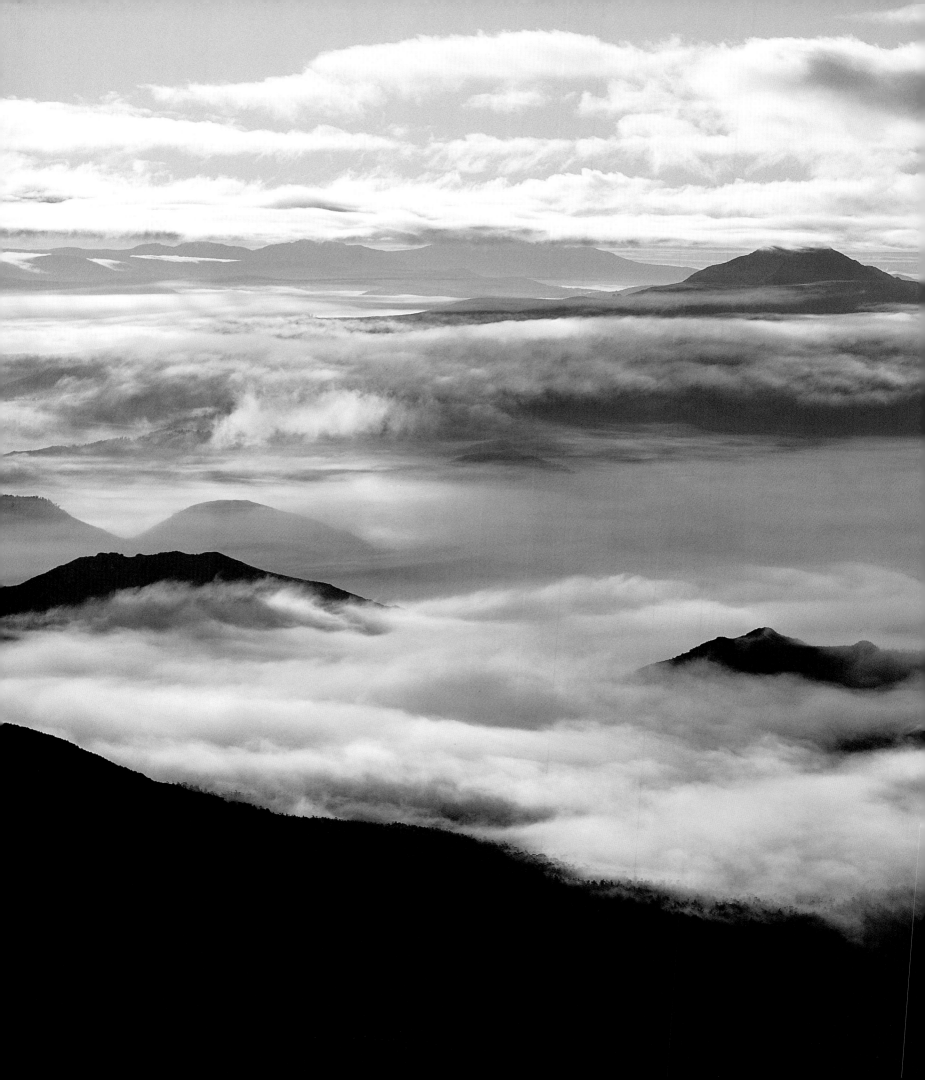

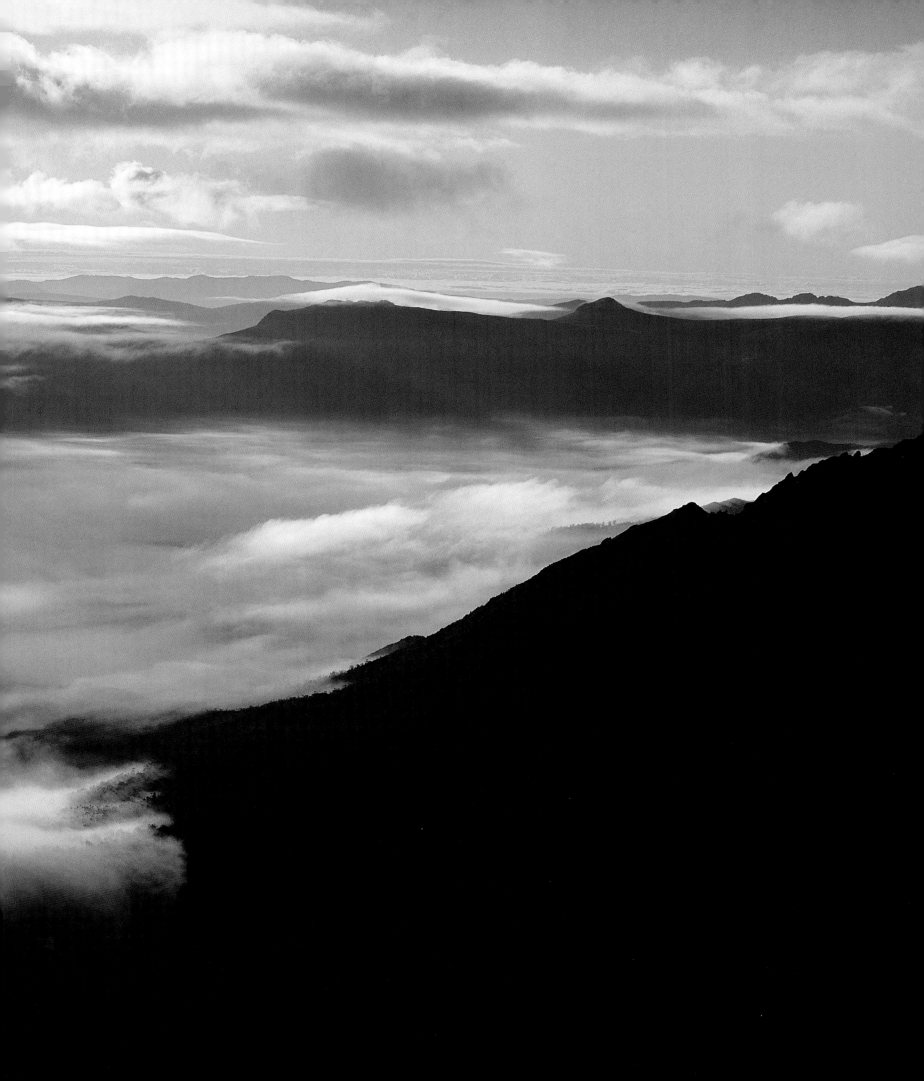

ACKNOWLEDGEMENTS

The photographs in this book are the result of several years work and would not have been possible without the assistance of many people and organisations, especially Jen Kelly my assistant.

The Royal Flying Doctor Service of Australia, for whom I produced the book *Australia's Flying Doctors*, as well as their calendars, over a few years gave me the opportunity to see parts of the outback not normally accessible.

Jan and Penny Ende invited me to join them in the Mobil and Qantas sponsored air race, enabling me to obtain a lot of new material for this book.

I would also like to thank pilots of the Royal Aero Club, Jandakot, Robyn Stewart of Northam and Sam Haynes of Sydney. Also the many people from outback stations and towns who have shared their local knowledge, enthusiasm and support over the years.

Much information and inspiration was gained from various other publications, in particular Reg Morrison's *Australia, The Great Southern Ark* and George Seddon's *Landprints*.

Other individuals and companies I owe thanks to are Gary Dufour, Alan Woodward, Janet Holmes à Court, Ray van Kempen and Hamersley Iron.

Finally, and very importantly, my thanks to Alan Fox for his knowledge of the landscape and his assistance with the captions.

All the photographs are as found, not manipulated or enhanced by computer. For me, to do otherwise would be an insult to the natural beauty of the Australian landscape which needs no such enhancement.

Richard Woldendorp